SPECTRUM 17: The Best In Contemporary Fantastic Art

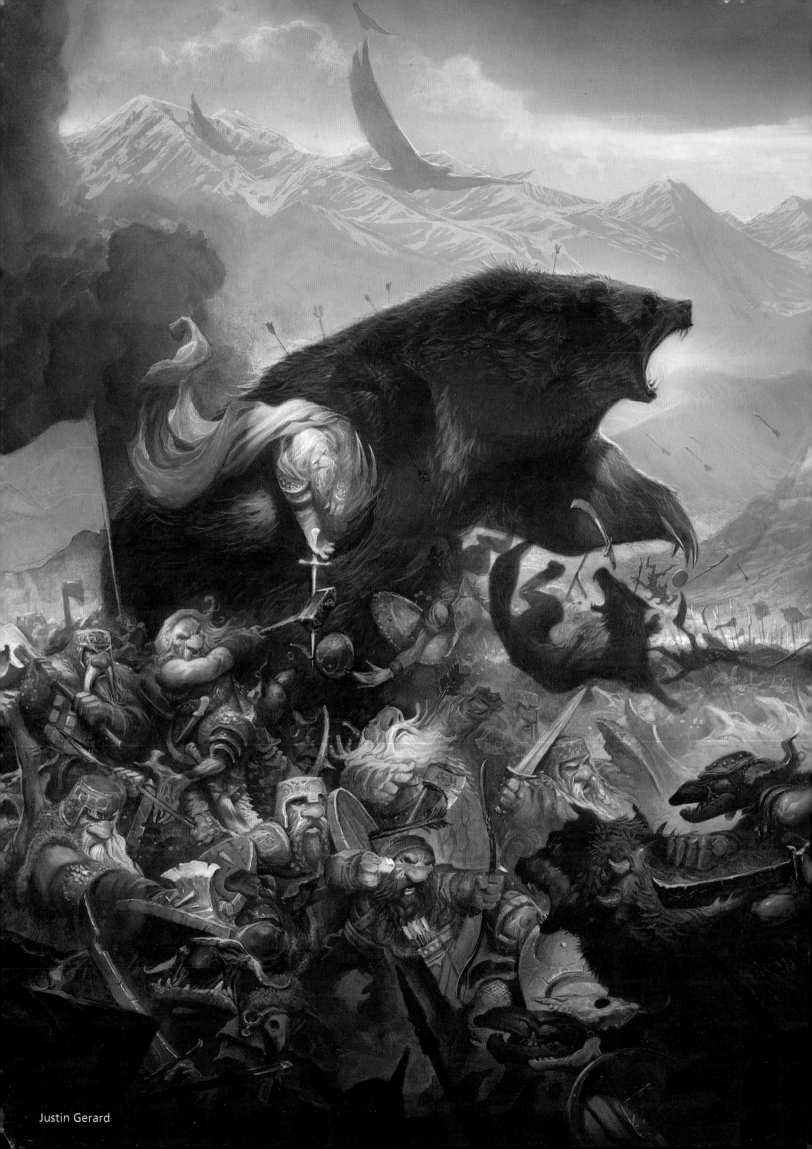

Justin Gerard

SPECTRUM 17

The Best in Contemporary Fantastic Art

Edited by

Cathy Fenner

and

Arnie Fenner

UNDERWOOD BOOKS
Nevada City, CA

Trade Softcover Edition ISBN 1-59929-043-X ISBN-13: 978-1599290430
Hardcover Edition ISBN 1-59929-044-8 ISBN-13: 978-1599290447

10 9 8 7 6 5 4 3 2 1

Artists, art directors, and publishers interested in receiving entry information for the next Spectrum competition should send their name and address to:
Spectrum Fantastic Art, LLC, P.O. Box 4422, Overland Park, KS 66204
Or visit the official website for information & printable
PDF entry forms: **www.spectrumfantasticart.com**
Call For Entries posters (which contain complete rules, list of fees, and forms for participation) are mailed out in October each year.

Published by
UNDERWOOD BOOKS
P.O. BOX 1919
NEVADA CITY, CA 95959
www.underwoodbooks.com
Tim Underwood/*Publisher*

Page 1, top to bottom:
Sean Murray
Steven Belledin
Gary Lippincott
Joe DeVito
Karlsimon

At right:
Android Jones

Contents

2009

by Cathy Fenner

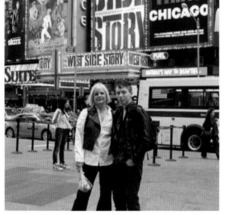

Cathy & son Rob Fenner in Times Square, New York City.

In 1970 I walked into the local card factory to get what I thought would be "just a job." I didn't have any plans for a career but just needed a dependable source of income to fund my young lifestyle. After filling out the required forms and surviving the interview—which included the question "are you planning on having a baby anytime soon?" (yes, that was a perfectly legal question at that period in history)—they happily hired me.

The job I took was a clerical position and I performed those duties for them in different divisions of the company (we're talking corporate headquarters here with several thousand employees) before I took the opportunity to learn what was then called "paste-up" in the Lettering Department. Our job was to put all the words on all the products that the company produced. We originally used rubber cement (and eventually moved on to wax) to place type onto paper "flats" that were then statted and combined with artwork to make finished products. Believe me, cutting between letters of 6 point type with an exacto knife is probably what helped to ruin my eyes. Flash forward to 1985: that was the year we started using desktop computers to help us do our work. I think we may have been one of the first art departments to use computers for that purpose. It made doing our jobs a little easier since size, editorial, and layout changes were able to be done faster and definitely cleaner. It also opened the door much wider for creativity. I loved my job—and it wasn't "just a job" anymore, it was a career. And while it was never lost on me that Hallmark was something of a dysfunctional asylum that often mistreated those who were most loyal to it (almost as a matter of policy), I learned a lot and made many friends.

Leap forward a few decades: by 2009 I had worked for the company for a total of 35 years—I had quit twice before, but, like Al Pacino in *The Godfather Part 3*, after short breaks they "dragged me back in." But by '09 things were not going quite so well for the House of Cards: they weren't making their projected profits and they had decided that some employees had to go to help make the accountants happy. They had been cutting staff through various methods and buy-outs and "forced retirements" for several years already and, regardless of their reputation of caring for their employees like "family," had been systematically targeting many of their older staffers—those with salaries and benefit packages that were harder to justify in lean economic times when fresh faces were lined up in front of the door, willing to work for less and likely to move on before getting too comfortable (and expensive). I got the dreaded e-mail one morning in October that told me I had a meeting in Personnel. (At least they didn't "tweet" me.) It was over, not just for me, but for another 100 or so of my friends and coworkers, too. (After they had trimmed all the "dead wood," CEO Don Hall Jr. announced they'd be giving raises again to the workers still there—so glad we could help!)

I can't say it wasn't a slap in the face; I know too many others that have experienced the same thing in the last year. I felt numbed and sad for, oh, about 30 minutes...then I started realizing what a *good* thing it was. No more corporate politics, no more dealing with middle-managers who practiced nepotism and felt threatened by anyone with half a brain. No more getting wrapped up in other people's ridiculous agendas. No more performance reviews! I was now free to focus on what had a long time ago snuck in and stolen my heart and passion—*Spectrum*. Of course. My *real* career. There's no place like home.

The *Spectrum* jury convened on Friday, February 26 in Kansas City. Surprisingly everyone arrived on time and we hosted a Friday night get-to-know-each-other dinner: we've got a fairly long list of potential judges

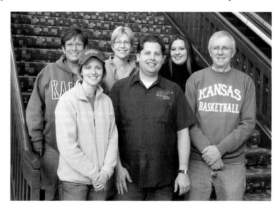

Front row: *Gillian Titus, Arlo Burnett, Terry Lee.*
Back row: *Lucy Moreno, Armen Davis, Angela Wheeler.*

and try to mix and match members each year so that it will not only be invigorating for us, but for them as well. *Spectrum's* life-blood is diversity and each panel needs to reflect the community as a whole: with illustrators, educators, art directors, publishers, cartoonists, gallery painters, and film designers (these five extraordinary talents wear a *lot* of hats!) doing their duty for #17, we happily met our goal. On Saturday morning the jury gathered for breakfast; the judging began at 8:30 AM sharp. We had set up in a new very large ballroom this year and looking out over the seemingly endless rows of tables must have been daunting to the jurors but they dove in eagerly. We broke for lunch at noon and, after about an hour, were back at it until the awards discussions ended around 6:00 PM. The awards debates were lively yet moved along fairly quickly—as always you never know until the last minute which piece will be given the Silver or Gold and this year the judges elected to

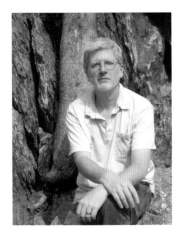

Kerry Callen

Bill Carman

John Fleskes

Rebecca Guay

Bill Carman's depiction of Super Juror

Iain McCaig

present two additional Silver Awards. A video announcement of the winners by the jury was posted on the *Spectrum* web site immediately following the final votes. After a brief respite everyone met in the hotel lobby for a short walk to Pierpont's in Union Station for the traditional jury dinner in a private dining room to conclude the event.

We were again assisted by a group of dedicated individuals who graciously give up their Saturday to help keep the *Spectrum* judging moving along in an organized, efficient manner: we could never pull off this event without their help. This year we would especially like to thank our son Arlo Burnett—who also does an outstanding job as our web administrator—for his dedication to making the organization run smoothly, being the judging photographer, and effectively troubleshooting any unexpected problems that crop up. Also assisting us this year were Terry Lee, Lucy Moreno, Armen Davis, Gillian Titus and Angela Wheeler.

I say it each year, but it is absolutely true that *Spectrum* is only made possible by the participation of the artists, art directors, and publishers—whether their entries are selected for inclusion in the annual or aren't—and to all the readers that continue to purchase each volume. We might act as ringmasters or hucksters, but this book belongs to all of you. To everyone we again sincerely extend our warmest thanks for allowing us to be part of this community and to share our love of fantastic art.

Al Williamson

Born 1931, New York City

Born in New York in 1931, Al Williamson spent the majority of his childhood in Bogotá, the result of his American mother's marriage to a Colombian man. Son and mother returned to the States in 1943, eventually finding their way back to New York City.

But in 1940, in Bogotá, Al discovered Flash Gordon during a visit to the local theater. The serial FLASH GORDON CONQUERS THE UNIVERSE made an indelible impression, leading him to the Alex Raymond Flash Gordon strips, which he eagerly copied. Raymond's masterful inking and fluid brushwork made both the fictional character and its creator early heroes of Al's. From this beginning, the young Al could not be aware of the fame and success he would achieve doing what he loved most.

At eighteen, Al had the opportunity to meet and talk with his idol when Alex Raymond invited him to visit for a few hours. His assistant later told Al that Raymond expressed admiration for Al's abilities and wished he had come back to possibly do some work with him. Al always felt he missed an opportunity. Al said he hadn't returned because he lacked confidence and he didn't want to disturb Raymond at home again. Regardless, it was a huge thrill to meet his hero and to be treated so well.

In the mid-forties Al attended life-drawing classes under Burne Hogarth. Al's formal art education stopped there. In later years, he acknowledged that the lack of an art degree infused an inferiority complex in him. But, if this

Al Williamson. *Photograph by & © 2010 John Fleskes.*

was a mental handicap, his instincts and skills in networking were superb and he met two instrumental people who impacted his path in life. The first was Wally Wood, who, along with Joe Orlando, encouraged him to meet with Bill Gaines, publisher of Entertaining Comics (EC), and led to his employment there. Al also met Roy Krenkel, who soon became a father figure and a frequent collaborator. They remained close lifelong friends. It was Roy who exposed Al to the master pen-and-ink illustrators of the past. Unbeknownst to Al at the time, he would take over Roy's mantle as the gatekeeper to those master illustrators for the new generation of artists. Al's sheer love for art was contagious to his fans, peers and students alike.

In 1952, Al began working for EC. He provided art most notably for their Weird Science and Weird Fantasy titles. Al's work began to soar. The energy of his youth evoked a determined Williamson to match the quality of his fellow EC artists. His foliage, inspired by the jungle environment of his childhood home in Bogotá, surrounded his characters. These lush backgrounds—including flying snakes, giant mushrooms, overturned trees with dense vines, ferns and moss—with the occasional dinosaur or spaceship mixed in, or even a few hero-types saving a beautiful woman, all made his fans and peers take notice. His art at EC is still exciting today.

Al illustrated EC stories alone or with fellow artists George Evans, Frank Frazetta, Angelo Torres, Krenkel, and Wood. These early collaborations had to do as much with his cramming in a story the evening before a deadline as with his lack of faith in his own inking abilities at the time. Al's determination to better himself was matured by an early talent in knowing who best to learn from and work with. In 1960, he broke into comic strips, assisting John Prentice with the Rip Kirby daily. Under Prentice, Al learned discipline and became a mature professional.

In the mid-Sixties, Al began a professional working relationship with

writer Archie Goodwin. This highly regarded team would last nearly twenty years. They created stories for Warren's Creepy, Eerie and Blazing Combat magazines. They also did a now-classic Flash Gordon run for King Comics in 1966. The fourth issue of the series ran an X-9 story by Al and Archie in 1967. This impressed King Features Syndicate enough to place this team on the daily strip, renamed Secret Agent Corrigan, from 1967 to 1980.

The first half of the Eighties were some of Al's most diverse years, with a variety and output never again matched. He illustrated a number of movie adaptations, including The Empire Strikes Back (1980), Flash Gordon (1980), Blade Runner (1982), and The Return of the Jedi (1983). His artwork appeared in various comic books, including Alien Worlds (1982), Superman #400 (1984), and Star Wars #98 (1985). This was followed by artwork for stories written by Goodwin for Marvel's Epic Illustrated (1985). On top of all this, Al was drawing the Star Wars daily and Sunday strip. In 1976, while STAR WARS was still in production, George Lucas sought out Williamson to do the strip. Being committed to Corrigan, Al declined. Then, in 1981, the opportunity arose again. Archie and Al jumped over to Star Wars until 1983.

The demands and deadlines associated with producing fully rendered drawings for the previous 35 years became wearing. Being too slow to continue to make a good living, Al found that inking allowed him a good influx of money. He could do this quickly, allowing him to relax. Al began a 15 year stint of inking at Marvel, where he was discovered by a new generation of artists and fans. Inking over Mike Mignola on Fafhrd and the Gray Mouser and John Romita Jr. on Daredevil are among his most notable associations.

In the early Nineties, Al drew a memorable run of new covers for the Classic Star Wars comic series. In 1995 the opportunity arose to do a two-issue Flash Gordon entirely penciled and inked by himself. Marvel editor-in-chief Tom DeFalco allowed Al to take his time and create the pages purely from his imagination, without the use of models or photographs (something that had been necessary with the grueling deadlines when doing strips and movie adaptations). By this time, Al was semi-retired and would do only a handful of small projects before pulling back the reins entirely.

When working, Al shined when he had people around him in a studio environment. His love of art is matched by his joy in sharing art. He has always been generous with his time when it came to helping a friend or newcomer. He would help fellow artists obtain work by introducing people to one another. Al never felt professionally threatened yet he continued to be artistically insecure. He could get frustrated with himself if he was having problems with a drawing. His standards are so high and difficult to achieve that they could almost paralyze him at times. But it is these insecurities and perfectionism that make the man: if not for them, his greatness would surely be diminished. Al's inner drive has led to greater recognition, of which this Grand Master Award is representative. The difficulty in reducing Al's accomplishments into a short appreciation is testimony to the legacy of excellence in his-50-plus-year career.

—John Fleskes

EDITORS' NOTE: *Sadly, several months after being awarded the Grand Master honor, Al Wiiliamson passed away June 12, 2010.*

Grand Master Honorees

Frank Frazetta Don Ivan Punchatz Leo & Diane Dillon James E. Bama John Berkey Alan Lee Jean Giraud Kinuko Y. Craft
Michael William Kaluta Michael Whelan H.R. Giger Jeffrey Jones Syd Mead John Jude Palencar Richard V. Corben Al Williamson

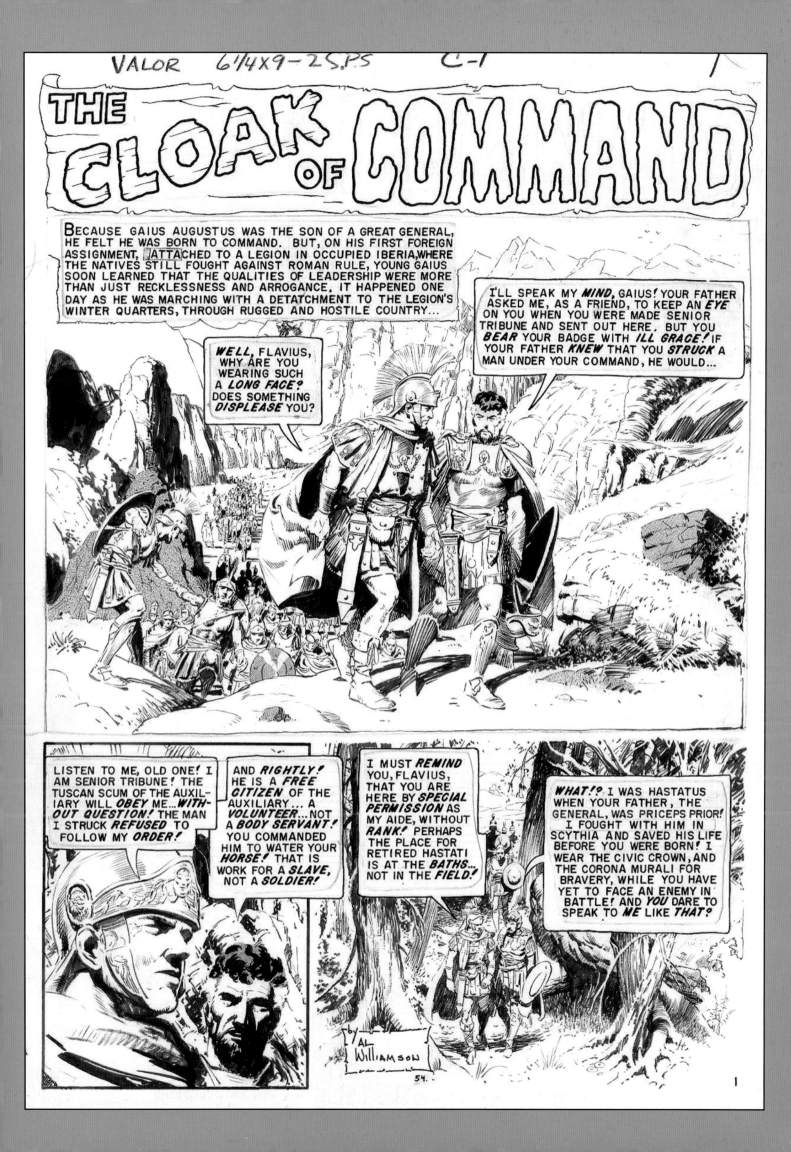

The Year In Review

2009

by Arnie Fenner

"Back in the day, an opinion was something ventured with caution and usually with great thought and deliberation by someone who knew something. Now, it's just the shit that pours off these mountains of lava of stupid remarks."
Harlan Ellison commenting on Internet message boards and blog sites.

"This is only phase one of the scandal. Phase two: I go on *Oprah* and sob."
David Letterman making light of being blackmailed for having sex with women on his staff.

"Some employees may prefer weapons such as chain saws, baseball bats and explosives
that have been shown to be effective against zombies."
University of Florida in a disaster preparedness plan on its e-Learning website on how to deal with a campus-wide zombie attack.

"If I'd only followed CNBC's advice, I'd have a million dollars today. Provided I'd started with a hundred million dollars."
Jon Stewart lambasting CNBC's *Mad Money* host Jim Cramer for advising viewers to invest in companies that collapsed.

"We're going to have no paper, no printing plants, no unions. It's going to be great."
Rupert Murdoch hailing prospect of electronic devices like Amazon Kindle displacing newspapers,
a process he estimates will take about 20 years.

"Poor Grendel's had an accident. So may you all."
Grendel by **John Gardner**

About the only thing I know with any certainty after the dust settled on 2009 is that...I'm *tired.*

I'm tired of the fighting and empty rhetoric, the divisiveness and stupidity. I'm tired of pundits and prophets, of spin and sound bites, of hype and hooey and, let's admit it, bullshit. I'm tired of the hate. I'm tired of the bigotry and hypocrisy. And, boy, am I tired of this recession!

The winding-down of the war in Iraq and the heating-up of the one in Afghanistan became less "important" (unless, of course, you or your family members were the ones doing the fighting) as the world-wide recession deepened and people's anger grew. Civil discourse was replaced by boorish rudeness, paranoia, and naked hostility. In the U.S., "Tea Party" advocates disrupted town hall meetings and yelled about "death panels" and socialism (while conversely espousing an entitlement to Social Security and Medicare), ammunition and gun sales skyrocketed in fear of laws restricting the Second Amendment (that were never proposed and haven't materialized), and even Kannye West felt compelled to jump on stage during Taylor Swift's acceptance speech at the MTV Video Music Awards to insist that the honor should have really gone to Beyoncé instead.

Above: Rebecca Guay's Illustration Master Class met in June at the University of Massachusetts/Amherst for its second annual session and drew a large group of enthusiastic students and instructors. [**www.illustrationmasterclass.com**] *Facing page:* The CG Society [**www.cgsociety.org**] sponsored a Steampunk art competition with outstanding results. One of the most exciting pieces—among many—was "Titanomachy: fall of the Hyperion" by Polish artist Marcin Jakubowski [**www.balloontree.com**].

All of the hope and positive feelings following the Obama inauguration were relatively short-lived and Washington quickly devolved into the usual partisan fisticuffs. The auto industry crashed, the housing bubble burst (resulting in record foreclosures as home owners were unable to afford to pay their mortgages), and unemployment "officially" hovered around 10% (though when those that had been forced into "early retirement" or had run out of unemployment benefits or had otherwise dropped off the radar were considered the percentage could be appreciably higher). Retailers suffered, advertising suffered, the entertainment and publishing industries suffered: about the only people smiling were executives at the oil companies (who racked up record-setting profits). You *know* times are tough when the strip clubs are hurting for business: many waived cover charges and discounted drinks to appeal to a "downscale" clientele. It was much the same around the world as governments strained under massive debt and businesses cut costs (which inevitably translated into job losses) in an attempt to stay afloat. Spain, Greece, Italy, and Portugal were particularly hard hit as their mounting debts had a chilling effect on other governments. Businesses opting to outsource to other countries with cheaper

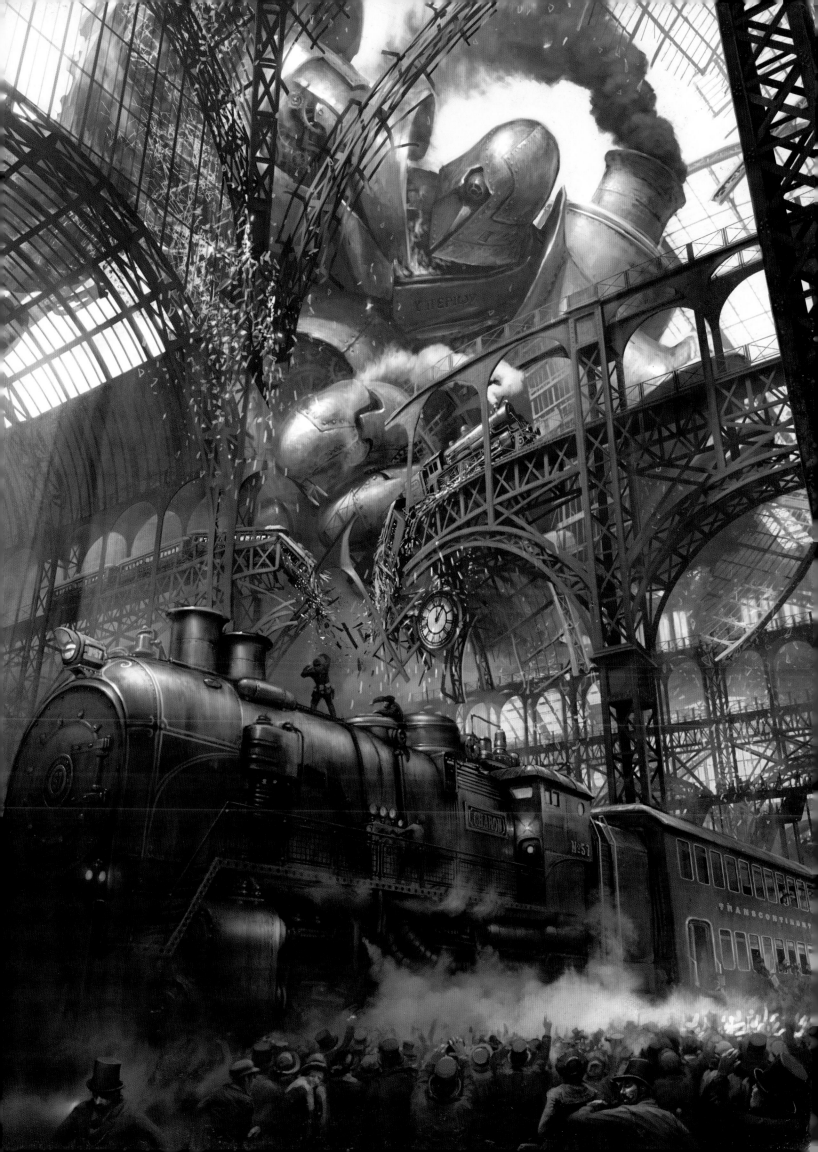

work forces became much more prevalent (and greatly buffered the economies of China and India, helping to offset their own shares of financial worries). CEOs remained oblivious

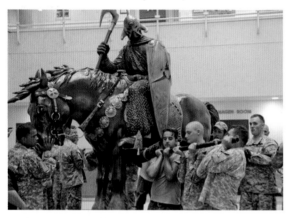

Above: Rick Berry and Charles Vess wowed audiences with live painting demonstrations during the legendary Lucca Comics & Games Festival that takes over the entire town of Lucca, Italy each October. Other guest included *Spectrum* stalwarts Phil Hale and Donato Giancola. Rick painted the official poster for the event. *Below:* This life-sized statue of Frank Frazetta's "Death Dealer" was installed on the grounds of Fort Hood, TX as the mascot for the U.S. Army's III Corp.

to the harm their focus on their share-holders' interests was having on regular people and only contributed to a growing sense of anger.

Tensions with Iran (who experienced their own internal troubles as the rigged reelection of Mahmoud Ahmadinejad prompted protests that were suppressed by the government's Basij militia) and North Korea over their nuclear weapons programs continued through the year and didn't show any signs of improving. The Israelis and Palestinians did their part in making sure the Middle East remained a source of worry, earthquakes rocked Italy, Sumatra, and Samoa, Australia endured the eighth year of a devastating drought, and Somalia pirates continued to plague the waters off the Horn of Africa (though their numbers were decreased by three when U.S. Navy SEAL snipers shot the pirates holding the captain of the Maersk Alabama container ship hostage). Oh, and then there was the hoopla over a possible H1N1 pandemic, that prompted people to wear masks as an attempt to ward off infection and made hand sanitizer a must-have accessory.

There were the typical celebrity scandals and meltdowns, the senseless crimes that left us

shaking our heads wondering what the world was coming to, attempted terrorist attacks (like the Christmas underwear bomber), and the passing of iconic members of the culture—including Walter Cronkite, Andrew Wyeth, Ted Kennedy, and Michael Jackson. As Jon Stewart said on *The Daily Show,* "However you felt about the man, whatever your opinions are, I believe we—as a people—should make a rule that once you die … whatever derisive nickname that we used for you, it dies with you. So can we stop calling him 'Jacko' now?"

All of this *sturm ünd drang* naturally contributed to making 2009 a less than happy year for many people, artists included, and a sort of spiritual torpor seemed to settle in. Oh, it wasn't all gloom and despair: no matter what, there are always positives and always things to learn and do and see and experience that renews a sense of wonder. Not the least of which was the completion of the High Line Park in New York City: an abandoned elevated train track along the Lower West Side was converted to a winding promenade planted with native grasses and flowers that provided a respite from the grit of the city streets below.

Scientists revealed the discovery of a "pocket T-Rex" that had been found several years ago (but kept secret until '09) in Inner Mongolia. The new dinosaur, *Raptorex kriegsteini,* was 9 feet long (about a fifth of the size of *Tyrannosaurus Rex*). Researchers from the University of Florida and the Smithsonian also announced that they had found the remains of a whopper of a prehistoric snake. Named *Titanoboa cerrejonensis,* it measured 42 feet long and lived 60 million years ago.

Fantastic themed films once again dominated the box office and included *District 9, Up, Transformers 2: Revenge of the Fallen, Harry Potter and the Half-Blood Prince, Start Trek, The Twilight Saga: New Moon, Sherlock Holmes, Monsters Vs. Aliens, Ice Age: Dawn of the Dinosaurs, X-Men Origins: Wolverine, Paranormal Activity,* and some little movie—what was it called? oh yeah—*Avatar.* The much anticipated *Watchmen* and *Where the Wild Things Are* adaptations unfortunately failed to connect with enough viewers to offset their enormous budgets.

There were all manner of conventions, events, and exhibitions through the year that satisfied people's appetites for fantastic art in all it's myriad forms. We did our part by sponsoring the second SPECTRUM EXHIBITION at the Museum of American Illustration in New York. The six

week show drew healthy crowds and the artist reception, despite stormy weather, was absolutely packed.

Even though this volume of *Spectrum* is even fatter than last year's, I have a little less space to crack wise—which will certainly make some people happy. Readers will notice that while I've always tried to point out some of the highlights each year (from my perspective, of course) of the various venues for fantastic art, obviously I often fall short. Some ideas have been percolating for awhile now and maybe when Volume 18 rolls around there will be a slightly different approach.

But in the meantime...boy, am I tired. Can somebody wake me when all the singing and drinking starts again?

ADVERTISING • • • •

One of the first casualties of a recession is the advertising business. As companies tighten their belts and cut their budgets they tend to sit on their wallets in an attempt to weather the storm. That was especially true in 2009. Traditional print and television markets took the biggest hits through the year as did the agencies that acted as a conduit for clients. Page counts and original content dropped in newspapers and magazines as a direct result of fewer advertisers while television stations sold more infomercial-type spots at cut-rate prices rather than pay for traditional entertainment programing.

The Internet was awash in ads for everything under the sun, but the question remained: how effective are they? No one knows. Advertising revenues helped FaceBook and YouTube reach profitability (Twitter is still in the red), but there aren't statistics showing how many people are buying anything after they click on the link.

Regardless, the heavily hit North American ad market overall was expected to suffer a third year of decline with a projected drop of 2.4% into 2010. The western Europe ad biz was seen as "stagnant." Both markets were expected to recover in 2011, while the ad industry across the rest of the world will return to growth this year. Depending, of course.

Despite the dire state of the global ad business this year industry analyst ZenithOptimedia pointed out that of the 79 markets it covered annually, 25 were actually still growing. China was expected to grow 5.4% to overtake the UK as the world's fourth biggest ad market: I'm sure the numbers can only increase as the country modernizes in the coming years.

As I've said all along there will always be advertising in one form or another and artists will always be called upon to create it—stock images or layouts always look like...stock images and layouts. Some of the *original* work that caught my eye in '09 included pieces by Lukas Ketner (Gigantic Music), Marc Burckhardt (Cult

Records), Dan Craig (Grand Victoria Casino), Chris Buzelli (Penfield Children's Center), and Timothy Cook (Teen Tones).

BOOKS • • • •

If 2008 was gloomy for the book industry, 2009 was downright glum. Sales were down, publishers cut lines and staff, and retailers were stressed. The business as a whole was worried about the fragility of the Borders book chain because of its increasing debt load and declining revenues (sales were down 15% for the year). Borders Group Inc., the country's second-largest brick-and-mortar bookseller, closed 200 of its Waldenbooks stores and laid off approximately 1,500 employees. The move left the company with about 130 mall-based locations and over 500 Borders-branded superstores. In the meantime, Barnes & Noble Inc. (the nation's largest bookstore chain, thank you very much) closed all but two of its remaining 50 B. Dalton mall stores by the end of '09. Barnes & Noble (which currently has 774 superstores in the U.S.) had been closing 35 to 40 stores per year as their leases expired. Though their sales had dropped a more modest 5% for the year, the introduction of their own e-book reader, The Nook, greatly helped their profitability.

The Waldenbooks and B. Dalton store closures added to the woes of mall owners. Vacancy rates at shopping centers in the largest 76 U.S. markets rose to 8.6%. In addition, the vacancies led to declines in average mall rents by 3.5% in the past year to $39.18 per square foot.

Another woe was the Attributor Study which reported that publishers were losing $3 billion to online book piracy. The industry was all worked up about "digital delivery of content" thanks in no small part to the popularity of the Kindle, Nook, and just-around-the-corner's IPad (which debuted in 2010), but few were taking the time to consider just how easily this content can be shared. Cory Doctorow may encourage giving books away for free since he makes a nice bit of change with speaking gigs, but let's see if he still feels that way when the invitations stop arriving and the light bill needs to be paid.

Each pebble caused another ripple in the economic pond. Every domino knocks down another. Until retail sales turn around, stores will take fewer chances on new books and focus more on franchises and brand-name bestsellers, publishers will take fewer chances with new creators and books will have lower press runs and fewer reprints, artists and writers will have fewer opportunities, and readers will have fewer choices. In many ways this economy is robbing us of variety and choice.

Oh, and just in case you were worried about Amazon during these tough times...they're now the biggest book retailer, both in North America and overseas, with domestic sales of $5.96 billion and Amazon International sales of $6.81 billion.

I wish I owned stock.

Anyway, looking back at 2009 there were still a number of books that defied the odds and made it onto the shelves. I think my absolute favorite of the single artist collections I grabbed last year was *A Sketchy Past: The Art of Peter de Sève* [Akileos]. Peter, of course, is as inventive as the day is long and his characters ooze individuality; that his text was as funny as some of the images only added to the fun. A close second on my favorites list was *Reynold Brown: A Life in Pictures* by Daniel Zimmer and David Hornung [Illustrated Press]. Featuring a far-ranging selection of movie posters (*Attack of the 50 Foot Woman, The Creature from the Black Lagoon, I Was A Teenage Werewolf, Ben Hur*), Western art, and commercial work, the book is truly breathtaking. *Todd Schorr: American Surreal* was another stunning gathering of Todd's work: he not only turns pop culture on its head, but gives it a spanking in the process. I defy anyone to look at his "Ape Worship" painting and not smile: go on, I dare you. I was also tickled by *Travis Louie's Curiosities* [Baby Tattoo], a monstrous album of ghoulish portraits. Charles Vess' *Drawing Down the Moon* [Dark Horse] was a strikingly beautiful, impeccably designed retrospective that may have been long in the making but more than worth the wait. *Conceptual Realism: In the Service of the Hypothetical* by Robert Williams [Fantagraphics] was a nice compilation celebrating an artist *The New York Times* described as "Norman Rockwell's evil twin." *The Art of Michael Parkes Vol 2* [Swan King] was a beautiful collection of delicate paintings and robust bronzes; *Boris Vallejo and Julie Bell: The Ultimate Illustrations* [Collins Design] showcased the husband and wife team's mastery of anatomy; *Scott Musgrove: The Late Fauna of Early North America* [Last Gasp] was a nice catalog of freakishly endearing "extinct creatures" dwelling in the twilight; James Gurney revealed all (okay, *most*) of his painting secrets in *Imaginative Realism: How to Paint What Doesn't Exist* [Andrews McMeel], which did double duty as a sweet collection of his commercial work as well; and our favorite Monkey Boy, Frank Cho, was well represented with a pair of books, *Apes and Babes Book 1* [Image] and *Frank Cho: Sketches and Scribbles Book 5* [Monkey Boy Press]. *Norman Rockwell Behind the Camera* by Ron Schick [Little Brown] took us inside the studio, exploring Rockwell's methodology and comparing his reference photos with the finishes—and succeeded in making the artist's career even more noteworthy and exemplary. And I'm firmly convinced that *William Stout: Prehistoric Life Murals, New Dinosaur Discoveries A-Z*, and *Dinosaur Discoveries* (all also by Bill) [Flesk Publications] will have the same profound effect on young paleotologists (and budding film makers) as did Rudolph Zallinger did with "The Age of Reptiles" mural for the Yale Peabody Museum. (Don't look at me like that, goddamit: I'm not *that* old! Zallinger's mural was reproduced in *all* the encyclopedias and text books and probably still is.) Anyway, the Flesk books beautifully chronicle Bill's love for the terrible lizards (but I'll *never* be able to look at a feathered T-Rex the same way I did at a scaly one). *The Marvel Art of Marko Djurdjevic* [Marvel] was what I hope will be only the first of a long series of single artist retrospectives from the House of Ideas: Marko's book was a great way to start (and he's one of the few artists to make Thor's dorky outfit look cool). I liked *Sparrow Volume 10: Jim Mahfood, Sparrow Volume 11: John Watkiss, Sparrow #12: Sergio Toppi*, and *Sparrow Volume 13: Camilla d'Errico*

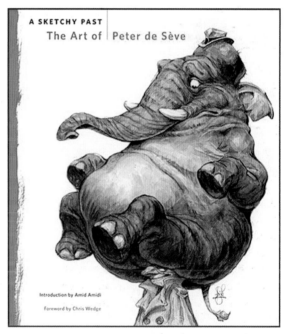

Above: Inventive and often irreverent *A Sketchy Past* was an exquisite retrospective of Peter de Sève's work. A favorite cover artist for *The New Yorker* and the character designer for numerous animated feature films (including *The Prince of Egypt, Mulan, Tarzan*, and *Ice Age*), Peter is an artist who delights in surprising his audience—as this collection amply proved.

[all from IDW]—and I was extremely glad to see *A Fine Line: Scratchboard Illustrations by Scott McKowen* [Firefly], which I found both insightful and inspirational. But when it came to *From the Pen of Paul: The Fantastic Images of Frank R. Paul* edited by Stephen D. Korshak [Shasta]... eh. Paul deserves historical recognition for being one of the very first SF artists back in the pulp era, but I don't feel that he was ever able to draw or paint people particularly well and this book, while interesting, calls attention to that overall weakness.

Some of 2009's single artist sketchbooks I was delighted to snatch up included *The Art of Daren Bader* (more of a "book" than "sketchbook," really, and a beauty at that), *Major Thrill's Adventure Book* by Gary Gianni [Flesk] (which boasted a *killer* cover painting), *Daisies: Wendling* by Claire Wendling [Stuart Ng] (no one's work charms quite the way Claire's art does), *Travis Charest 2009 Pictures* [Big Wow!] (and no one's art packs the same punch that Travis' does), *Arthur Adams Ocho* [John Fannuchi], and *Horley 2009 Sketchbook* by Alex Horley [Blaze]. Could

Above: DC's *Wednesday Comics* summer series was a refreshing change of pace that reminded viewers of just how great it was back in the good ol' days, when a Snickers bar was a nickel and newspaper comics were printed as full-tabloid pages.

I pass up such knock-outs like *From the Vault 2* by Mike Mignola, *Oh, Wow!* by Adam Hughes, or *Mark Schultz Various Drawings 4* [Flesk]? Are you *kidding*?

The anthology books that I happily plunked down some hard-earned scratch for included *Illustrators 51* edited by Jill Bossert [Collins Design], which boasted 600 pages of goodness by...everybody; *Juxtapoz: Dark Arts* [Ginko], which included edgy pieces by James Jean, Elizabeth McGrath, Travis Louie, Jeff Soto, Chris Mars, Greg 'Craola' Simkins and then some; *Imaginaire 2: Magic Realism* edited by Claus Brusen [Fantasmus-Art] showcased the art of Gil Bruvel, David Bowers, Patrick Woodroffe, Steven Kenny, Kinuko Craft, Wolfgang Harms, and Brigid Marlin among others; *Dreamscapes: Contemporary Imaginary Realism 2009* [Imaginary Edition] highlighted works by Daniel Merriam, Michael Parkes, Micha Lobi, Bas Sebus, Sjaak Kieft, and Boris Shapiro; and *Knowing Darkness: Artists Inspired by Stephen King* by George Beahm [Centipede Press was an amazing (and amazingly *huge*) extravaganza of all art dark and wonderful, all creatures scaled and fanged. A mere handful of the illustrators featured in the collection include Michael Whelan, Bernie Wrightson, Phil Hale, Dave McKean, John Jude Palencar, Drew Struzan, and Don Maitz. A smaller monograph that packed a huge wallop was *The Art of Guild Wars 2* [ArenaNet] thanks

to memorable works by Danile Dociu, Kekai Kotaki, Hyojin Ahn, and many more. Other noteworthy collections included *Sci-Fi Art: A Graphic History* by Steve Holland [Collins Design], *Visions of Never: The Collection of Fantastic Art* edited by Patrick and Jeannie Wilshire [Vanguard Productions], *The Future of Fantasy Art* edited by Aly Fell and Duddlebug [HarperCollins], *Massive Black Vol 1* [Ballistic], and *Exposé 7* edited by Daniel Wade and Paul Hellard [also from Ballistic]. Mentioned without comment was a pulp art posterbook we put together for Underwood Books, *Strange Days: Aliens, Adventurers, Devils, and Dames.*

Looking over at the "Illustrated Books" shelf, I felt that one of the best of the year (and one that deserves an English edition—publishers, pay attention) was *Merlin* by Jean-Luc Istin, Aleksi Briclot, and Jean Sébastien Rossbach [Soleil]. Beautifully designed, wonderfully told, stunningly illustrated,

Photograph by Arlo J. Burnett.

it's the type of book that immerses the reader in another time and place. I greatly enjoyed Brom's dark take on the Peter Pan story with *The Child Thief* [Eos], Philip Straub's beautiful and fully-realized *Utherworlds* [Ballistic], Michael Whelan's exemplary paintings for *The Little Sisters of Eluria* by Stephen King [Donald M. Grant], and Paul Guinan's and Anina Bennett's extremely clever conceit, *Boilerplate: History's Mechanical Marvel* [Abrams]. Also noted and appreciated were books illustrated by Adam Rex (*Billy Twitters and His Blue Whale Problem* by Marc Barnett [Hyperion]), Lane Smith (*Princess Hyacinth (The Surprising Tale of a Girl Who Floated)* by Florence Parry Heide [Schwartz & Wade], Lincoln Agnew (*Harry and Horsie* by Katie Van Camp [Balzer + Bray]), and Peter McCarty (*Jeremy Draws a Monster*, which McCarty also wrote [Henry Holt]).

Some of the covers that stood out last year (beyond what you'll find in the pages ahead, of course) included those by Scott Altmann (*The Mall of Cthulhu* by Seamus Cooper [Night Shade]), Sam Weber (*Prospero Lost* by L. Jagi Lamplighter [Tor]), Chris McGrath (*Child of Fire* by Harry Connolly [Del Rey]), David Ho (*Sacred Scars* by Kathleen Duey [Antheneum]), Scott Fischer (*The Mermaid's Madness* by Jim C. Hines [DAW]), Jon Foster (*Heart of Veridon* by Tim Akers [Solaris]), and Donato Giancola (*Imager's Challenge* by L.E. Modesitt [Tor]).

Yeah, 2009 was a tough year—and, as I write this 2010, looks to have its challenges, too—but when all of the excellent art that was published is considered, we actually came out of the year much richer (spiritually) than we did going in.

Thanks to the artists.

COMICS • • • •

Hmmm. If anything could be said about the comics industry is this:

It wasn't boring.

I mean, think about it. Disney bought Marvel for $4 billion (yep, that's a "b"); Warners formed DC Entertainment, the *Watchmen* 1995 graphic novel set unheard of sales records (even as the film underperformed and writer Alan Moore gnashed his teeth—while cashing gigantic royalty checks); bookstore returns of unsold copies hammered publishers as the recession deepened, greatly affecting publishers' cash flow; the manga market reached that magical saturation point and began to experience its own domestic down-turn; IDW and Dark Horse were among the first out of the gate with digital content and apps for IPhones and e-readers; DC and the Jerry Siegel heirs continued their scorched-earth legal battle over the copyright of Superman and spin-off characters with each

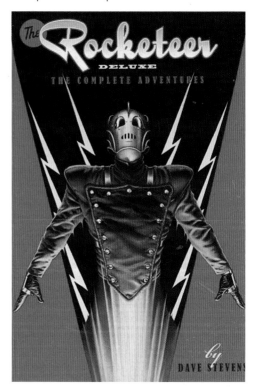

Above: IDW did the late Dave Stevens proud with this single volume collection of his two graphic novels. A nice reminder of just how great Dave truly was!

side winning some and losing some; Jack Kirby's heirs filed suit against Marvel to regain the copyrights to 45 characters (which strikes me as a hard row to hoe since Kirby was either on staff or doing work-for-hire); Marvel in turn sued the Kirby heirs, seeking to invalidate their copyright termination notices.

See? I told you it wasn't a boring year.

For me one of the major high points of the year was DC's tabloid weekly mini-series, *Wednesday Comics*. Under the guidance of Mark Chiarello and harkening back to the Golden Days when newspapers devoted a full page to the most popular strips, *Wednesday Comics* brought back the spirit of rip-roaring adventure with 15 different original tales told as 12-part serials. Some of the featured artists included Lee Bermejo, Joe Quiñones, Paul Pope, Ryan Sook, Joe Kubert, Eduardo Risso, Amanda Conner, and Kyle Baker. Simply a stunning piece of work. DC's big "event" for the year was the *Blackest Night* cross-title series. Written by Geoff Johns and penciled by Ivan Reis, the story involved a personified force of death resurrecting deceased superheroes—the focus on Green Lantern and the Green Lantern Corps seemed like a nice set-up for the forthcoming live-action film. DC is always impressive artistically and I greatly enjoyed works by Phil Noto, Joshua Middleton, Sam Keith (*Lobo: Highway to Hell* was a hoot), Yuko Shimizu, Brian Bolland, Andy Park, Bill Sienkiewicz, Frazer Irving, Jock, Daniel LuVisi, Chrissie Zullo, Darwyn Cooke, Esao Andrews, and Joao Ruas (whose covers for *Fables* were outstanding).

There was more than a little speculation in the blogoshere regarding possible changes to Marvel in the wake of the Disney take-over, but I'd be greatly surprised if there will be much interference: you don't mess with success. While the costumed heroes dominated their lines with various spin-offs they also experimented with literary adaptations and titles aimed at young readers. Jai Lee continued to produce top quality art for the adaptation of Stephen King's *The Dark Tower* series while Skottie Young engagingly illustrated *The Wonderful Wizard of Oz*; King's *The Stand* and even Jane Austen's *Pride and Prejudice* (with solid covers by Sonny Liew and interiors by Hugo Petrus) got Marvelized. Darcy **SMASH!** I really liked *Wolverine Art Appreciation* that featured such luminaries as Ed McGuinness, Russ Health, and Paolo Rivera depicting Logan in the styles of Dali, Warhol, and Magritte while Peter Bagge and company obviously had a good time illustrating the *Strange Tales* mini-series. I spotted some exciting work by Marko Djurdjevic, Francesco Mattina, Frank Cho, Tim Bradstreet, Richard Corben, Howard Chaykin, Art Adams, Sean Phillips, and Esao Ribic—and that's just to name a few.

Dark Horse differs from the other big boys in that they don't own a stable of characters to star in their comics, but rather functions like book publishers and each of their titles is licensed (either from the creators or from media com-panies). It's a business model that works pretty well and allows for an eclectic and electrifying line. Naturally I'm a big fan of Mike Mignola's Hellboy and the latest series (*Hellboy: The Wild Hunt*, written by Mike with Scott Allie and art by Duncan Fegredo, Patric Reynolds, and Dave Stewart) did not disappoint. And did I buy the *Hellboy Library Edition Vol. 3: Conqueror Worm and Strange Places*? Why, yes, and gladly, too. DH relaunched Jim Warren's *Creepy* anthology, featuring new stories in a comics-size format, while also continuing with their hardcover ar-

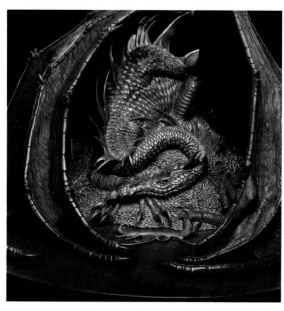

Above: Daniel Cockersell sculpted this evocative version of *The Hobbit's* dragon, Smaug, based on a painting by John Howe for the Weta Workshop. The first in a projected series, it was avaiable in a painted resin version and as a limited edition bronze. [**www.wetanz.com**]

chive editions of the classic *Creepy* and *Eerie* magazines. Greg Broadmore's *Dr. Grordbort Presents: Victory* was a lot of steampunkish fun while Raymond Swanland hit two home runs with his covers for the *Aliens* and *Predator* series. DH published some dynamite work by Eric Powell, Jill Thompson, Jo Chen, Tomás Giorello, and Travis Charest among others.

The recession has taken it's toll on publishers and comics shops together and while there occasionally was talk about a separate economy that was somehow immune...that was only wishful thinking. I saw far fewer independent titles in the comics shops I frequent: a sure sign that both they and their clientele were watching their budgets. I did note some quality work from Darwyn Cooke and Ashley Wood for IDW, some stunning art by John Bolton for Radical, the dandy *The Peanuts 60th Anniversary Book* from Andrews McMeel, the must-have *The Art of Harvey Kurtzman: The Mad Genius of Comics* by the legendary Denis Kitchen and Paul Buhle [Abrams], the absolutely definitive *Gahan Wilson: 50 Years of Playboy Cartoons* [Fantagraphics], and perhaps my favorite for the year, *Al Williamson's Flash Gordon: A Lifelong Vision of the Heroic*, edited by Mark Schultz [Flesk Publications]. This is the type of respectful and exhaustive—but never dry—retrospective that comics fans long for. Oh, and how could I not mention *The Rocketeer: The Complete Collection* by the late great Dave Stevens [IDW]? We had talked with Dave many times through the years about doing this book—and we got painfully close—but I know for a fact that we could *never* have done everything that Kelvin Mao and Dave Mandel did to bring this gorgeous book to fruition. This—and Al's collection—should be on *everybody's* bookshelves.

DIMENSIONAL • • • •

And to continue with my broken-record essay, the 3D market took its lumps in 2009 along with everyone else. Not to say that there wasn't some great work produced, just that the market faced challenges.

Perhaps one of the most interesting 3D stories of the year had to do with Frazetta— and, of course, there was more to come out of East Stroudsburg as the year progressed. Way back in April, 1986, Ellie Frazetta reached an agreement with General Crosbie Saint to use Frank's "The Death Dealer" as a mascot for III Corps. The general wanted to provide a symbol to the troops to convey his vision of the heavy maneuver force; they referred to it as the "Phantom Warrior" (for P.R. purposes) and the art has served as the III Corps symbol for nearly 23 years. In May 2009, Deep in the Heart Foundry was commissioned to build a "Phantom Warrior" statue for the grounds at Ft. Hood. Created life-size, the Death Dealer (whoops! "Phantom Warrior") was unveiled at a ceremony at Ft. Hood on September 15 and was presided over by Lt. General Rick Lynch, the current commander of III Corps.

But an interesting wrinkle to the story surfaced in an on-line posting by renowned sculptor Randy Bowen on Heidi MacDonald's must-read blog, *The Beat* [www.comicsbeat.com], which revealed that he had recently discovered that, "...Frank [Frazetta] Jr. presented the 'Death Dealer' sculpture (that I had sculpted many years ago) as *his* creation to the army brass." Despite assurances that he would be compensated and properly credited, by year's end Bowen reported that he had received neither.

In more positive dimensional news, DC Direct produced a nice batch of 3D collectibles last year that were pretty irresistible. Their Jack Mathews-sculpted and Adam Hughes-designed *Cover Girls of the DC Universe* series raised the excellence bar (*Wonder Woman* and *Catwoman* were knock-outs) while the squat *Blammoids!* figures of various heroes and villains were funky conversation starters. They produced some impressive busts, action figures, and props to coincide with the *Watchmen* film and expanded

their line of *World of Warcraft* figurines.

If you didn't grab the full-sized Thor's Hammer replica, you might have been tempted by any of Marvel's multitude of 3D offerings, such as *Black Panther* or *Ant-Man* (sculpted by Jason Smith) or *Ironman: Stealth Version* (sculpted by the Kucharek Brothers). produced some amazing additions to their *Star Wars* line along with "animated" versions of popular fantasy and

Above: The subgenre of "steampunk" (SF set in an alterante 19th Century in which the robots run on...steam...imagine that!) continues to grow in popularity, thanks in no small part to the constructions of artists like Belgian-born Stephane Halleux. His work is prominently displayed in the Device Gallery in San Diego. www.devicegallery.com

horror film characters (Freddy Krueger was pretty amusing); Dark Horse released additions to their Classic Comic Book Characters collectibles (as well as lunchboxes, gelskins, and PVC sets—*The Goon* figures were terrific); Clayburn Moore unveiled his gigantic statue inspired by Frazetta's *Conan the Conqueror* cover as both a painted resin collectible and as a limited-casting bronze; and Yamato USA made a fine addition to their Fantasy Figure Gallery with "Monica's Axe," based on the painting by Boris Vallejo and exquisitely sculpted by Tobe.

There were an infinite number of fantastic-themed figures, artist toys, plush toys, and everything in between released last year, including the *Hellsing: Seras Victoria* statue, various *Halo*-based busts, intricate *Final Fantasy* figurines, all manner of Ugly Dolls, and pretty much anything else you might imagine based on movies, video games, comics, books, or the artists' fertile imaginations. There was undoubtedly something that appealed to everyone who appreciates 3D collectibles, but

with the cautious approach many retailers took through 2009, finding that unique item was more difficult than in years past.

EDITORIAL ● ● ● ●

Okay, let's get this out of the way first:
Print is *not* dead.

Oh, sure, that's what everybody was *saying* hither and yon in '09 in light of the dour economy and the rise of the e-reader, but that's all hooey. There will *always* be traditional newspapers and magazines—maybe not exactly the same as we grew up with, but still ink on paper. Will they be like *Esquire*'s experimental December issue with Augmented Technology (pages played videos, while photos for a fashion spread containing graphics showed an animated snow storm): who knows? I personally doubt it, simply because of cost (and disposal issues): what makes regular newspapers and magazines attractive is that they're relatively inexpensive and can be read—enjoyed—at you leisure. If I've got to make my magazine interact with my computer...why not just read it on the computer?

Anyway, it wasn't technology that hurt the editorial business, it was the serious dip in advertising revenues. Ads are the life-blood of the papers and mags and since advertisers had cut back...remember the analogy of ripples in the pond. Things will bounce back, the economy *will* improve, but that truth didn't help any of the publishers caught up in the crisis last year.

The short-fiction magazines wrestled yet again with declining circulations and rising costs. *Realms of Fantasy* was rescued from oblivion by a new publisher, but found itself struggling by year's end. *The Magazine of Fantasy & Science Fiction* featured some nice work by Bryn Barnard Cory and Catska Ench, Max Bertolini, Ron Miller, and Kent Bash, while *Isaac Asimov's SF* and *Analog* both sported some excellent covers by Vincent Di Fate, Bob Eggleton, Dominic Harman, Michael Whelan, and Duncan Long. Not all of the art was "new" (the magazines bought reprint rights or print rights to portfolio or gallery paintings in some cases), but they all functioned as nice covers. Unfortunately, I wasn't especially impressed by the art appearing in many of the other genre magazines. In some cases I think it's because they're victims of their budgets and are simply doing the best they can with the money they have to spend. But in other cases, I think it's a matter of not being able to tell the good from the not-so-good. That's the windmill I continue

to tilt against in the SF community as a whole: for the field to be taken seriously, it has to be represented in a serious, sophisticated manner. And that means art that looks like *art*, not like the study hall doodles on a Snapper cover. I'm just sayin'.

The always indispensable *Entertainment Weekly* (they've even taken to doing a San Diego Comic-Con International issue with tips to attendees), *Sci Fi Magazine*, Esquire, *Backpacker*(!), *Discover*, *Time*, *National Geographic*, *Cricket*, and *Rolling Stone* all regularly featured imaginative illustration. *Playboy*, despite declining ad revenues, the silliness of *The Girls Next Door*, and digital challenges, carried on their superlative illustration tradition and featured the work of Olivia, Gèrard DuBois, Dan Adel, and Phil Hale.

My favorite artist-focused publications last year included Dan Zimmer's excellent *Illustration*, *Juxtapoz* (which I found as the best way to keep track of the Outsider art and toy communities),

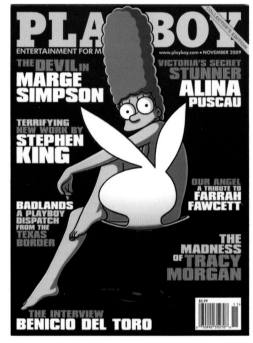

Above: Doh! Marge Simpson became the first cartoon character to be featured on the cover of *Playboy* in November. Regardless of challenges in the marketplace, Internet competition, and dipping ad revenues, *Playboy* remained one of the last bastions of cutting-edge editorial illustration.

Communication Arts, *Print*, *How*, *Art Scene International*, *Hi-Fructose*, *Giant Robot*, and *ImagineFX: Fantasy & Sci-Fi Digital Art* (which increasingly included profiles of traditional artists like Donato, Gurney, and Brom).

I was saddened to lose a good friend in 2009, the crusty and cantankerous publisher of *Locus*, Charles Brown. Charlie was one of those movers-and-shakers you wouldn't expect to be a mover-and-shaker. In many ways he helped to legitimize the F&SF field with *Locus* and his insight and, though I disagreed with him regularly, I always respected his opinion and his accomplishments. He had planned for

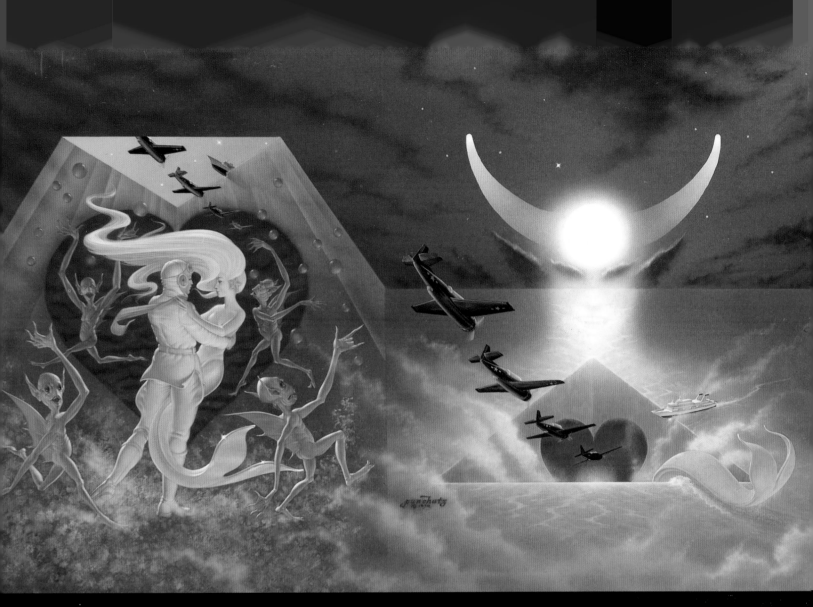

Don Ivan Punchatz (1936-2009)

We were shocked and saddened on Ocrtober 22 last year when we were informed of the passing of legendary artist, colleague, Spectrum Grand Master, Advisory Board member, and close friend Don Ivan Punchatz.

Don suffered a cardiac arrest on the morning of October 11 and never regained consciousness.

If you didn't know Don Ivan Punchatz's work or who Don was... you should have. A true giant of American illustration of the last half of the 20th Century, he joined Mark English, Bob Peak, and Bernie Fuchs as one of the most important and high-profile artists of the day. Don was renowned for his illustrations for *Playboy, National Geographic, Boys Life,* and *Penthouse*; for his advertising work for *Exxon*, the *Doom* video game, and Atlantic Records; for his book covers for Ace, Warner, Berkley, and Dell; and for his covers for *Time, Newsweek,* and *National Lampoon*. Punchatz was also accepted in the Fine Art world and his paintings are part of the permanent collections of the Dallas Art Museum and the Smithsonian Portrait Gallery.

He was comfortable with any style and switched between photo-realism, humorous illustration, and surrealism with ease. When he moved from New Jersey to Arlington, Texas, Punchatz became the first major illustrator to prove that you didn't have to live in the New York area to be successful nationally; other artists followed his lead and regional studios popped up like mushrooms. He became teasingly known as "The Godfather of Dallas Illustration" and his Sketch Pad Studio helped launch the careers of Gary Panter, José Cruz, Mike Presley, and Roger Stine among many, many others.

Don also taught illustration and graphic design at Texas Christian University for nearly 40 years and was a regular guest instructor at Syracuse University: the number of student artists he influenced and helped and encouraged over the decades is countless. He taught through nudges and suggestions and gentle guidance, always colored with his quick and mischievous sense of humor.

Through it all Don was a humble and self-effacing man: he was always far more interested in listening to what others were doing than he was in talking about himself. And he never groused about the business or the "ones that got away."

Ray Bradbury once wrote, "Don Punchatz! [Don's] ability to touch men with acrylic and melt them into beasts, or touch beasts with oil and ink – and: voila! they are senators or brokers – is endlessly stunning. Metaphor, after all, is the universal language. [Punchatz] could teach at Berlitz!"

Rick Berry says, "I think of Don as one of the pivotal artists in our field. His work simply made the world bigger and freer for me, long before I ever knew how sweet a guy he was." Harlan Ellison describes Don as "...one of the truly great modern artists."

In this world there are great artists and there are great men; being one sometimes precludes being the other for any number of reasons. But not when it comes to Don Ivan Punchatz: he was a great artist *and* a great man. He will be deeply missed.

the continuation of the magazine when he was no longer around to fuss about it (and fuss he did) and it is now in the hands of Liza Trombi and her talented staff. They'll not only carry on the *Locus* tradition, but they'll continue to evolve the magazine to better serve and reflect

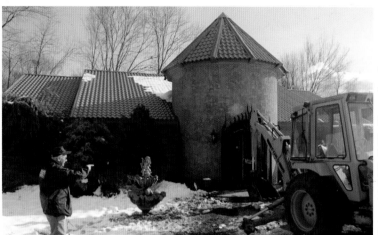

Above: While Frank Frazetta was vacationing in Florida the museum housing his work in East Stroudsburg, PA, became a sad memory when his son, Frank Jr., and two associates used a backhoe to tear off the front gates in December. Arrested at the scene while loading 90 paintings into a pick-up truck (to do *what* with, exactly, wasn't clear), Frank Jr.'s supporters sprang to his defense and an ugly family dispute over money was fought in public and on the Internet.

the community as a whole. Charles would have been grumpily pleased. Check them out on the web at www.locusmag.com.

INSTITUTIONAL • • • •

The "Institutional" category covers works that were created for package design, promotions, greeting cards, prints, gallery exhibitions, and any number of other possibilities that aren't generally easily described or summarized.

Fights continued over the Orphan Works legislation proposals (the economic crisis put the subject on Congress' back-burner...for now) and the Google plan to digitize and make available... *anything* they wanted to. Writers and artists groups led the charge and actually made some headway in blocking Google, but it seemed that everytime one breach in the wall was plugged, the corporations found another weak spot to attack. It really all boils down to a matter of respecting copyrights, of asking first, instead of an end-run that benefits business at the expense of creators. This circles around to again wagging my finger at Cory Doctorow, Lawrence Lessig and similar pundits who espouse "free culture" and pretend copyright is passé. Theft is theft, whether you're downloading movies and music or plagiarizing other artists and selling it as your own (as a "fine artist" did when he "borrowed" Jon Foster's "Dragon and Herdsman" art from Jon's on-line portfolio for a print, "Dragon Tree," that sold out at $50 a pop before some astute observers called him out and informed Foster).

Personally, one the saddest events for me in 2009 (beyond the passing of friends) was the

demise of the Frazetta Museum in early December. After the death of Matriarch Ellie Frazetta in July, a vicious fight between the four children ultimately resulted in Frank Jr. and two helpers breaking into the museum with a backhoe on December 9th while his father was vacationing in Florida. Frazetta Jr. was arrested while leaving the property with a truck-load of art; every news service and Internet site reported the incident, naturally including an embarrassing mug shot. Though criminal charges were dropped several months later after court-ordered mediation, the break-in and close of the museum will always be a disappointing part of the Frazetta story and legacy. If Ellie were alive, she would have whupped *everyone*.

Photograph by & © David Kidwell/Pocono Record.

Moving on to more pleasant matters, some of the art calendars I saw and liked in '09 included those by Luis Royo, Simon Bisley, Ciruelo, Boris Vallejo & Julie Bell, Daniel Merriam, and Frank Frazetta. The role-playing game community was probably still the largest single market for fantastic-themed art last year, Graphitti Designs [www.graphittidesigns.com] and Mad Engine [www.madengine.com] each pumped out some high-quality T-shirts featuring various comics characters, while prints of one sort or another were available from virtually any artist you might name.

Every year there are numerous worthwhile gallery shows and exhibitions featuring works for virtually every taste and interest. An absolutely astonishing show of Rick Berry's oil paintings of new abstract and figurative works, "Seeing in the Dark: Pattern Recognition/Discovery in the Marks," was held at the Sharon Arts Exhibition Gallery in Peterborough, NH; Jeff Soto exhibited at the Stolen Spaces Gallery in London; Nicoletta Ceccoli and Eric Fortune both had standing-room-only shows at the Roq La Rue Gallery in Seattle; the Kemper Museum in Kansas City hosted "Wyeth: Three Generations of Artistry"; and Travis Louie organized a first-class multi-artist "Monster" exhibition (which featured many *Spectrum* alumni) at the CoproGallery in Santa Monica. Baby Tattooville held its third annual weekend-long event geared toward the art collecting community: limited to 45 members, each became part of the Secret Society and received a package of collectible gifts, including

originals, prints, and limited edition toys. We've put our heads together with Baby Tattoville's Maestro Bob Self to see about creating a *Spectrum Live!* event in the near future: keep checking the *Spectrum* website for news as things progress [www.babytattooville.com}.

REQUIEM • • • •

In 2009 we sadly noted the passing of these valued members of our community:

Donald Addis [b 1935] cartoonist
Michael Atchison [b 1933] artist
Dina Babbitt [b 1924] animator
Bill Bates [b 1939] cartoonist
Frank Becarra [b 1927] cartoonist
Andres Cascioci [b 1936] artist
James Diaz [[b 1937] animator
Shel Dorf [b 1933] artist/SDCCI co-founder
John Donegan [b 1926] cartoonist
Boris Drucker [b 1920] artist
Heinz Edelman [b 1934] art director
Dean Ellis [b 1920] artist
Ric Estrada [b 1928] comic artist
Alfons Figueras [b 1922] artist
Steve Fiorilla [b 1961] artist
Ellie Frazetta [b 1935] publisher
Bernie Fuchs [b 1932] artist
Ricardo Garijo [b 1954] artist
Gilbert Gascard [b 1931] comic artist
José "Pepe" Gonzalez [b 1939] comic artist
Donald M. Grant [b 1927] publisher
Rusty Haller [b 1965] comic artist
Tony Hart [b 1925] artist
Draper Hill [b 1935] cartoonist
Bill Hume [b 1916] artist
Waldo Hunt [b 1920] designer
Jim Lange [b 1927] cartoonist
David Levine [b 1926] artist
Charles Luchsinger [b 1914] artist
Ilene Meyer [b 1939] artist
Jeremy Mullins [b 1976] cartoonist/educator
Marty Murphy [b 1933] cartoonist/animator
Jef Nys [b 1927] cartoonist
Irving Penn [b 1917] photographer
Don Ivan Punchatz [b 1936] artist/educator
Harry Roland [b ?] artist
Joe Rosen [b 1920] comic lettering artist
Dave Simons [b 1954] comic artist
Francis "Smilby" Smith [b 1927] cartoonist
Frank Springer [b 1930] comic artist
Corky Trinidad [b 1939] cartoonist
Sonny Trinidad [b ?] comic artist
Irving Tripp [b 1921] comic artist
George Tuska [b 1916] comic artist
Yoshito Usui [b 1958] manga artist
Ed Valigursky [b 1926] artist
Mike Van Audenhove [b 1957] cartoonist
Martin Vaughn-James [b 1943] artist
Graham Wadl [b 1931] cartoonist
Andrew Wyeth [b 1917] artist
Ray Yoshida [b 1930] artist/educator •

SUPER SPECTRUM XVII TURBO

CHARACTER SELECT

Magnum, D.P.I.	Compass Rose	Giclée	Quinn	Speed 'Raser
Commander Z (P2)	Super Skull P	Draft Horse	Scratch Broad	Mr. T-Square
The Drop Shadow	Vin Easel	Blanca	Sable Squirrel	Braying Mantis
Rick "Lens" Flare	PAL-ET 9000	Ricki Rake	The Ref Ref (P1)	Crop Cop
Darth Mahl	RED-209	The Ferrule Pig	WAC-O-Mole	Self-Healing Matt
Random Select	Owl Nighter	Kiln Bill	Écor-Ché	Custom

PAL-ET 9000: Hue / Saturation / Brightness / Your Life

TIME: 2 Min ► Until January 22, 2010 ◄ ∞

PLAYER 1		PLAYER 2
THE REF REF	**VS**	**COMMANDER Z**
"You're going to the morgue file!"	► PLAY ◄ QUIT	"This will be your undoing!"

The Show
Call for Entries Poster by Paolo Rivera

Sam Weber

Art Director: Jim Burke *Designer:* Jim Burke *Client:* Dellas Graphics *Title:* Absinthe Drinker *Size:* 16"x24" *Medium:* Acrylic/digital

Jim Mahfood

Art director: Tim Doyle *Designer:* Jim Mahfood *Client:* Nakatomi, Inc. *Title:* Aqua Boogie *Size:* 18"x24" *Medium:* Ink/digital

Howard Lyon

Art Director: Kathleen Bellamy *Client:* Orson Scott Card *Title:* Body Language *Size:* 10"x15" *Medium:* Digital

Dan Seagrave

Art Director: Dan Seagrave *Client:* Stormspell Records

Title: Invection: Demented Perception *Size:* 13"x13" *Medium:* Acrylic

Stephen Youll

Art diretor: Teresa Rad *Client:* Michelin *Title:* Evil Gas Pump

Size: 7"x10" *Medium:* Digital

Eric Deschamps

Art director: Jeremy Jarvis *Client:* Wizards of the Coast *Title:* Worldwake Fatpack *Size:* 17"x13" *Medium:* Digital

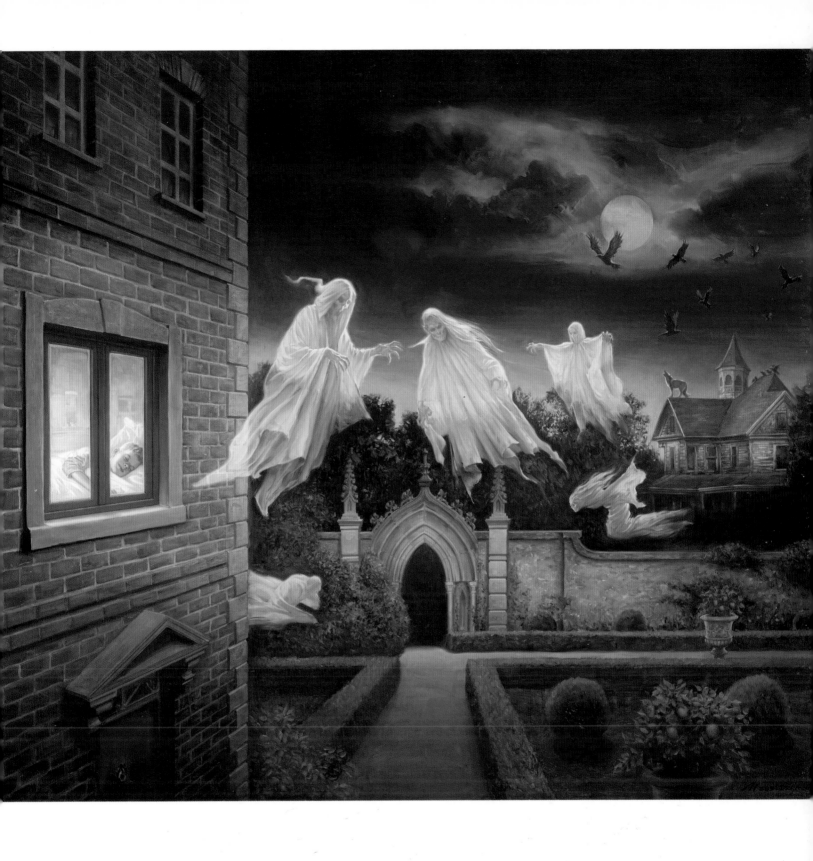

Petar Meseldžija

Art Director: Anselmo Tumpić *Client:* D'Adda Lorenzini, Vigorelli BBDO, Italy *Title:* SPI Windows *Size:* 85x70cm *Medium:* Oil on panel

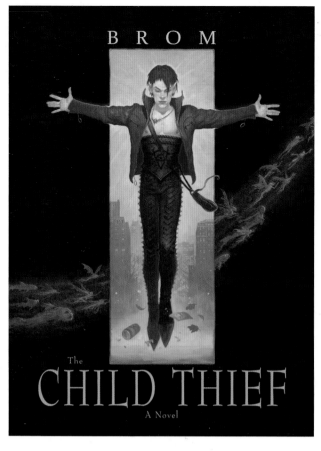

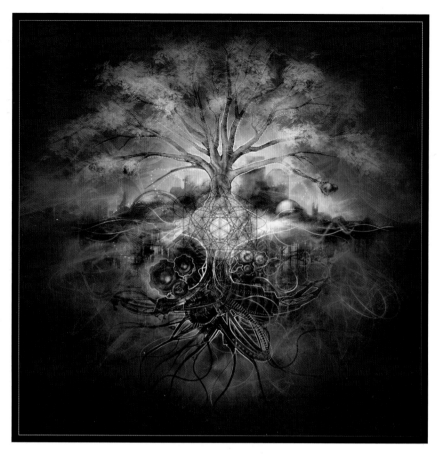

Brom

Designer: Brom *Client:* Eos *Title:* The Child Thief
Size: 9"x11" *Medium:* Mixed

Ryan Johnson

Client: Lynx & Janover *Title:* Between Worlds
Size: 10"x10" *Medium:* Digital

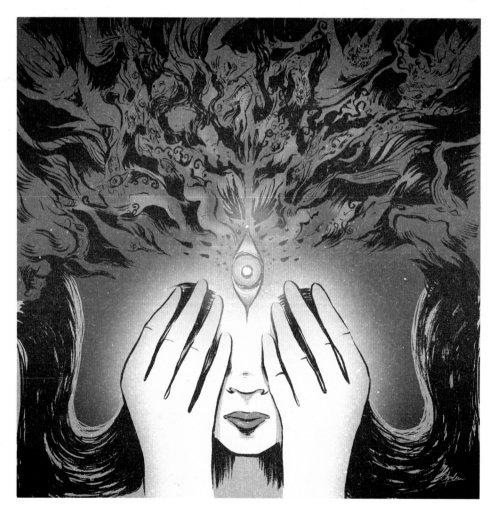

Charlene Chua

Designer: Charlene Chua *Client:* Black Hole Transmissions *Title:* Ideosphere CD Cover *Size:* 10"x10" *Medium:* Ink & Photoshop

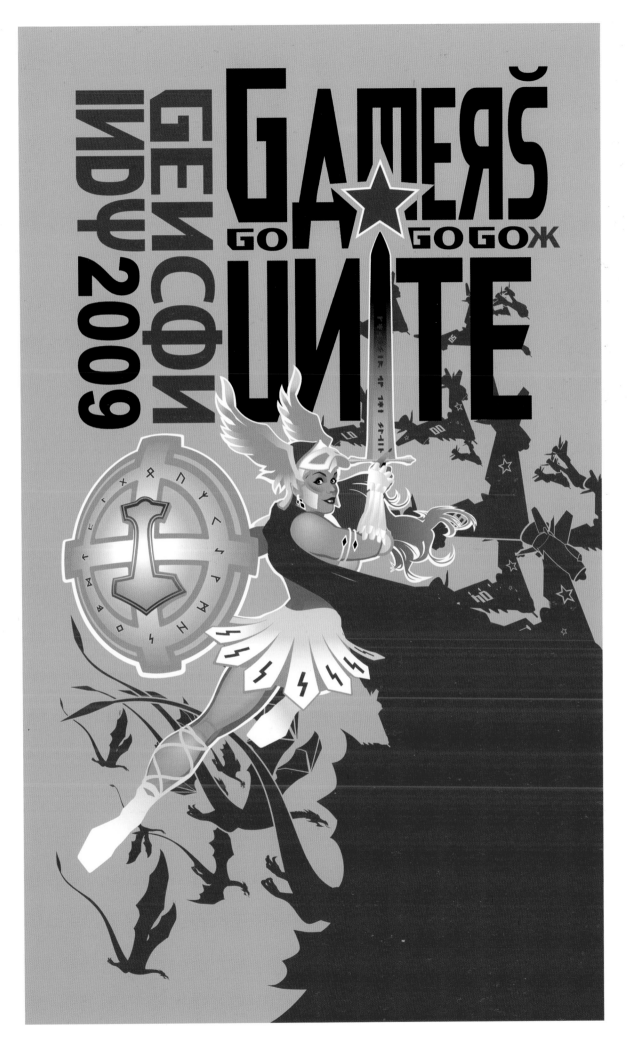

Andrew Bawidamann

Art Director: Rick Achberger *Client:* Gen Con *Title:* Gamers Unite *Size:* 18"x26" *Medium:* Digital

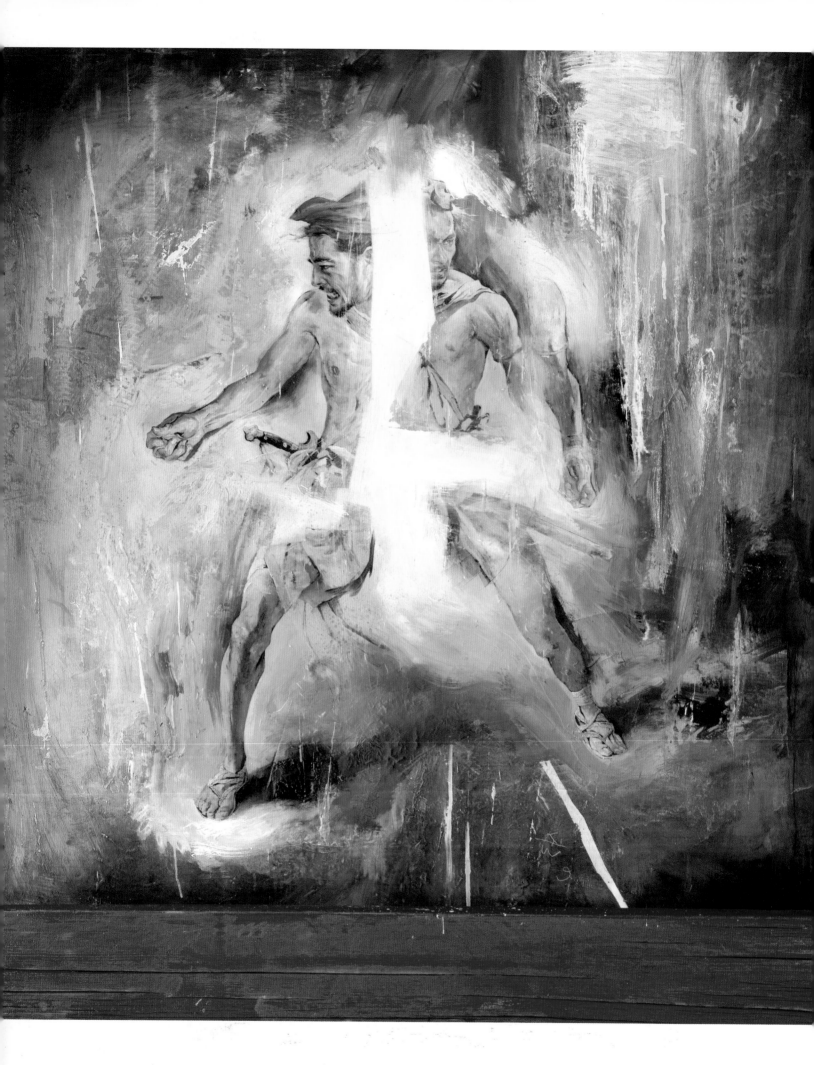

Kent Williams

Art director: Eric *Designer:* Eric *Client:* Criterion *Title:* Rashomon *Size:* 2'x4' *Medium:* Mixed

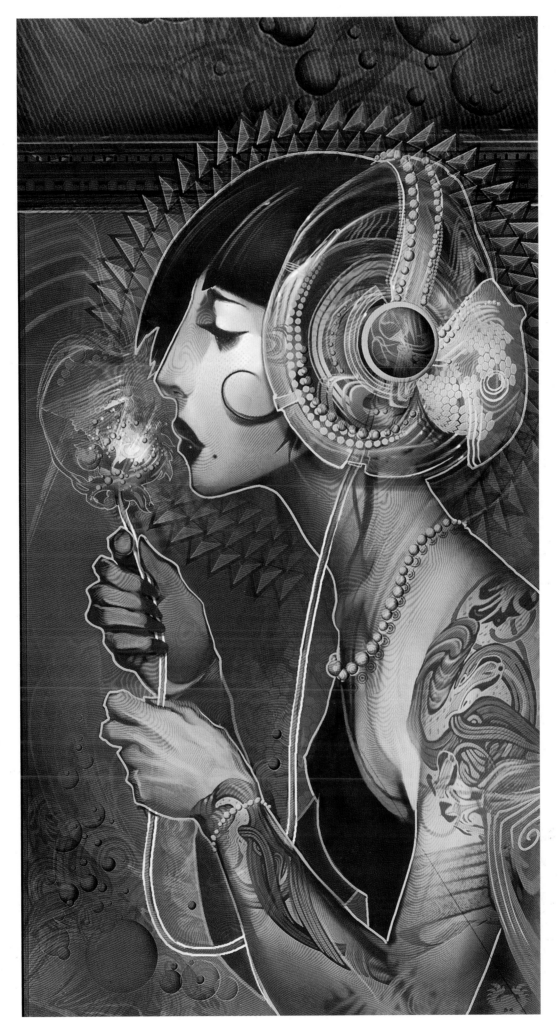

Android Jones

Art Director: Mike Vos *Client:* Tecknowledge *Title:* O.P.M *Size:* 14"x26" *Medium:* Digital/Painter II

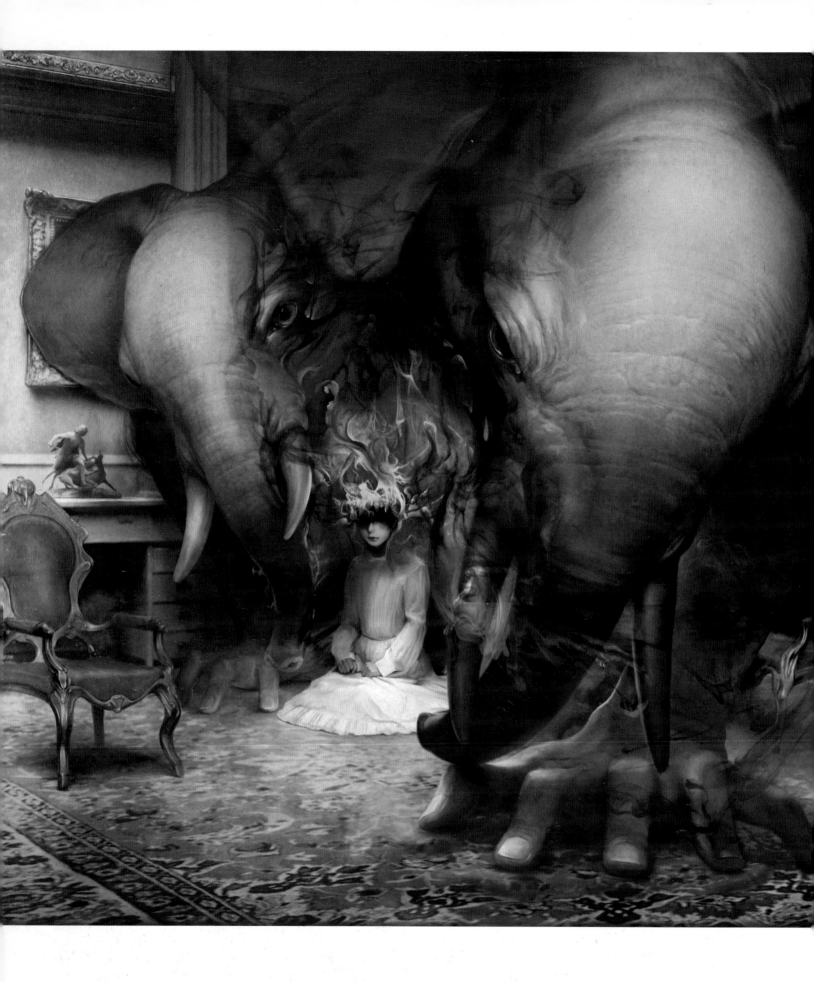

Ryohei Hase
Client: Magnolius *Title:* Mary Musth *Size:* 12x12cm *Medium:* Digital/Painter

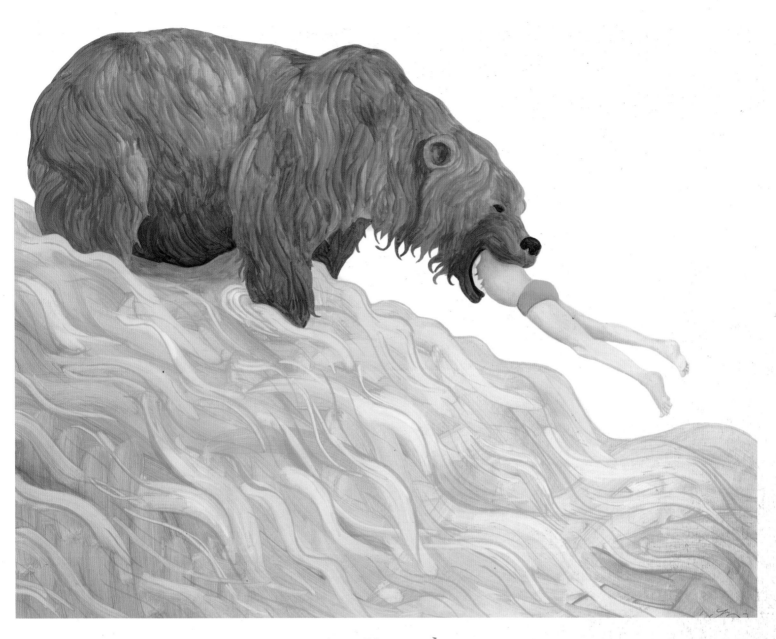

Jorge Mascarenhas

Art diretor: Helen O'Neill *Client:* Lürzer's Archive *Title:* Bear Attack *Size:* 24"x18" *Medium:* Oil/ink on board

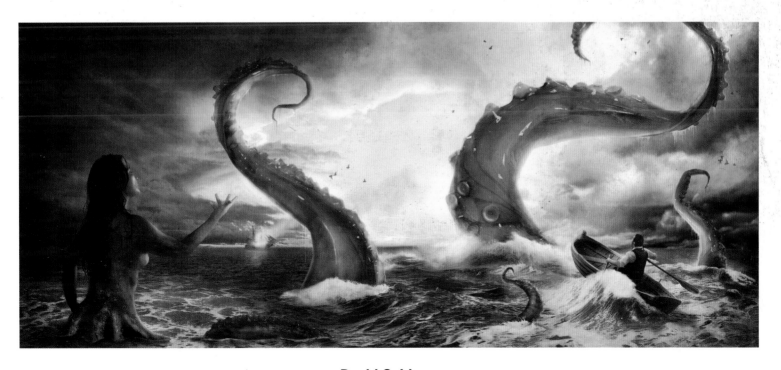

David Seidman

Client: The Smash Up *Title:* The Sea and the Serpent Beneath *Medium:* Digital

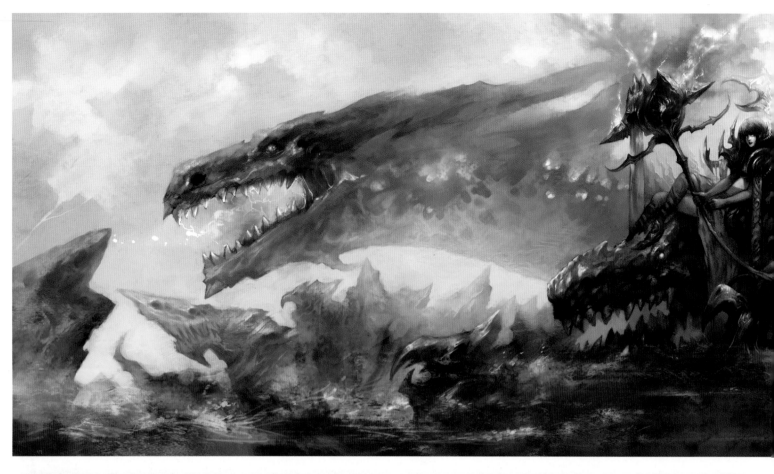

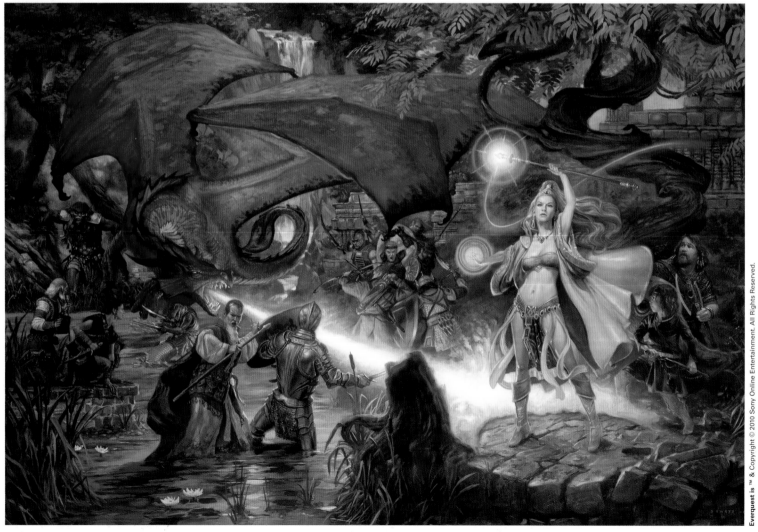

Donato Giancola

Art director: Joe Shoopack *Client:* Sony Online Entertainment *Title:* Everquest: 10th Anniversary *Size:* 40"x25" *Medium:* Oil on panel

Xiaochen Fu

Art director: Xiaochen Fu *Title:* The Boat of Twin Goddesses *Medium:* Digital

Lucas Graciano

Art Director: Derek Herring/Roger Chamberlin *Client:* SOE *Title:* Silverwing *Size:* 24"x18" *Medium:* Oil

Jasmine Becket-Griffith

Client: Gothic Beauty Magazine *Title:* Alice in a Bosch Landscape *Size:* 18"x24" *Medium:* Acrylic on masonite

Richard Tilbury

Client: 2D Artist Magazine *Title:* Impasse *Medium:* Digital

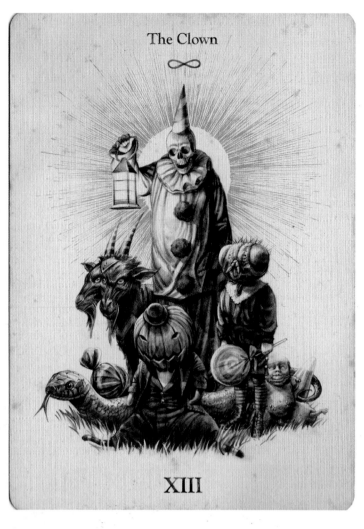

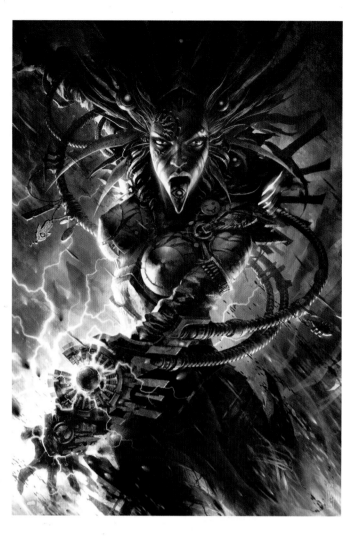

John Dunivant

Art Director: John Dunivant *Client:* Theatre Bizarre

Title: Clown Tarot *Size:* 9 1/2"x13" *Medium:* Pencil/digital

Raymond Swanland

Art Director: Tim Miller *Client:* Kevin Eastman/Blur Studios

Title: Heavy Metal (teaser film poster) *Medium:* Digital

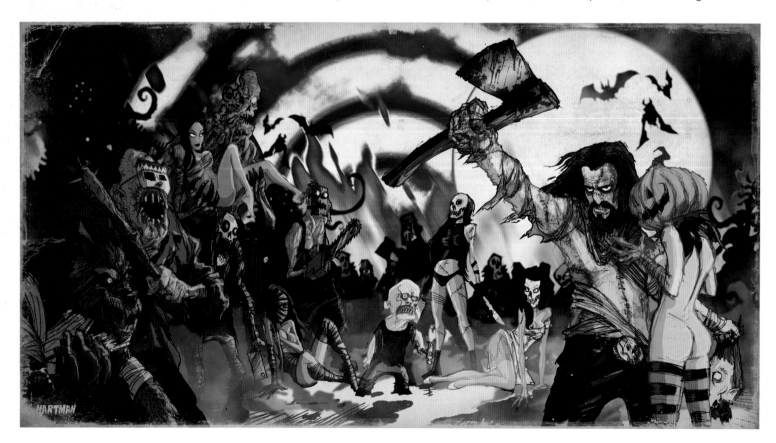

David Hartman

Client: Rob Zombie *Title:* Hellbilly Deluxe 2 *Size:* 19"x10" *Medium:* Traditional/digital

Dan Seagrave

Art director: Dan Seagrave *Client:* Prosthetic Records *Title:* Landmine Marathon: Soverign Decent *Size:* 13"x13" *Medium:* Acrylics

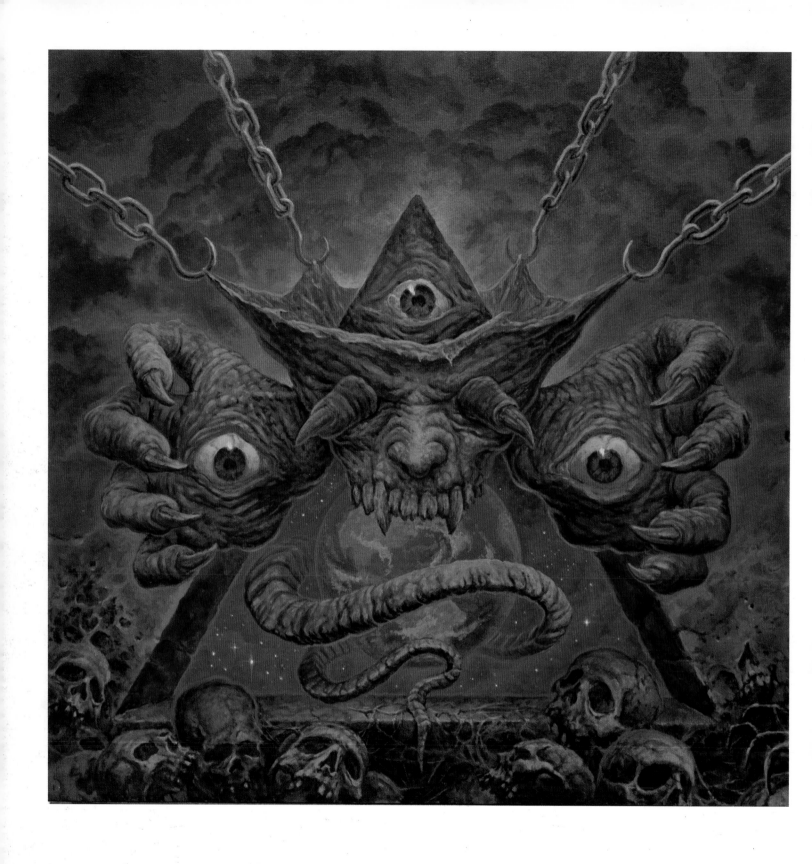

Wes Benscoter
Client: Defiled/Season of Mist Records *Title:* In Crisis *Size:* 17"x17" *Medium:* Acrylics

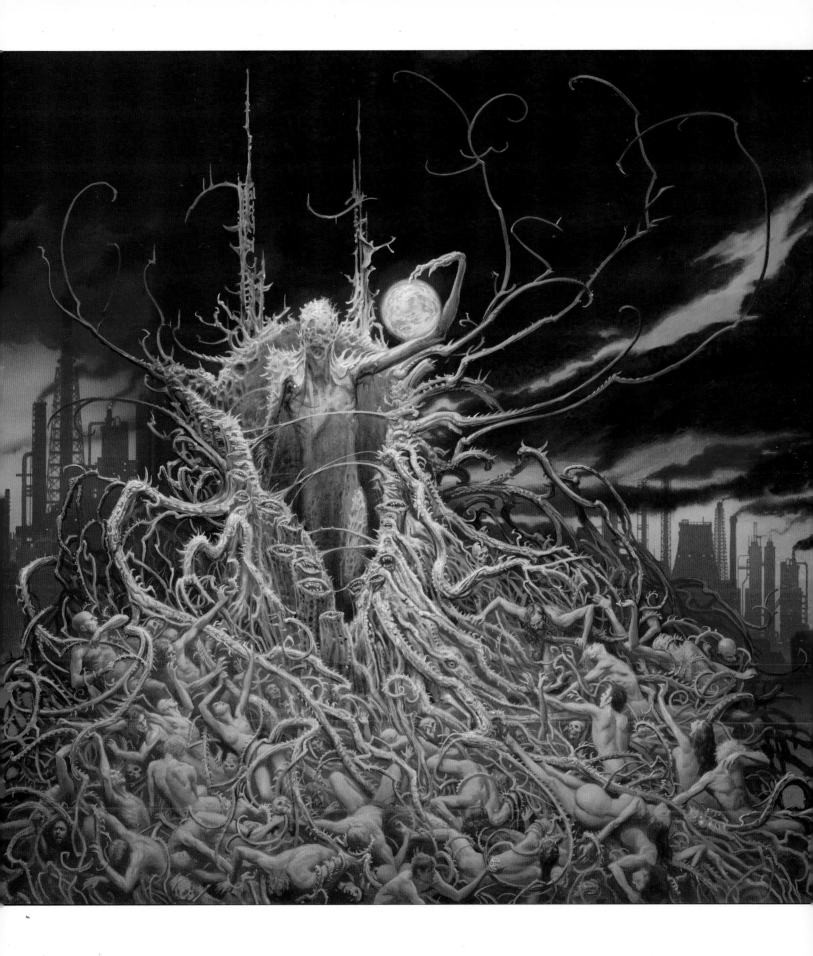

Michael Whelan

Art Director: Matt Drake *Designer:* Oliver Drake *Client:* Earache Records *Title:* Infected Nations *Size:* 20″x20″ *Medium:* Acrylics on panel

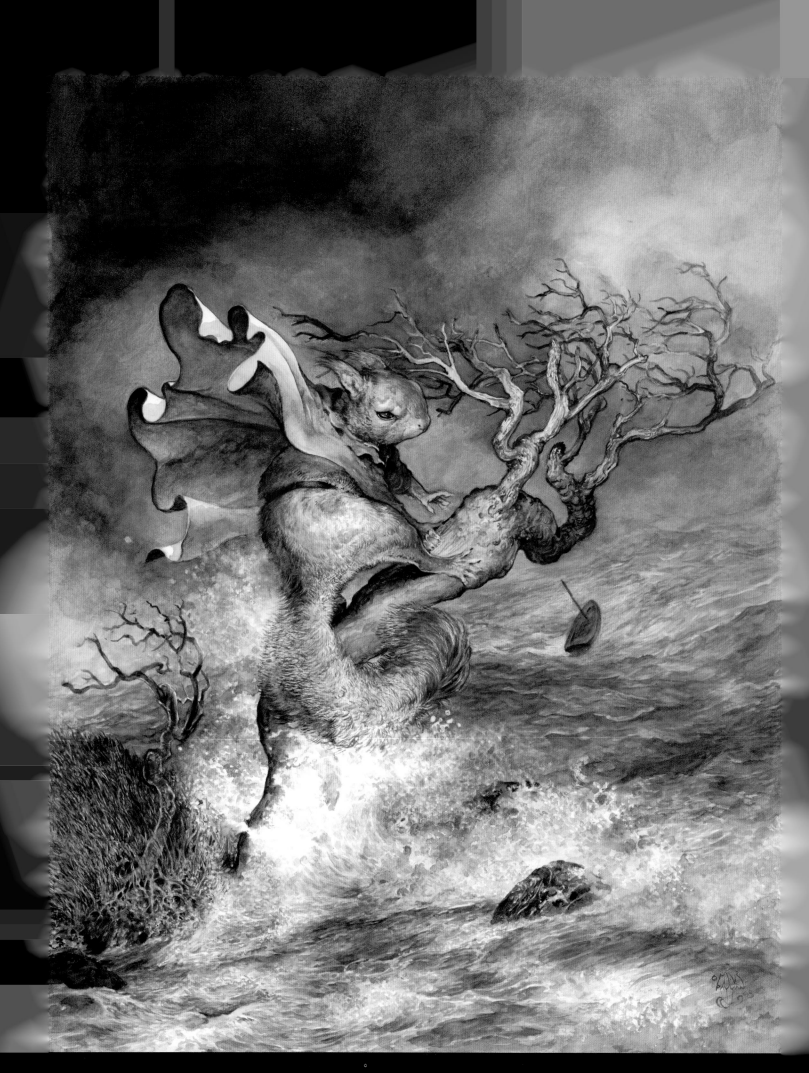

Omar Rayyan

Art Director: Christian Trimmer *Client:* Hyperion Books *Title:* Mistmantle—The Rage Tide *Size:* 12″x21″ *Medium:* Watercolor

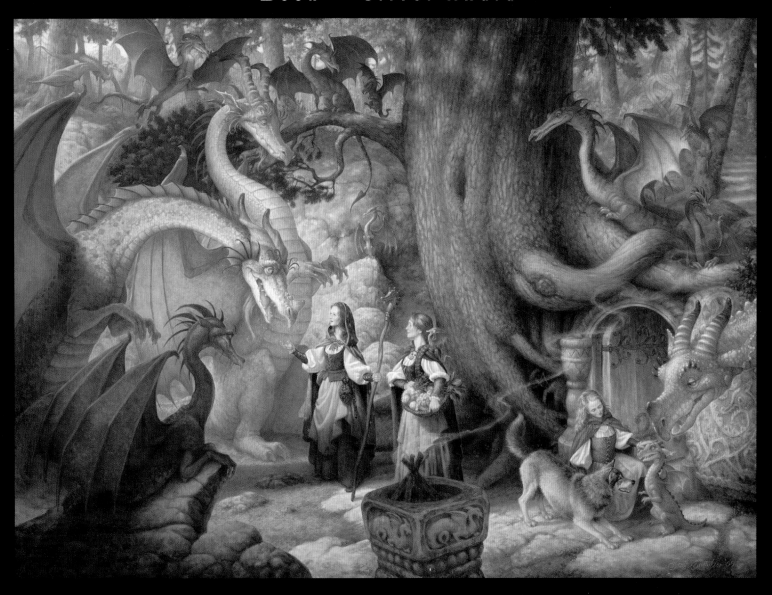

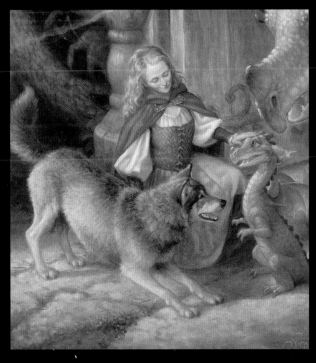

Scott Gustafson

Art Director: Scott Gustafson *Client:* The Greenwich Workshop *Title:* A Confabulation of Dragons *Size:* 46"x34" *Medium:* Oil on canvas

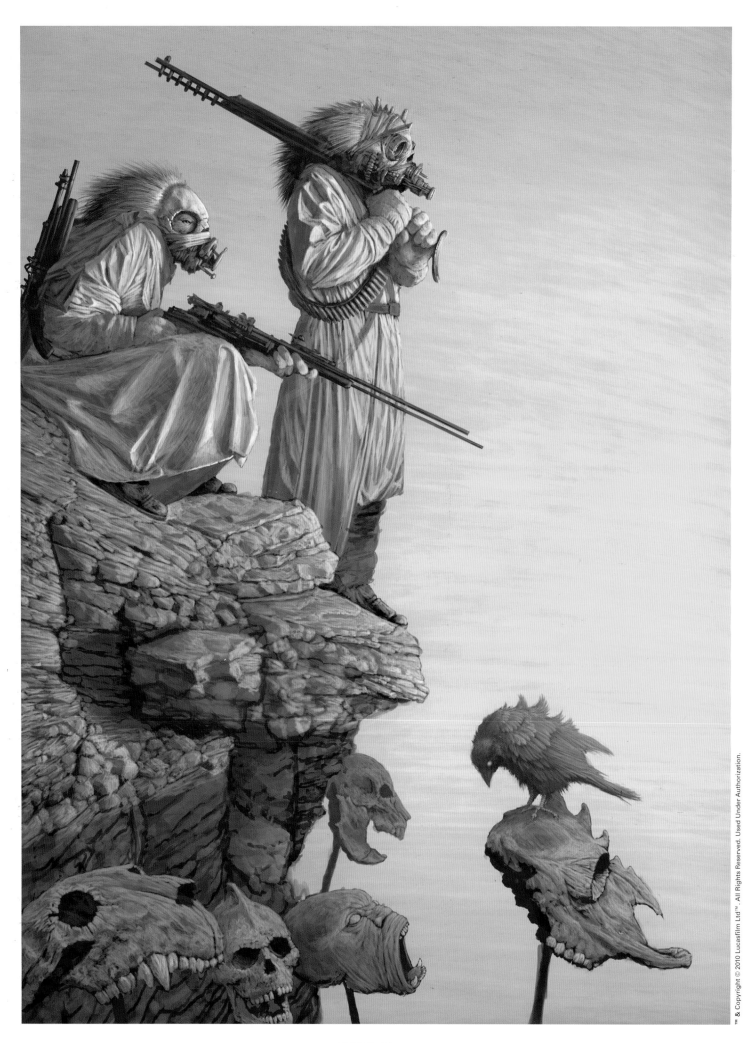

Ed Binkley

Art Director: Kirk Smith *Client:* Lucasfilm Ltd.™ *Title:* Star Wars Visions *Medium:* Digital

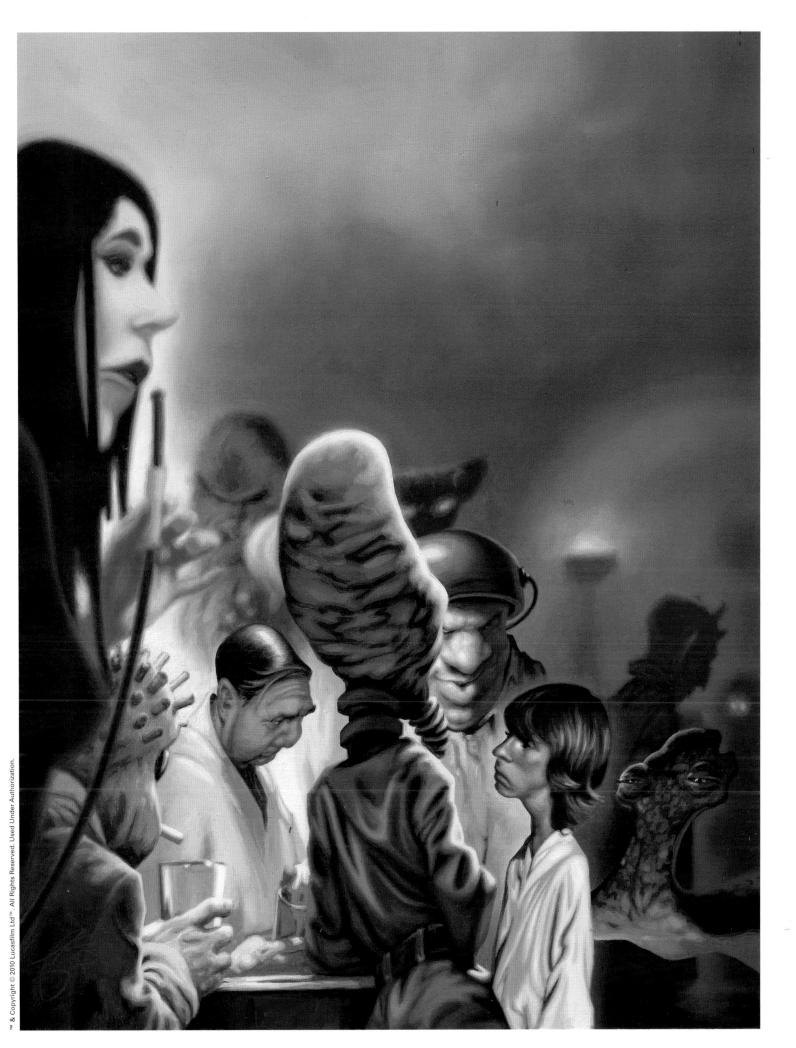

James Bennett

Art Director: James Bennett *Client:* Lucasfilm Ltd.™ *Title:* Star Wars Visions: The Cantina *Size:* 16"x20" *Medium:* Oil on wood

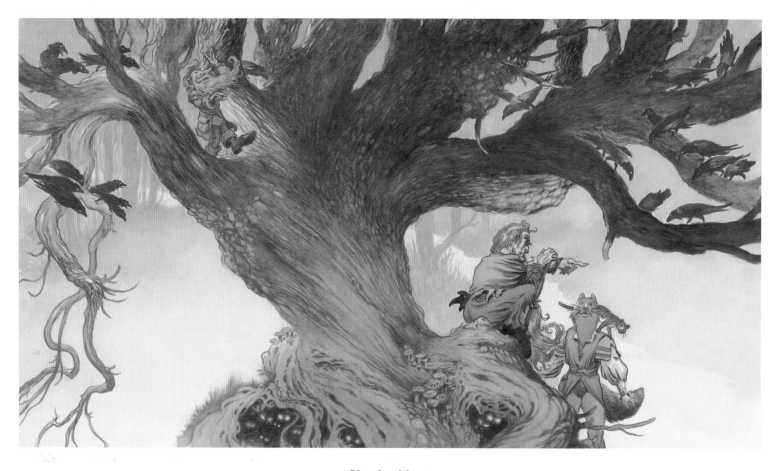

Charles Vess

Art director: Alson Donalty *Client:* HarperCollins *Title:* Instructions *Size:* 26"x15" *Medium:* Colored inks

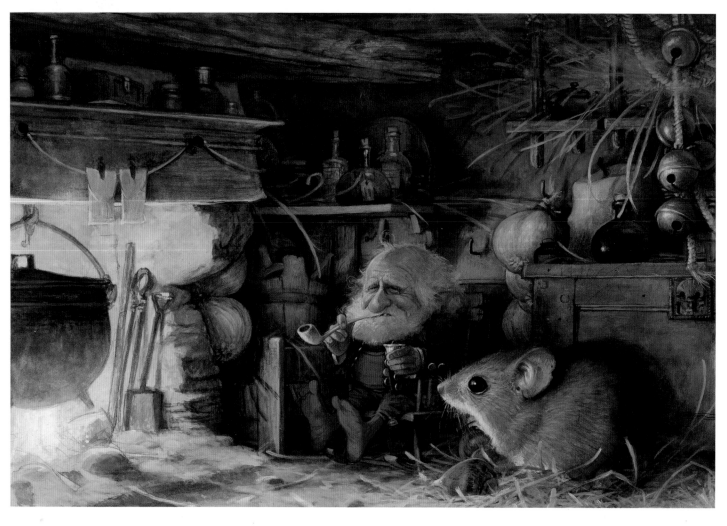

Jean-Baptiste Monge

Art director: Jean-Baptiste Monge *Client:* Au Bord Des Continents *Title:* Home Sweet Home *Size:* 13"x9" *Medium:* Watercolor & gouache

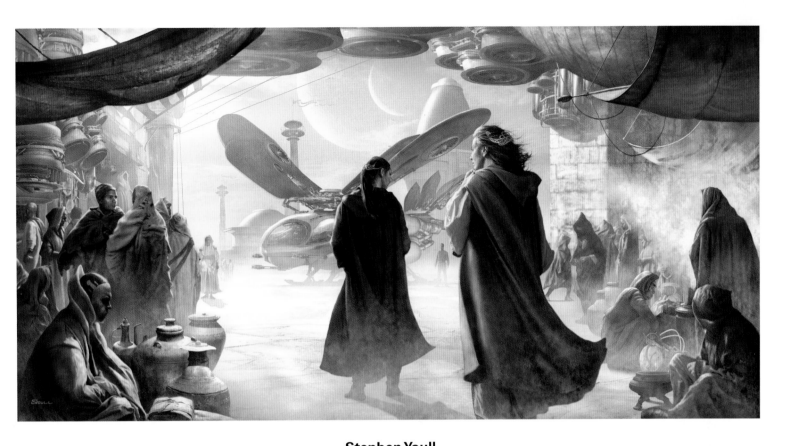

Stephen Youll

Art Director: Irene Gallo *Designer:* Stephen Youll *Client:* Tor Books *Title:* Winds of Dune *Size:* 10"x6" *Medium:* Traditional/digital

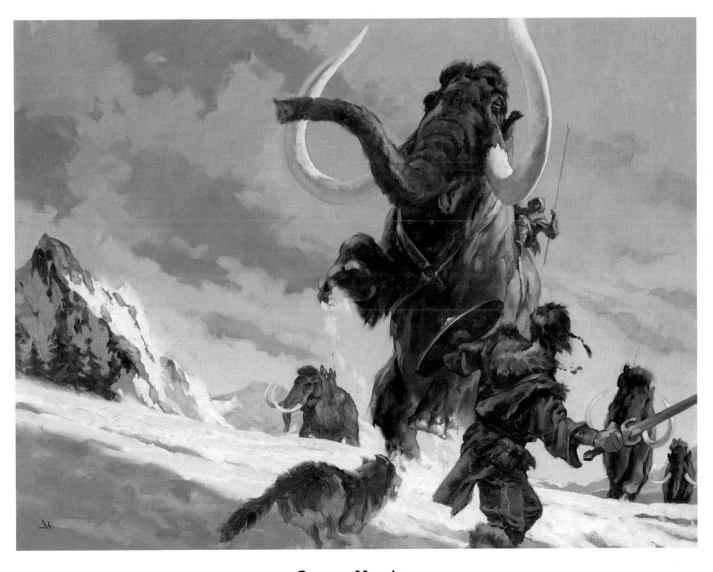

Gregory Manchess

Art Director: Irene Gallo *Client:* Tor Books *Title:* Breath of God *Medium:* Oil on linen

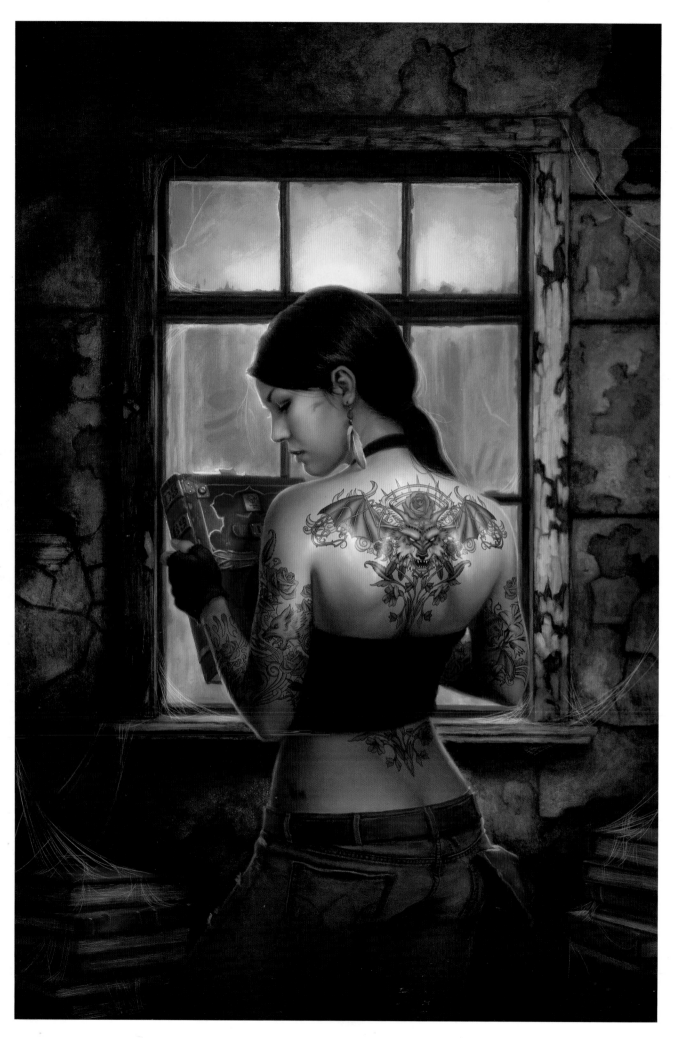

Dan dos Santos

Art Director: Judith Murello *Client:* Ace Books *Title:* Silver Borne *Size:* 20"x30" *Medium:* Oils

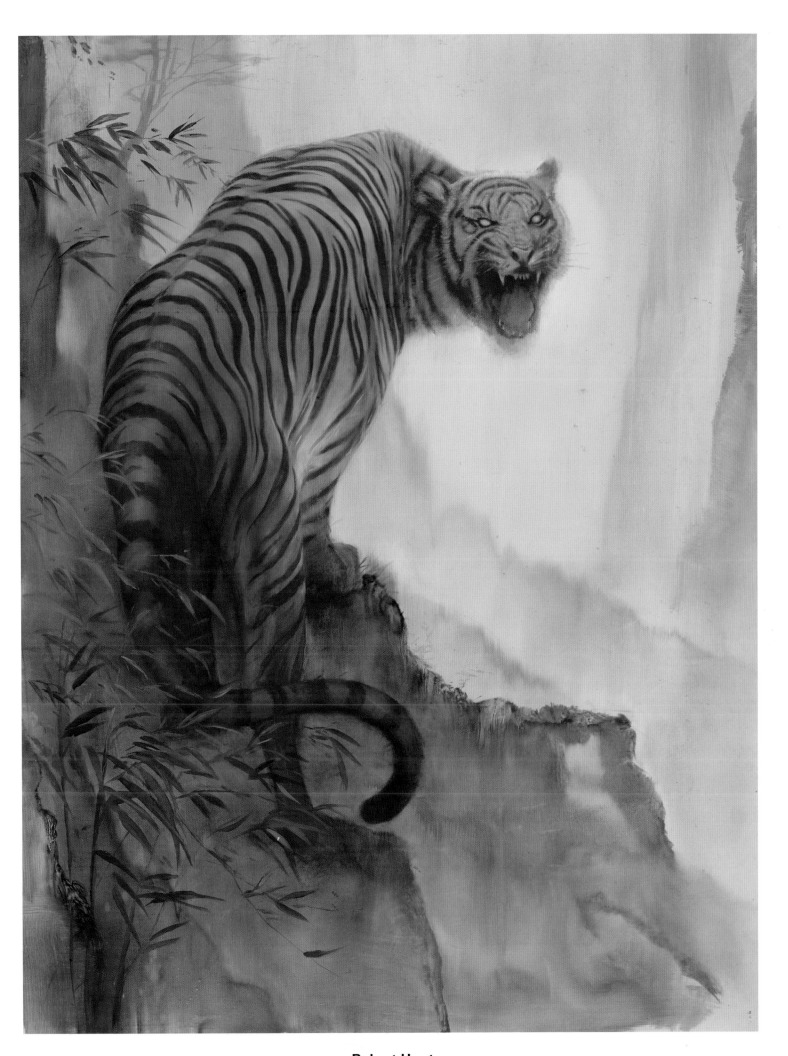

Robert Hunt

Art Director: Dave Stevenson *Client:* Random House *Title:* Jade Man's Skin *Size:* 24"x33" *Medium:* Oils

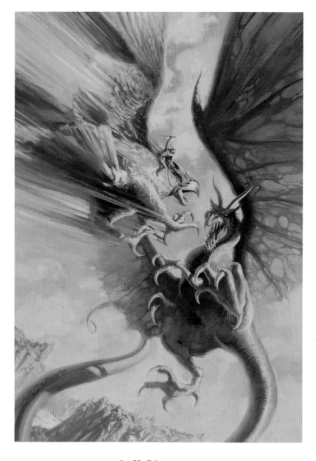 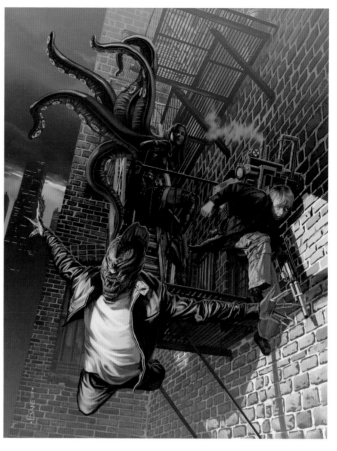

Jeff Slemons

Art Director: Ben avery *Client:* Rising Star Studios

Title: Armor Quest *Size:* 14"x20" *Medium:* Gouache

Mark Evans

Art Director: Kevin Siembieda *Client:* Palladium Books

Title: Nightbane Survival Guide *Medium:* Digital

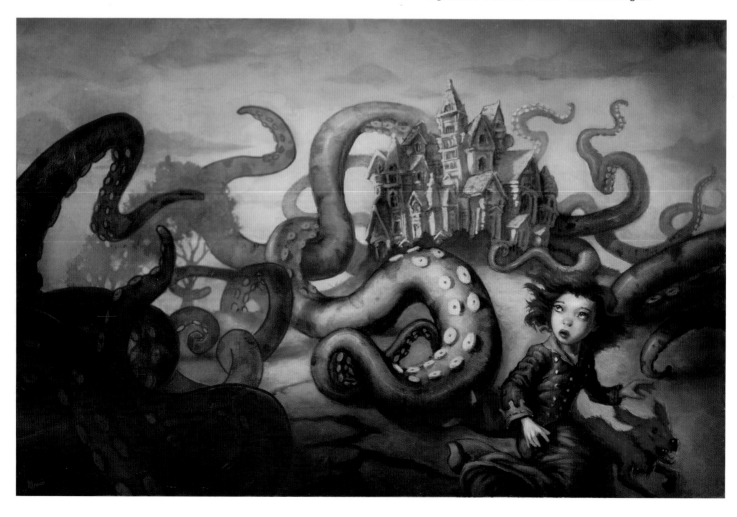

Scott Altmann

Art Director: Matthew Kalamidas *Client:* Science Fiction Book Club *Title:* Flora Fydraaca *Size:* 19"x13" *Medium:* Oils/digital

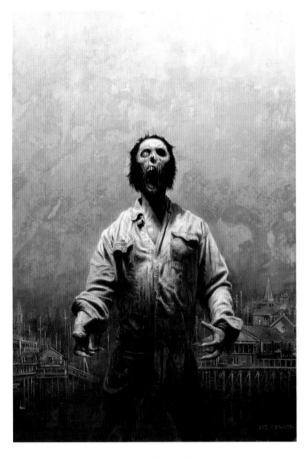
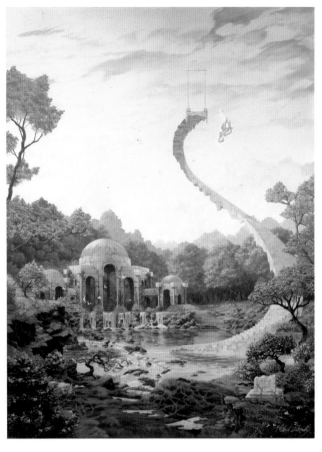

Les Edwards
Client: PS Publishing *Title:* Pelican Cay
Size: 14"x21" *Medium:* Oils

Chad E. Beatty
Client: St. Martin's Press *Title:* Mediation *Size:* 38"x48"
Medium: Oil on canvas

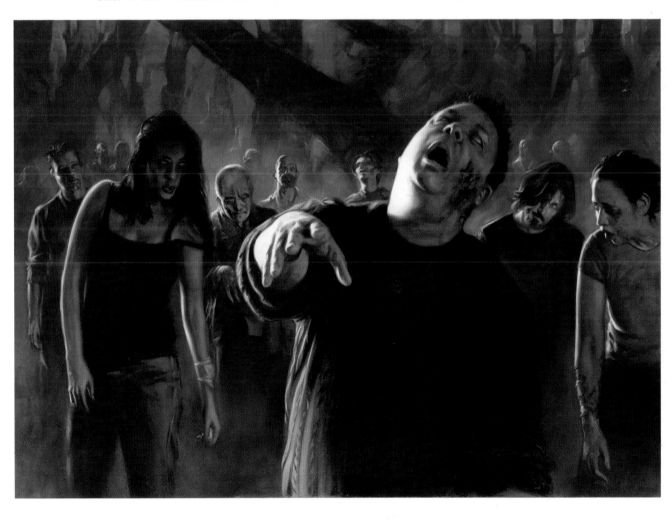

David Palumbo
Art Director: Jeremy Lassen *Client:* Night Shade *Title:* The Living Dead 2 *Size:* 21"x15" *Medium:* Oils

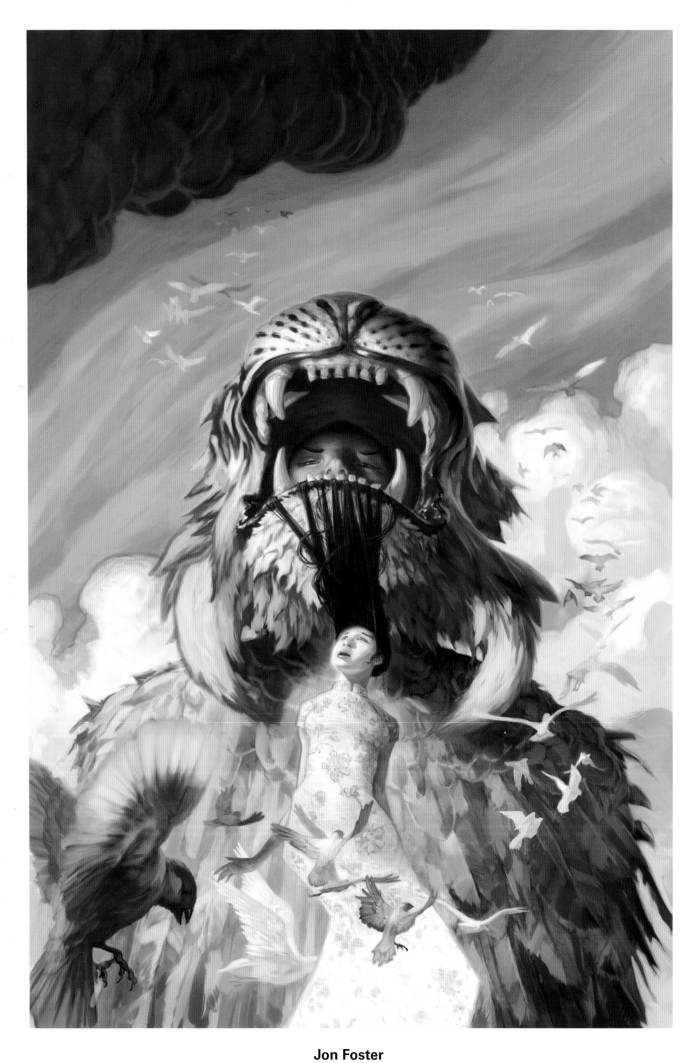

Jon Foster

Art Director: Bill Schaffer *Client:* Subterranean Press *Title:* Bridge of Birds *Medium:* Digital

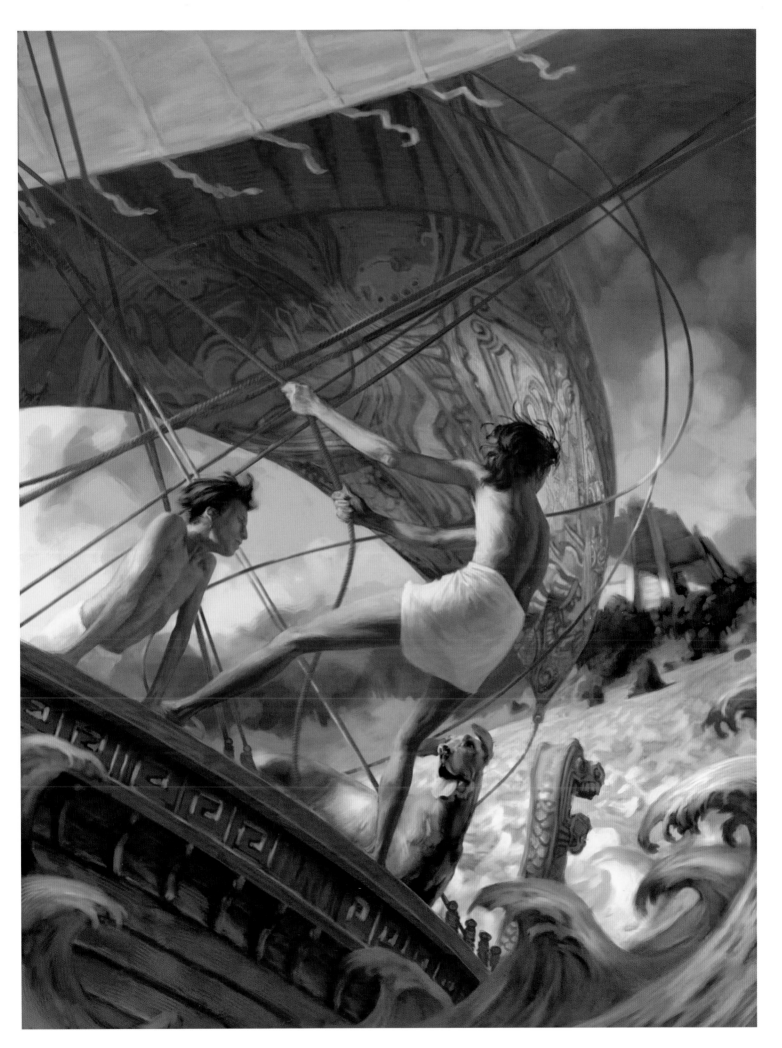

Jon Foster

Art Director: Chloe Foglia *Client:* Simon & Schuster *Title:* Sea of the Dead *Medium:* Digital

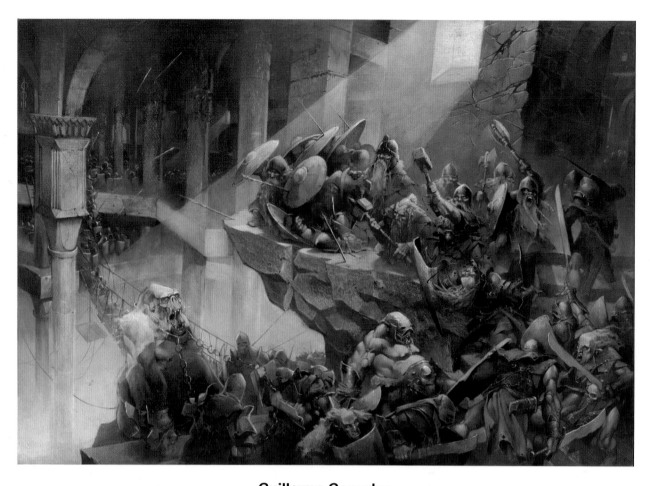

Guillermo Gonzalez

Art director: Olivier Souille *Client:* Daniel Maghen *Title:* Lúnivers Des Nains *Size:* 60x40cm *Medium:* Pastels

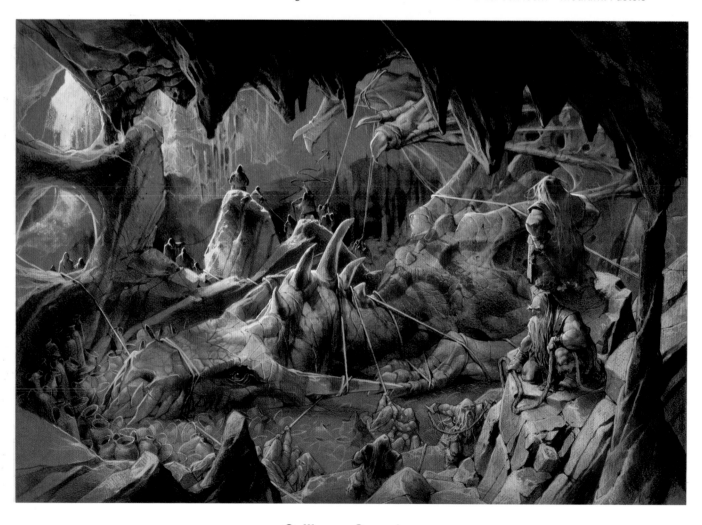

Guillermo Gonzalez

Art director: Olivier Souille *Client:* Daniel Maghen *Title:* Lúnivers Des Nains *Size:* 60x40cm *Medium:* Pastels

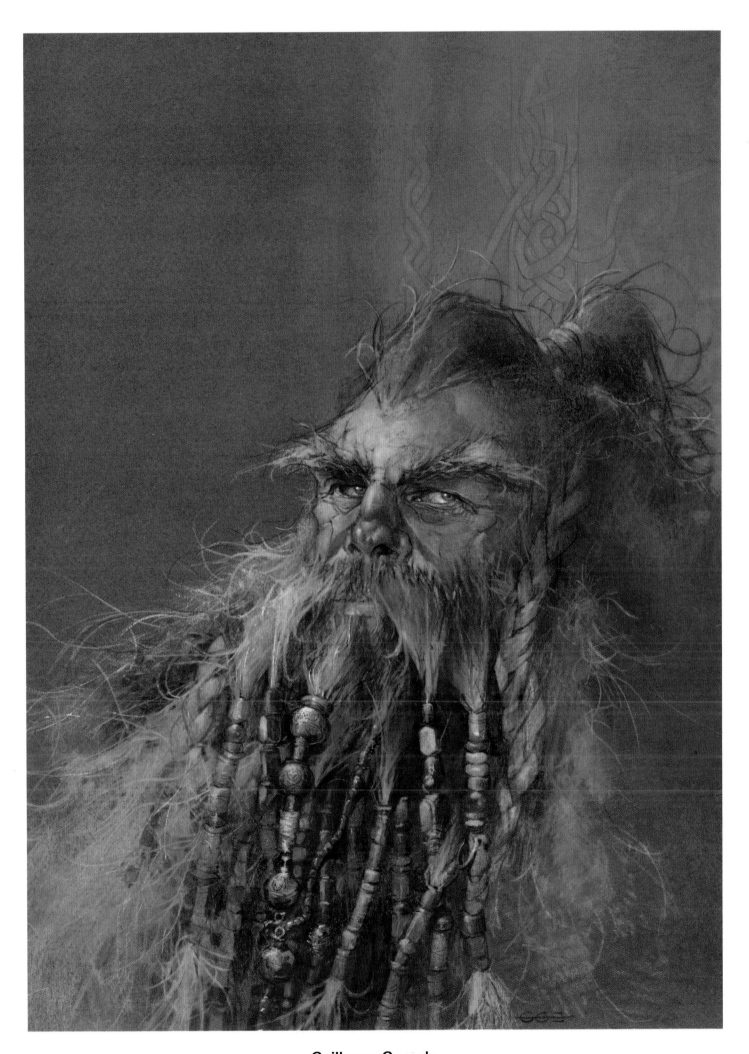

Guillermo Gonzalez

Art director: Olivier Souille *Client:* Daniel Maghen *Title:* Lúnivers Des Nains *Size:* 21x30cm *Medium:* Pastels

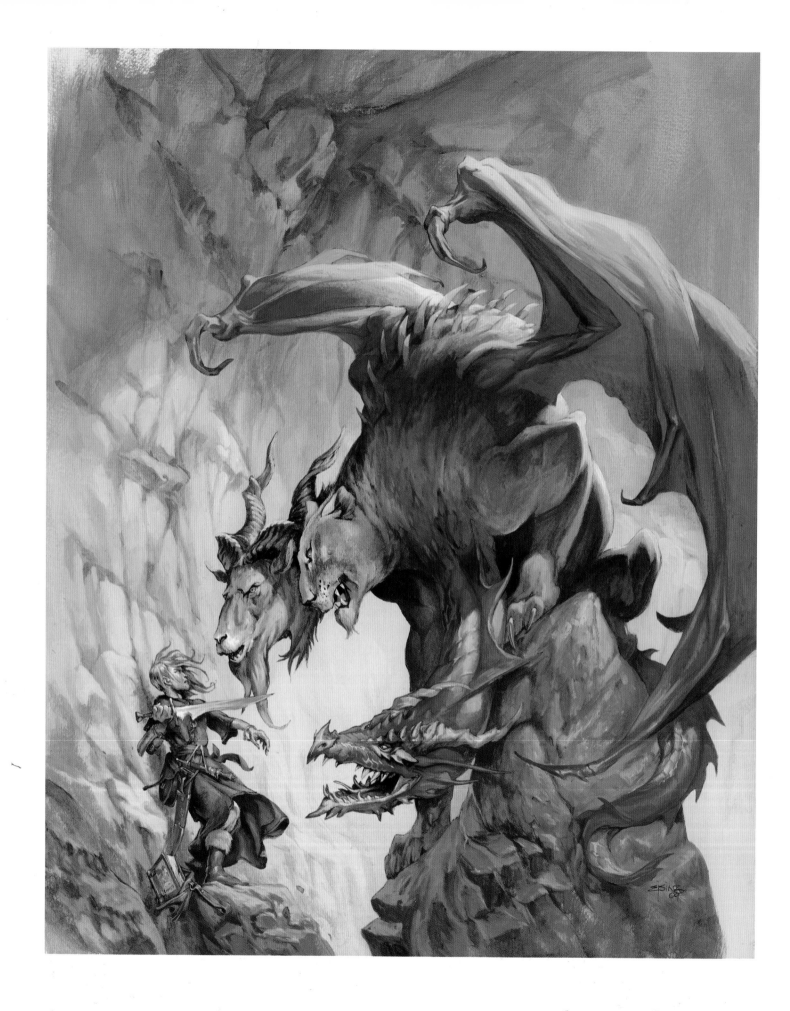

Jesper Ejsing

Art Director: Kate Irwin *Client:* Wizards of the Coast *Title:* Monster Slayers Cover *Size:* 40x50cm *Medium:* Acrylic

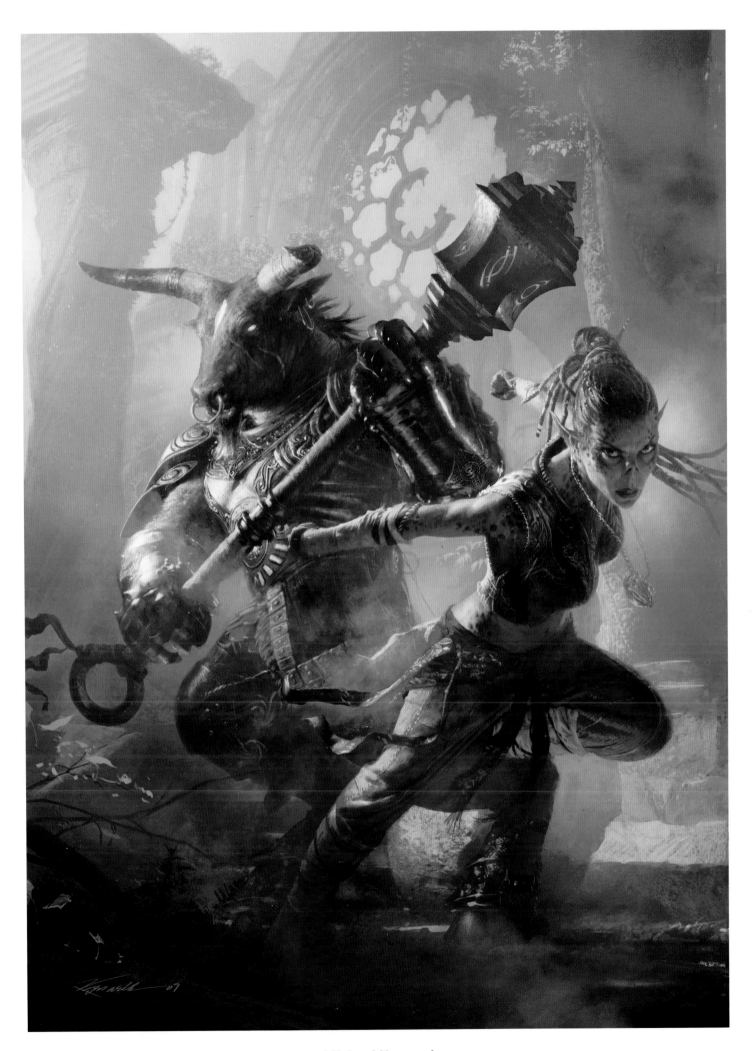

Michael Komarck

Art Director: Kate Irwin *Client:* Wizards of the Coast *Title:* Player's Handbook 3 Cover *Size:* 9"x12" *Medium:* Digital

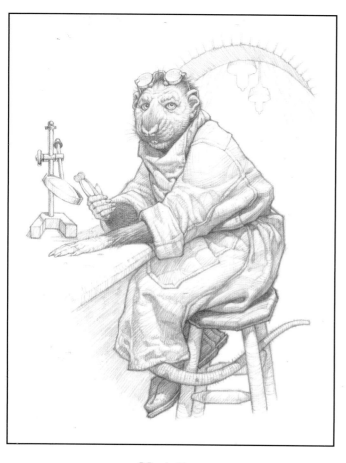

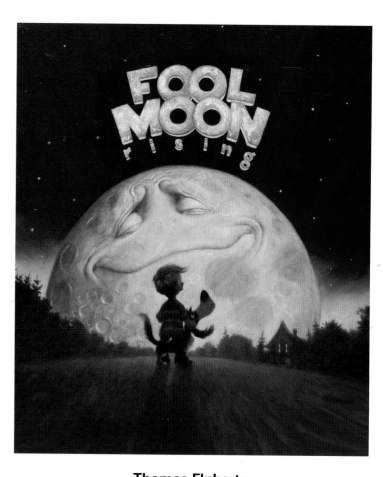

Mark Zug

Art Director: Hilary Zarycky *Client:* HarperCollins

Title: Ephaniah Grebe *Medium:* Pencil

Thomas Fluharty

Art Director: Thomas Fluharty/Josh Deunis *Client:* Crossway Books

Title: Fool Moon Rising *Size:* 10"x9" *Medium:* Oil

Chris Ayers

Client: Design Studio Press *Title:* The Daily Zoo Year Two—Day 695: Chinchilla, Jacked Around *Size:* 8"x6" *Medium:* Digital

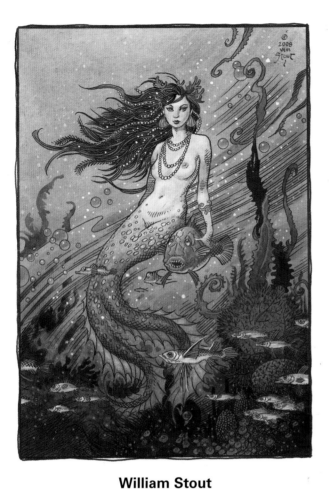

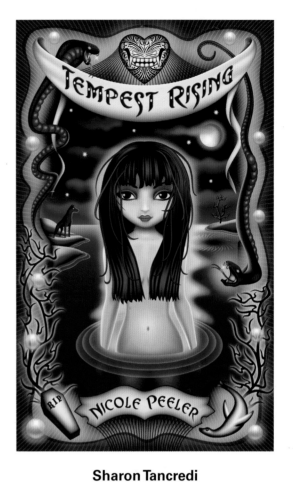

William Stout
Designer: Randall Dahlk *Client:* Flesk Publications
Title: Pearls Before Brine *Size:* 7"x10" *Medium:* Ink & watercolor

Sharon Tancredi
Art Director: Lauren Panepinto *Client:* Orbit Books
Title: Tempest Rising *Size:* 5"x7" *Medium:* Digital

Agata Kawa
Art Director: Françoise Mateu *Client:* Editions Le Sevil *Title:* Sewing *Size:* 43x35cm *Medium:* Graphite/digital

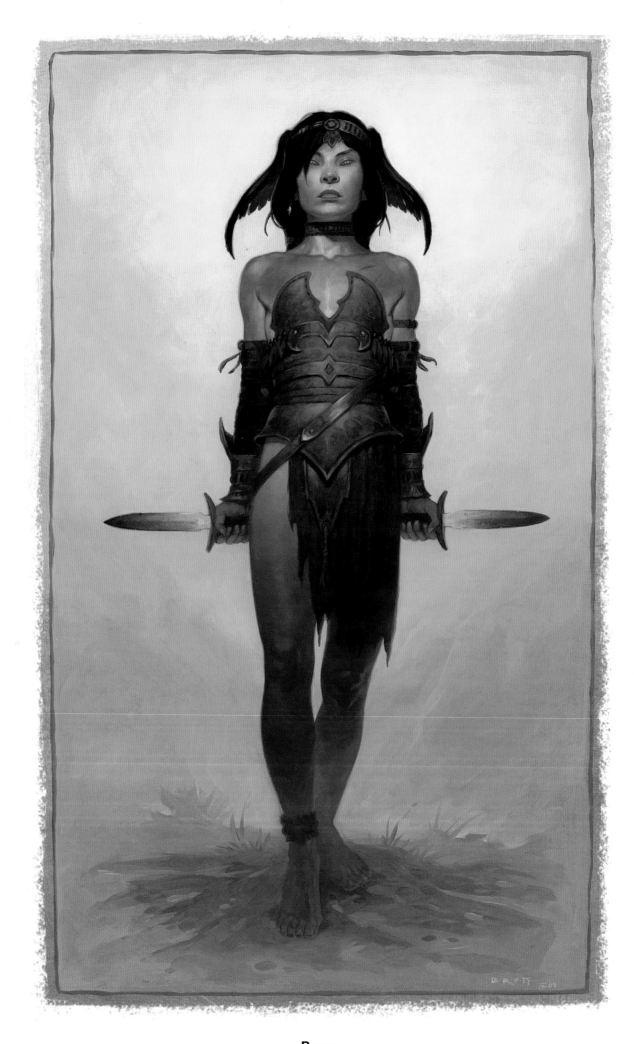

Brom

Client: Eos *Title:* Sekeu *Size:* 12"x18" *Medium:* Oil

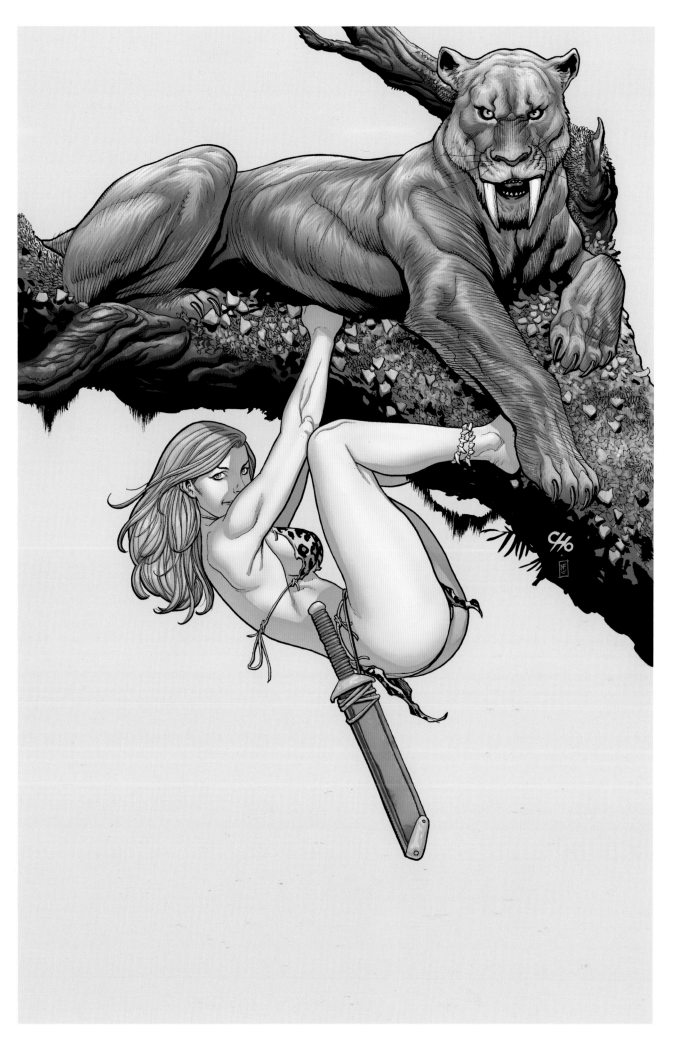

Frank Cho

Colorist: Nathan Fairbairn *Client:* Monkey Boy Press *Title:* Tara Green *Size:* 14"x21" *Medium:* Ink/digital color

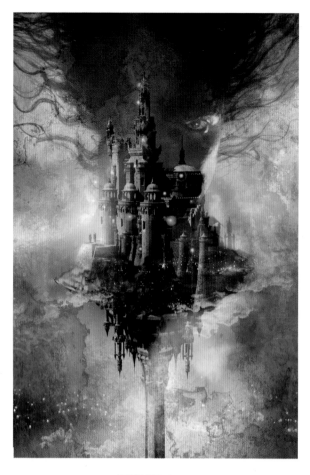

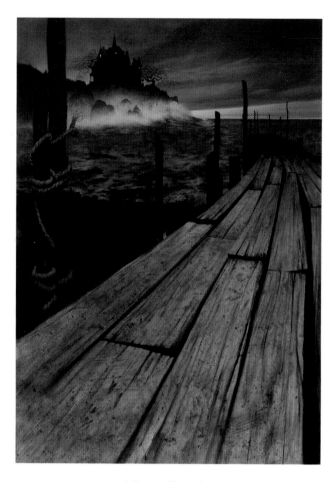

Cliff Nielsen

Art Director: Lauren Panepinto *Client:* Orbit Books

Title: The Hundred Thousand Kingdoms *Medium:* Digital

Vince Natale

Art Director: Irene Gallo *Client:* Tor Books

Title: The Harbour *Size:* 15"x20" *Medium:* Oil

Sam Weber

Art Director: Sheri Gee *Client:* The Folio Society

Title: Painted Faces and Log Hair *Medium:* Acrylic/digital

Matt Smith

Art Director: Craig Grant *Client:* White Wolf Publishing

Title: Dement *Size:* 9"x9 3/4" *Medium:* White pencil on black paper

Sam Weber

Art Director: Sheri Gee *Client:* The Folio Society *Title:* The Lord of the Flies *Size:* 12"x18" *Medium:* Acrylic/digital

John Jude Palencar

Art Director: Irene Gallo *Client:* Tor Books *Title:* The Mystery of Grace (Version #2) *Size:* 18"x23" *Medium:* Acrylic

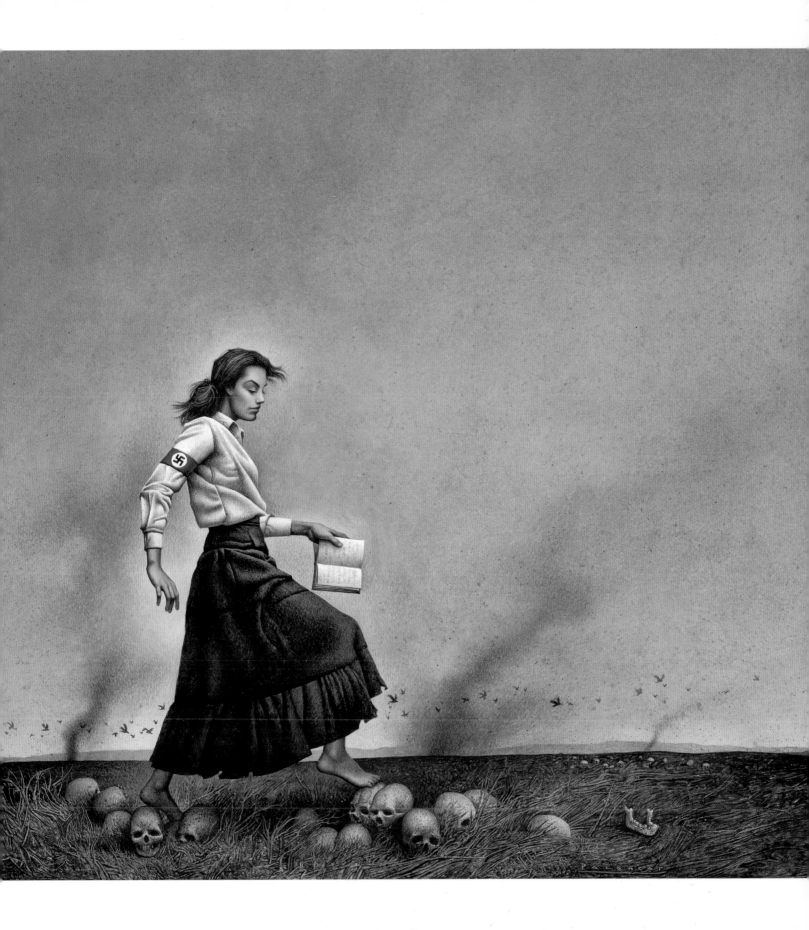

John Jude Palencar

Art Director: Irene Gallo *Client:* Tor Books *Title:* Bitter Seeds *Size:* 27"x25" *Medium:* Acrylic

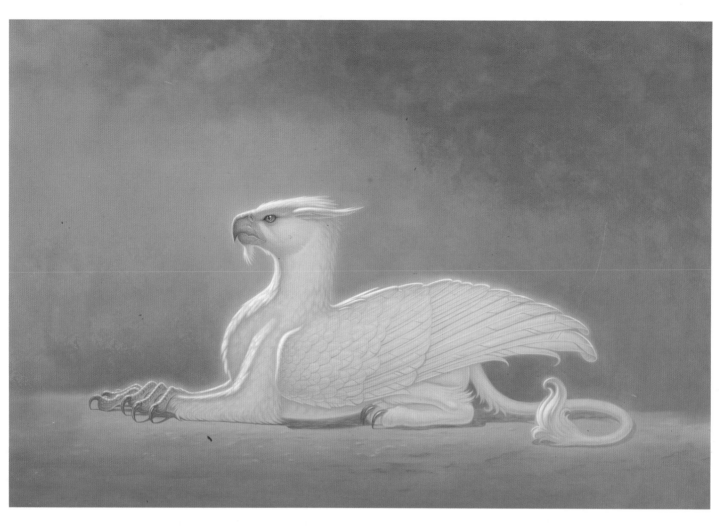

Paul Kidby

Art director: Olivier Souille *Client:* Daniel Maghen *Title:* Le Royaume Enchante *Size:* 72x48cm *Medium:* Oil

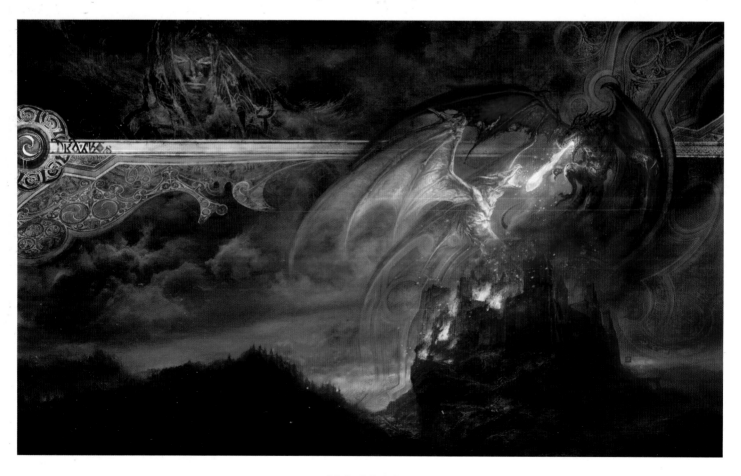

Aleksi Briclot

Art director: Aleksi Briclot/Jean-Sebastien Rossbach *Client:* Soleil Éditions *Title:* Merlin: Red & White *Size:* 22"x13" *Medium:* Digital

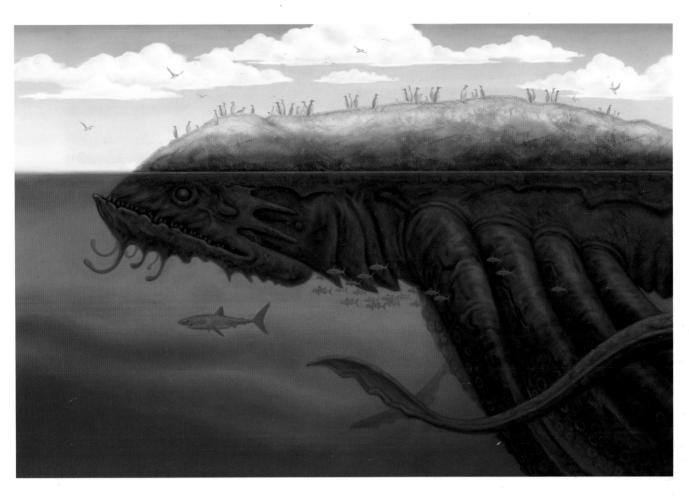

Allen Douglas

Art Director: Diane Choi *Client:* Random House *Title:* The Kraken *Medium:* Digital

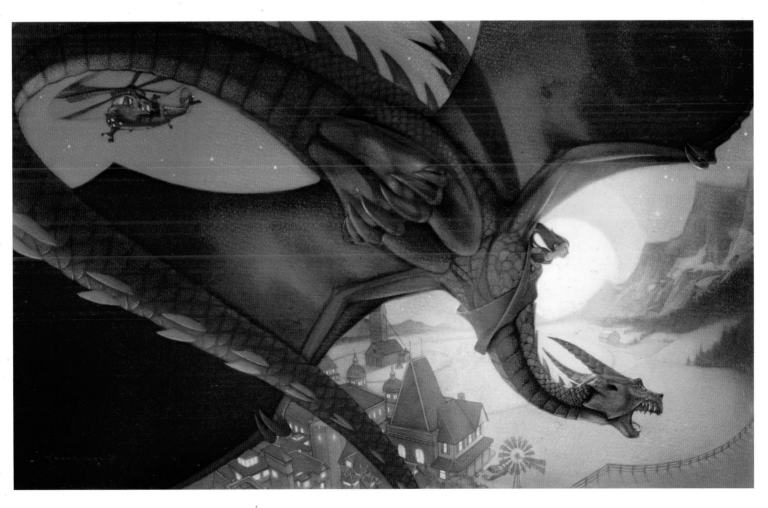

Greg Swearingen

Art Director: David Caplan *Client:* HarperCollins *Title:* The Dragons of Ordinary Farm *Size:* 16"x10" *Medium:* Mixed

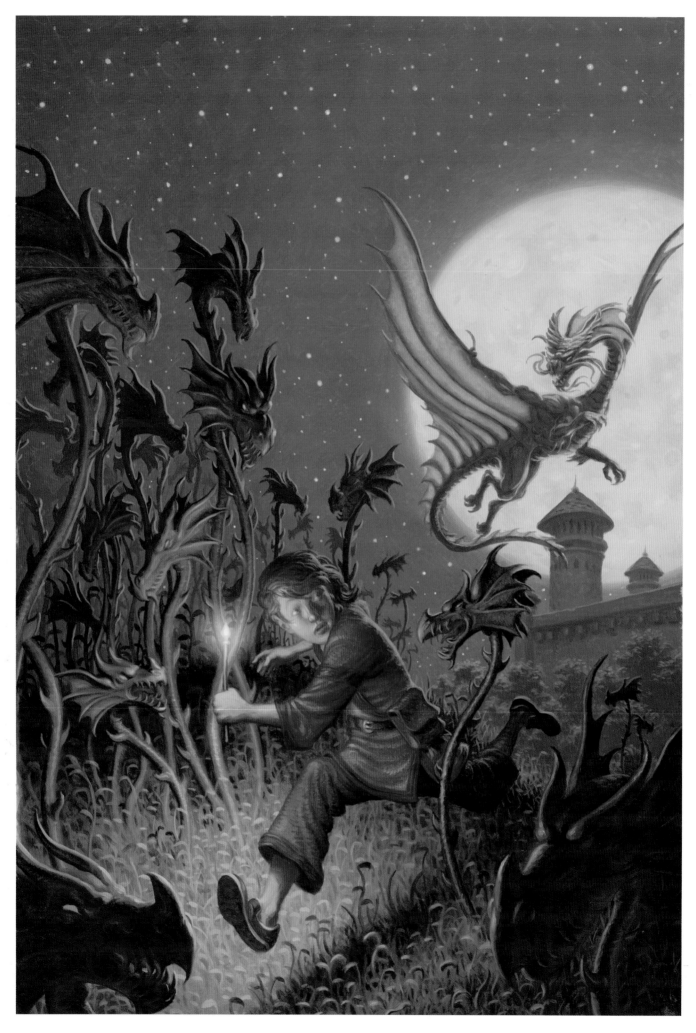

Peter Ferguson

Art dirctor: Kate Irwin *Client:* Wizards of the Coast *Title:* Aldwyn's Academy Cover *Size:* 7 7/8"x11 3/16" *Medium:* Acrylic

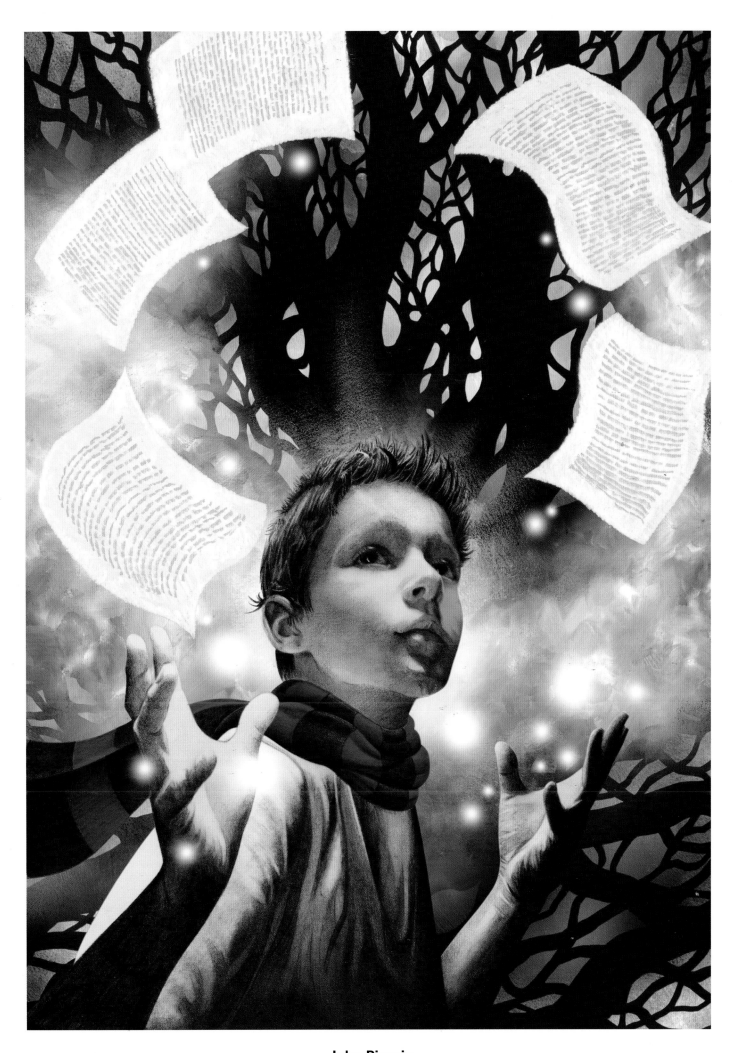

John Picacio

Art Director: Lisa Vega *Client:* Simon & Schuster/Aladdin *Title:* The 13th Reality *Size:* 11"x15" *Medium:* Pencil/paint/digital

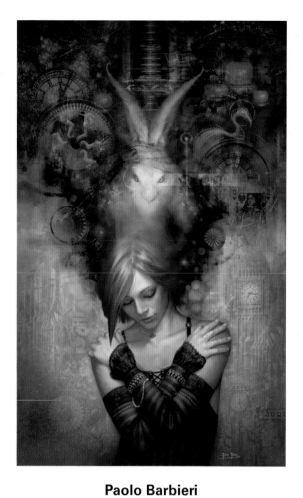

Paolo Barbieri

Art Director: Valentina Paggi *Client:* Salani Editore
Title: Alice *Size:* 12"x76" *Medium:* Digital

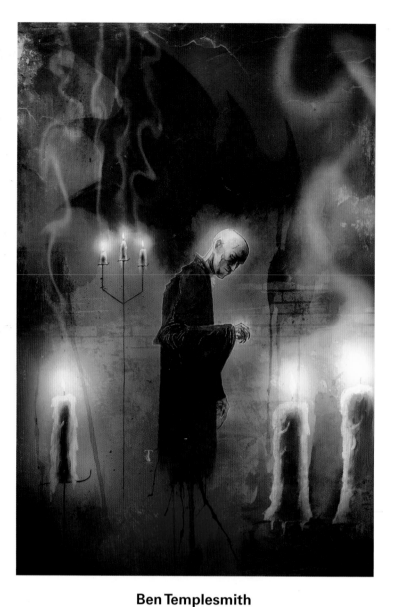

Ben Templesmith

Client: IDW Publishing *Title:* Dracula 1 *Size:* 11"x17" *Medium:* Mixed

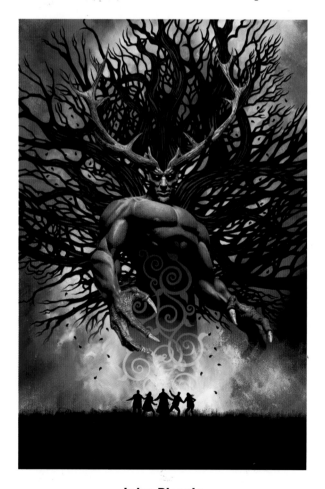

John Picacio

Art Director: Lou Anders *Client:* Pyr *Title:* Age of Misrule
Size: 13"x19" *Medium:* Pencil/paint/digital

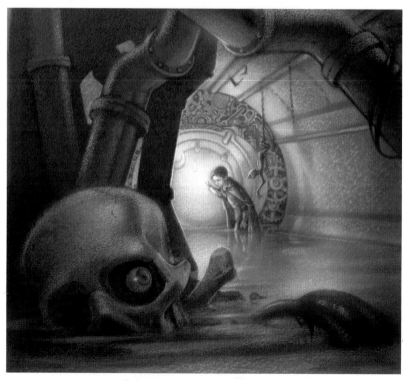

Greg Swearingen

Art Director: Regina Griffin *Client:* Egmont
Title: Candle Man: Society of Doom *Size:* 6"x5" *Medium:* Mixed

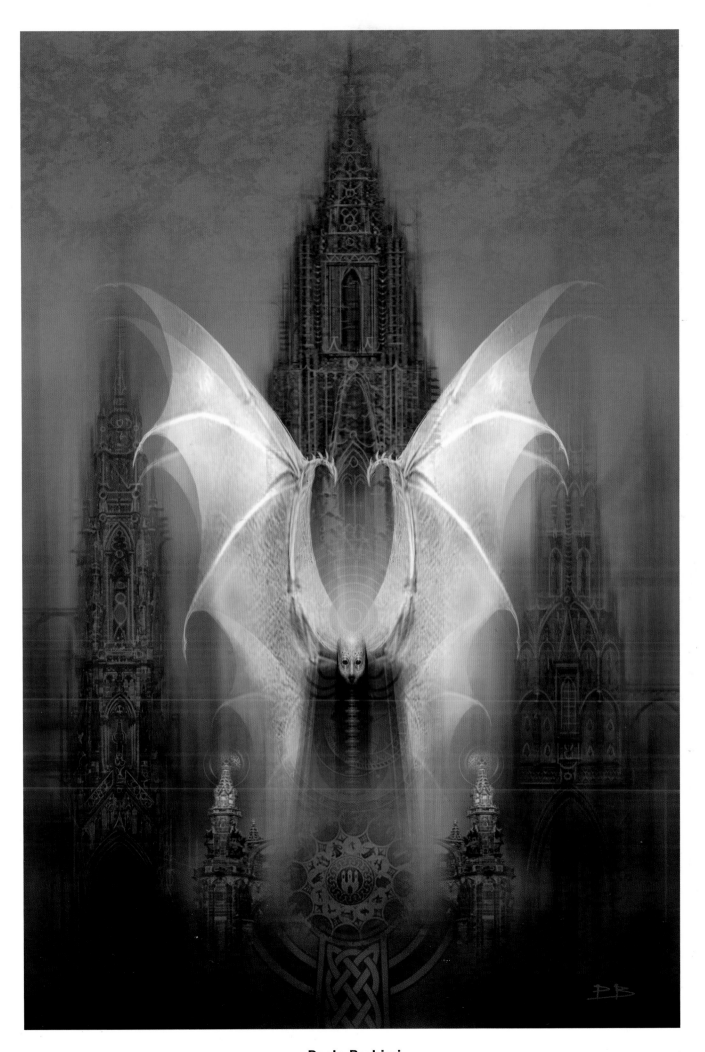

Paolo Barbieri

Art Director: Paolo Barbieri *Client:* Asengard Edizioni *Title:* Sanctuary *Size:* 8"x12" *Medium:* Digital

Peter J. Jones

Designer: Geoff O'Neil *Client:* Easton Press *Title:* Earth Abides *Size:* 11 1/2"x16" *Medium:* Oil/digital

Stephan Martiniere

Art Director: Lou Anders *Client:* Pyr *Title:* The Dervish House *Medium:* Digital

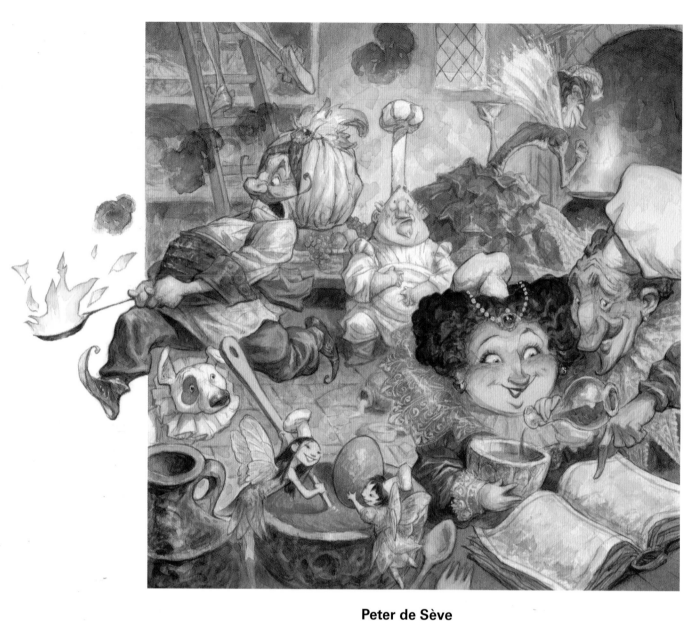

Peter de Sève

Art director: Semadar Megged *Client:* Philomel Books *Title:* The Chef Took III... (*The Duchess of Whimsy*) *Medium:* Ink & watercolor

Dan Santat

Art director: Scott Piehl *Client:* Hyperion *Title:* Oh No! (Or How My Science Project Destroyed the World) *Size:* 22"x14" *Medium:* Digital

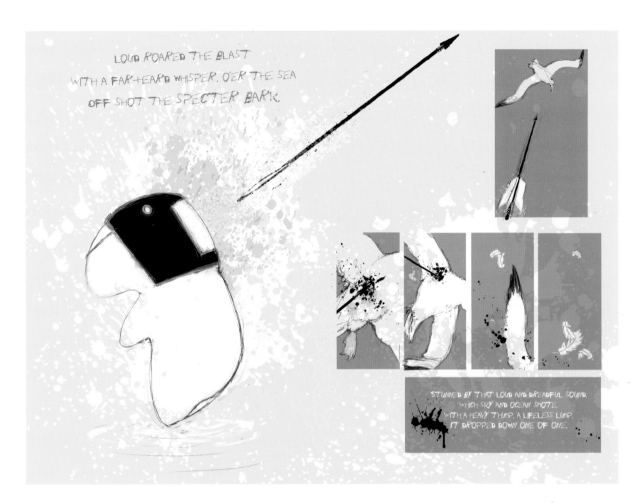

Camilla D'Errico

Title: Tanpopo, Volume 2, Spread 15 *Medium:* Pencils/Photoshop

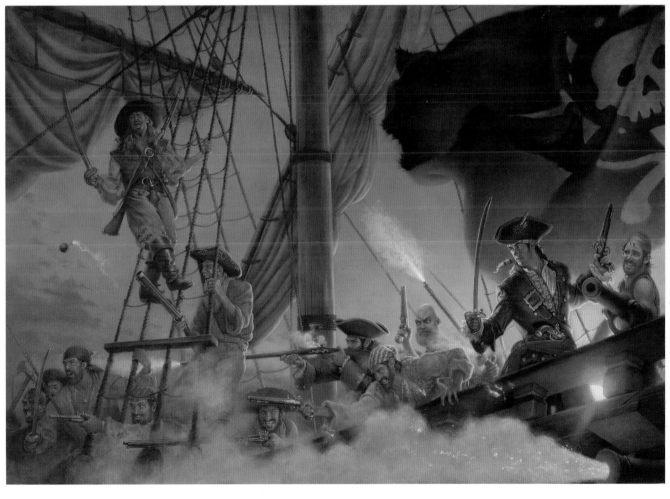

Don Maitz

Art Director: Flag/Don Puckey *Client:* Hachette *Title:* Pirate Devlin *Size:* 40"x28" *Medium:* Oil

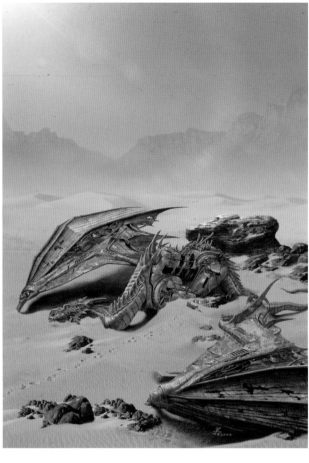

Paul Youll

Art Director: David Stevenson *Client:* Random House

Title: Dragonsoul *Medium:* Mixed

Didier Graffet

Art Director: Dave Stevenson *Client:* Ballantine Books

Title: The Children of Hurin *Size:* 12″x18″ *Medium:* Acrylic on board

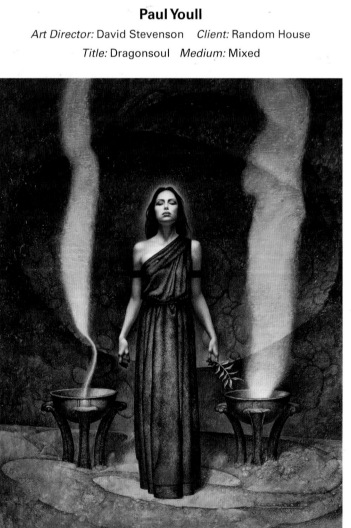

John Jude Palencar

Art Director: Lauren Panepinto *Client:* Orbit Books

Title: Black Ships *Size:* 19″x28″ *Medium:* Acrylic

Jon Foster

Art Director: Irene Gallo *Client:* Tor Books

Title: Day of Shadows *Medium:* Digital

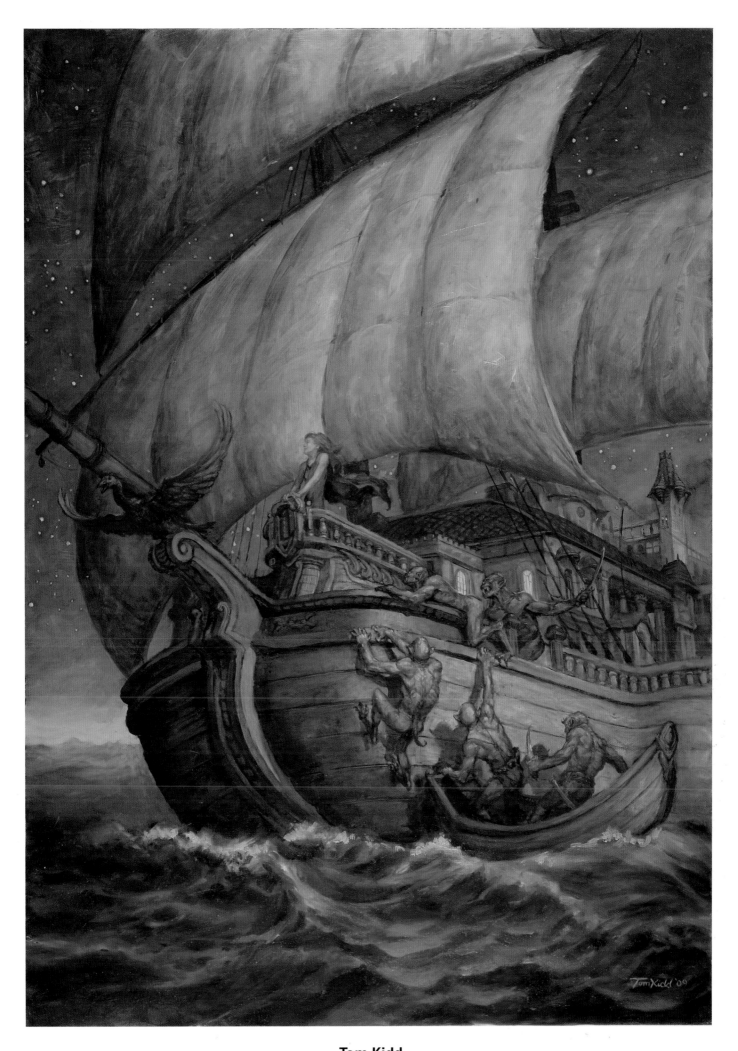

Tom Kidd

Art Director: Irene Gallo *Client:* Tor Books *Title:* Bird of the River *Size:* 20"x30" *Medium:* Oil

Mélanie Delon

Art dirctor: Mélanie Delon *Client:* Norma Editorial *Title:* Elixir Book 2: Whispers *Medium:* Digital

Katrina Sokolova

Art Director: Katrina Sokolova *Client:* Norma Editorial *Title:* Insomnia: Fans *Medium:* Digital

Cameron Scott Davis

Client: Pillonian Books *Title:* The 3rd-Eye Express

Size: 8 1/2"x11" *Medium:* Watercolor/digital

Owen Richardson

Art Director: Christian Trimmer *Client:* Hyperion

Title: Artemis Fowl *Size:* 8"x11" *Medium:* Digital

Dave Seeley

Art Director: Seth Lerner *Client:* Tor Books *Title:* The Unincorporated Man *Medium:* Digital

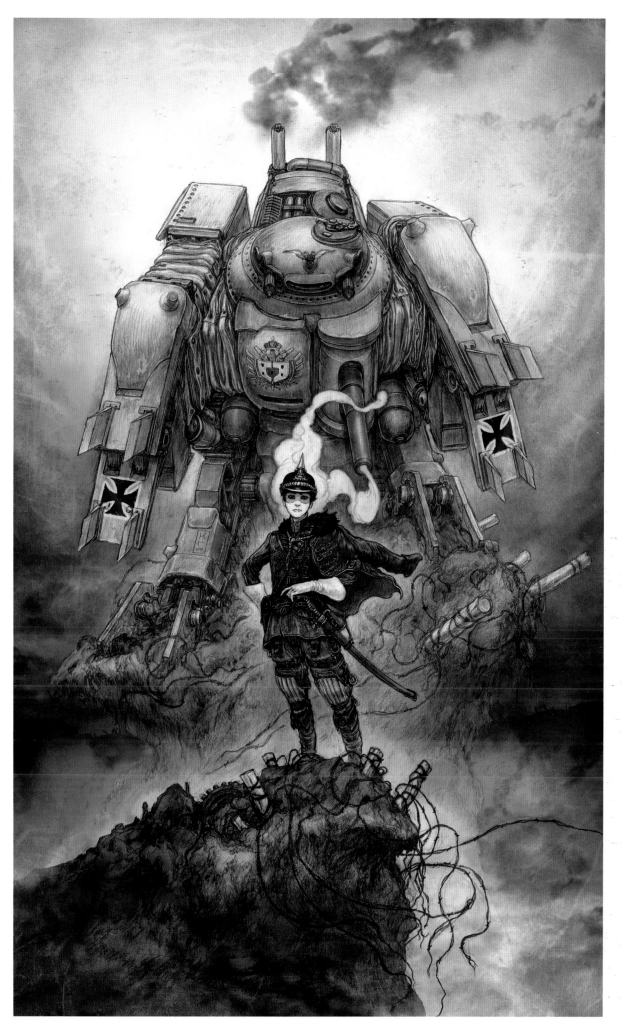

Keith Thompson

Art Director: Sammy Yuen Jr *Client:* Simon & Schuster *Title:* Alek & His Stormwalker *Size:* 12″x19″ *Medium:* Mixed

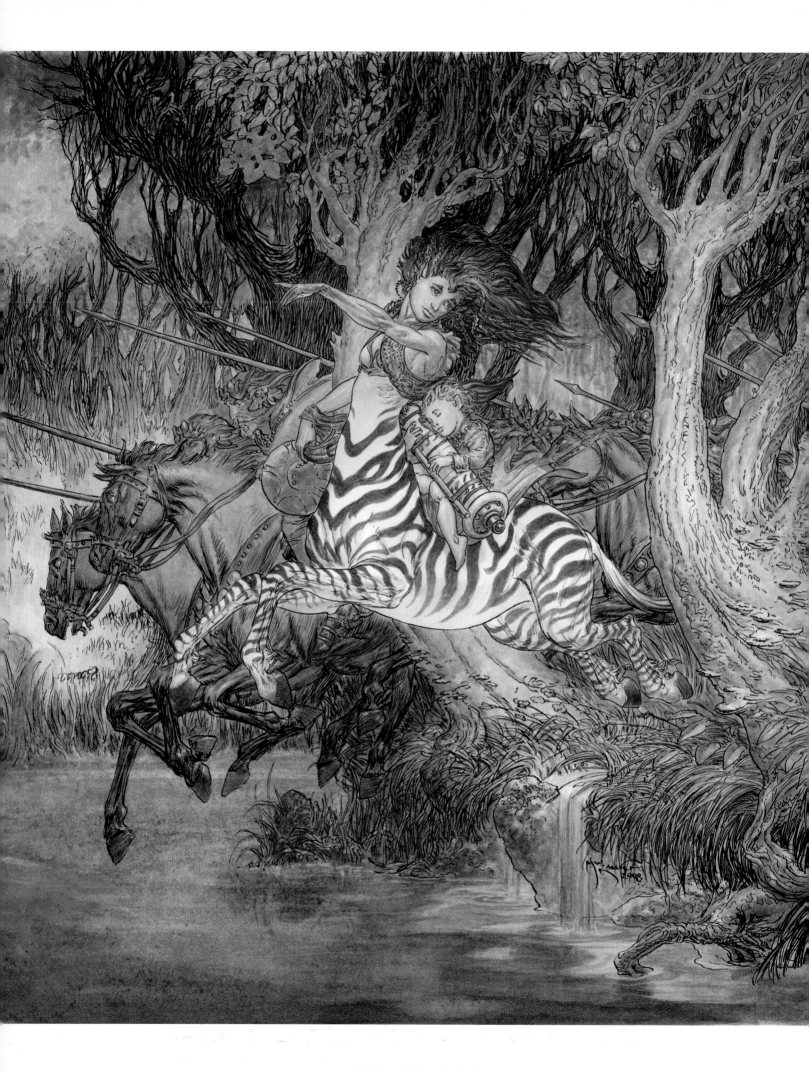

Michael Wm Kaluta

Art dirctor: Irene Gallo *Client:* Tor Books *Title:* A Forthcoming Wizard *Size:* 14"x17" *Medium:* Ink/watercolor

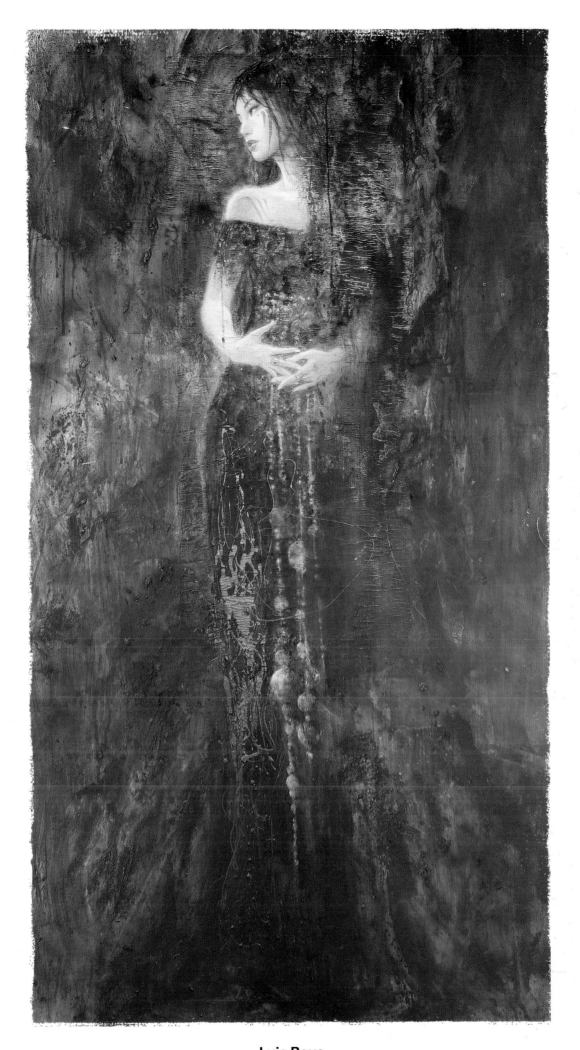

Luis Royo

Art Director: Luis Royo *Client:* Norma Editorial *Title:* Dead Moon Epilogue: Moon One *Size:* 12"x24" *Medium:* Oil

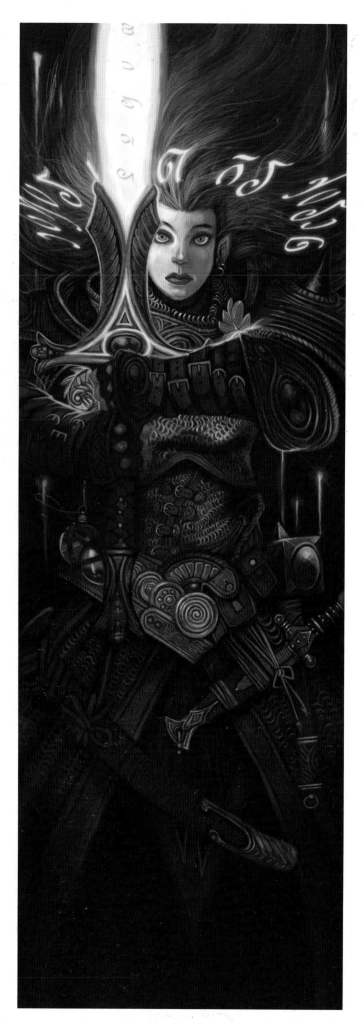

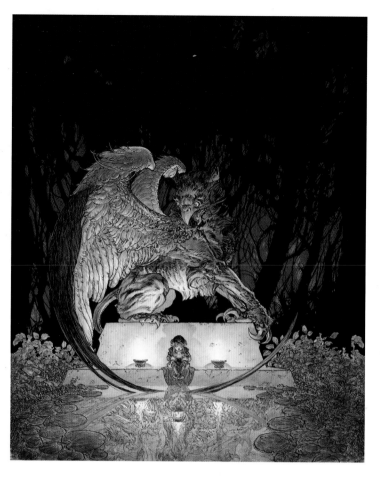

Michael Wm Kaluta

Art Director: Bill Schafer *Client:* Subterranean Press

Title: Mirror Kingdoms *Size:* 14"x17" *Medium:* Ink/watercolor

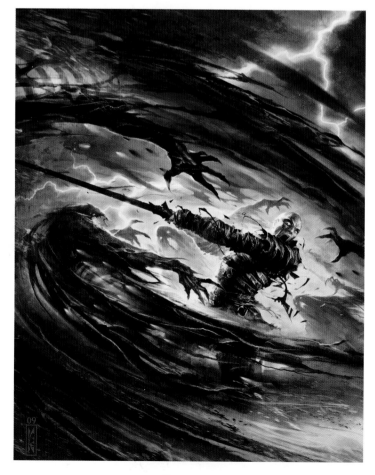

William O'Connor

Art Director: Kate Irwin *Client:* Wizards of the Coast

Title: Ardent *Size:* 5"x15" *Medium:* Digital

Raymond Swanland

Art Director: Matt Adelsperger *Client:* Wizards of the Coast

Title: The Erevis Cale Omnibus *Size:* 9"x12" *Medium:* Digital

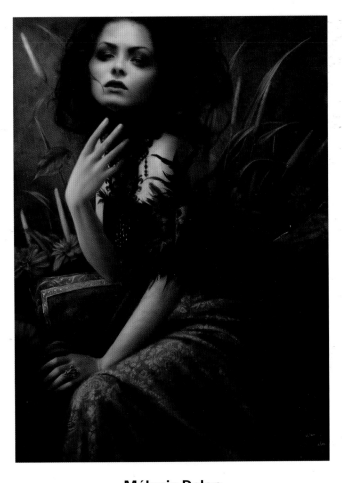

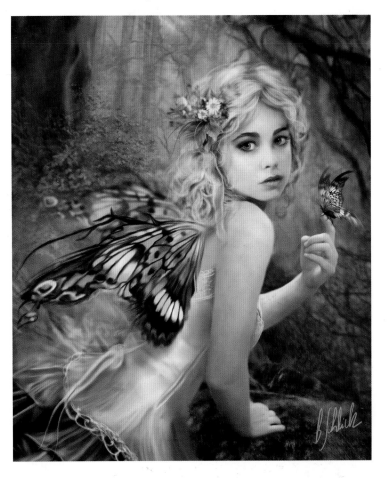

Mélanie Delon

Art Director: Mélanie Delon *Client:* Norma Editorial

Title: Elixir Book2: Disturbed *Size:* 8"x10" *Medium:* Digital

Bente Schlick

Art Director: Bente Schlick *Title:* Touch of Gold

Size: 3500x4145px *Medium:* Digital

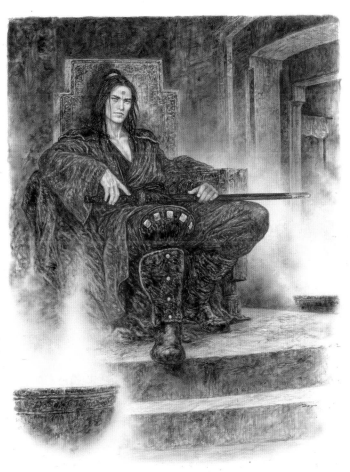

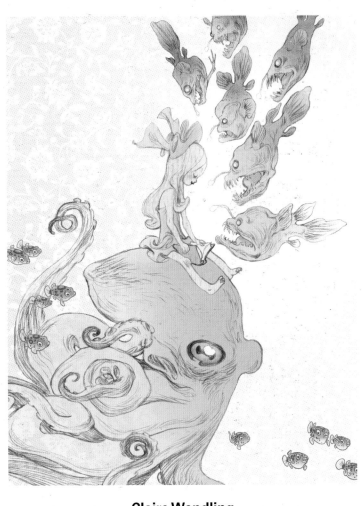

Luis Royo

Art Director: Luis Royo *Client:* Norma Editorial

Title: Dead Moon Epilogue: Against Destiny *Medium:* Oil

Claire Wendling

Client: Stuart Ng Books *Title:* Daisies *Medium:* Mixed/digital

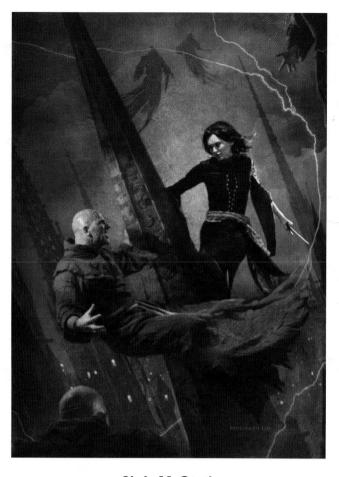

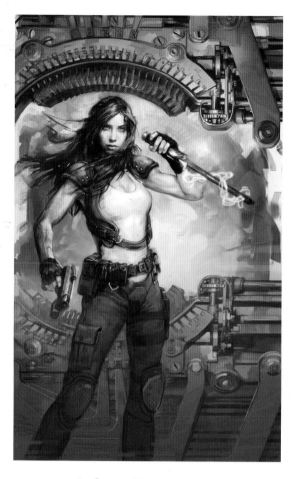

Chris McGrath

Art Director: Seth Lerner *Client:* Tor Books
Title: Well of Ascension *Medium:* Digital

Scott M. Fischer

Art Director: Lesley Worrell *Client:* Penguin
Title: Killbox *Medium:* Digital

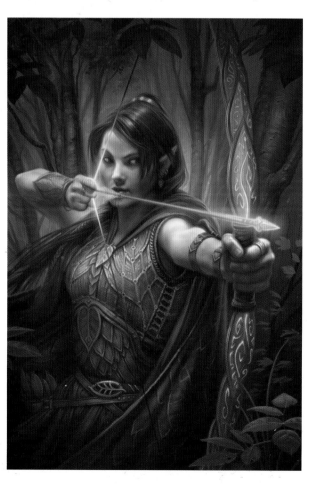

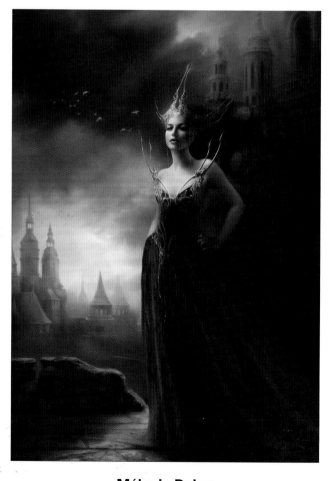

Howard Lyon

Art Director: Jon Schindehette *Client:* Wizards of the Coast
Title: Seldarine *Size:* 10"x15" *Medium:* Acrylic

Mélanie Delon

Art Director: Mélanie Delon *Client:* Norma Editorial
Title: Elixir Book 2: Taste of the Day *Medium:* Digital

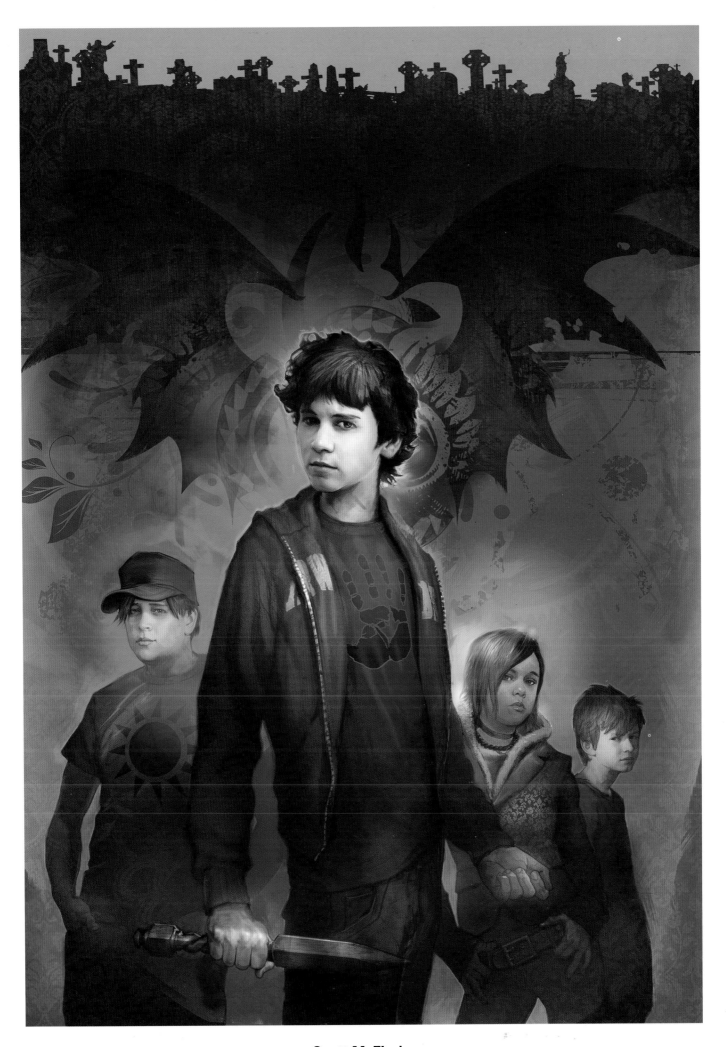

Scott M. Fischer

Art Director: Hilary Zarycky *Client:* HarperCollins *Title:* Hawkmoon: Alex Van Helsing *Medium:* Digital

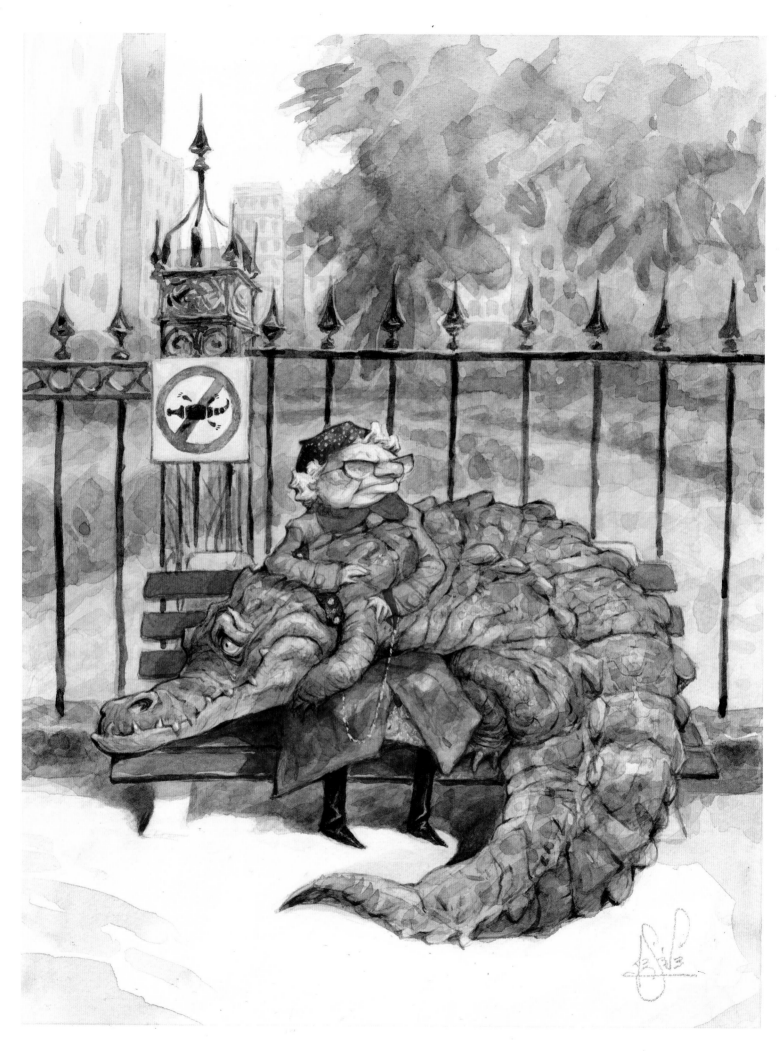

Peter de Sève

Designer: Lori Barra *Title:* Crocodile Tears (from *A Sketchy Past: The Art of Peter de Sève*) *Medium:* Ink/watercolor

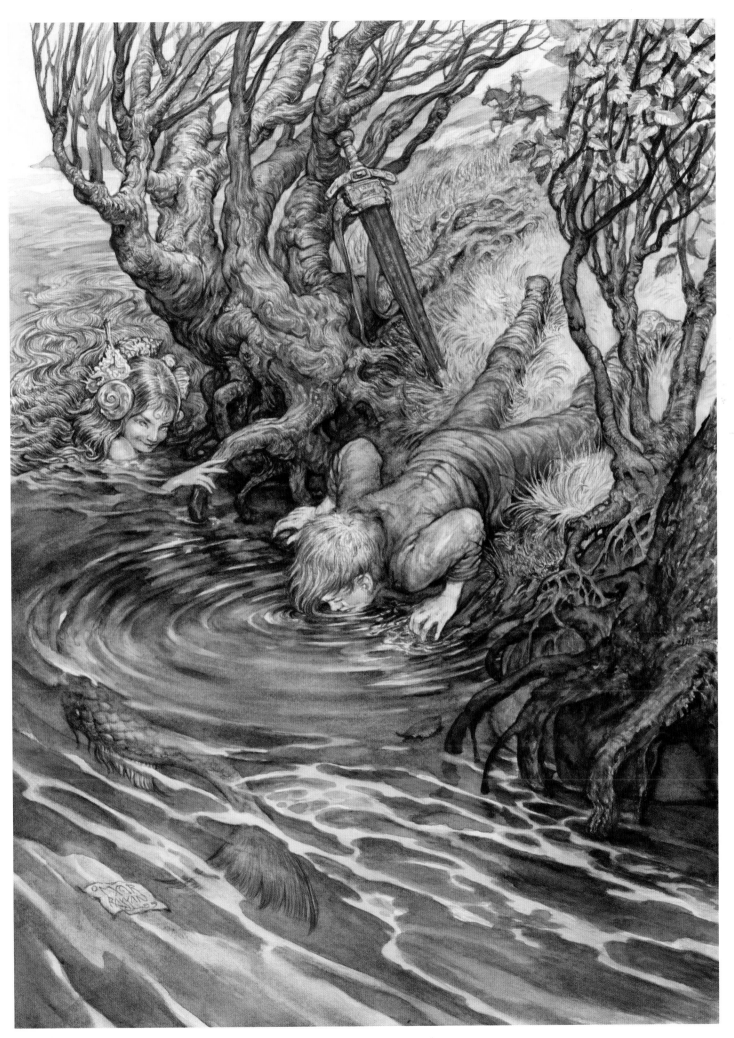

Omar Rayyan

Art Director: Sheri Gee *Client:* Folio Society *Title:* Mermaid & Boy *Size:* 9"x12" *Medium:* Watercolor

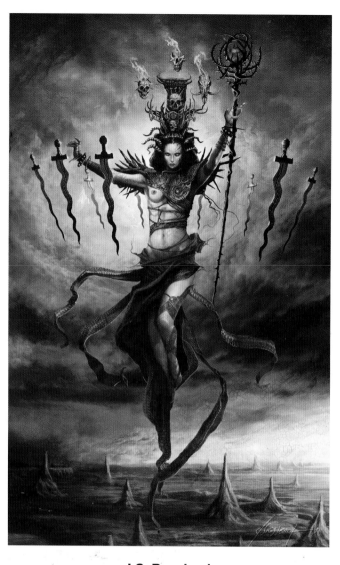

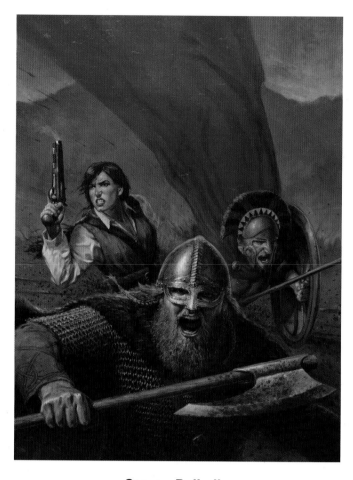

Steven Belledin
Art Director: Milan Bozic *Client:* HarperCollins
Title: Badass *Size:* 14"x20" *Medium:* Oil

J.S. Rossbach
Client: Soleil Editions *Title:* Morrigo *Size:* 24x42cm *Medium:* Digital

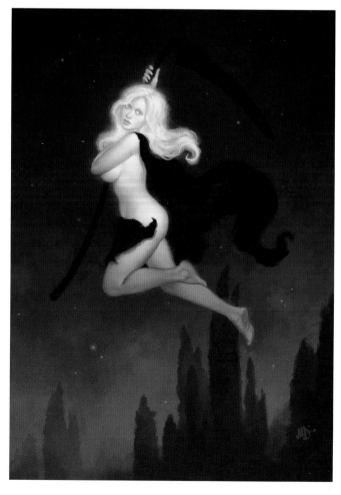

Claire Wendling
Client: Stuart Ng Books *Title:* Daisies *Medium:* Mixed/digital

Matt Dixon
Client: SQP, Inc. *Title:* The Messenger *Medium:* Digital

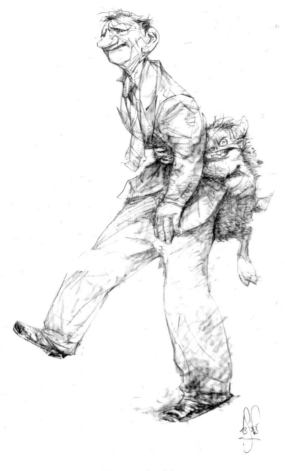

Peter de Sève
Designer: Lori Barra *Title:* The Twitch (from *A Sketchy Past:*
The Art of Peter de Sève) *Medium:* Crayon

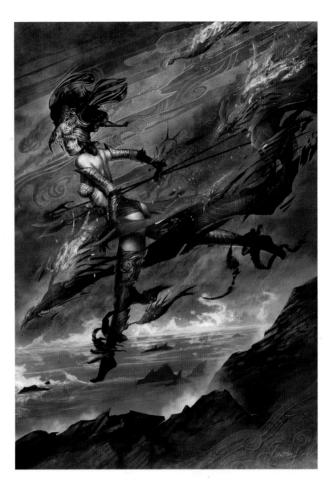

J.S. Rossbach
Client: Soleil Editions *Title:* Belisama
Size: 31x45cm *Medium:* Digital

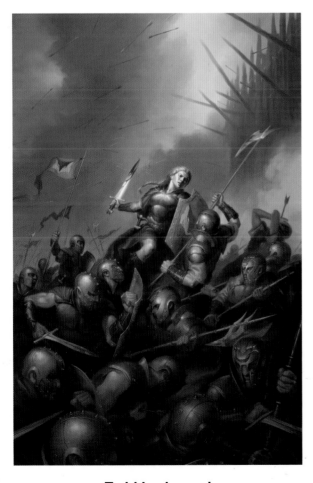

Todd Lockwood
Art Director: Toni Weisskopf *Client:* Baen Books
Title: Sheepfarmer My Ass *Size:* 12"x19" *Medium:* Digital

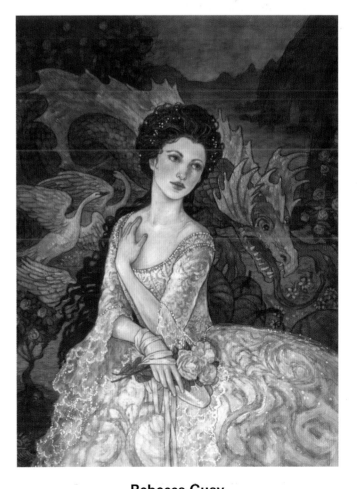

Rebecca Guay
Client: Barefoot Books *Title:* Ballet Tapestry
Size: 12"x15" *Medium:* Gouache

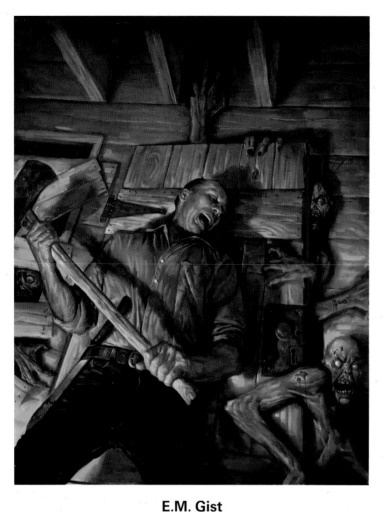

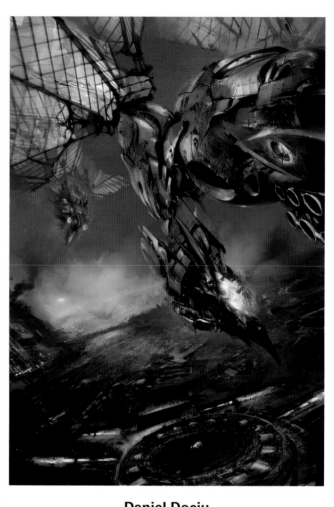

E.M. Gist
Art Director: Kevin Siembieda *Client:* Palladium Books
Title: I Hate Solicitors *Size:* 16"x20" *Medium:* Oil

Daniel Dociu
Art Director: Jeremy Lassen *Client:* Night Shade Books
Title: Starfishers: Space Scene 2 *Size:* 13"x19" *Medium:* Digital

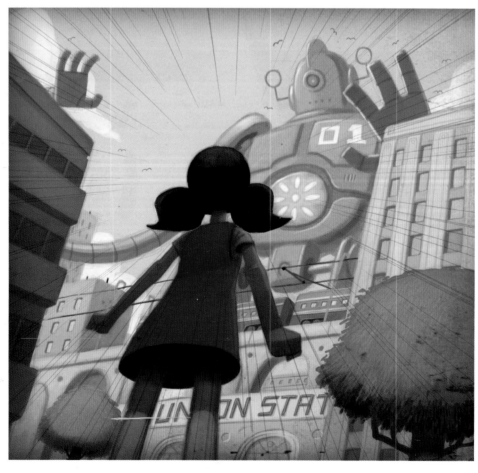

Dan Santat
Art director: Scott Piehl *Client:* Hyperion *Title:* Oh No! (Or How My Science Project Destroyed the World) *Size:* 14"x11" *Medium:* Digital

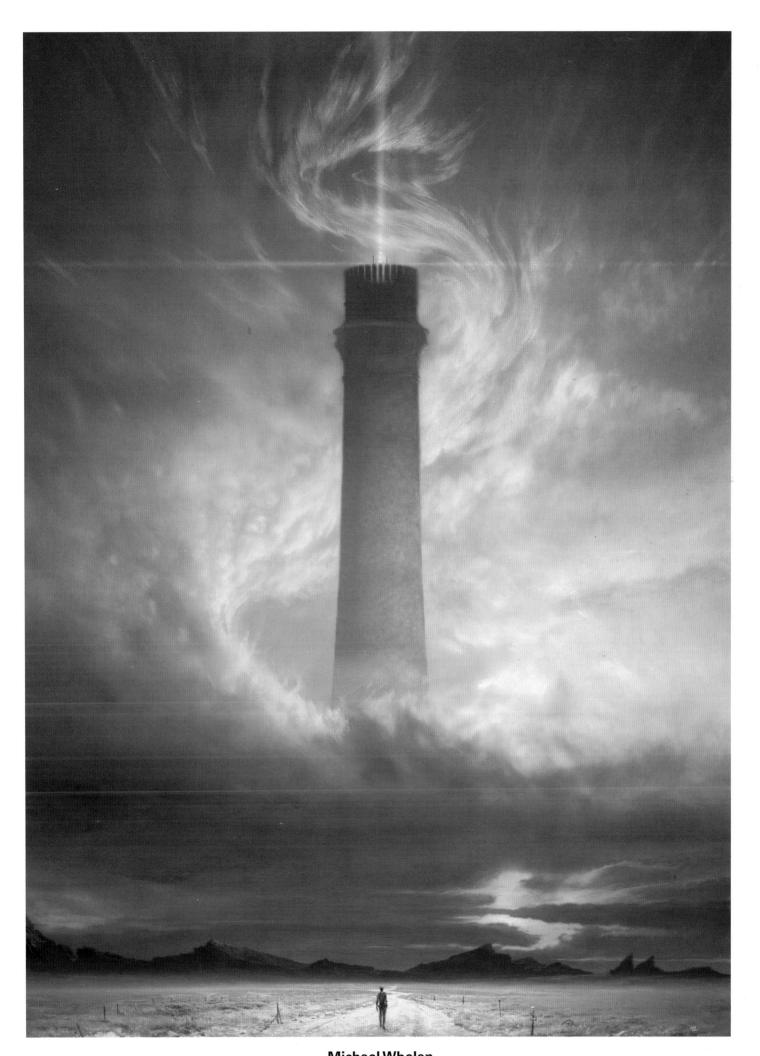

Michael Whelan

Art Director: Jerad Walters *Client:* Centipede Press *Title:* The Long Road *Size:* 22"x30" *Medium:* Acrylics on canvas

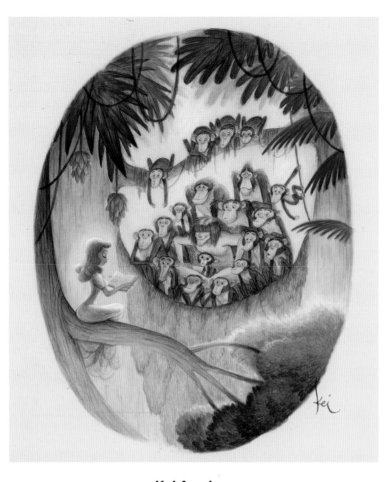

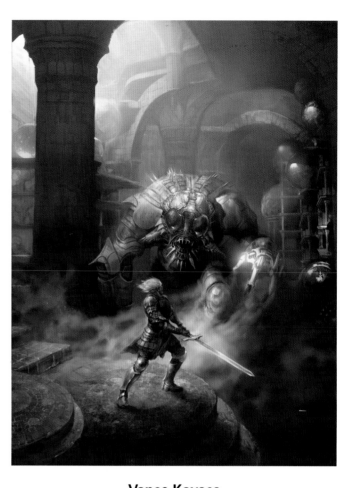

Kei Acedera

Client: My Séc du quai Branly *Title:* Storytime With Jane
Size: 13"x15 1/4" *Medium:* Gouache/colored pencil

Vance Kovacs

Art Director: Irene Gallo *Client:* Tor Books
Title: Hawkmoon: The Mad God's Amulet *Medium:* Digital

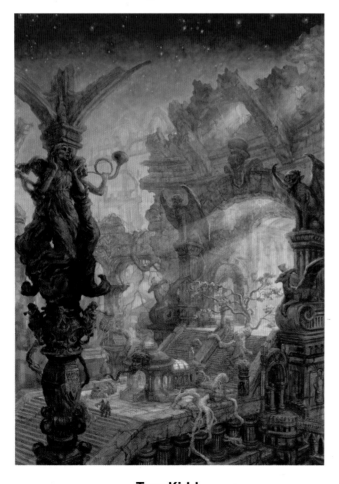

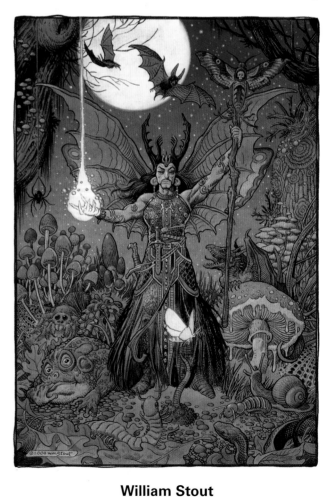

Tom Kidd

Art Director: Bill Schafer *Client:* Subterranean Press
Title: Song of Dying Earth *Size:* 20"x30" *Medium:* Oil

William Stout

Art Director: William Stout/John Fleskes *Client:* Flesk Publications
Title: Oberon *Size:* 11"x16" *Medium:* Ink & watercolor on board

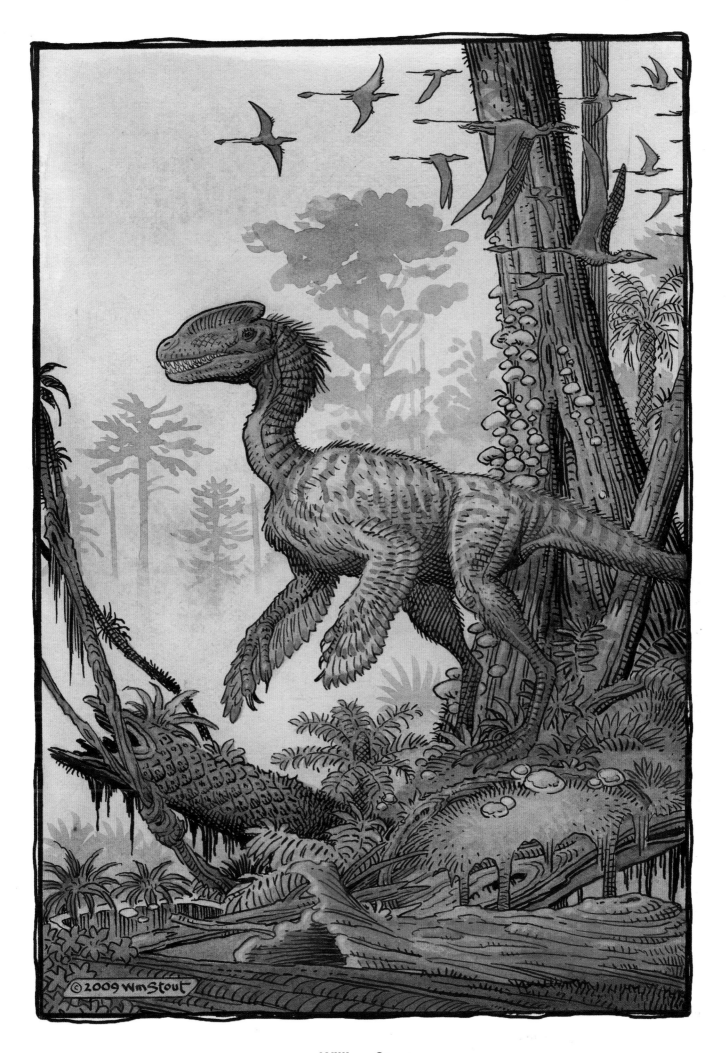

William Stout

Client: Flesk Publications *Title:* New Dinosaur Discoveries A-Z *Size:* 7 1/4"x10 1/2" *Medium:* Ink & watercolor on board

Steven Tabbutt

Art Director: Sungyoon Choi *Client:* Rabid Rabbit *Title:* The Incident *Size:* 11″x14 1/2″ *Medium:* Mixed/acrylic on paper

Eric Orchard

Art Director: Chris Staros *Client:* Top Shelf Productions *Title:* Cloud Cave 3 *Size:* 11"x17" *Medium:* Pen & ink

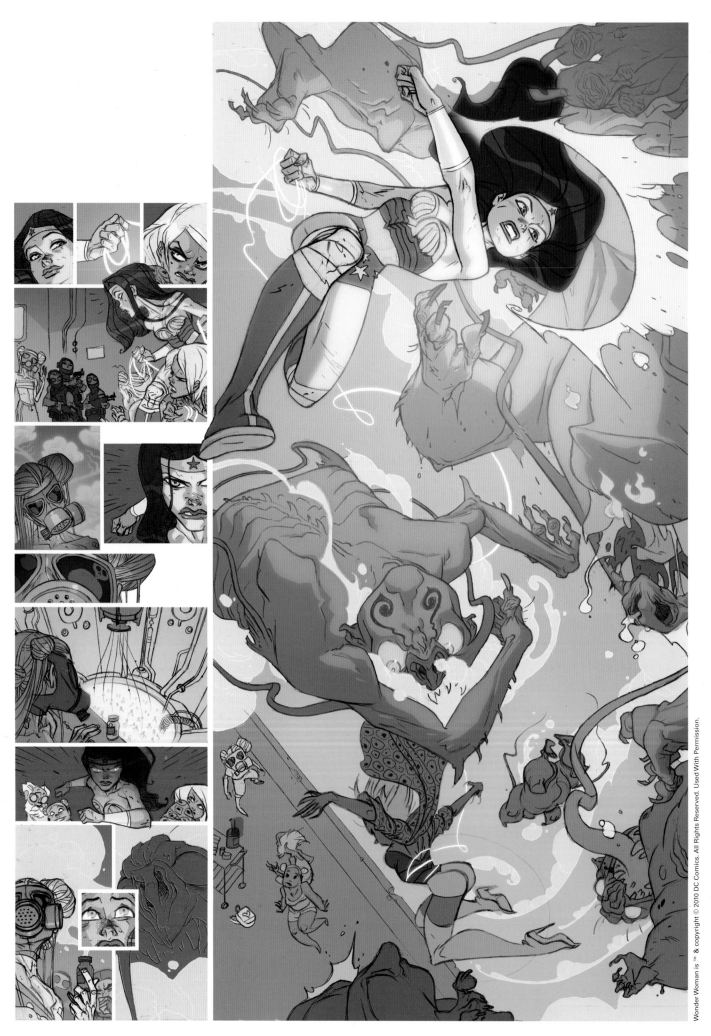

Ben Caldwell

Art Director: Mark Chiarello *Client:* DC Comics *Title:* Wednesday Comics/Wonder Woman Page 11 *Size:* 14"x20" *Medium:* Digital

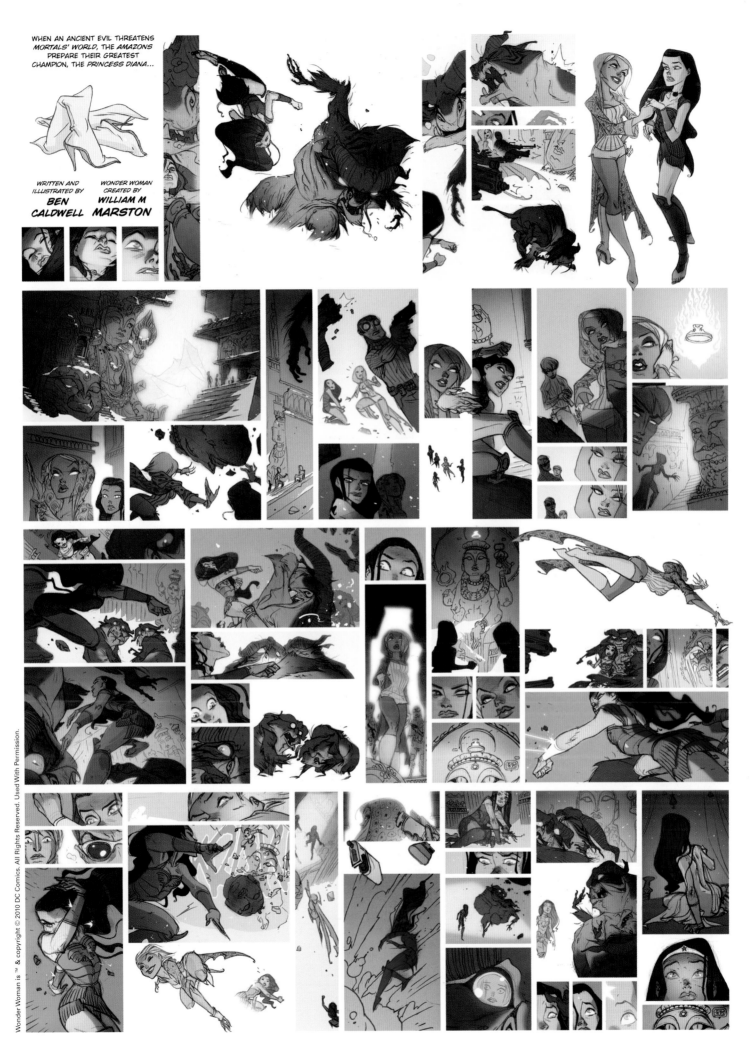

WHEN AN ANCIENT EVIL THREATENS *MORTALS' WORLD*, THE *AMAZONS* PREPARE THEIR GREATEST CHAMPION, THE *PRINCESS DIANA*...

WRITTEN AND ILLUSTRATED BY **BEN CALDWELL**

WONDER WOMAN CREATED BY **WILLIAM M MARSTON**

Ben Caldwell

Art Director: Mark Chiarello *Client:* DC Comics *Title:* Wednesday Comics/Wonder Woman Page 5 *Size:* 14"x20" *Medium:* Digital

Thomas Kovach

Title: The Deserters *Size:* 12"x17" *Medium:* Watercolor/digital

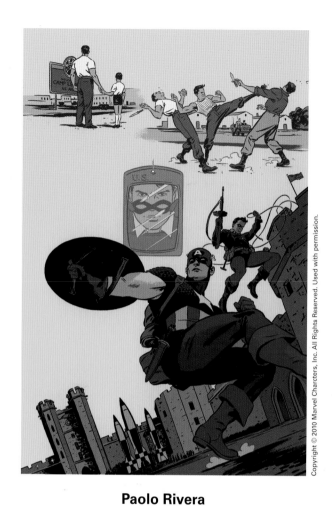

Paolo Rivera

Art Director: Tom Brennan *Client:* Marvel Comics

Title: Young Allies Page 2 *Size:* 11"x17" *Medium:* Ink/Photoshop

Michael Golden

Art Director: Mark Paniccia *Client:* Marvel Comics

Title: Life's a Bear *Size:* 11"x17" *Medium:* Pencil/ink/mixed

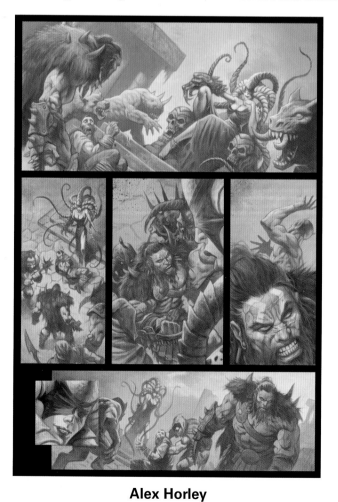

Alex Horley

Art Director: Jeremy Jarvis *Client:* Wizards of the Coast

Title: Path of the Planes Walker *Size:* 11"x17" *Medium:* Acrylic

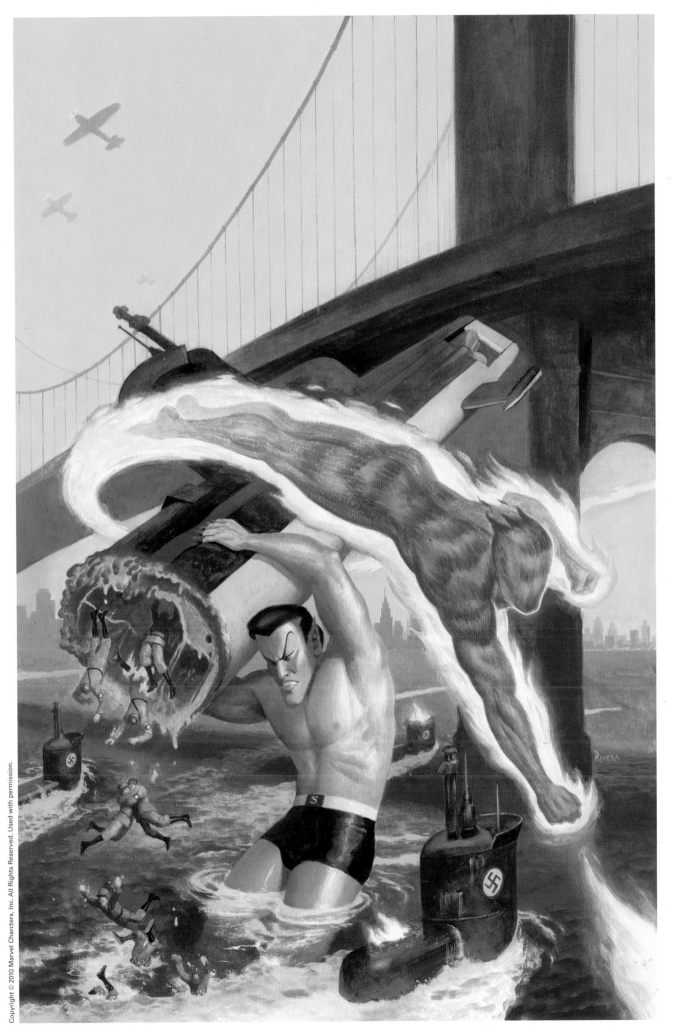

Paolo Rivera

Art Director: Tom Brevoort *Client:* Marvel Comics *Title:* Marvel Mystery Comics *Size:* 11″x17″ *Medium:* Acrylic/gouache

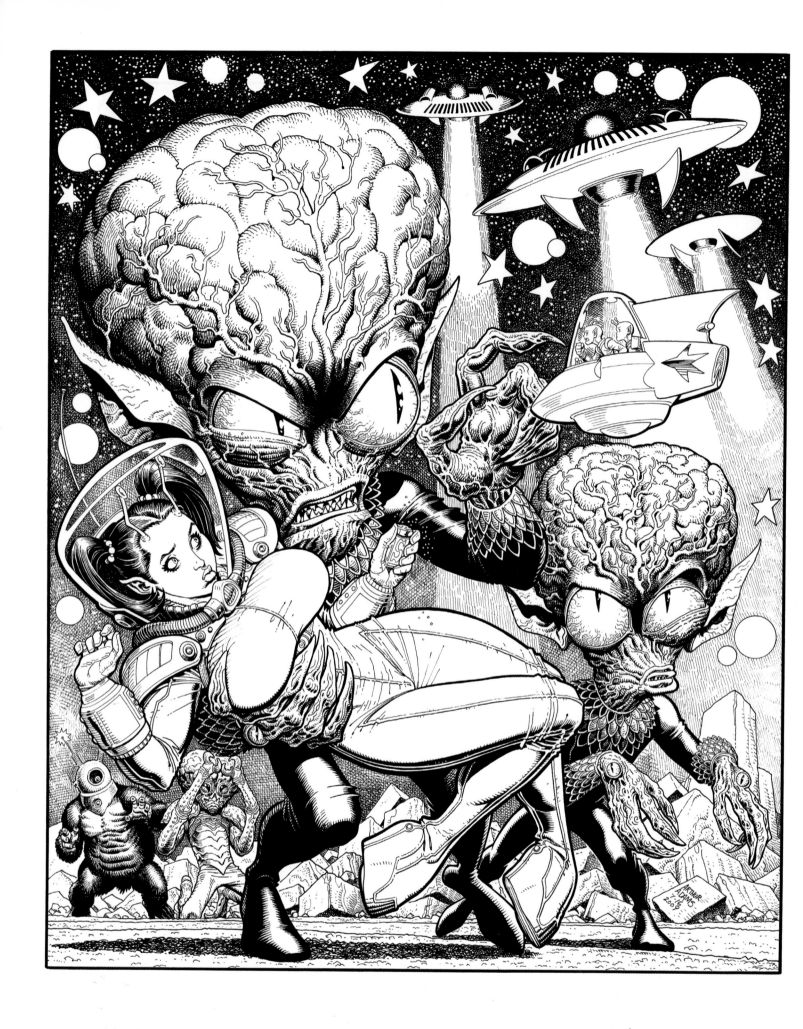

Arthur Adams

Title: Alien Courtship/Sketchbook 8 Cover *Size:* 14"x16 3/4" *Medium:* Pen & ink

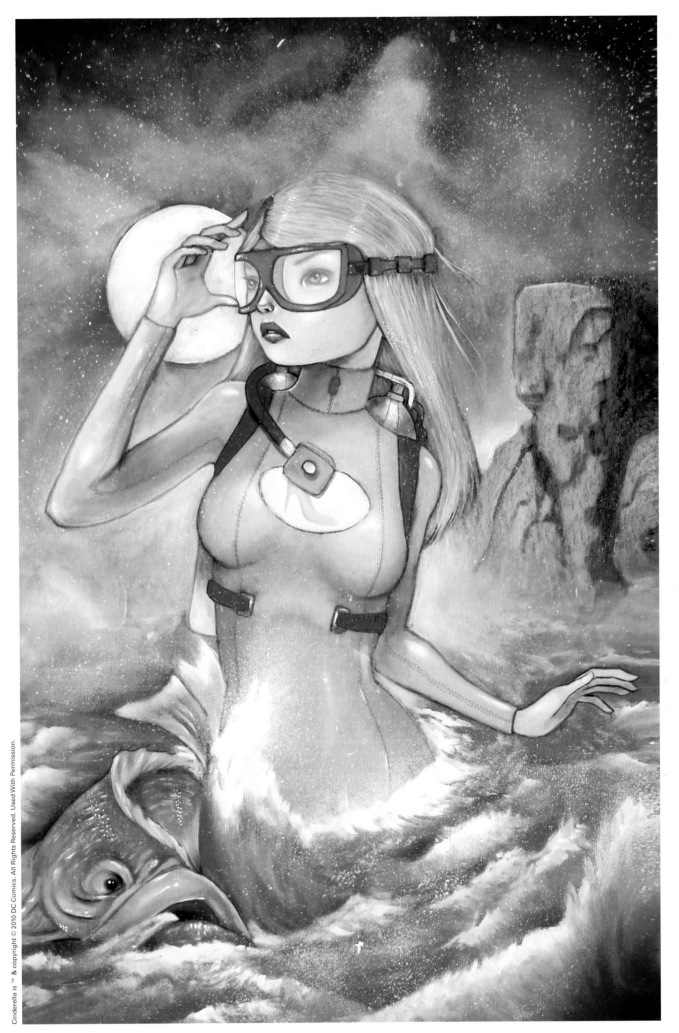

Chrissie Zullo

Art Director: Shelly Bond *Client:* DC Comics/Vertigo *Title:* Cinderella: From Fabletown With Love #3 *Size:* 20″x30″ *Medium:* Oils/digital

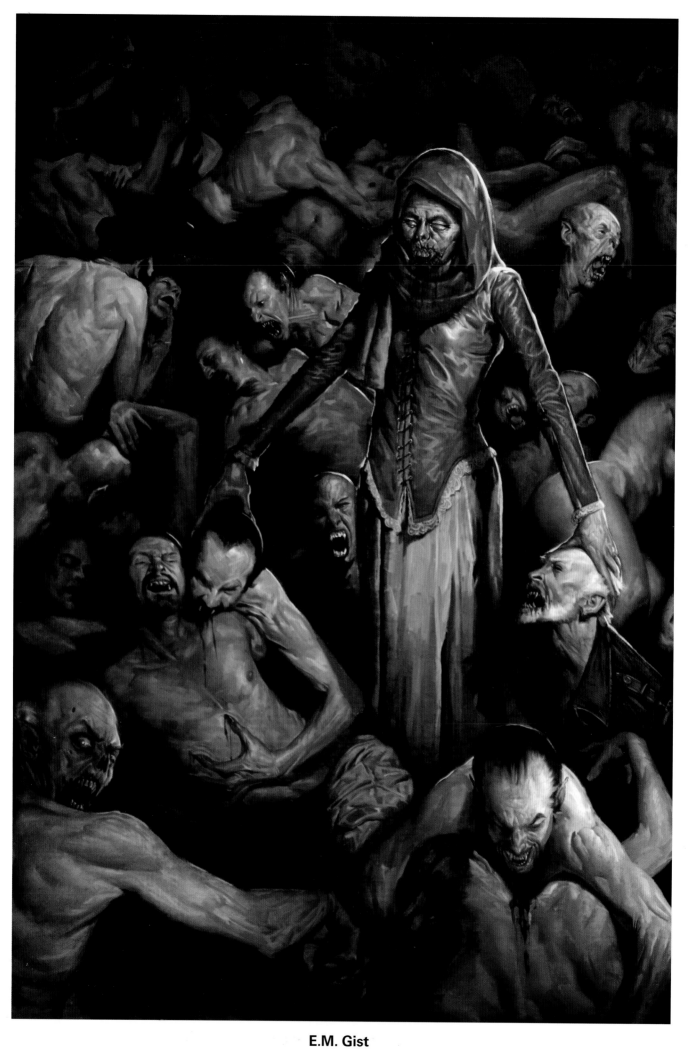

E.M. Gist

Art Director: Jeremy Berger *Client:* Radical Publishing *Title:* All In the Family *Size:* 24"x31" *Medium:* Oils

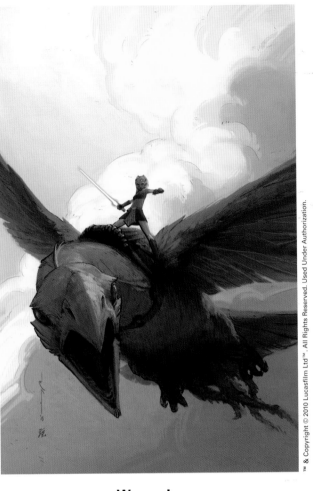

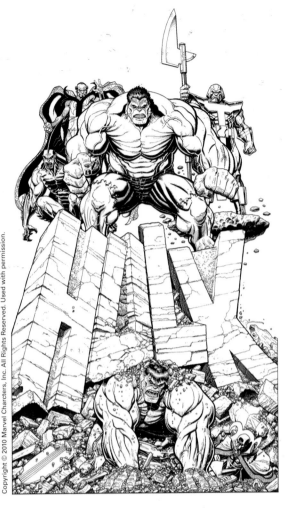

Wayne Lo

Client: Dark Horse Comics *Title:* The Clone Wars:
The Wind Raiders of Taloraan *Medium:* Pencil/digital

Arthur Adams

Client: Marvel Comics *Title:* Hulk #11 *Size:* 12"x21"

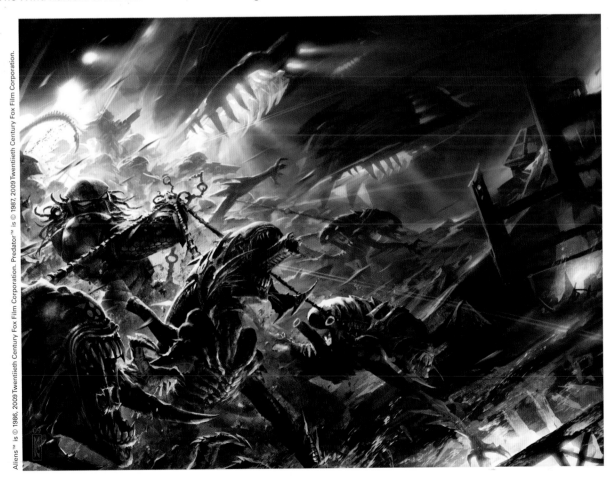

Raymond Swanland

Art director: Chris Warner *Client:* Dark Horse Comics *Title:* AVD #1 *Medium:* Digital

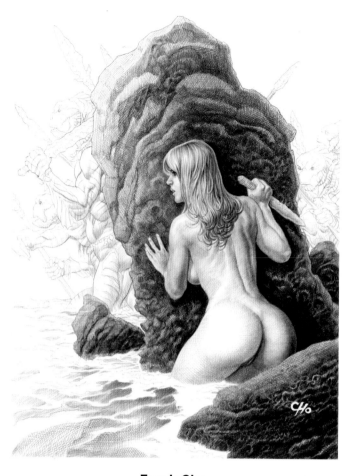

Frank Cho
Art Director: Frank Cho *Client:* Dynamite Entertainment
Title: Jungle Girl #4, Season 2 *Size:* 14"x21" *Medium:* Ballpoint pen

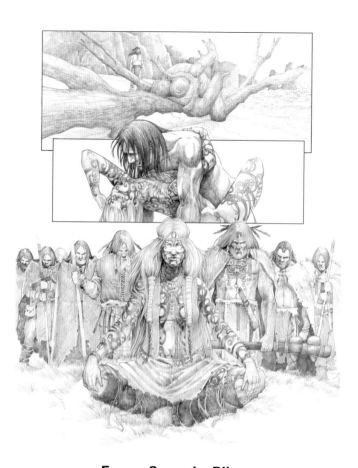

Erwan Seure-Le Bihan
Client: Soleil Celtique Publisher
Title: Odin *Size:* 23.5x39.5cm *Medium:* Pencil

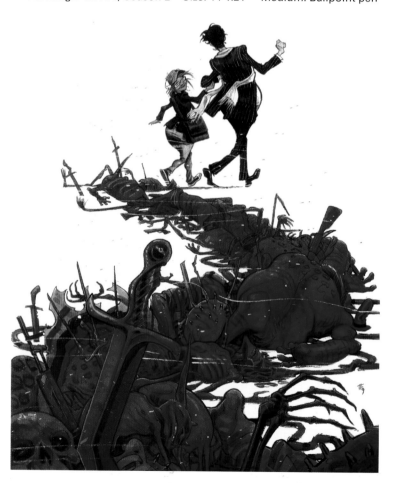

Tom Fowler
Art Director: Ben Abernathy *Client:* Wildstorm Productions
Title: Mysterius the Unfathomable *Size:* 11"x17" *Medium:* Mixed

Woodrow J. Hinton III
Art Director: Dave Ulanski *Client:* Moonstone Books
Title: Kolchak: Monsters Among Us *Size:* 11"x17"

Bill Carman

Client: Branko Djukic *Title:* Color Men, Guys, Things #2 *Size:* 7"x11" *Medium:* Mixed

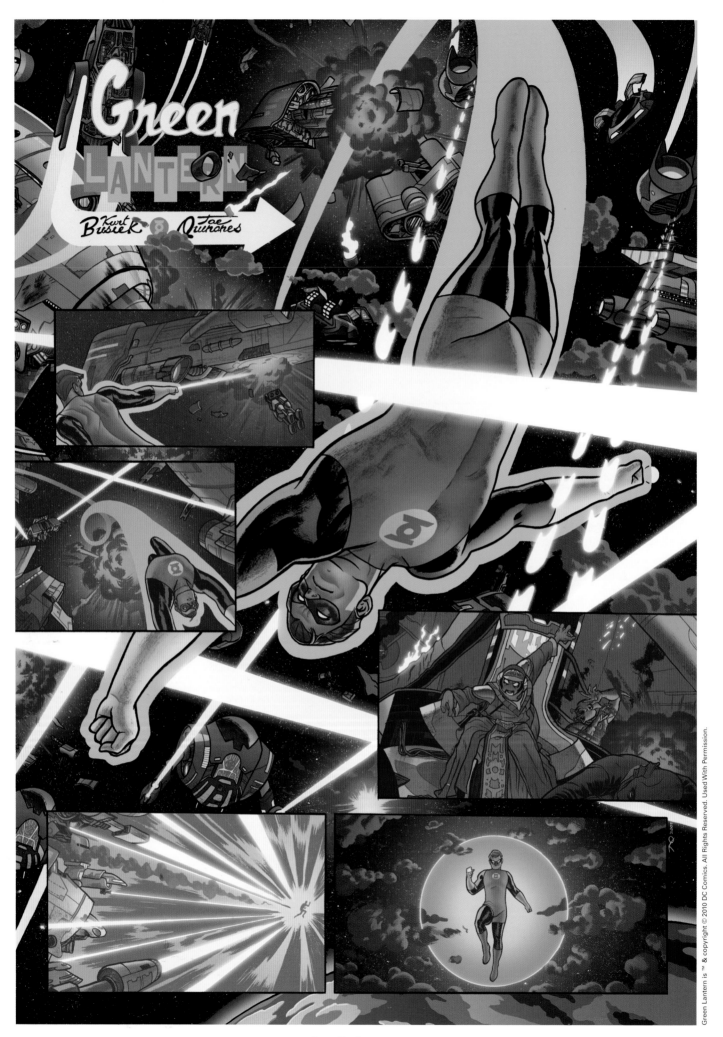

Joe Quinones

Art Director: Mark Chiarello *Client:* DC Comics *Title:* Wednesday Comics/Green Lantern, page 12 *Size:* 14"x20" *Medium:* Ink/digital

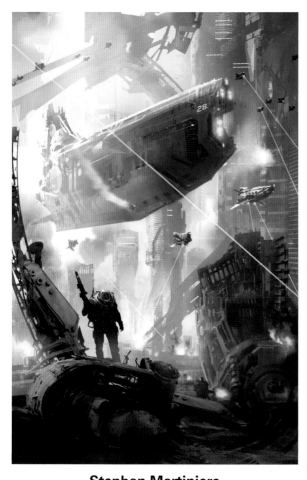

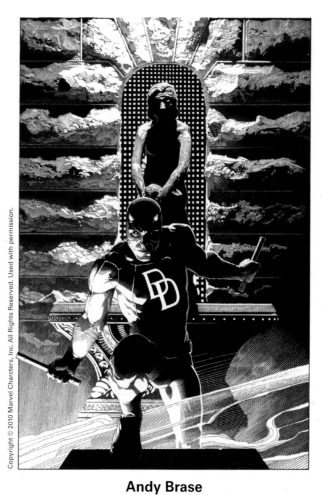

Stephan Martiniere

Art Director: Jeremy Berger *Client:* Radical Comics

Title: Shrapnel 3 *Medium:* Digital

Andy Brase

Client: Marvel Comics *Title:* Daredevil

Size: 11″x17″ *Medium:* Ink

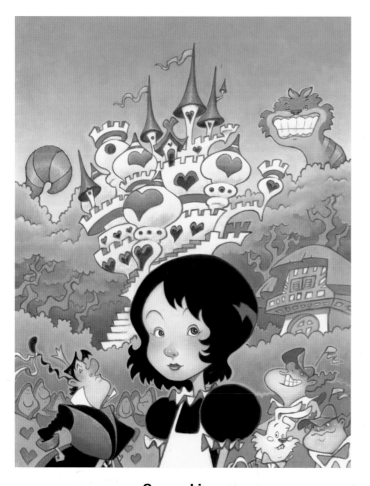

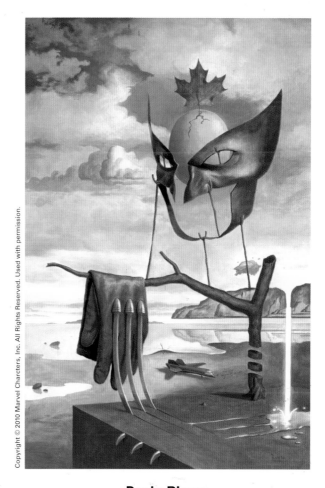

Sonny Liew

Art Director: Rich Thomas *Client:* Disney Press *Title:* Wonderland

Size: 11″x16″ *Medium:* Pencil/oil on canvas

Paolo Rivera

Client: Steve Wacker *Title:* Wolverine Art Appreciation Month

(after Salvador Dali) *Size:* 11″x17″ *Medium:* Acrylic/gouache

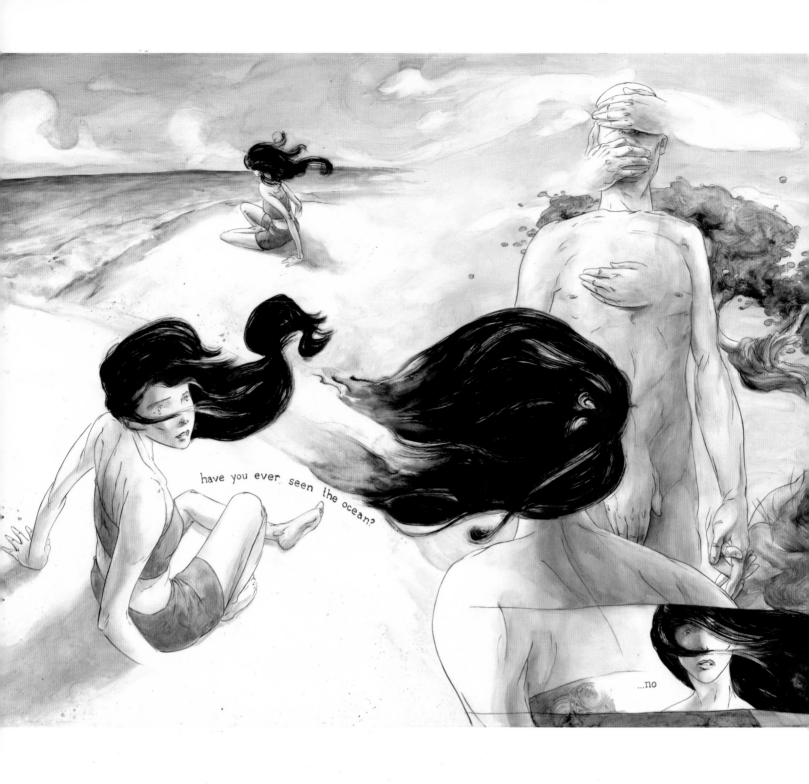

Grim Wilkins

Title: Ellipses: Chapter 1, pages 7 & 8 *Size:* 26"x20" *Medium:* Ink/acrylic

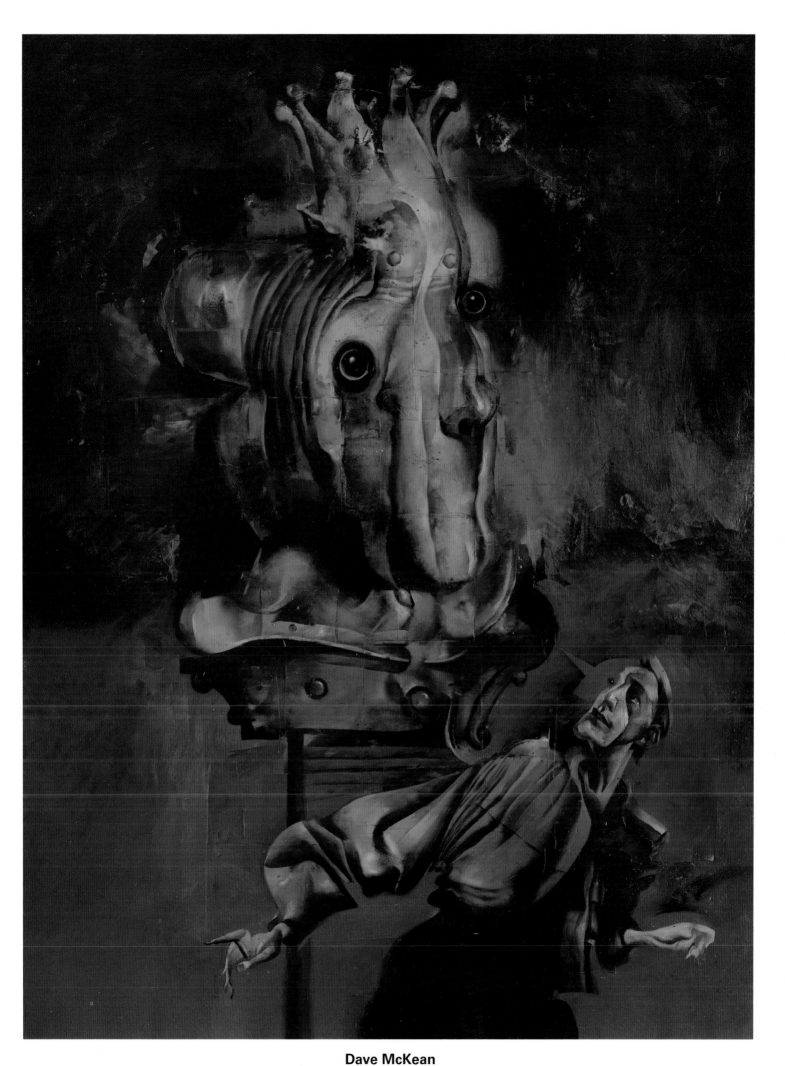

Dave McKean

Art director: Allen Spiegel *Client:* ASFA & Hourglass *Title:* The Coast Road: The King of Birds *Size:* 8″x11″ *Medium:* Mixed

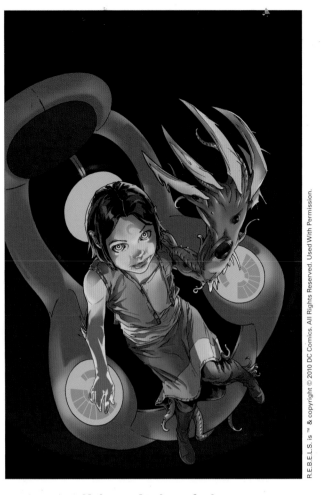

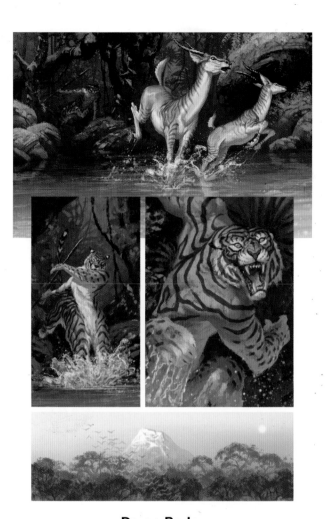

Kalman Andrasofszky
Art Director: Mark Chiarello *Client:* DC Comics
Title: R.E.B.E.L.S. #5 *Size:* 6 7/8"x10 3/8" *Medium:* Pen & ink/digital

Daren Bader
Client: Viscurreal *Title:* Starfishers: Pridelands
Size: 9"x12" *Medium:* Digital

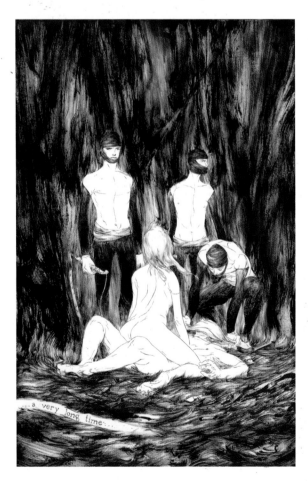

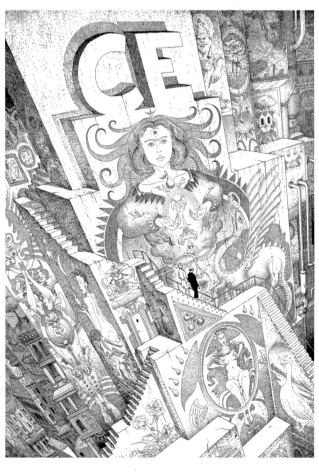

Grim Wilkins
Title: Ellipses: Chapter 1, page 13 *Size:* 13"x20" *Medium:* Ink

José Roosevelt
Title: CE: page 3 *Size:* 40x60cm *Medium:* Ink

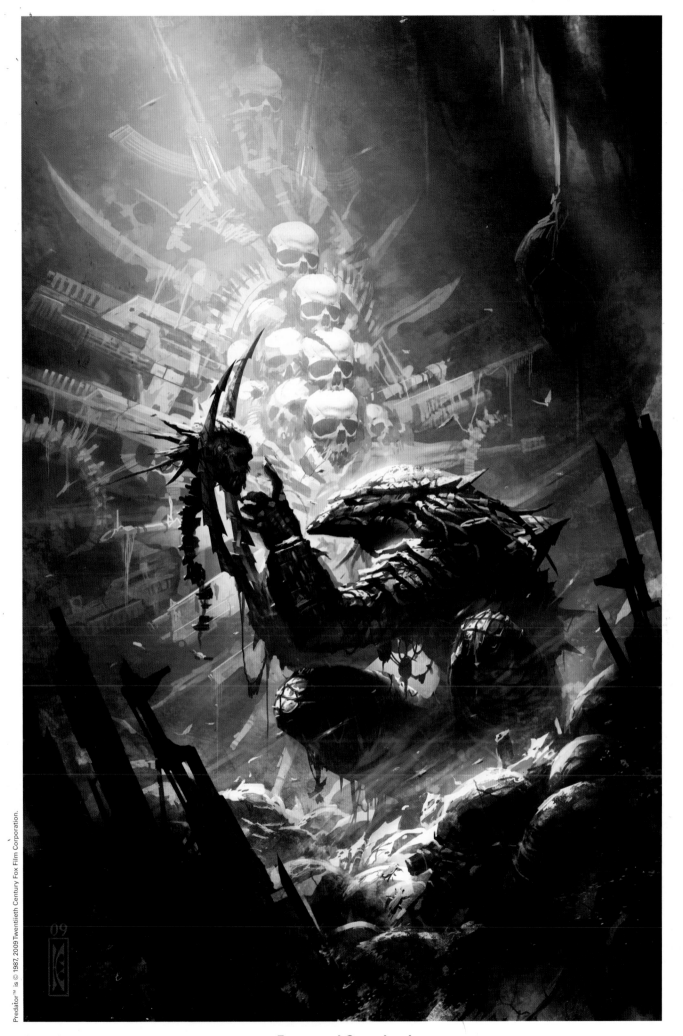

Raymond Swanland

Art director: Chris Warner *Client:* Dark Horse Comics *Title:* Predator #2 *Medium:* Digital

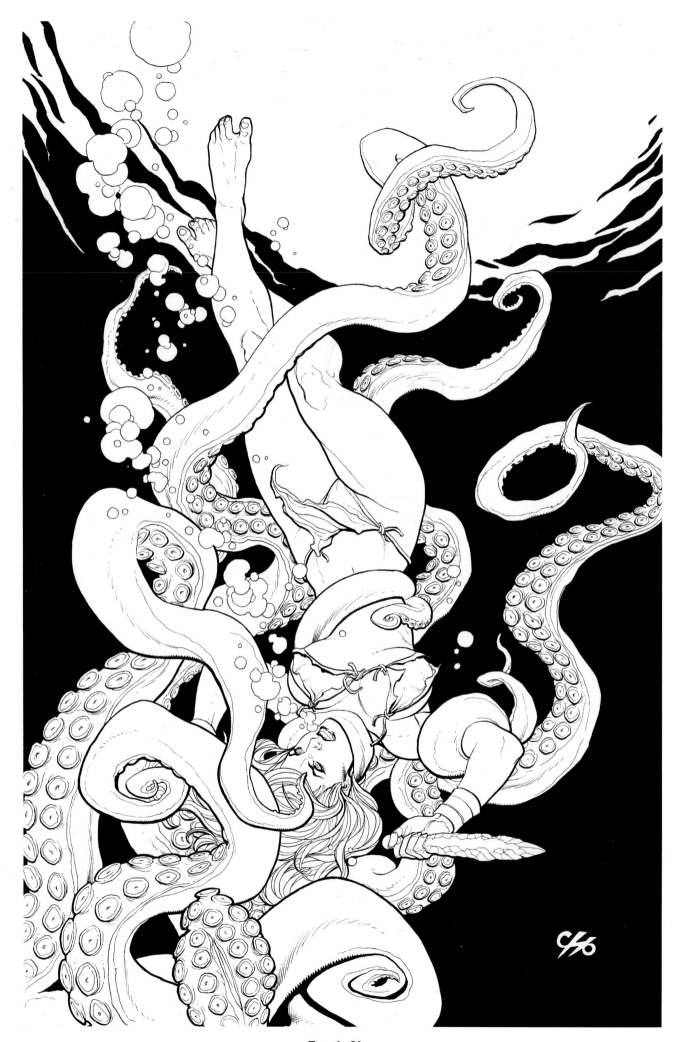

Frank Cho

Art Director: Frank Cho *Client:* Dynamite Enertainment *Title:* Jungle Girl #2, Season 2 *Size:* 14"x21" *Medium:* Ink

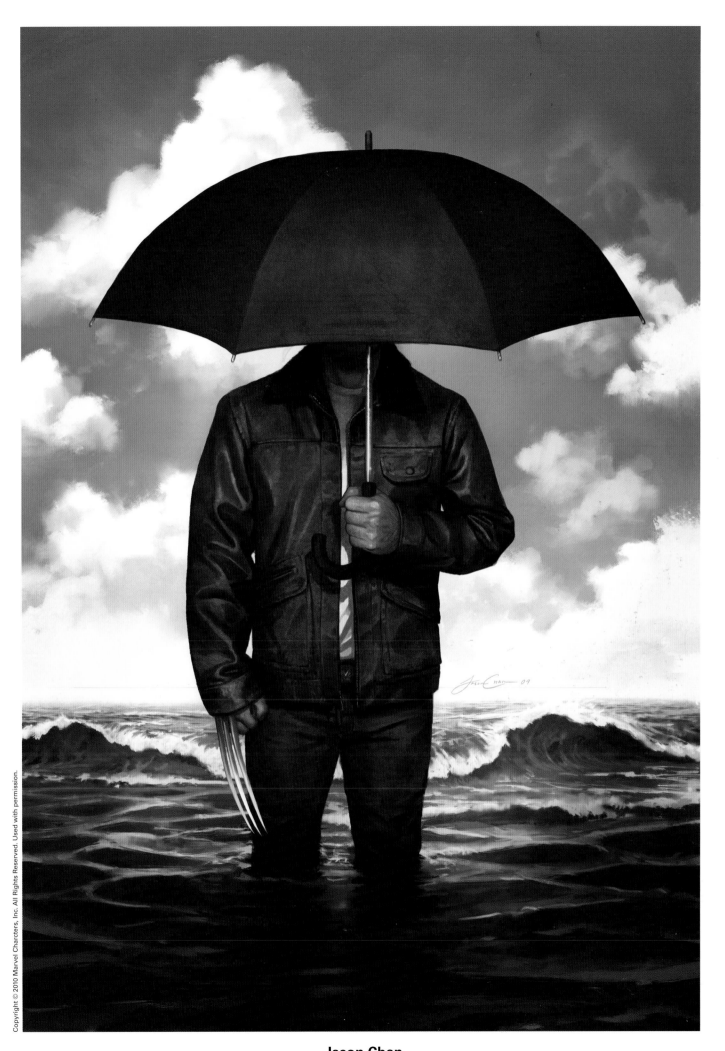

Jason Chan

Art Director: Charles Beckerman *Client:* Marvel Comics *Title:* Wolverine: Magritte *Size:* 14"x20" *Medium:* Digital

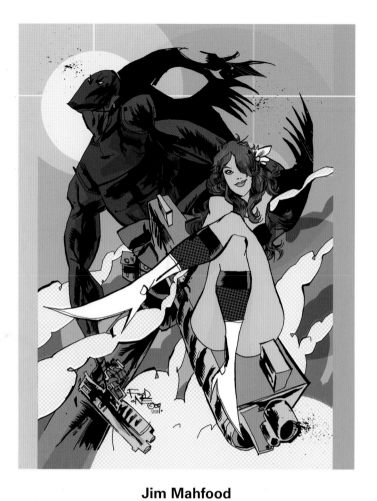

Steve Rude

Client: Rude Dude Productions *Title:* When She Was Young
Size: 12"x19" *Medium:* Watercolor

Jim Mahfood

Art Director: Will Wilson *Colorist:* Justin Stewart *Client:* Image
Title: Mayhem *Size:* 11"x17" *Medium:* Ink/digital color

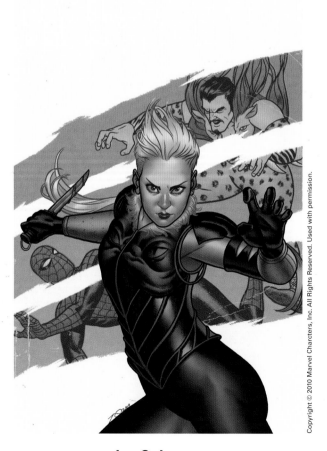

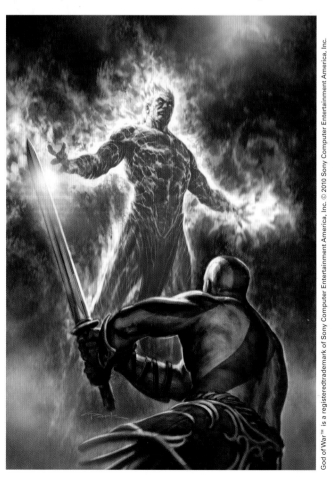

Joe Quinones

Art Director: Steve Walker *Client:* Marvel Comics
Title: Amazing Spider-man #633 *Size:* 10 3/8"x16" *Medium:* Mixed

Andy Park

Art Director: Stig Asmussen *Client:* Wildstorm/DC Comics
Title: God of War #4 *Size:* 11"x17" *Medium:* Digital

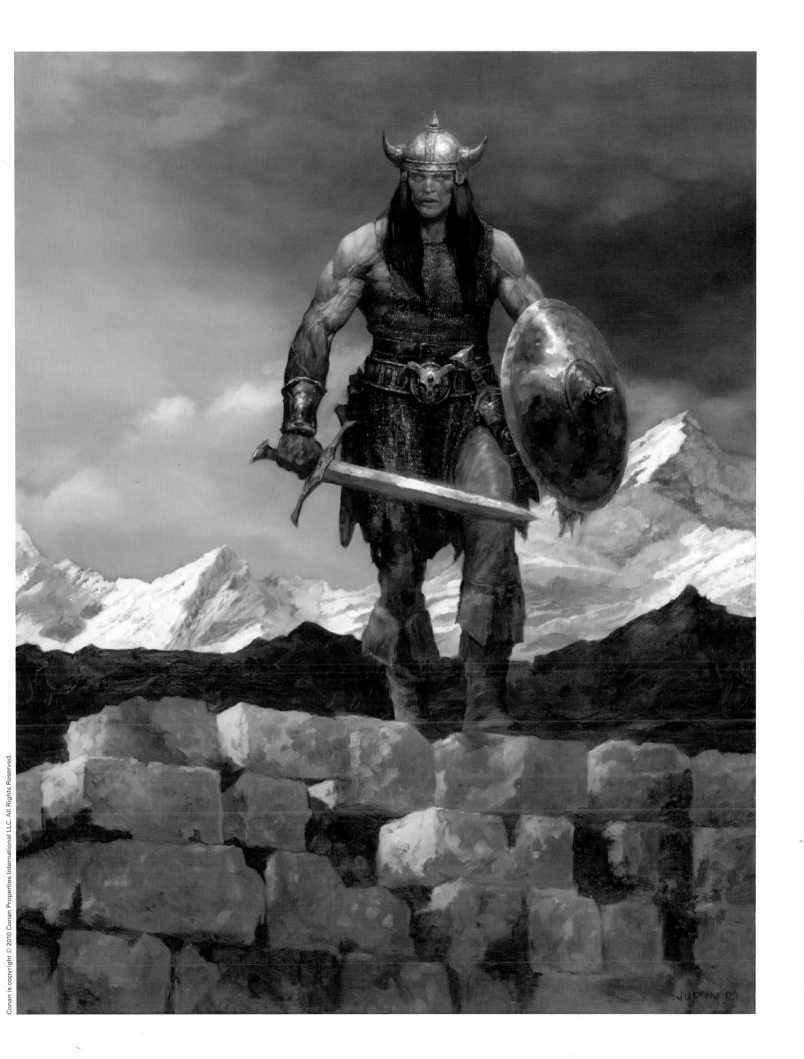

Justin Sweet

Art Director: Philip Simon *Client:* Dark Horse Comics *Title:* Conan the Cimmerian *Size:* 32"x40" *Medium:* Oil

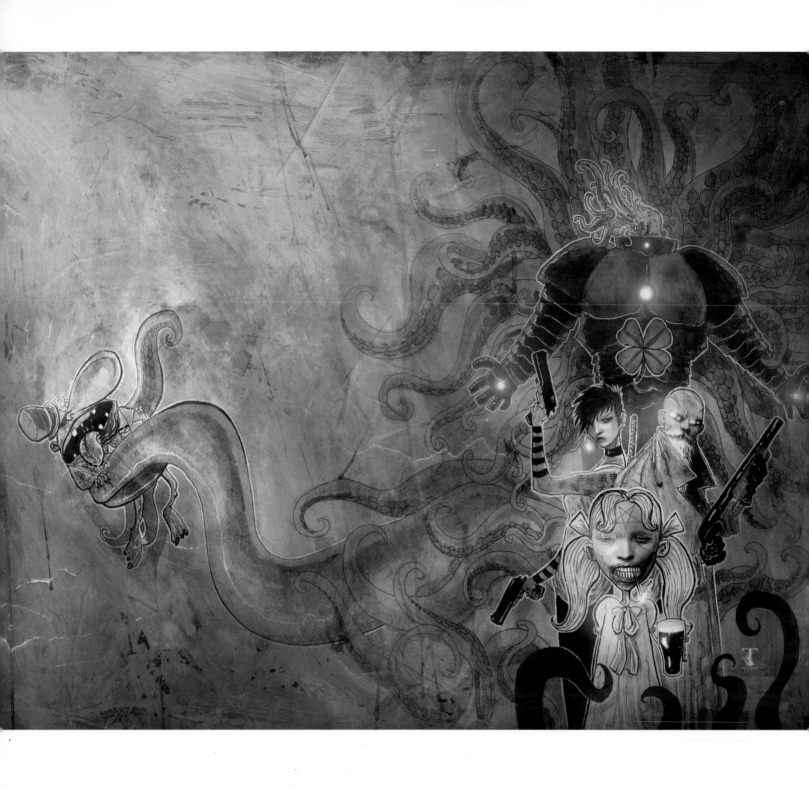

Ben Templesmith
Client: IDW Publishing *Title:* It Only Hurts When I Pee *Size:* 17"x11" *Medium:* Mixed

Chris Golden
Title: Gamma Flight *Medium:* Ink/digital

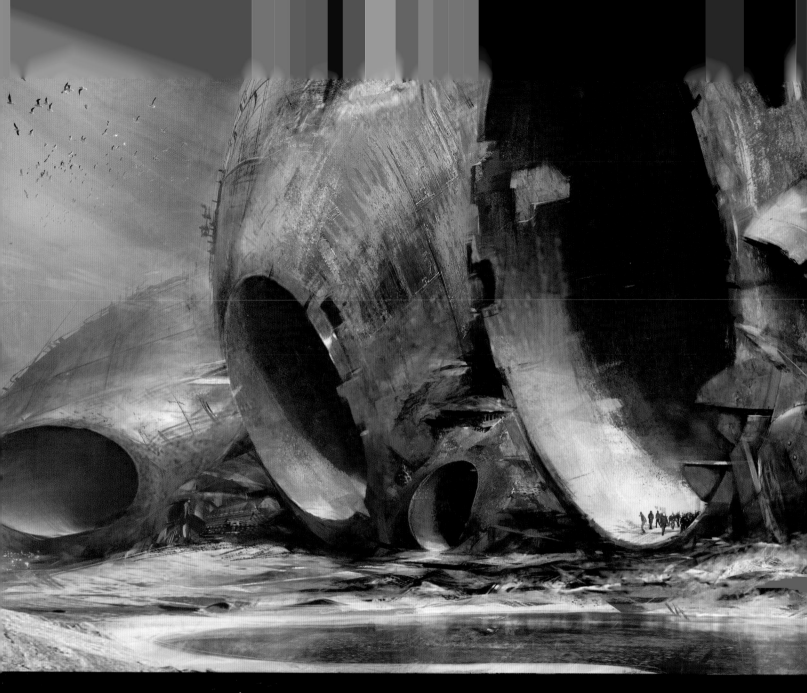

Daniel Dociu

Art Director: Daniel Dociu *Client:* ArenaNet Guild Wars 2 *Title:* Wasp Hives *Size:* 19"x13" *Medium:* Digital

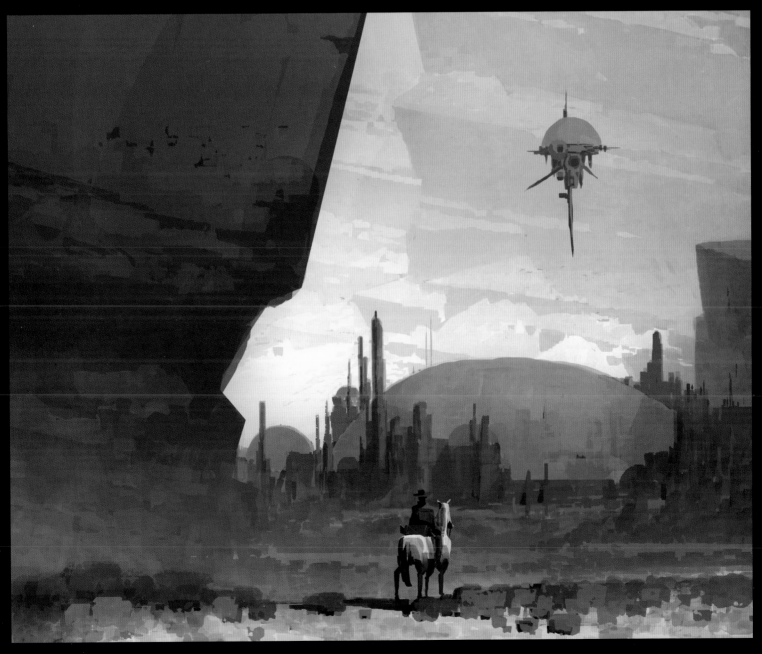

Ritchie Sacilioc

Title: Monuit Valley *Size:* 20"x8 1/2" *Medium:* Digital

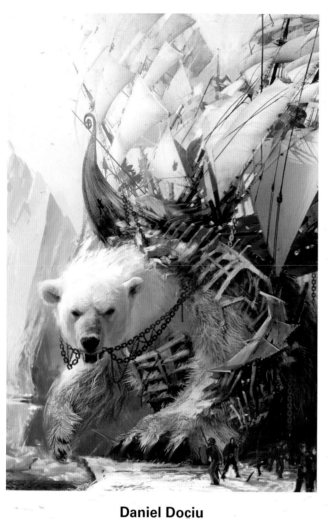

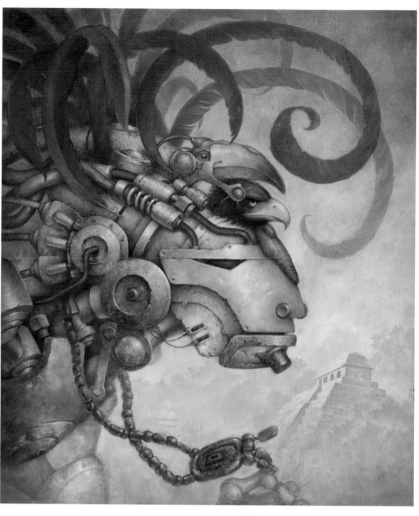

Daniel Dociu

Art Director: Daniel Dociu *Client:* ArenaNet Guild Wars 2
Title: Northern Giant *Size:* 13"x19" *Medium:* Digital

Raúl Cruz

Title: Neo Maya *Size:* 86x100cm *Medium:* Acrylic

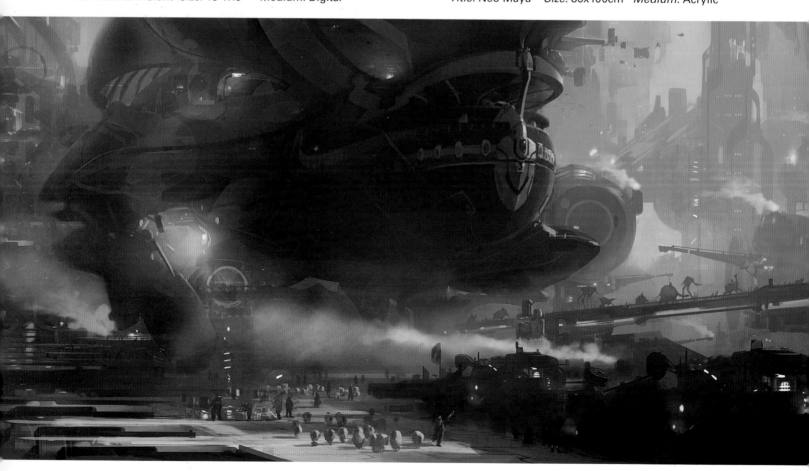

Thom Tenery

Art director: Scott Robertson *Client:* Design Studio Press/Alien Race *Title:* The Ark *Medium:* Digital

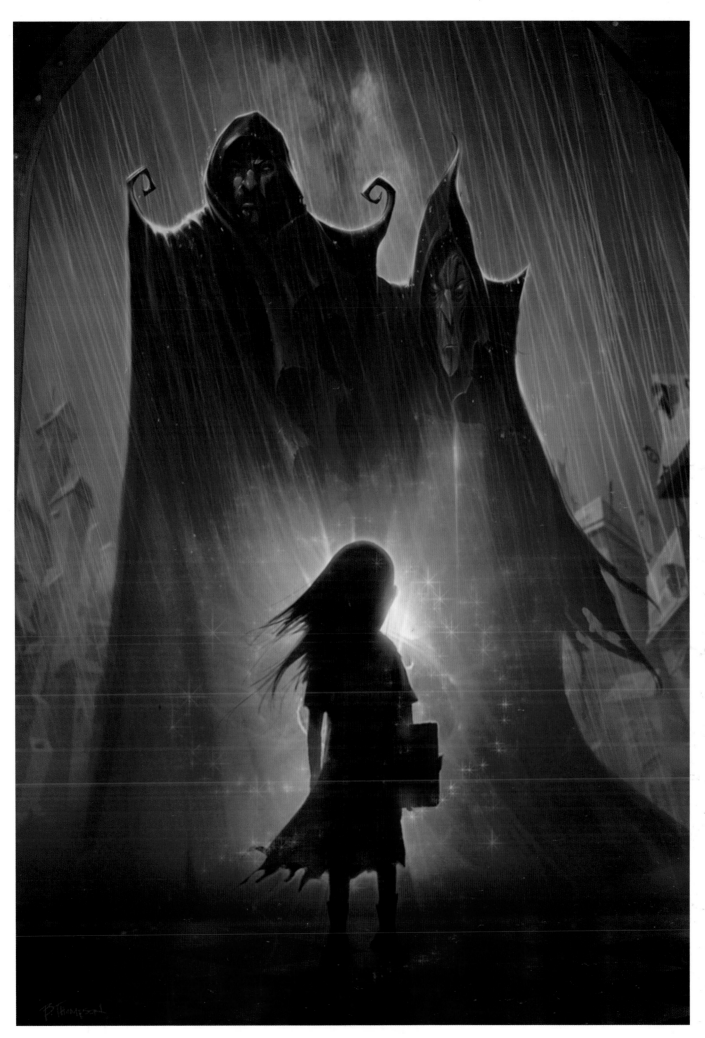

BRIAN THOMPSON

Art Director: Brian Thompson *Client:* Big Fish Games *Title:* Confronted *Size:* 13"x19" *Medium:* Photoshop

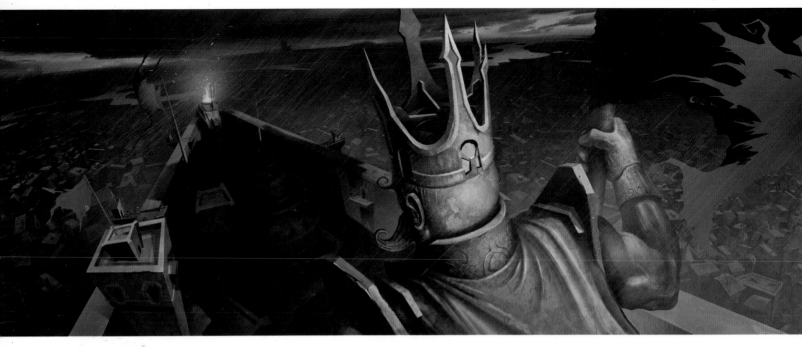

Soi H. Che

Art director: Brian Thompson *Client:* Big Fish Games *Title:* The king *Size:* 18"x7" *Medium:* Photoshop

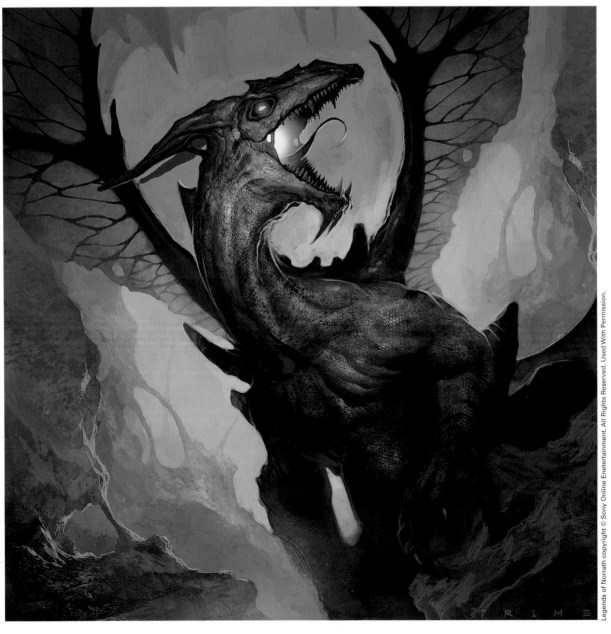

Michael Pedro

Art director: Roger Chamberlain *Client:* Sony Online Entertainment *Title:* Ice Dragon *Medium:* Photoshop

Kekai Kotaki

Art Director: Daniel Dociu *Client:* ArenaNet Guild Wars 2 *Title:* Kodan Attack *Size:* 11"x7" *Medium:* Digital

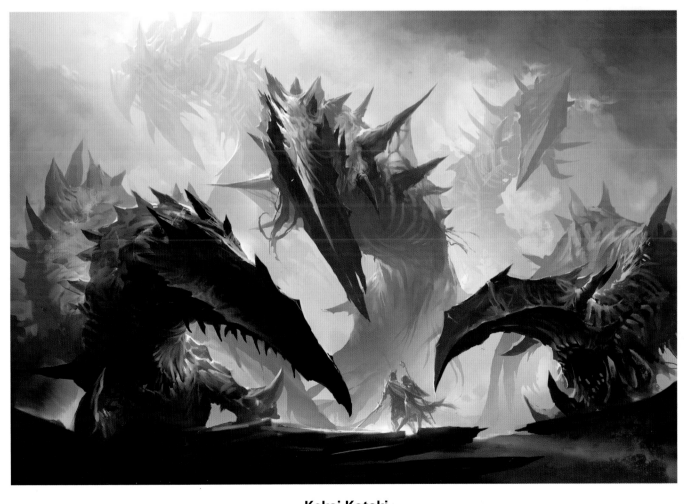

Kekai Kotaki

Art Director: Daniel Dociu *Client:* ArenaNet Guild Wars 2 *Title:* Left Hand of the Dragon *Size:* 11"x7" *Medium:* Digital

Lucas Graciano

Art director: Roger Chamberlain *Client:* Sony Online Entertainment
Title: Elddar Fury *Size:* 16"x20" *Medium:* Oil

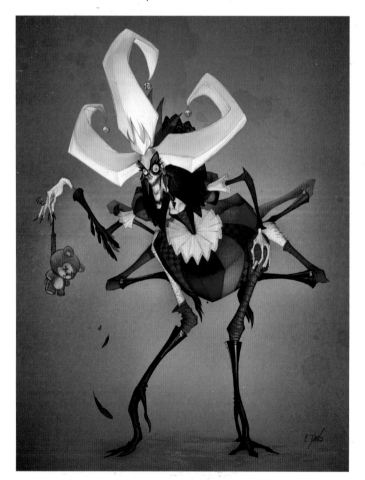

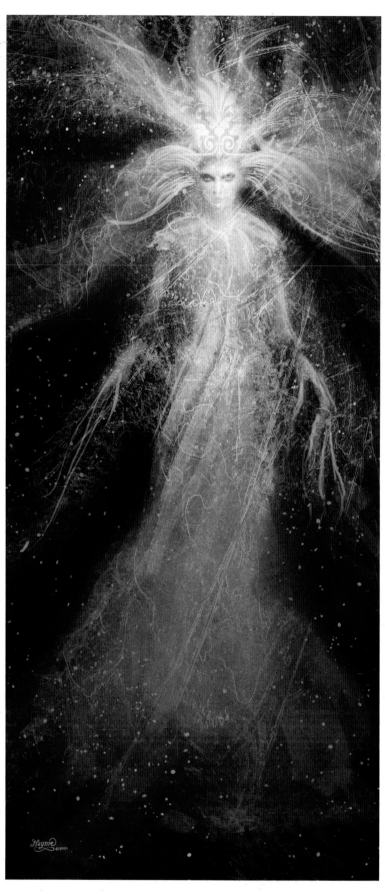

Cameron Scott Davis

Client: Gnomon Workshop *Title:* The Queen of Boogedyville!
Size: 8 1/2"x11" *Medium:* Digital

Jeff Haynie

Art Director: Jeff Haynie *Designer:* Adrian Woods
Client: Big Fish Games
Title: Banchee *Size:* 8"x18" *Medium:* Digital

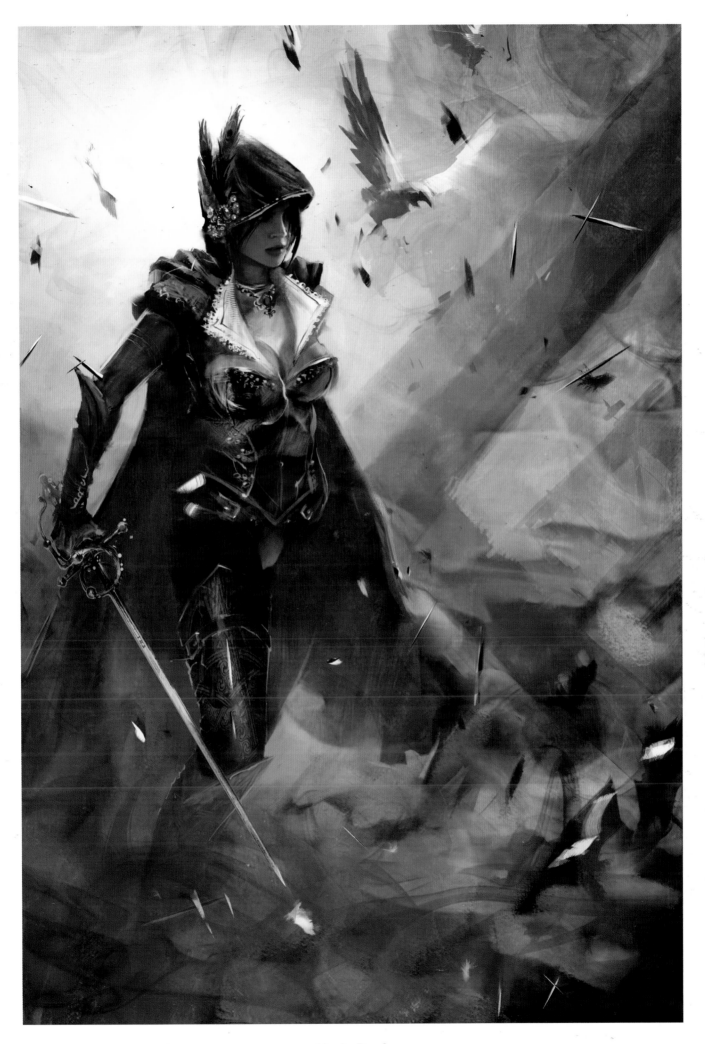

Horia Dociu

Art Director: Daniel Dociu *Client:* ArenaNet Guild Wars 2 *Title:* Thief Queen *Medium:* Digital

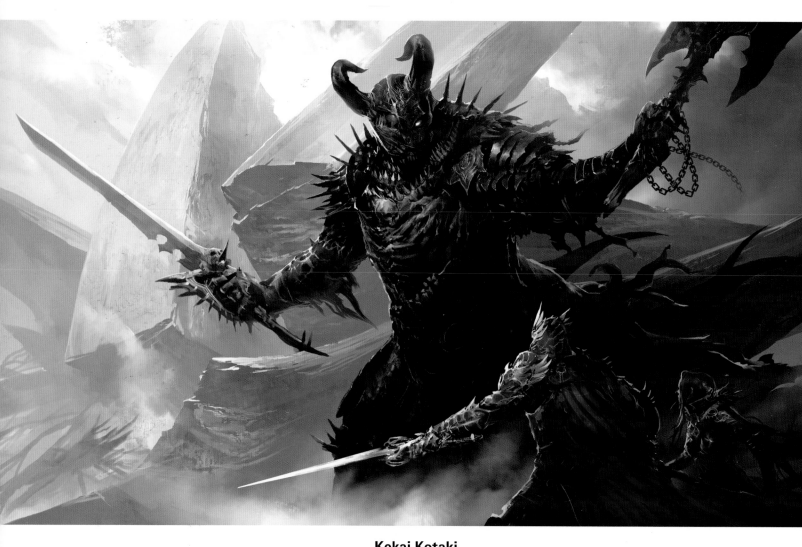

Kekai Kotaki

Art director: Daniel Dociu *Client:* ArenaNet Guild Wars 2 *Title:* Undead Guardian *Size:* 11"x7" *Medium:* Digital

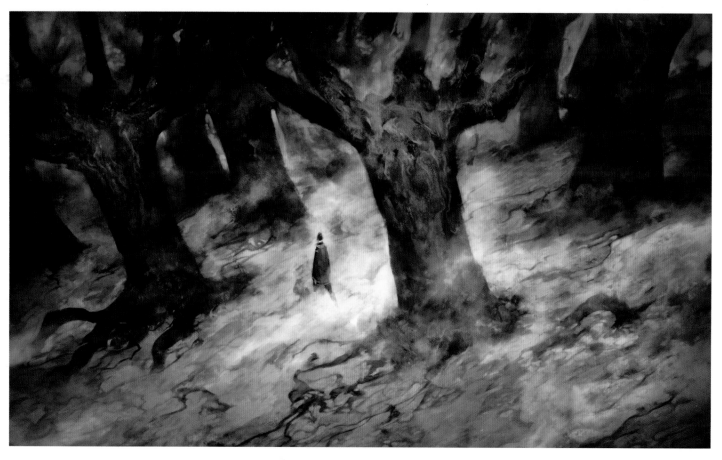

Emmanuel Malin

Art director: Emmanuel Malin *Client:* Beyond the Pillars *Title:* Forest Concept 1 *Size:* 40x25cm *Medium:* Digital

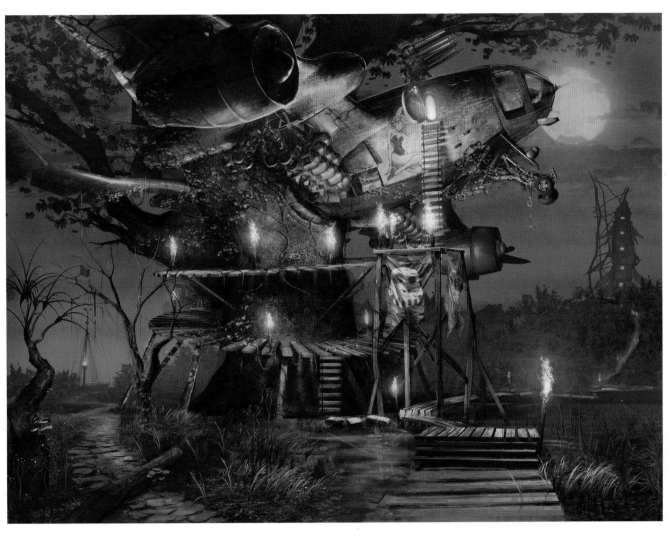

Shawn Wood

Art Director: Steve Firchow *Client:* Big Fish Games *Title:* The Clubhouse *Size:* 15"x10" *Medium:* Digital

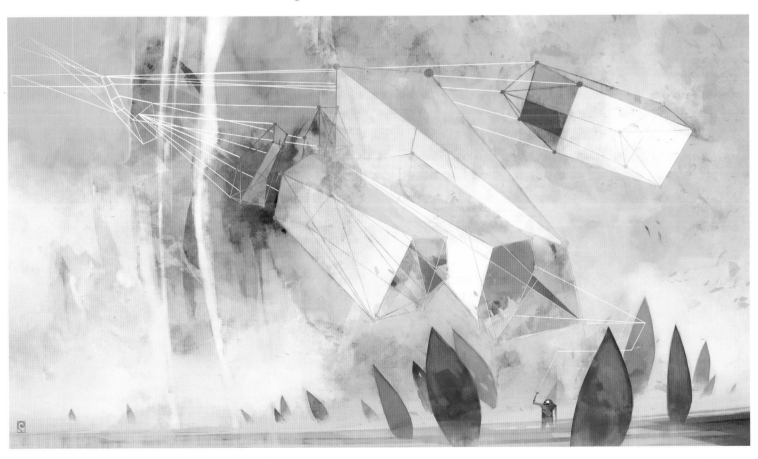

Emmanuel Malin

Title: Fields and Geometry 2 *Size:* 65x40cm *Medium:* Digital

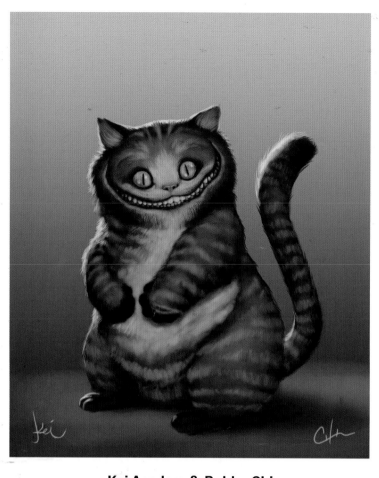

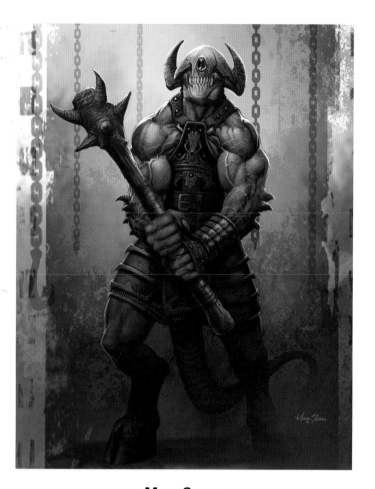

Kei Acedera & Bobby Chiu

Designer: Kei Acedera *Client:* Tim Burton's Alice In Wonderland
Title: Cheshire Cat *Size:* 6"x8" *Medium:* Digital

Marc Sasso

Art Director: Marc Sasso *Client:* Eternal Edge
Title: Cronos *Medium:* Digital

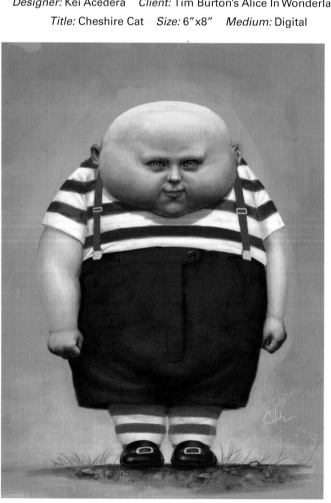

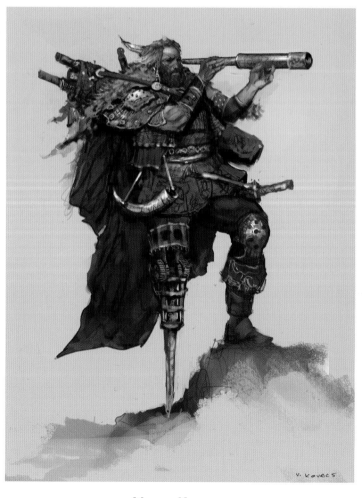

Bobby Chiu & Jason Seiler

Art Director: Bobby Chiu *Client:* Tim Burton's Alice In Wonderland
Title: Tweedles *Size:* 8 1/2"x11" *Medium:* Digital

Vance Kovacs

Client: Trion World Network *Title:* Harlan Quick *Medium:* Digital

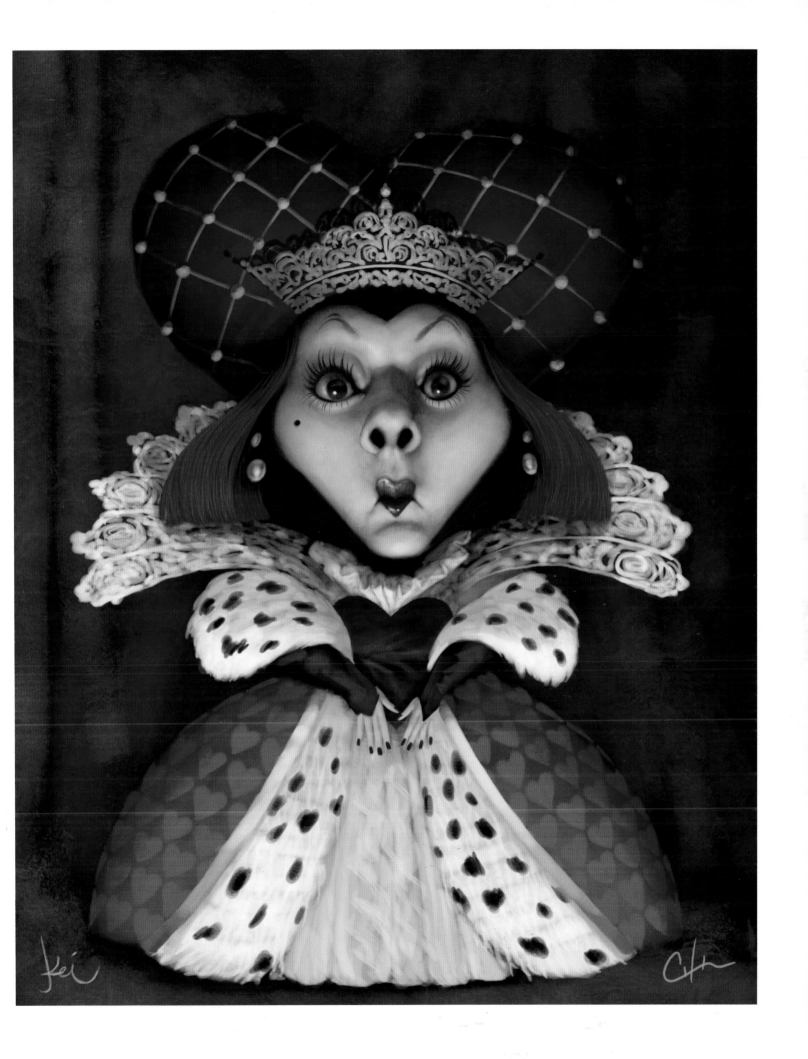

Kei Acedera & Bobby Chiu

Designer: Kei Acedera *Client:* Tim Burton's Alice In Wonderland *Title:* Red Queen *Size:* 8 1/2"x11" *Medium:* Digital

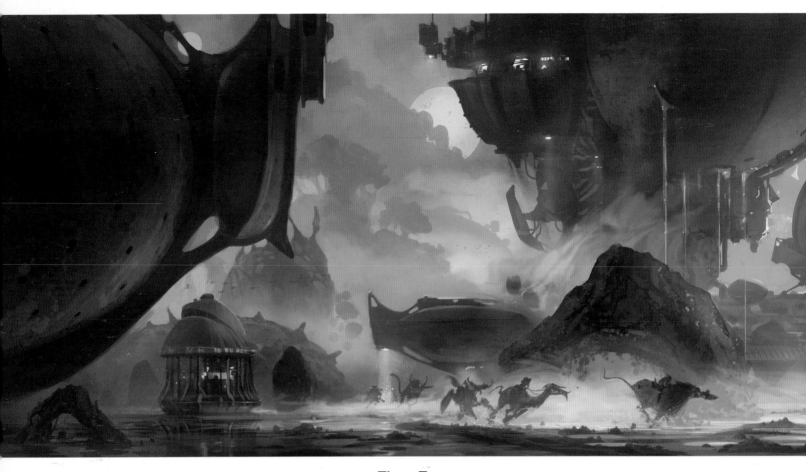

Thom Tenery

Art director: Scott Robertson *Client:* Design Studio Press/Alien Race *Title:* Through the Swamp *Medium:* Digital

David Stevenson

Art director: Jeff Haynie *Designer:* David Stevenson *Client:* Big Fish Games *Title:* Snowy Path *Size:* 13"x10" *Medium:* Digital

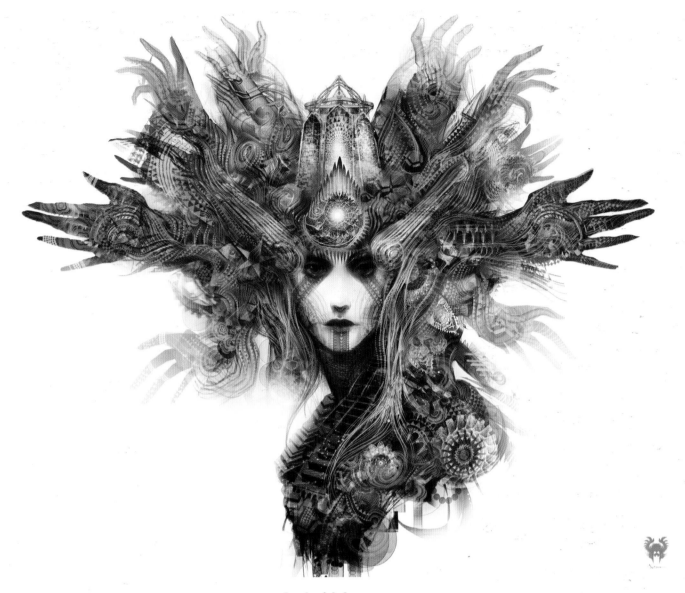

Android Jones

Art Director: Android Jones *Client:* www.conceptart.org *Title:* Kuska *Size:* 64"x38" *Medium:* Digital/Painter II

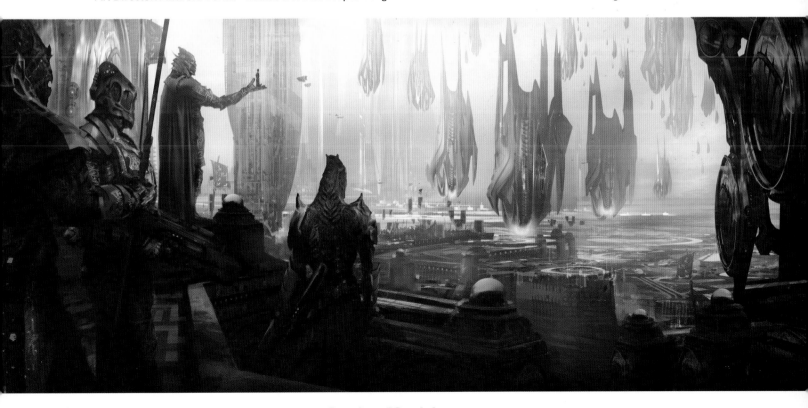

Stephen Martiniere

Art director: Greg McLean *Client:* Greg McLean *Title:* The Guardian/"Kreener Fleet" *Medium:* Digital

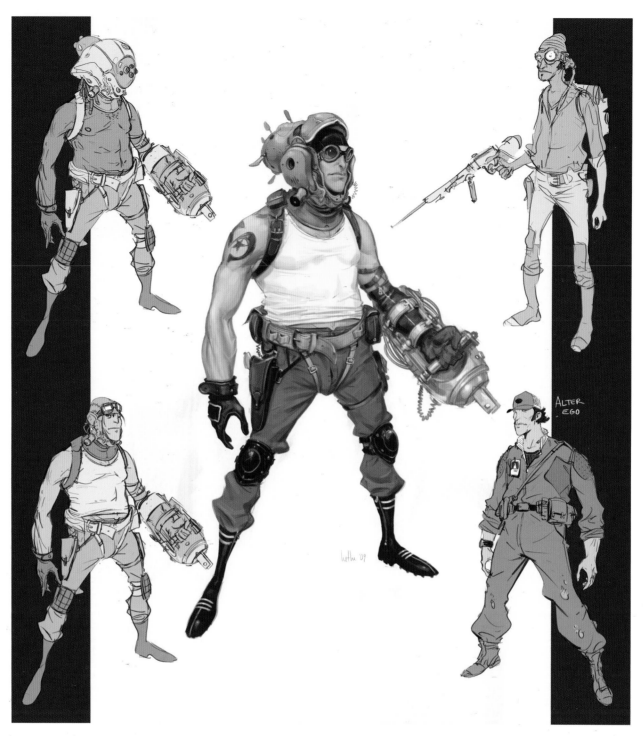

Hethe Srodawa

Title: Sci-Fi Guy *Medium:* Digital

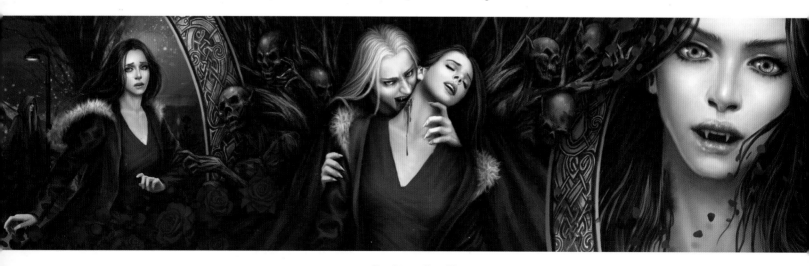

Carissa Susilo

Art Director: Lana McCarthy/Rhiannon Bell *Client:* Vampire Wars, Zynga *Title:* Vamps Never Say Die *Medium:* Digital

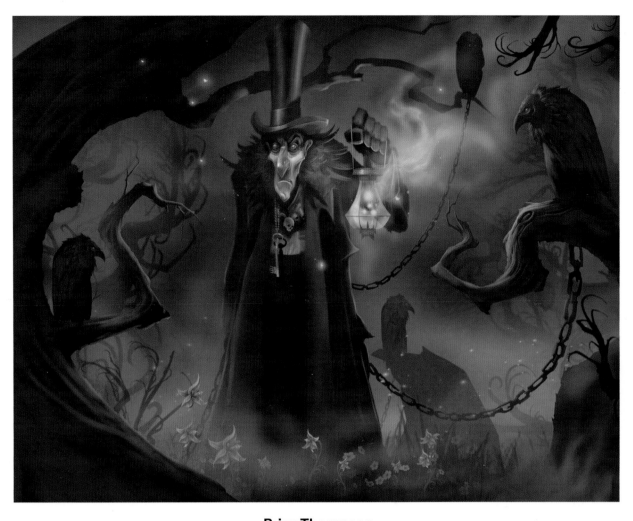

Brian Thompson
Art Director: Brian Thompson *Client:* Big Fish Games *Title:* Undertaker *Size:* 16"x212" *Medium:* Digital

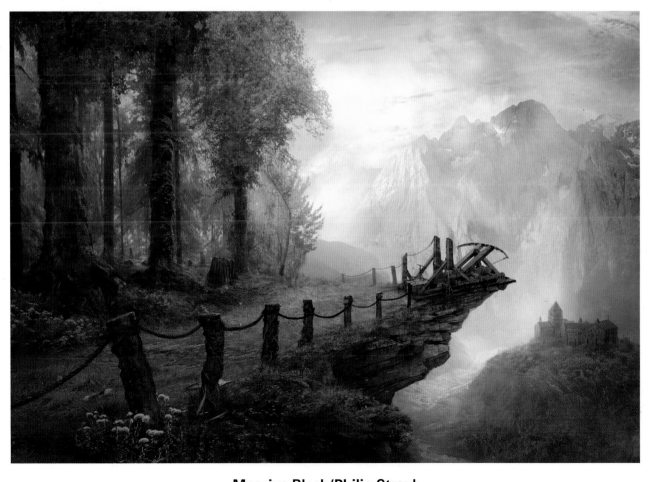

Massive Black/Philip Straub
Art Director: Philip Straub *Client:* Big Fish Games *Title:* Leo's Cliff *Size:* 17"x12" *Medium:* Digital

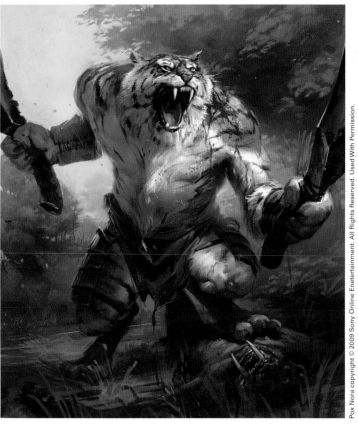

Slawomir Maniak

Art Director: Bryan Rypkowski *Client:* Sony Online Entertainment

Title: Ravager *Medium:* Photoshop

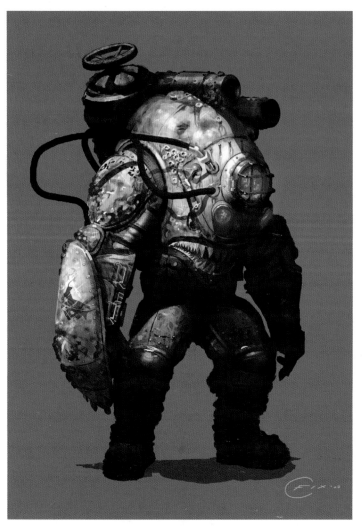

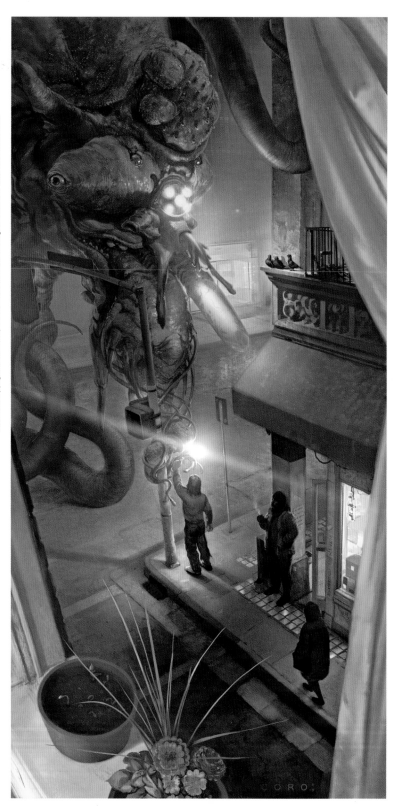

Colin Fix

Client: 2K Games *Title:* Demo Daddy

Coro

Art Director: Coro *Client:* Massive Black

Title: Have a Coke *Size:* 7"x13" *Medium:* Digital

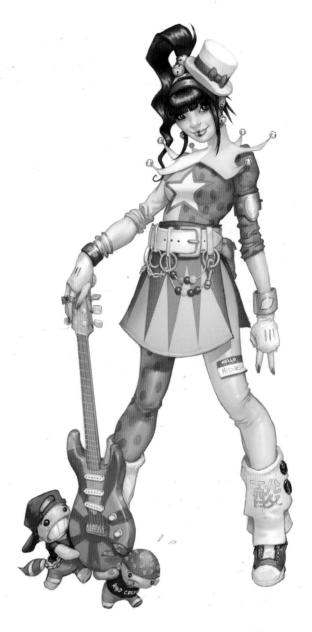

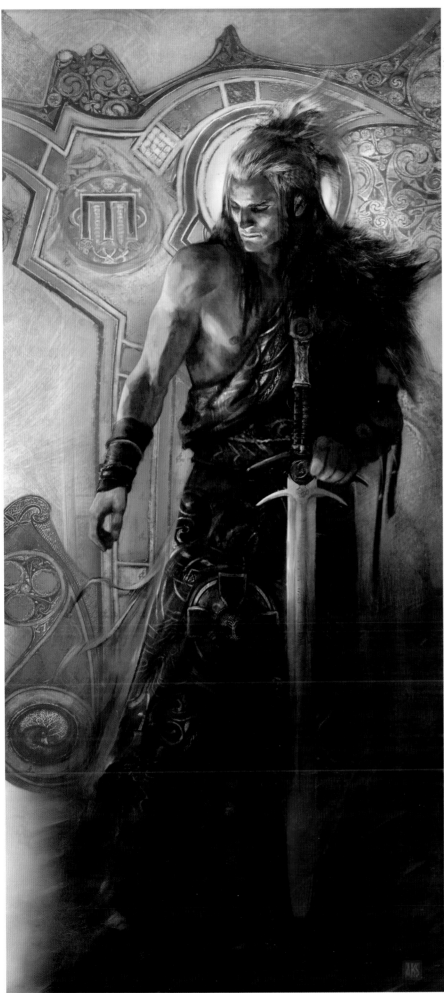

Aleksi Briclot

Art director: Aleksi Briclot/Jean-Sebastien Rossbach *Client:* Soleil Éditions

Title: Merlin *Size:* 6"x13" *Medium:* Digital

Cameron Scott Davis

Art Director: Nolan Nelson

Client: Activision/Neversoft

Title: Midori — Guitar Hero 5

Size: 8 1/2"x11" *Medium:* Digital

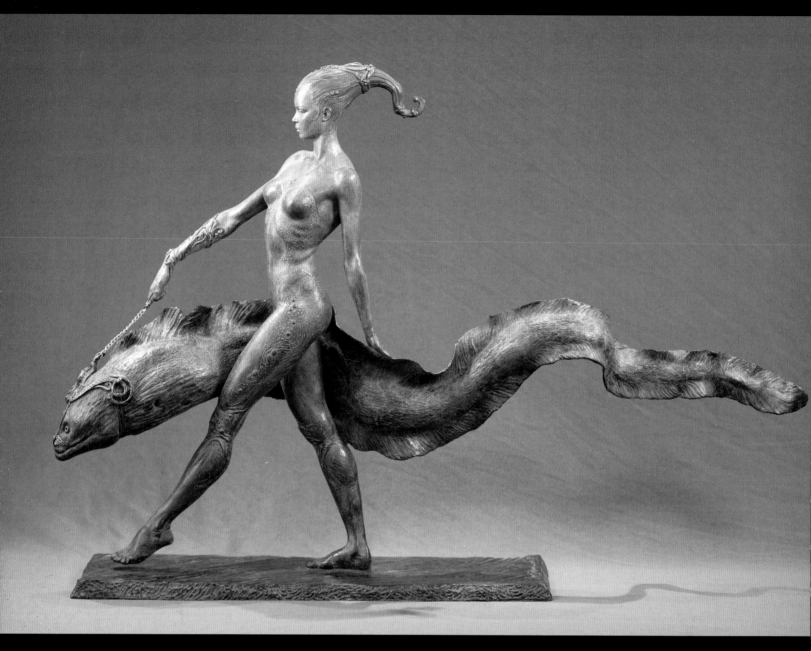

Mark Newman

Art Director: Mark Newman *Client:* Mark Newman *Title:* Eel Walker *Size:* 19" tall x 29" long *Medium:* Bronze

Dimensional — Silver Award

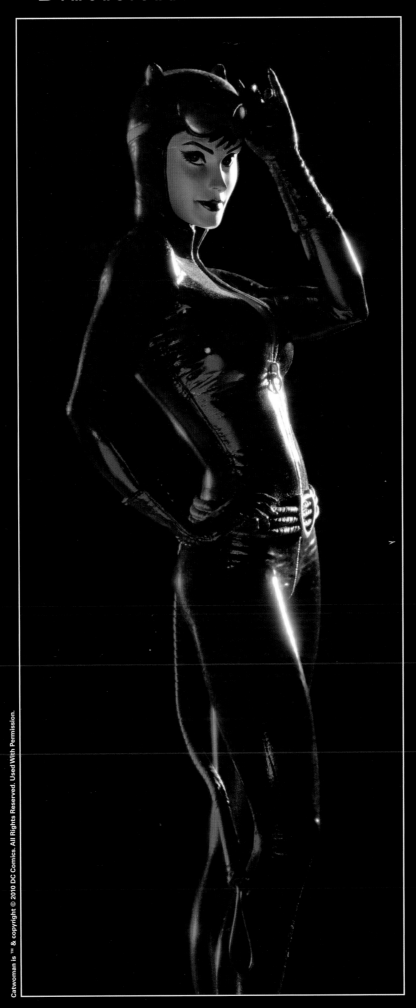

Jack Mathews

Art Director: Jim Fletcher *Designer/Photographer:* Adam Hughes *Client:* DC Direct *Title:* Catwoman *Size:* 10″ tall *Medium:* Resin

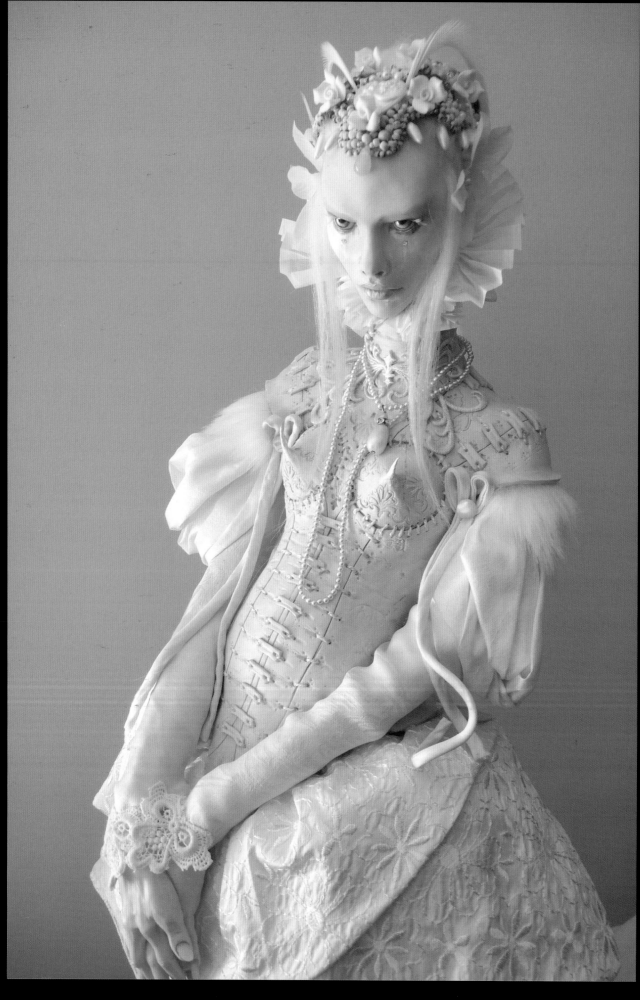

Virginie Ropars
Title: Alba *Size:* 29 1/2" tall *Medium:* Polymer/mixed media

DIMEN

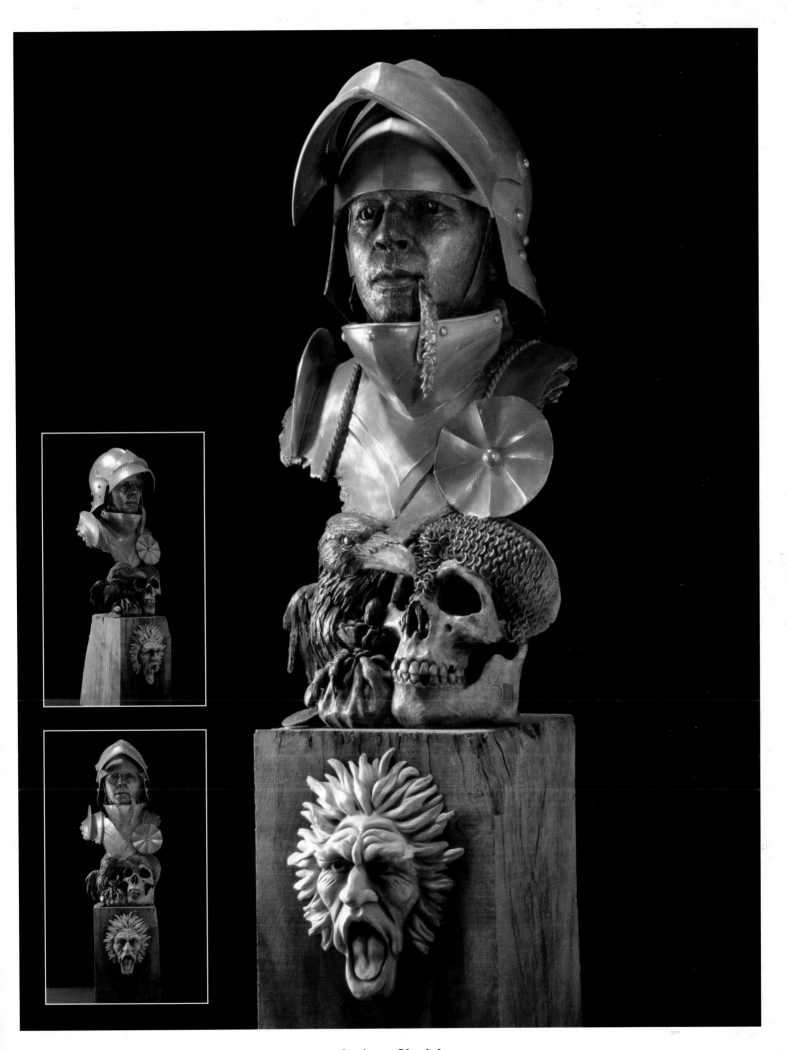

Andrew Sinclair

Art Director: Andrew Sinclair *Client:* Private collections *Title:* Condottiere *Size:* Life size *Medium:* Bronze

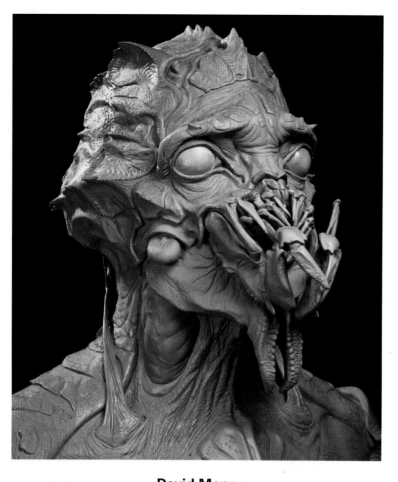

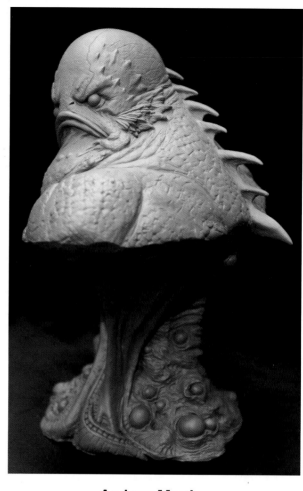

David Meng

Art Director: Richard Taylor/Weta *Client:* Neill Blomkamp/Sony
Title: Alternate Alien District 9 *Size:* Life size *Medium:* Chavant

Andrew Martin

Title: The Innsmouth Look *Size:* 15x11x7cm *Medium:* Polymer

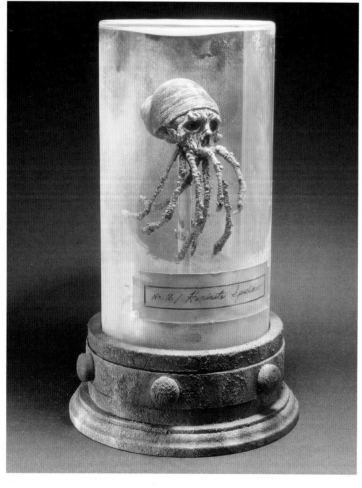

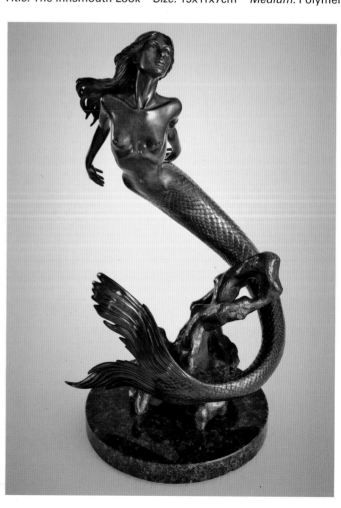

Tom Whittaker

Title: The Specimen *Size:* 7"x11" *Medium:* Sculpey/mixed

Paul Kidby

Client: Daniel Maghen *Title:* Mermaid *Medium:* Bronze

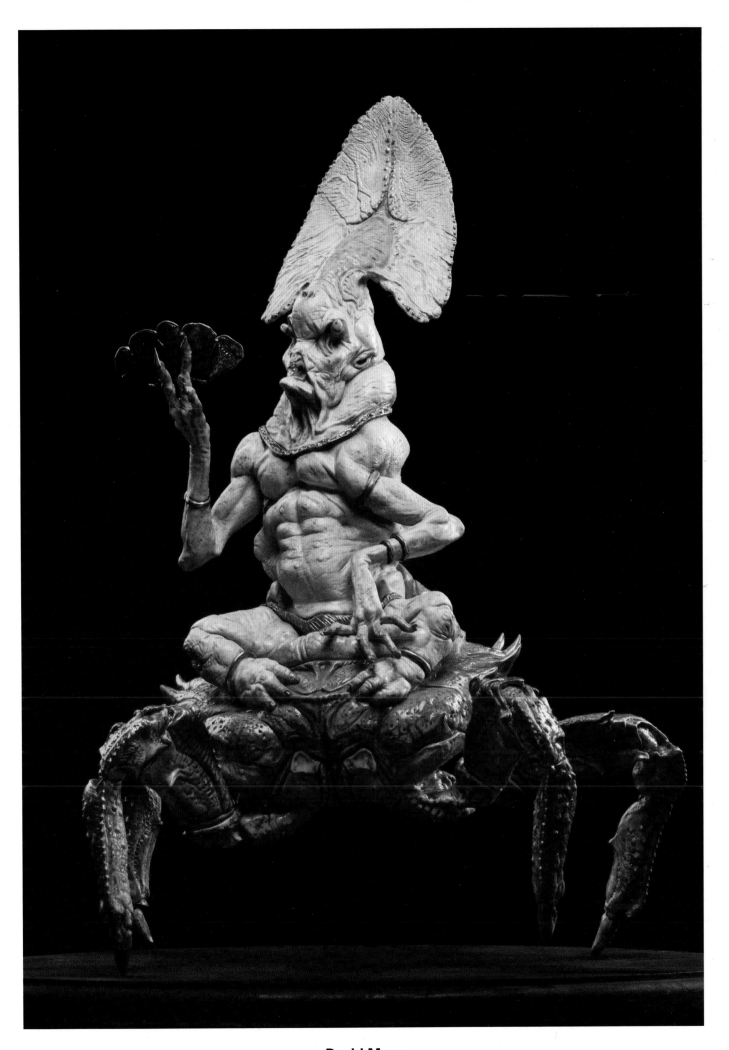

David Meng

Photographer: Dteve Unwin *Title:* The Cellar God *Size:* 33x30x40cm *Medium:* Resin

Bruce D. Mitchell

Title: Minotaur *Size:* 92W x 29D x 30Hcm *Medium:* Epoxy/mixed

Lawrence Northey

Client: www.robotart.net *Title:* General E. Lectric: The Treasure of Chantecler Eldorado *Size:* 33"H x 48"W *Medium:* Metal

Dave Pressler
Client: Gallery Show *Title:* Punch-Bot *Size:* 5"W x 6 3/4"H x 7"D *Medium:* Super Sculpey/mixed

Bruce D. Mitchell
Title: Th3seus *Size:* 23W x 26D x 27H cm *Medium:* Fiberglass/mixed

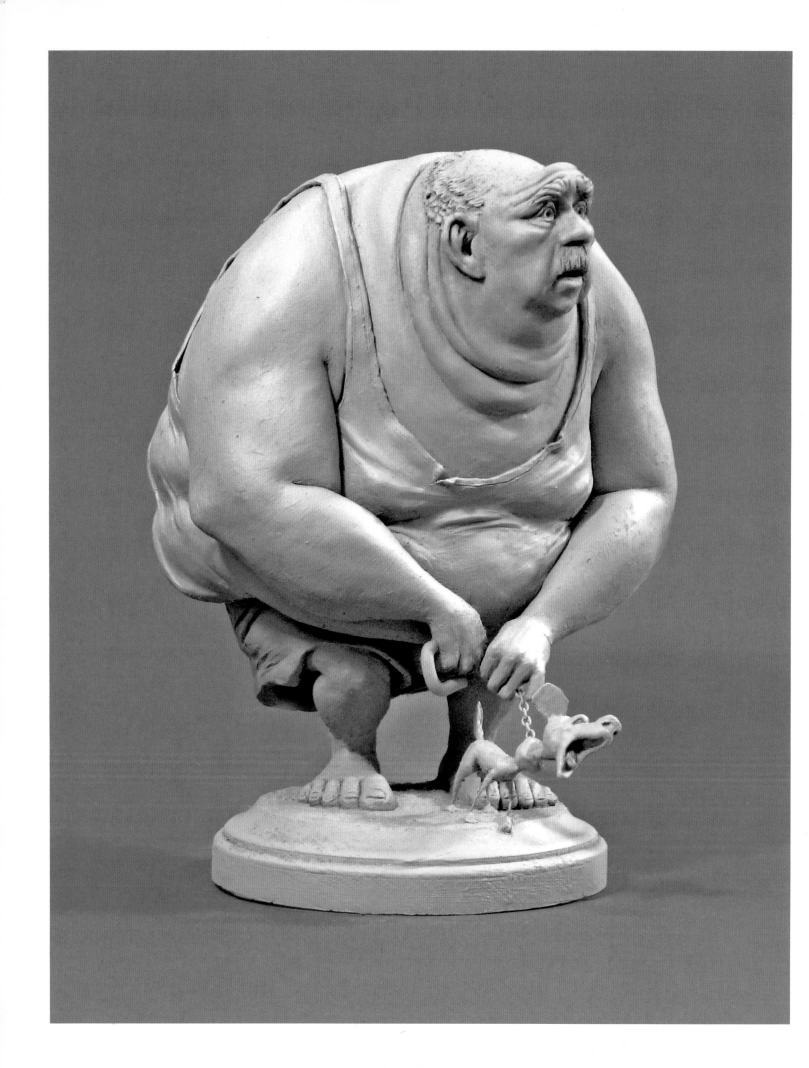

Alena Wooten
Designer: Peter de Sève *Title:* In Charge *Size:* 6 1/2"H x 5"W x 5"D *Medium:* Super Sculpey

Mark Nagata & Mairuzu
Art Director: Mark Nagata *Client:* Max Toy Co. *Title:* Kaiju Eyezon
Size: 22"H x 17"W x 7 1/2"D *Medium:* Ceramic

Mark Alfrey
Title: Dusty *Size:* 34"H *Medium:* Polystone

Vincent Villafranca
Client: Lizotte Collection *Title:* The Astro Ghoul Gun *Size:* 16"W x 10"H *Medium:* Digital

Jeff Feligno

Title: Faceplate *Size:* 8 1/2"x14"

Julie Mansergh

Art Director: Faeries in the Attic *Client:* Private collection *Title:* Absinthe Faerie

Size: 8"L *Medium:* Polymer

Sym 7

Client: Symbiosis Studio *Title:* Nosferatu *Medium:* Wax

David Silva

Client: Creative-Beast.com *Title:* Dilophosaurus Wetherilli *Medium:* Resin

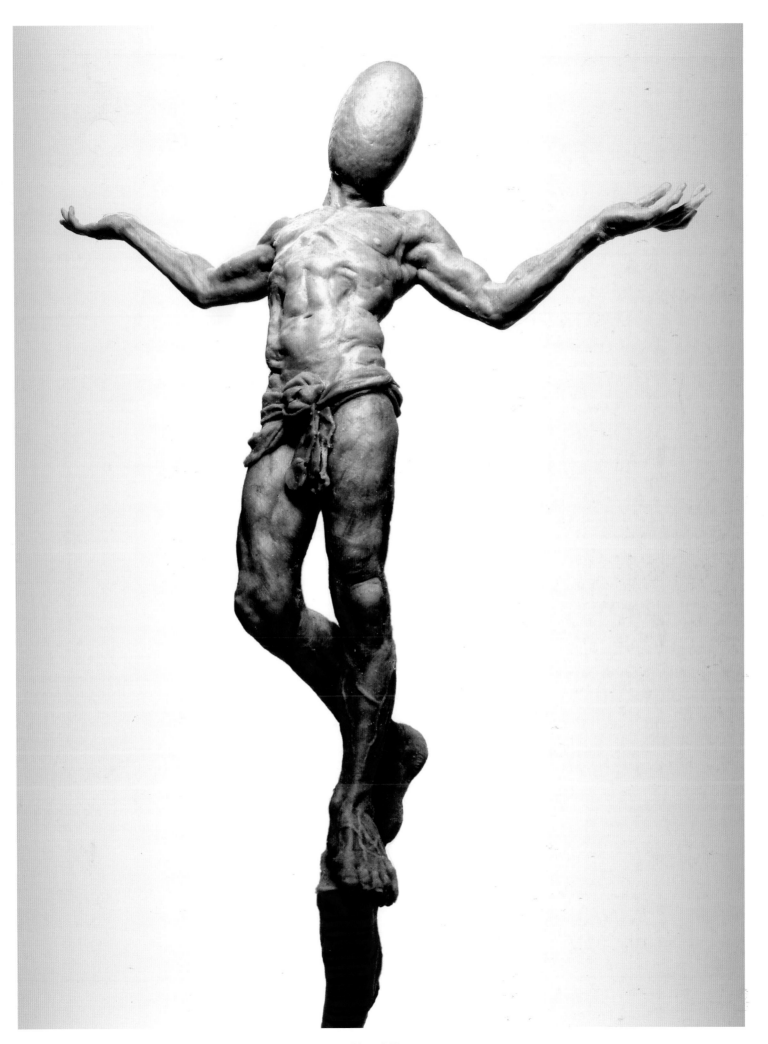

Chuck Tam

Title: The Martyr (Humpty Dumpty) *Size:* 8 1/2"H *Medium:* Super Sculpey

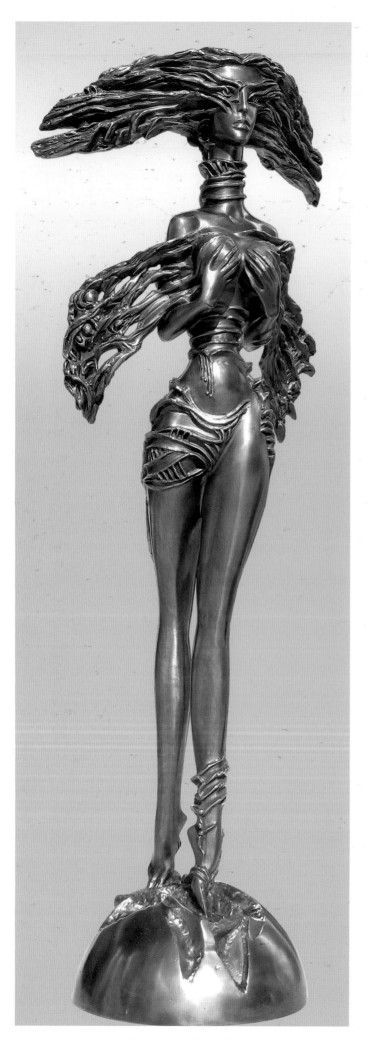

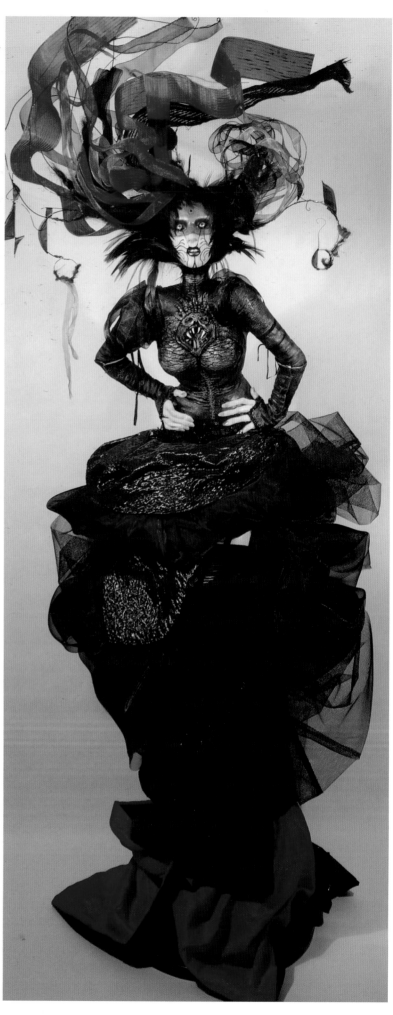

Igor Grechanyk

Title: Inanna Art of Dreams *Size:* 130cm H *Medium:* Bronze

Virginie Ropars

Designer: Jean_Sebastien Rossbach *Title:* Alligator 432

Size: 45"H *Medium:* Polymer/mixed

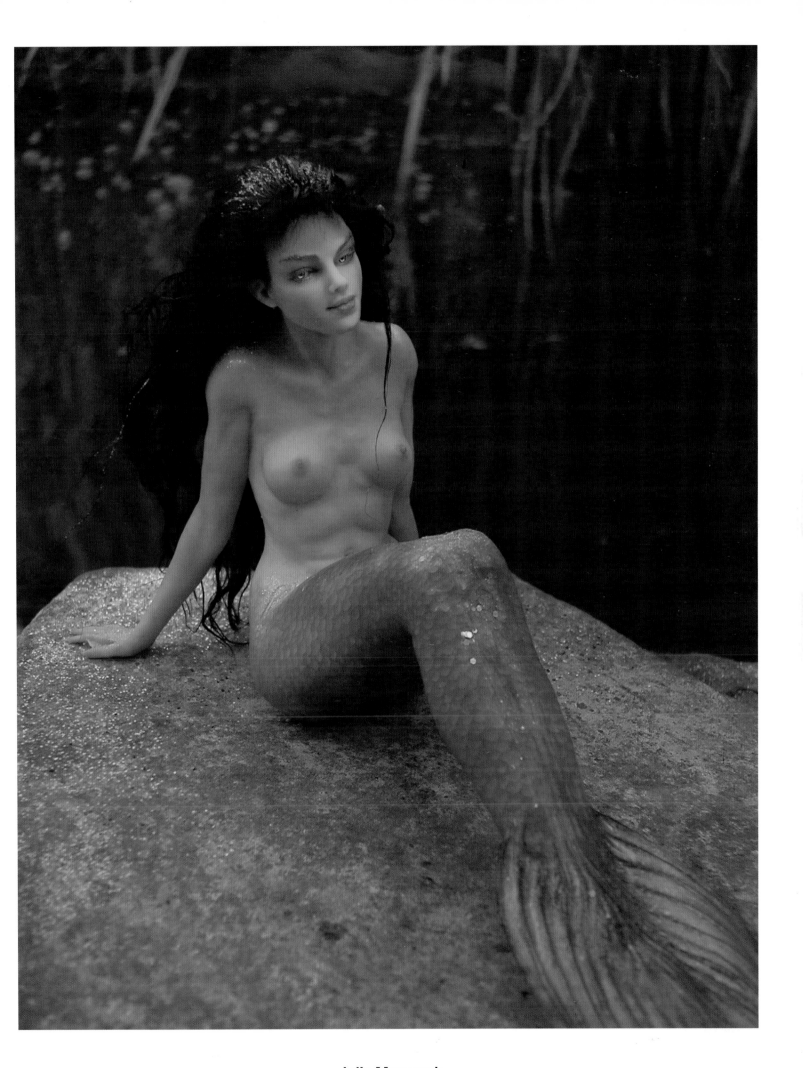

Julie Mansergh

Art Director: Faeries in the Attic *Client:* Private Collection *Title:* Coldwater Mermaid *Size:* 8"L *Medium:* Polymer

Thomas S. Kuebler
Title: Hitchcock *Size:* Life size *Medium:* Silicone/mixed

James Shoop
Client: Shoop Sculptural Designs, Inc. *Title:* Aleatha VS...
Size: 19"H x 7"W x 7"D *Medium:* Bronze/clear resin

Carisa Swenson
Photographer: Steve Harrison *Title:* Brother's Keeper
Size: 13"H *Medium:* Mixed

Jonathan Matthews

Art Director: Jim Fletcher *Client:* DC Direct *Title:* Manga Robin *Size:* 8"H *Medium:* Resin

Mike Rivamonte

Title: Roosevelt *Size:* 18"W x 31"H x 8"D *Medium:* Mixed

Thomas S. Kuebler

Title: Scream Queen *Size:* Life size *Medium:* Silicone/mixed

illworx

Title: Precarious Perch *Size:* 15"x7 1/2"
Medium: Mixed

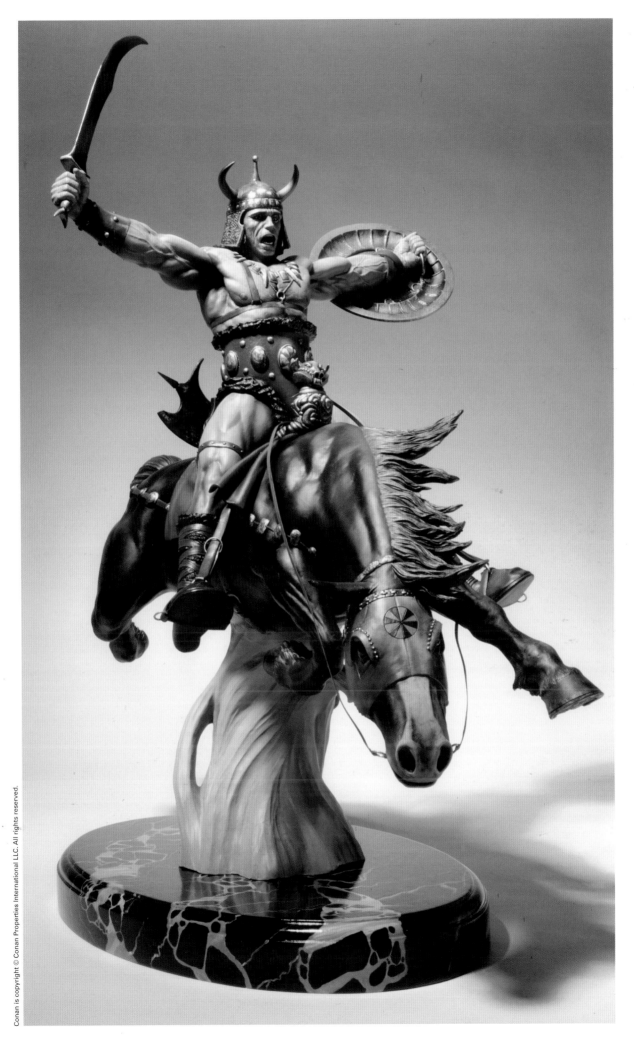

Clayburn Moore

Designer: Frank Frazetta *Client:* Conan Properties *Title:* Conan the Conqueror *Size:* 20"H *Medium:* Cold-cast Porcelain

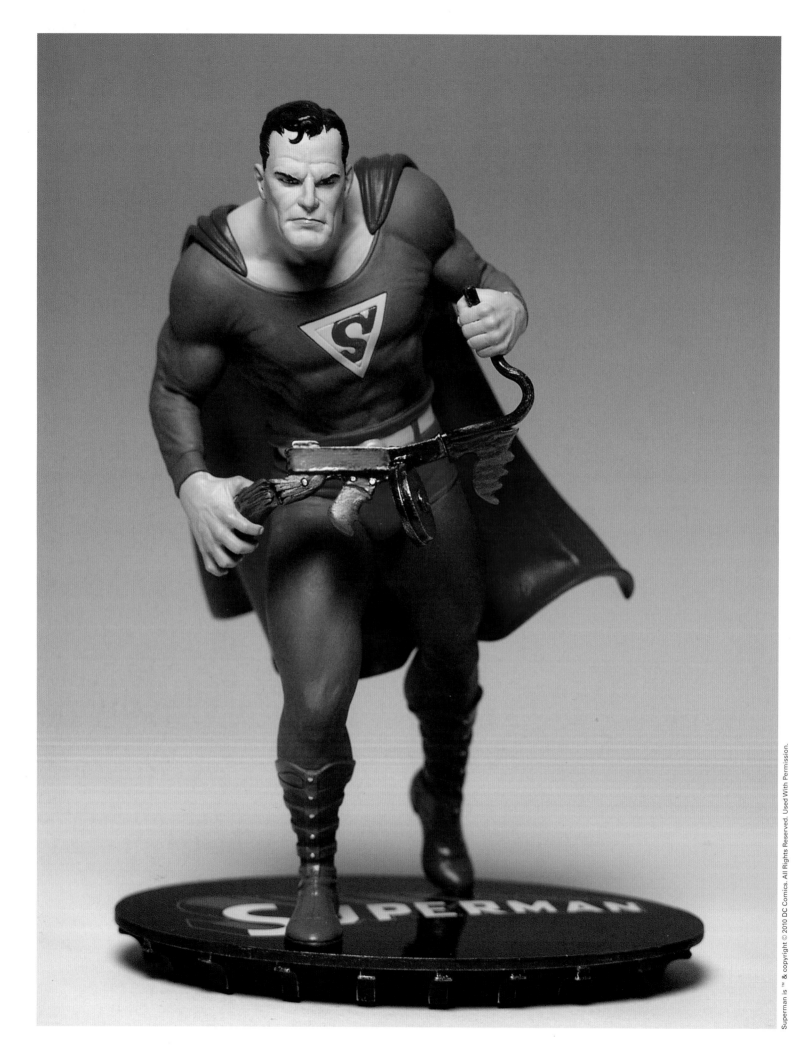

Tim Bruckner

Art Director: Georg Brewer *Client:* DC Direct *Title:* Chronicles Superman *Size:* 7"H *Medium:* Resin

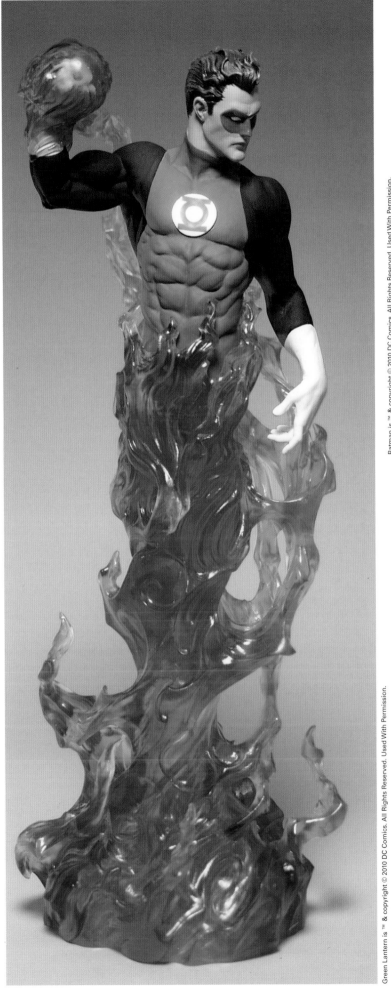

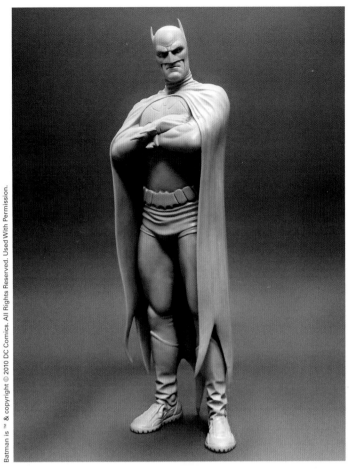

Paul Harding
Art Director: Jim Fletcher *Designer:* Frank Quitely
Client: DC Direct *Title:* Batman B&W *Size:* 7"H *Medium:* Wax

Tim Bruckner
Art Director: Georg Brewer *Client:* DC Direct
Title: DC Dynamics—Green Lantern *Size:* 13"H *Medium:* Resin

Juan Balandran
Art Director: Red Rooster *Photographer:* Phil Holland
Title: Veronica *Size:* 14"H x 7"W x 5"D *Medium:* Bronze

Vincent Villafranca

Client: Villafranca Sculpture *Title:* The Celestial Itinerant *Size:* 24"H x 18"W *Medium:* Bronze

Charles Vess and David Spence

Designer: Charles Vess and David Spence *Client:* The Barter Theatre *Title:* Midsummer Play *Size:* 15'x16' *Medium:* Bronze

Chris Buzelli

Art Director: SooJin Buzelli *Designer:* Maynard Kay *Client:* Asset Intl./AI5000 *Title:* Aging Tiger *Size:* 18"x21" *Medium:* Oil

Sam Weber

Art Director: Brian Morgan *Designer:* Brian Morgan *Client:* The Walrus *Title:* The Crow Procedure *Size:* 18"x26" *Medium:* Acrylic/digital

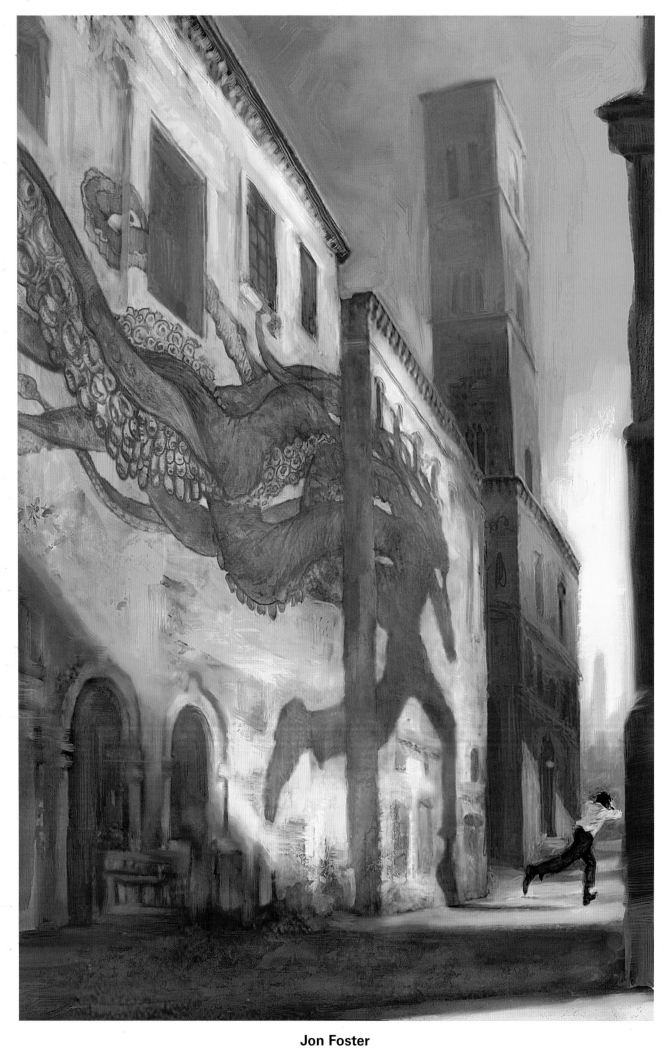

Jon Foster

Art Director: Irene Gallo *Client:* Tor.com *Medium:* Digital

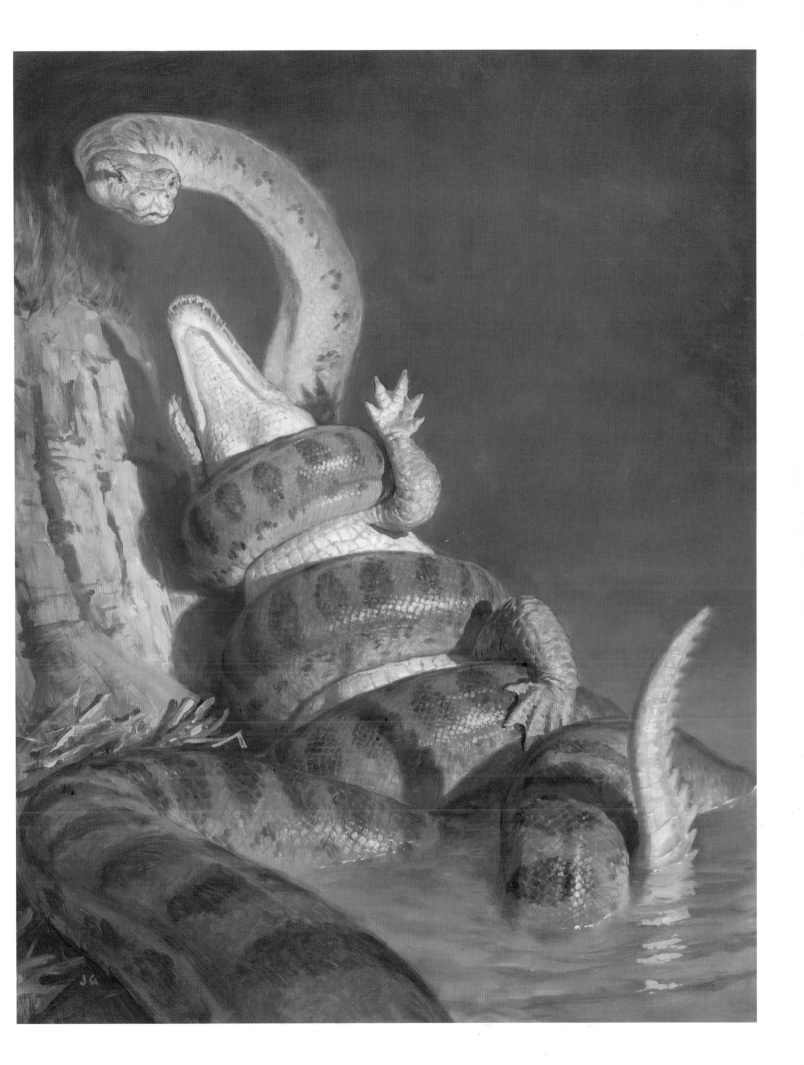

James Gurney

Art Director: Donna Miller *Client:* National Wildlife Federation *Title:* Titanoboa *Size:* 14"x18" *Medium:* Oil

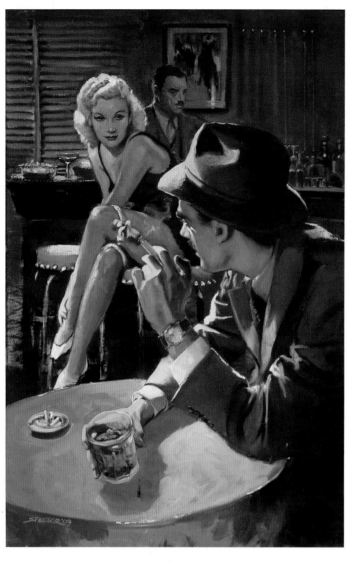

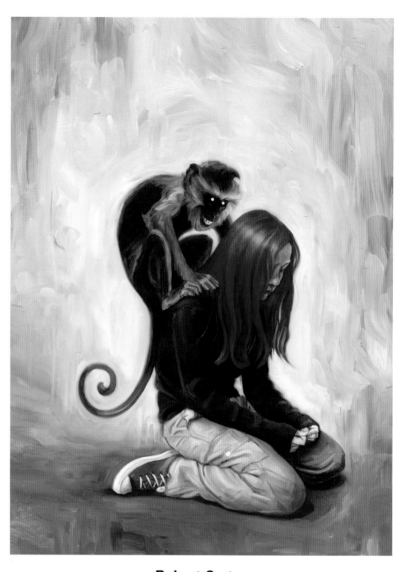

Joel Spector

Art Director: Irene Lee *Client:* Alfred Hitchcock Magazine
Title: How Aunt Pud...Kept Me Fron Hanging *Medium:* Oil

Robert Carter

Art Director: Charles Burke *Client:* Grip Magazine
Title: Teen Addiction *Size:* 20"x27" *Medium:* Oil on board

Robh Ruppel

Art Director: Robh Ruppel *Client:* 2D Magazine *Title:* Floating 2 *Size:* 3000x1600px *Medium:* Digital

Leo & Diane Dillon

Art Director: Harlan Ellison *Client:* Realms of Fantasy *Title:* How Interesting: A Tiny Man *Medium:* Mixed

Victo Ngai

Art Director: SooJin Buzelli *Client:* Asset International *Title:* The New Standard *Size:* 15 3/8"x20" *Medium:* Digital

Yuta Onoda

Designer: Teresa Johnston *Client:* West Magazine *Title:* Itinerant Killer *Size:* 8 1/2"x11" *Medium:* Mixed/digital

Chris Buzelli

Art Director: SooJin Buzelli *Client:* Plansponsor Magazine

Title: Weed Beasts *Size:* 18"x24" *Medium:* Oil on board

Kurt Huggins and Zelda Devon

Art Director: Laura Cleveland *Client:* Realms of Fantasy

Title: Hearts of Men *Medium:* Digital

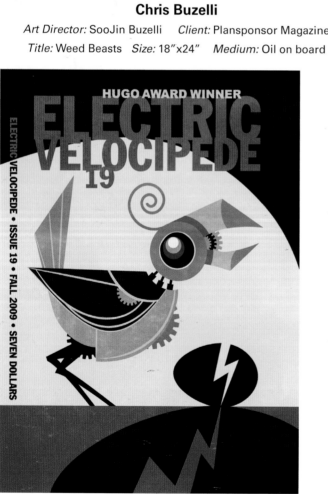

Thom Davidson

Art director: John Klima *Client:* Spilt Milk Press

Title: Electric Velocipede 19 *Size:* 8 1/2"x11"

Kali Ciesemier

Art director: Anthony Arias *Client:* Vegas Magazine

Title: Aries Awakening *Size:* 11 1/2"x11 1/2" *Medium:* Digital

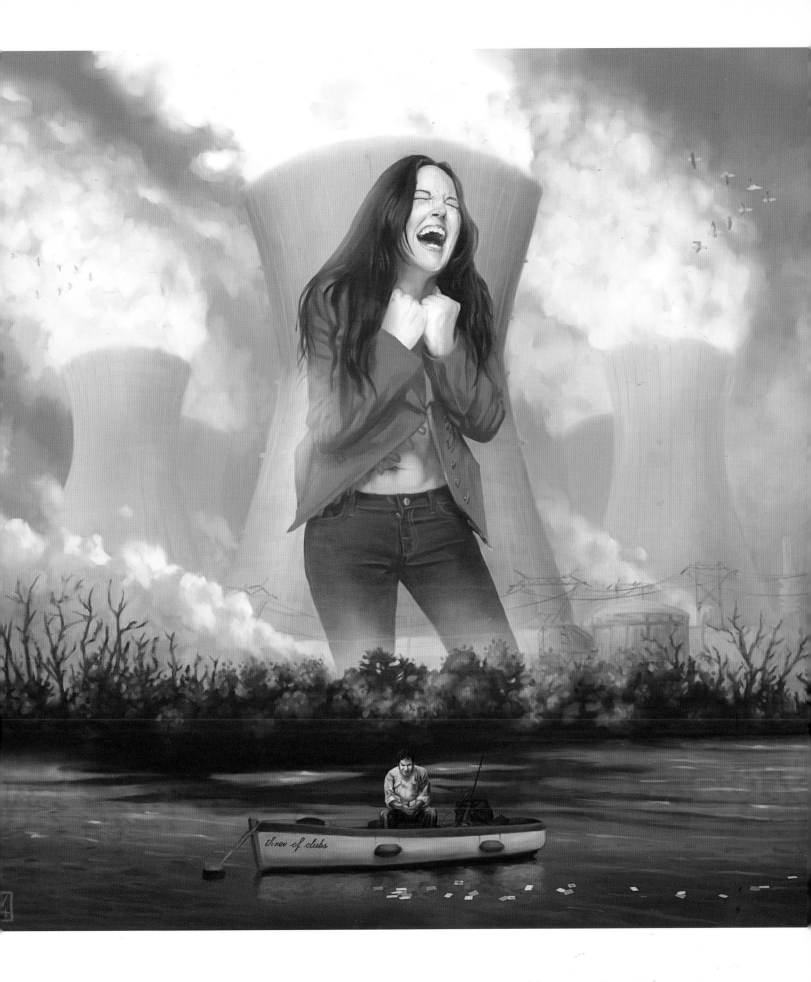

Cyril van der Haegen

Art director: Rob Wilson *Client:* Playboy *Title:* Lovely Rita (by Maile Meloy) *Medium:* Digital

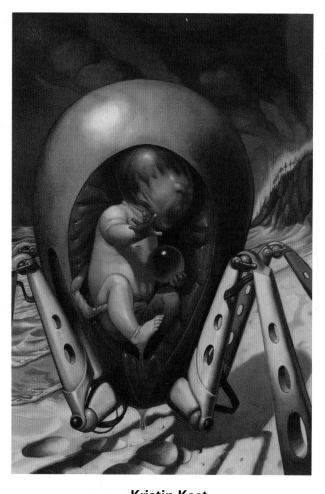

Kristin Kest

Art Director: Gordon Van Gelder *Client:* Magazine of F&SF

Title: Ghosts Doing the Orange Dance *Medium:* Oil

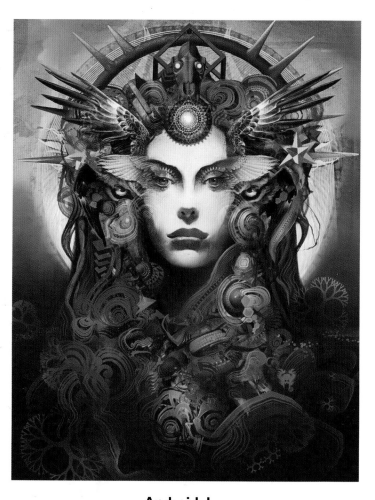

Android Jones

Art Director: Claive Howlett *Client:* ImagineFX

Title: Dusted *Size:* 8"x11" *Medium:* Digital/Painter II

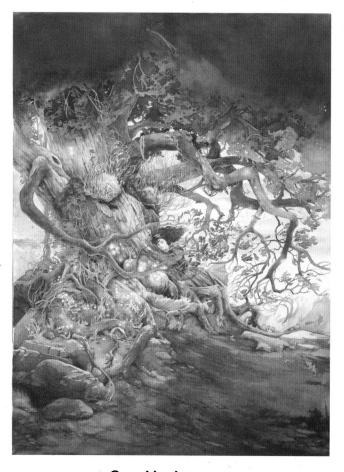

Gary Lippincott

Art Director: Douglas Cohen *Client:* Realms of Fantasy

Title: Mr. Oak *Size:* 18"x22" *Medium:* Watercolor

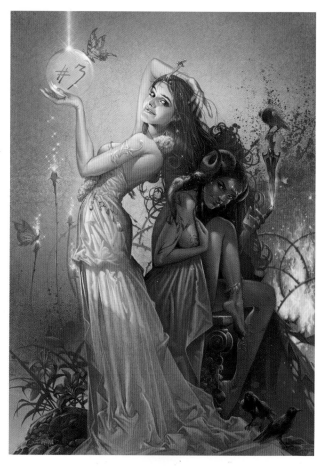

Su Hai Tao

Art Director: Su Hai Tao *Client:* #3 Magazine

Title: Angels and demons *Size:* 11 5/8"x16 1/2" *Medium:* Digital

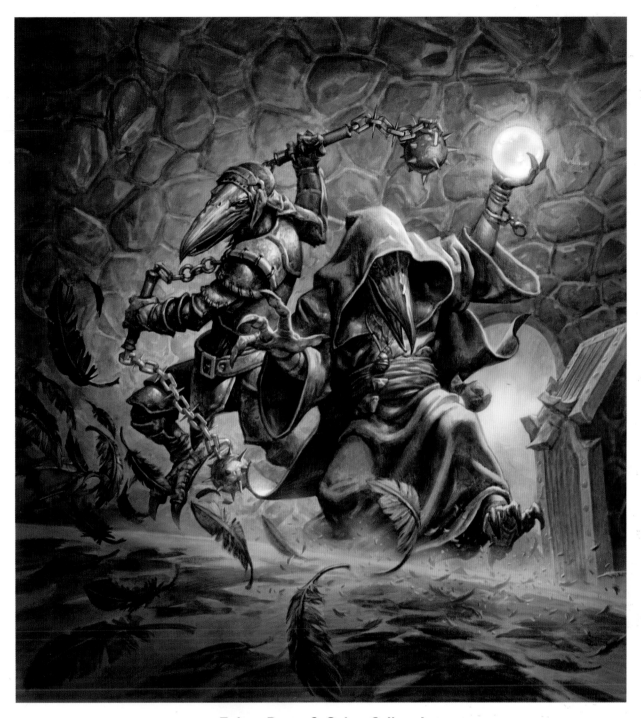

Zoltan Boros & Gabor Szikszai

Art Director: Jon Schindehette *Client:* Wizards of the Coast *Title:* Dungeon® Magazine #169 *Size:* 10"x10"

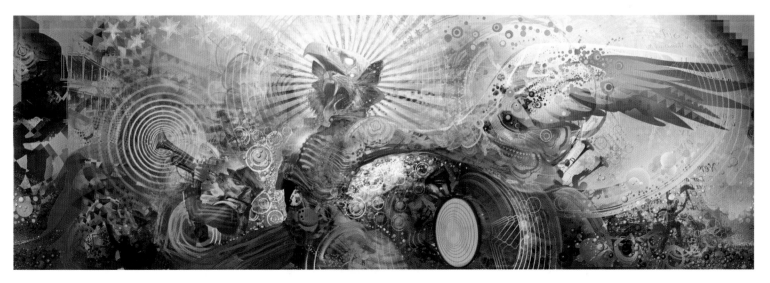

Android Jones

Art director: Android Jones *Client:* Cayton Kelly *Title:* Rize Up! *Size:* 49"x17" *Medium:* Digital/Painter II

John Dunivant

Art Director: Grayson Cardinell *Client:* Deliver Magazine *Title:* The Juggler *Size:* 9"x11" *Medium:* Pencil/digital

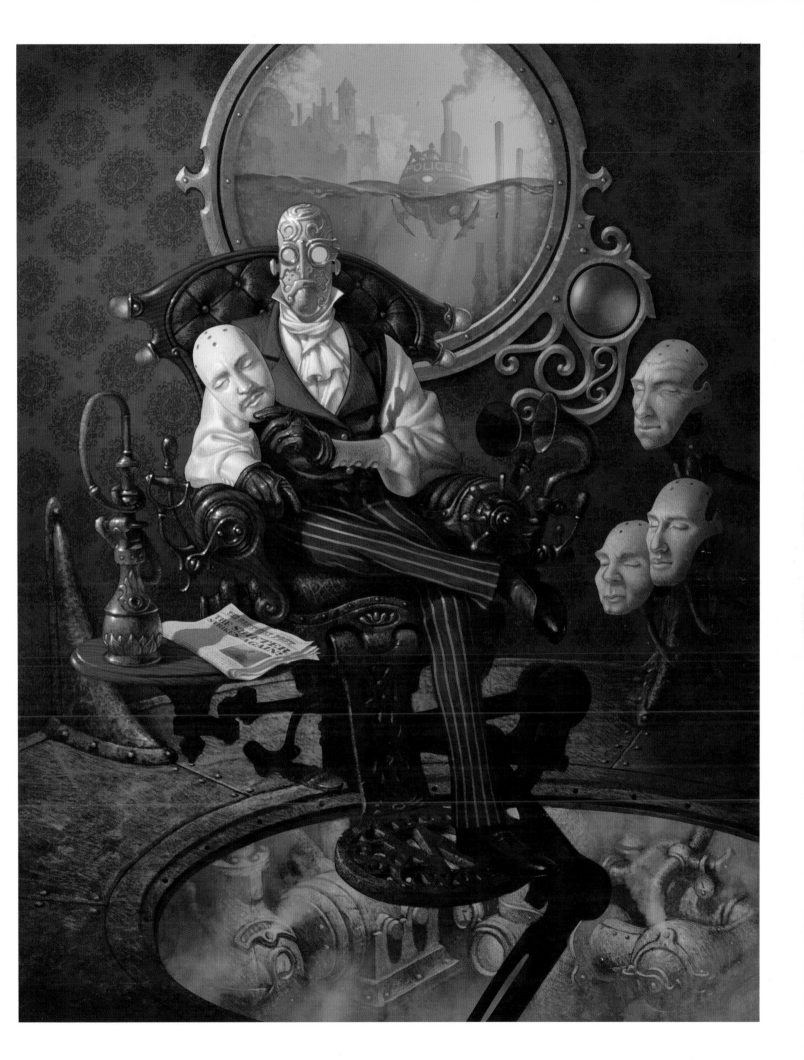

Antonio Javier Caparo

Art Director: Richard Hill *Client:* ImagineFX *Title:* The Shifter *Size:* 13"x16 5/8" *Medium:* Digital

Michael J. Deas

Art Director: Carl Herrman *Designer:* Carl Herrman *Client:* U.S. Postal Servic3 *Title:* Edgar Allan Poe *Size:* 13"x18" *Medium:* Oil

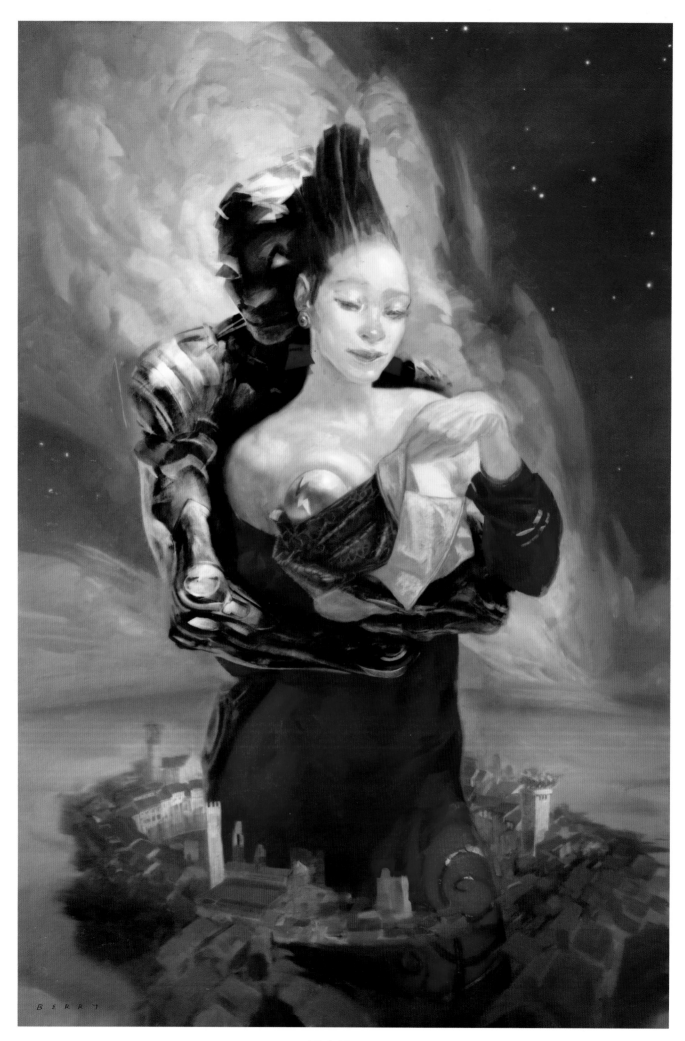

Rick Berry

Art Director: Cosimo Lorenzo Pancini *Client:* Lucca Comics & Games Festival *Title:* Nova Familia *Size:* 36"x52" *Medium:* Oil/digital

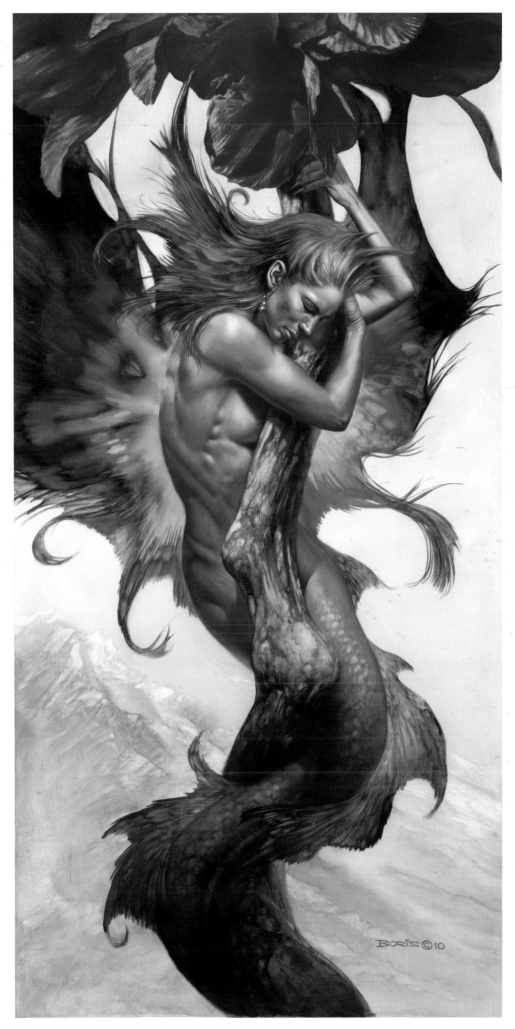

Boris Vallejo

Art Director: Boris Vallejo *Client:* Workman Publishing *Title:* To Reach the Top *Size:* 16"x32" *Medium:* Oil

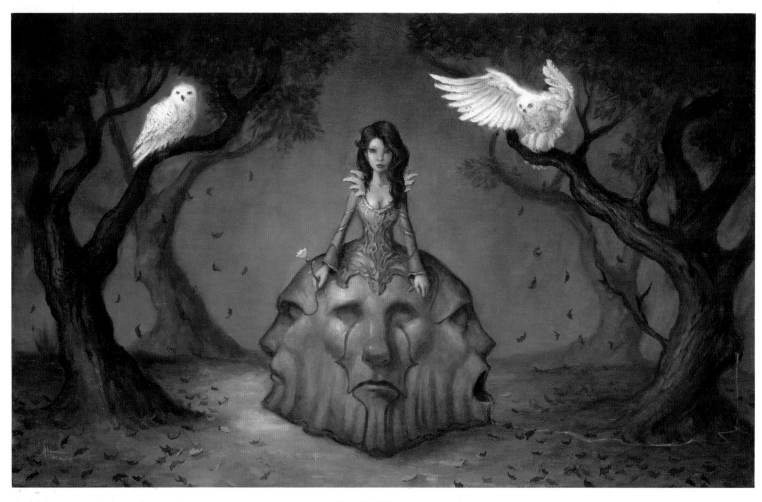

Scott Altmann

Art director: Pat Wilshire *Client:* IlluxCon2 *Title:* Misaligned *Size:* 26"x17" *Medium:* Oil on linen

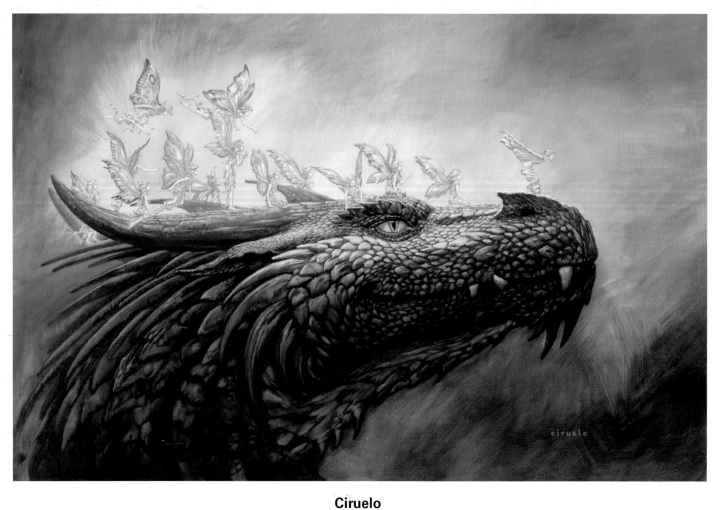

Ciruelo

Title: Rak Ruval and the Faeries *Size:* 28"x20" *Medium:* Oil

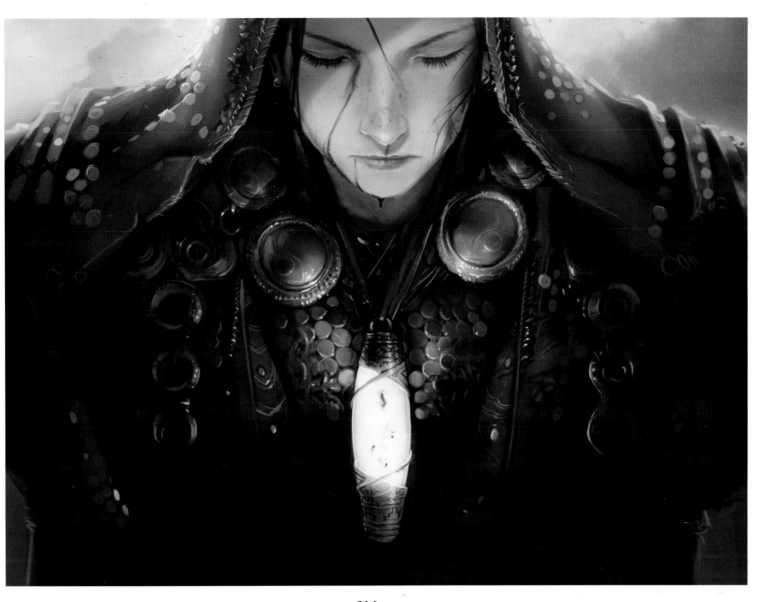

Chippy

Art Director: Jeremy Jarvis *Client:* Wizards of the Coast *Title:* Angelheart Vial *Medium:* Digital

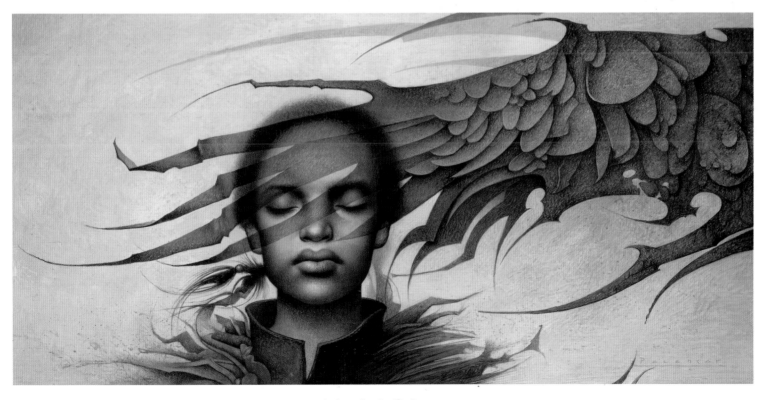

John Jude Palencar

Art Director: Irene Gallo *Title:* Tor.com *Title:* The Horrid Glory of Its Wings *Size:* 23"x14" *Medium:* Arcrylic

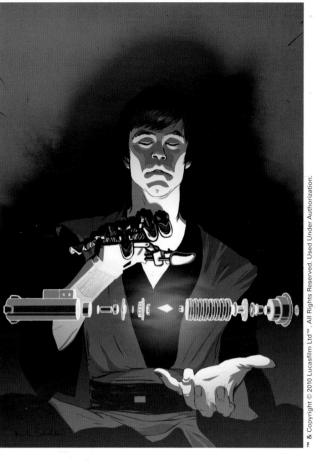

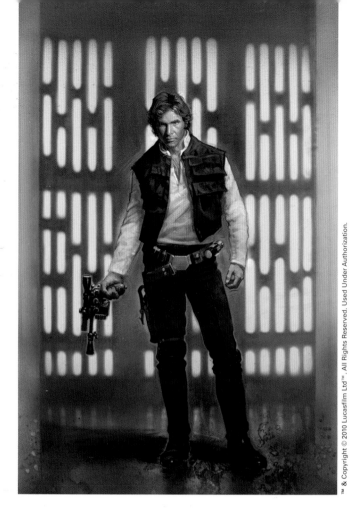

Frank Stockton

Art Director: David Waldeck *Client:* Topps

Title: Luke Assembles His Lightsaber *Medium:* Ink/digital

Terese Nielsen

Art Director: Paul Hebron *Client:* Wizards of the Coast

Title: Masters of the Force: Han Solo *Size:* 11"x17" *Medium:* Mixed

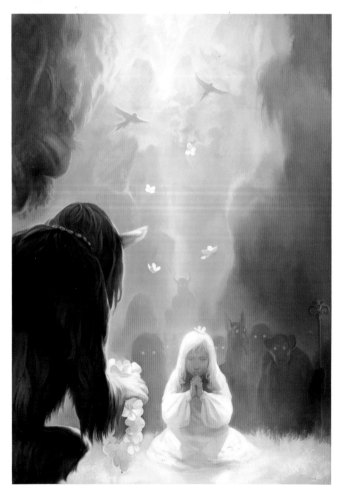

Robert Carter

Art Director: Mike Palecek *Client:* 7th Street Press

Title: Speaks English *Size:* 16"x23" *Medium:* Oil on board

Yukari Masuike

Title: Departure *Size:* 11 5/8"x16 1/2" *Medium:* Digital

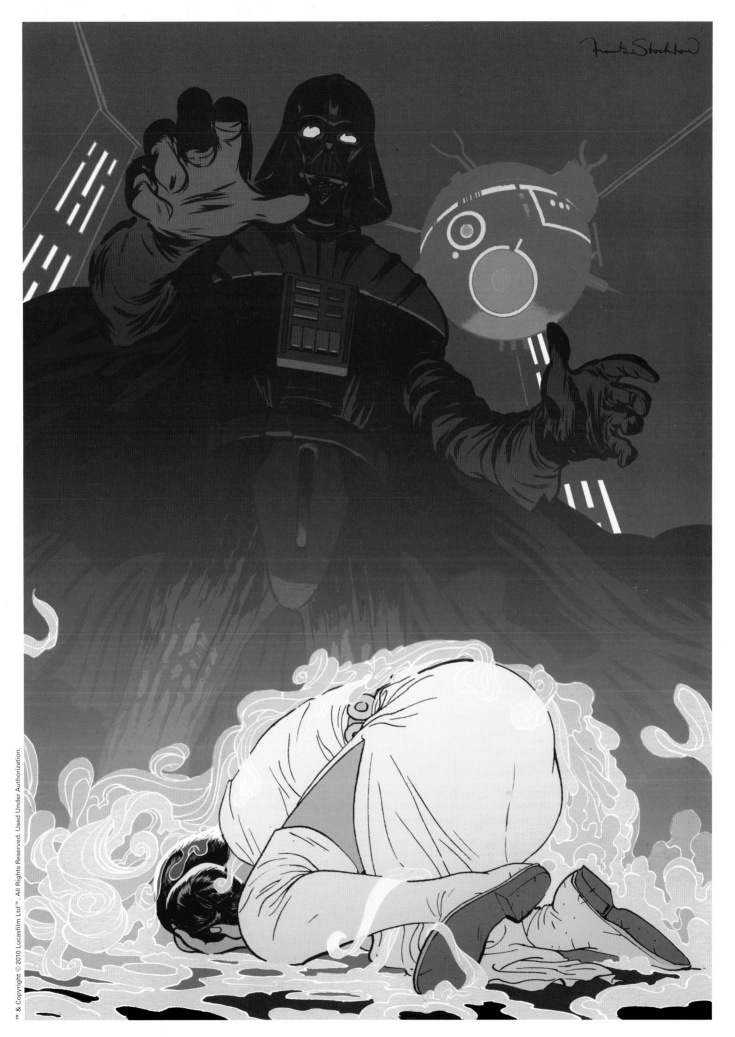

™ & Copyright © 2010 Lucasfilm Ltd™. All Rights Reserved. Used Under Authorization.

Frank Stockton

Art Director: David Waldeck *Client:* Topps *Title:* Vader/Leia *Size:* 8 1/2"x11" *Medium:* Ink/digital

Donato Giancola

Client: Massive Black *Title:* The Mechanic *Size:* 36"x20" *Medium:* Oil on panel

José Emroca Flores

Title: Against the Grain *Medium:* Mixed

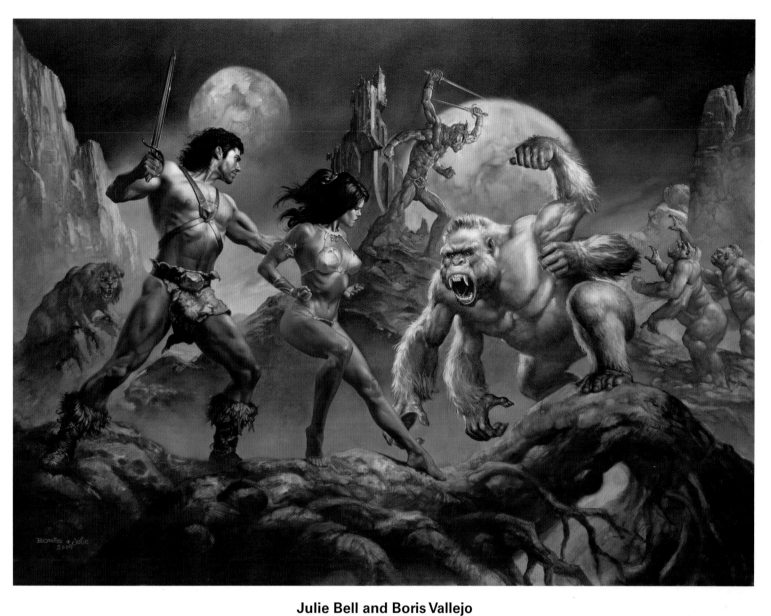

Julie Bell and Boris Vallejo

Art Director: Julie Bell *Client:* Bill Niemeyer *Title:* John Carter of Mars *Size:* 40"x30" *Medium:* Oil

Jeremy Geddes

Title: Heat Death *Size:* 38"x16" *Medium:* Oil on linen

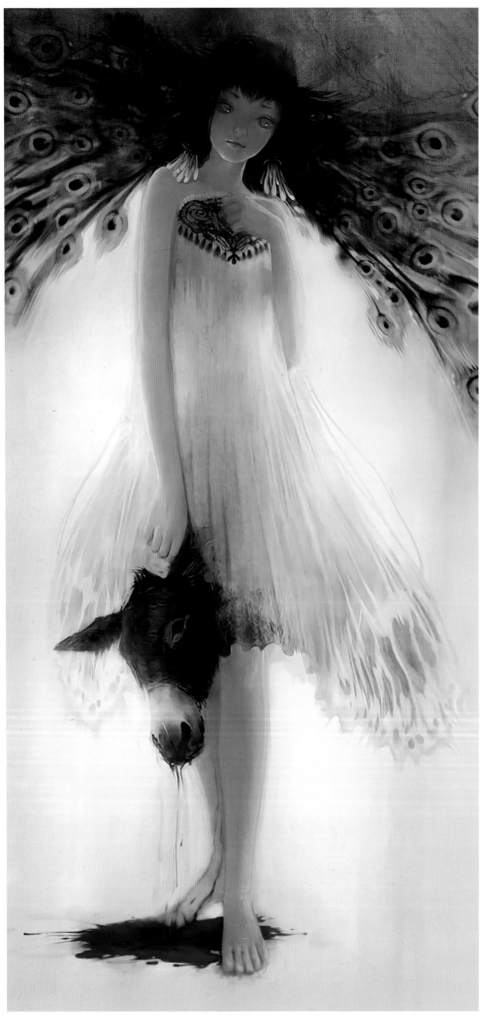

Ching Cia Ee

Title: Fairies Are As Cruel As Children *Size:* 1618x3308px *Medium:* Digital

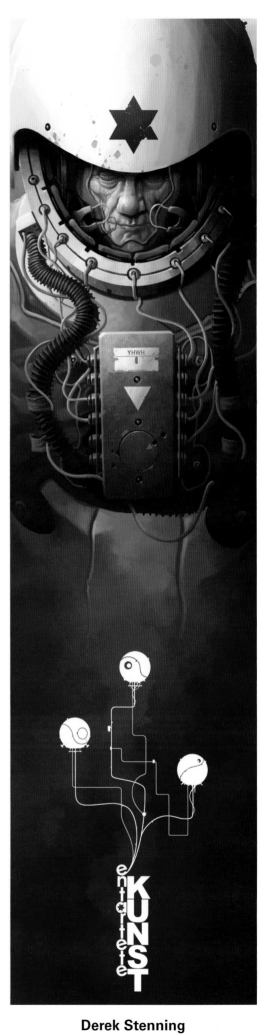

Derek Stenning

Client: Born in Concrete *Title:* Red (The Blade)

Size: 8"x33" *Medium:* Mixed

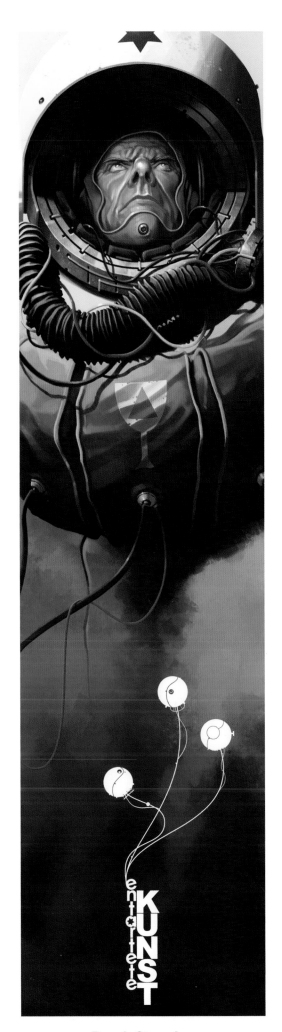

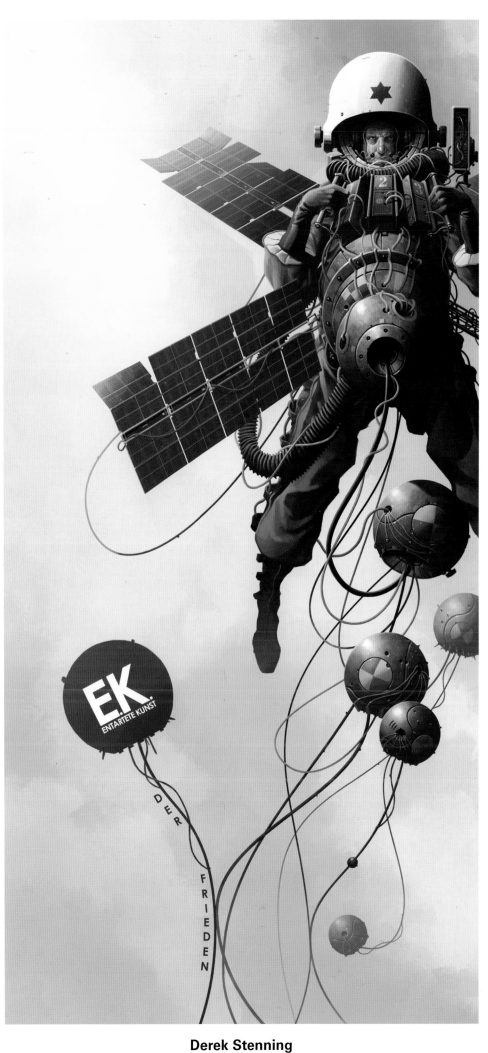

Derek Stenning

Client: Born in Concrete *Title:* Blue (The Chalice)

Size: 8″x33″ *Medium:* Mixed

Derek Stenning

Client: Born in Concrete *Title:* Peace *Size:* 12″x23″ *Medium:* Mixed

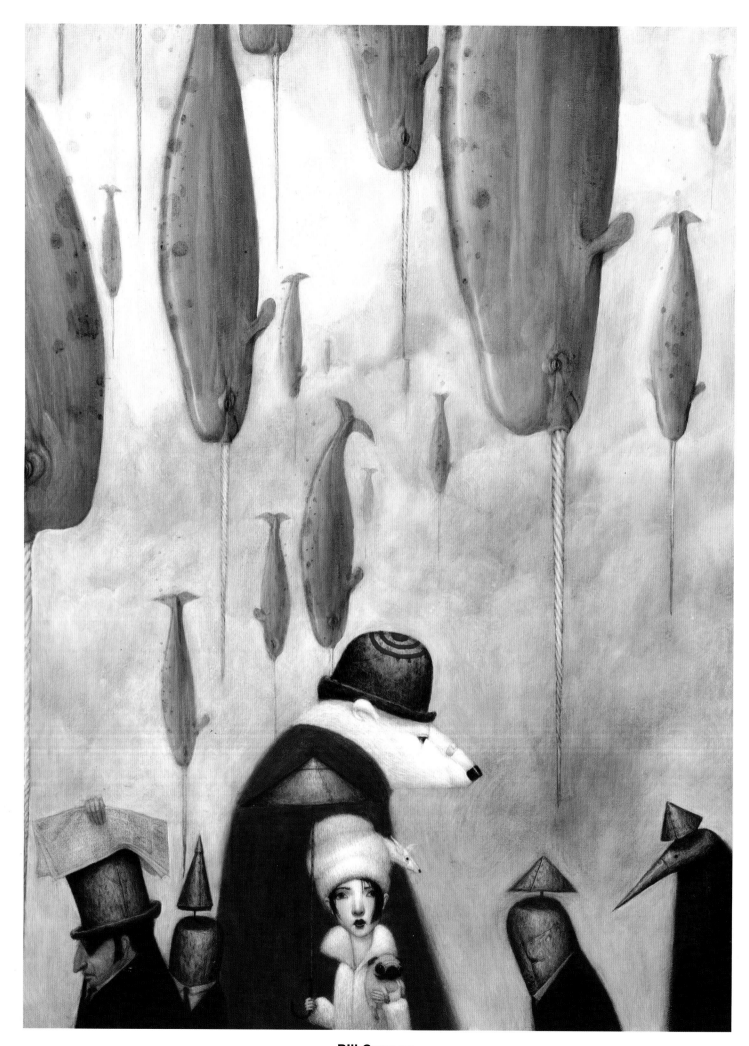

Bill Carman

Client: Society of Illustrators/Earth: Fragile Planet *Title:* Narwhal Rain *Size:* 12"x16" *Medium:* Acrylic/oil

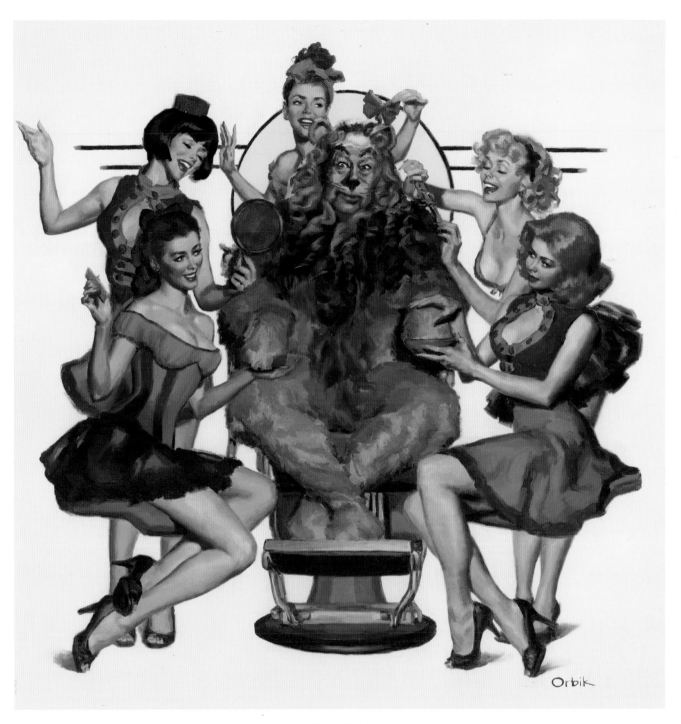

Glen Orbik

Art Director: Ruth Clampett *Designer:* Glen Orbik/Laurel Blechman *Client:* Clampett Studios *Title:* Emerald Beauties *Medium:* Oil

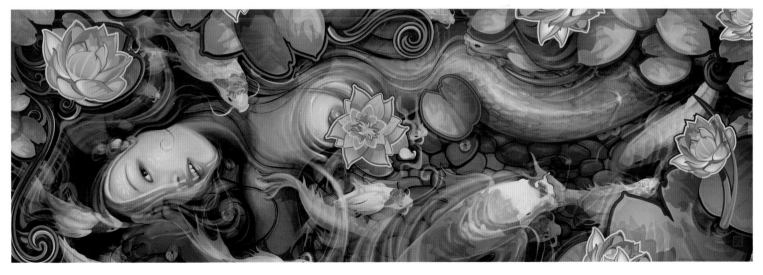

Echo Chernik

Designer: Echo Chernik *Title:* Coy *Size:* 72"x24" *Medium:* Digital

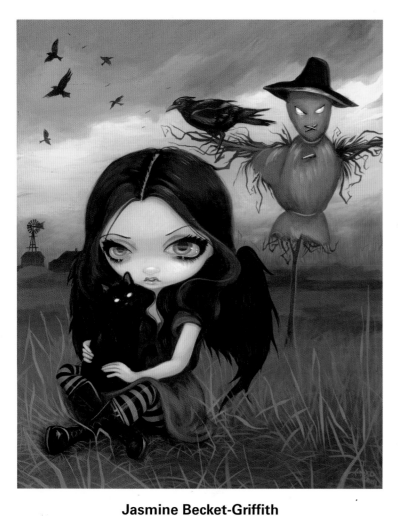

Jasmine Becket-Griffith

Title: The Scarecrow *Size:* 16"x20" *Medium:* Acrylic on masonite

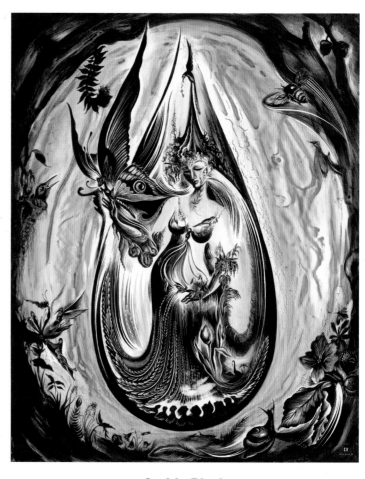

Cathie Bleck

Client: Butler Institute of American Art/Becoming Human Exhibition
Title: Aqua Regia 1 *Size:* 16"x20" *Medium:* Mixed

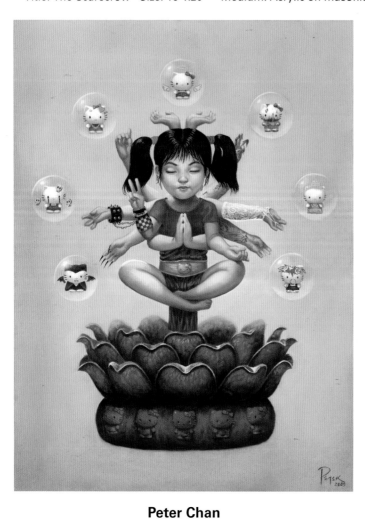

Peter Chan

Client: Sanrio *Title:* Serenity *Size:* 18"x24" *Medium:* Acrylic/oil

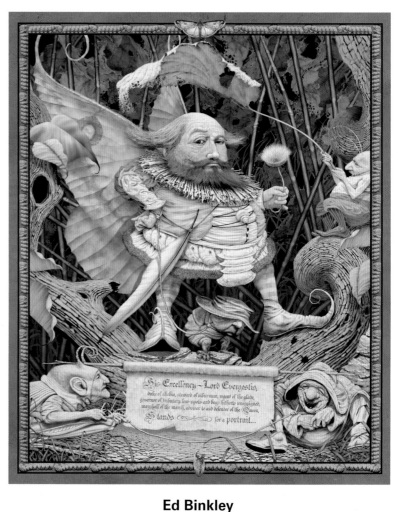

Ed Binkley

Title: Lord Evergestis *Size:* 15"x19" *Medium:* Digital

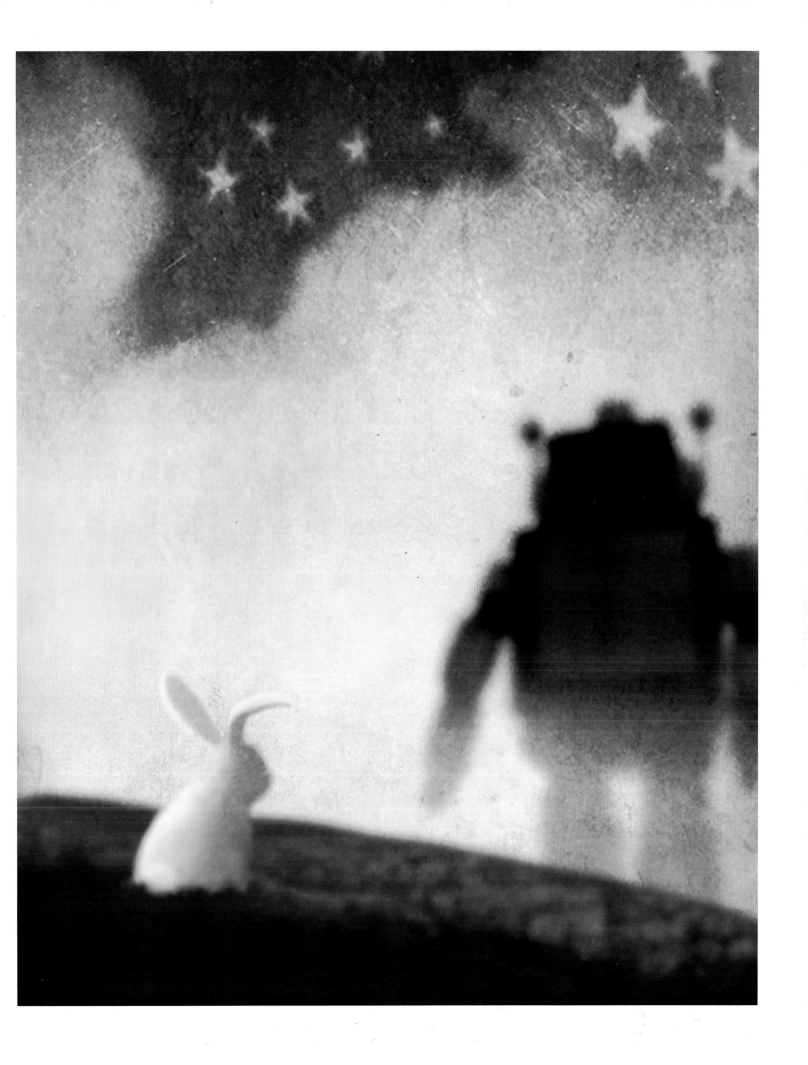

Dave Laub

Title: File found...Mermaid *Size:* 8"x10" *Medium:* Digital

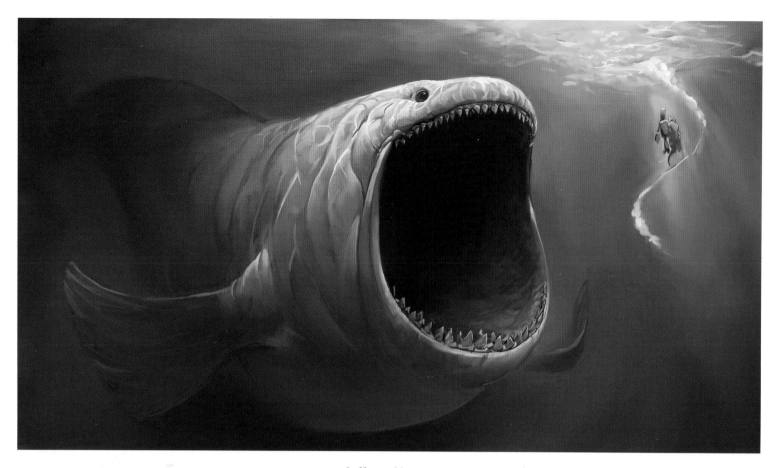

Jeffrey Chang

Title: The Levithan *Medium:* Digital

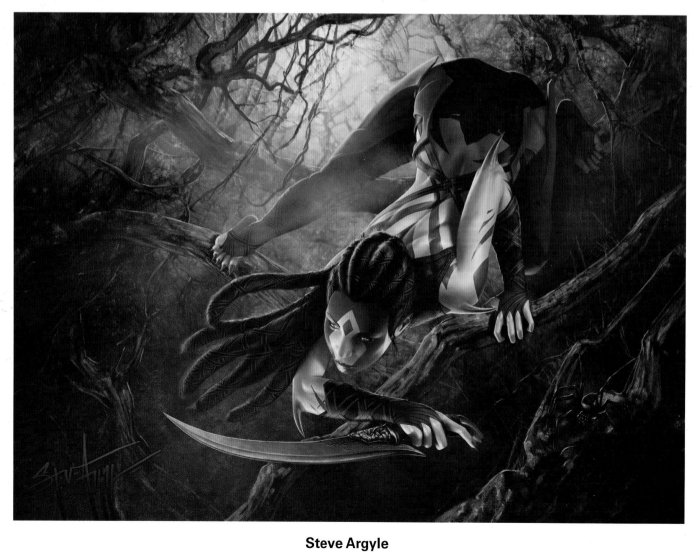

Steve Argyle

Art Director: Jeremy Jarvis *Client:* Wizards of the Coast *Title:* Gull Draz *Medium:* Digital

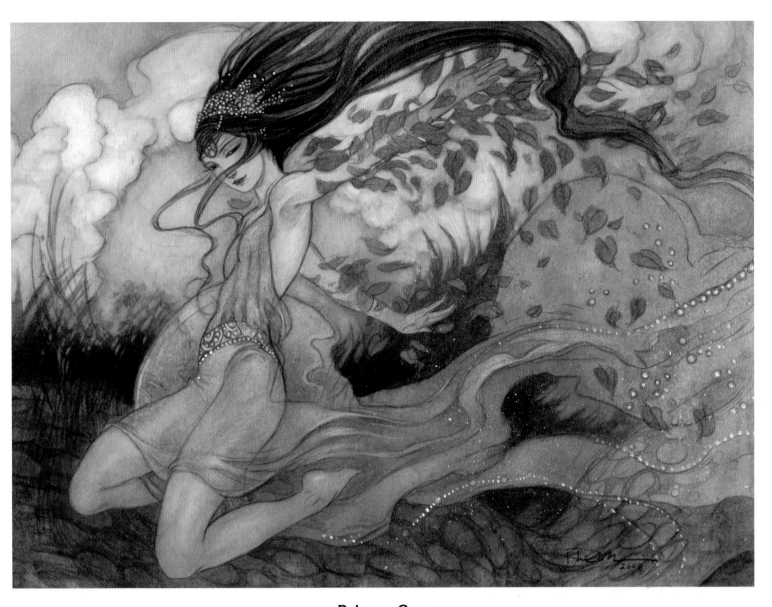

Rebecca Guay

Art Director: Jeremy Jarvis *Client:* Magic *Title:* Chanrel *Size:* 12"x9" *Medium:* Watercolor

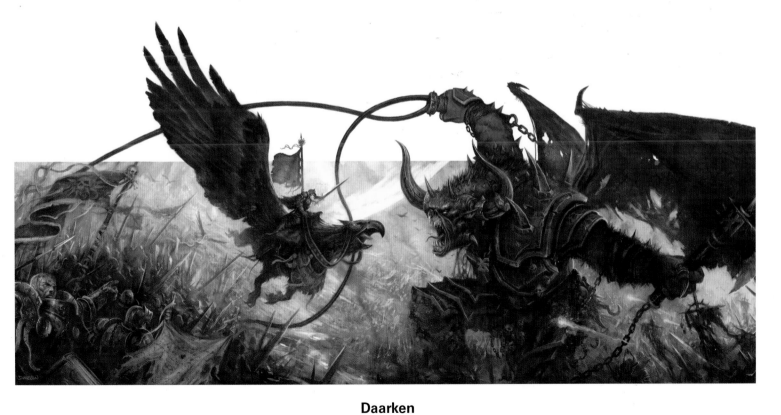

Daarken

Art Director: Zoe Robinson *Client:* Fantasy Flight Games *Title:* Warhammer: Invasion *Medium:* Photoshop

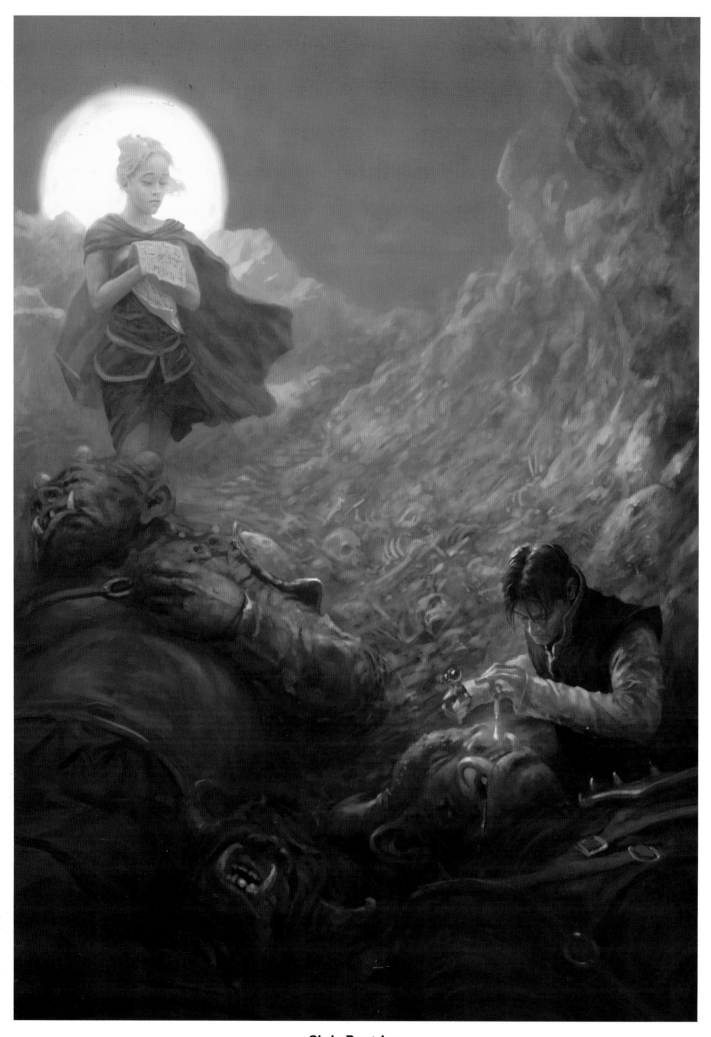

Chris Beatrice

Art Director: Dean Tompkins *Client:* Lighthouse Creative *Title:* The Precise Dosage *Medium:* Digital

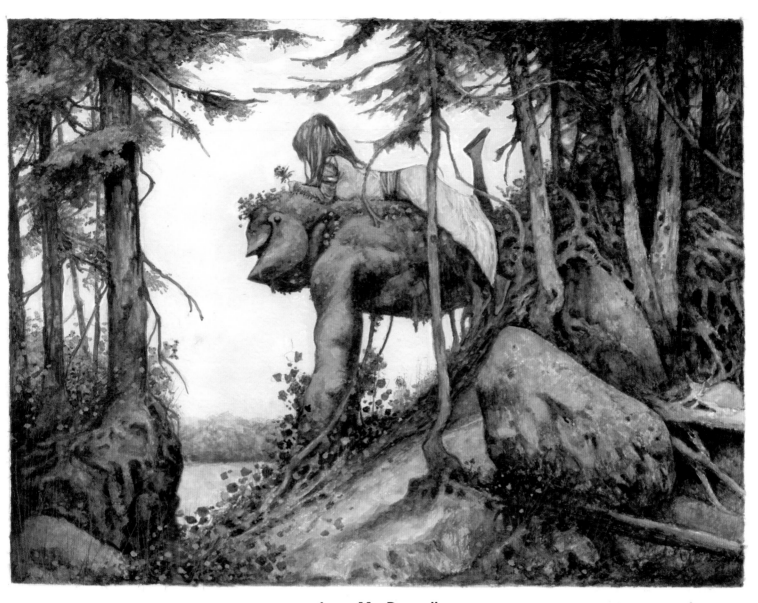

Larry MacDougall

Art Director: P.A. Lewis *Client:* Underhill Studio *Title:* Fossil *Medium:* Watercolor

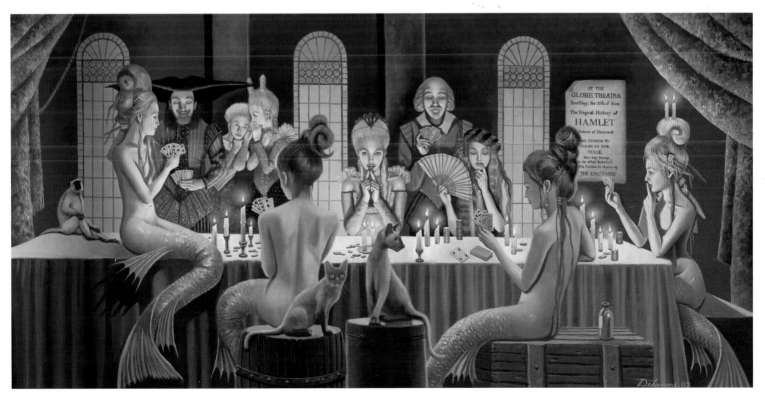

David Delamare

Client: Bad Monkey Productions *Title:* The Mermaid Tavern *Size:* 48"x24" *Medium:* Oil on canvas

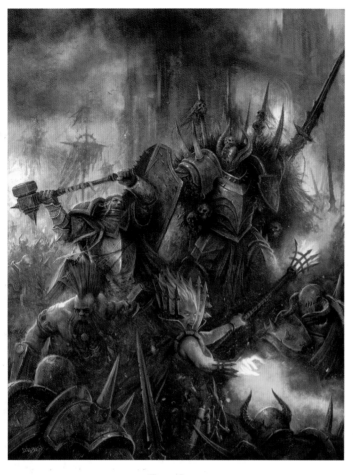

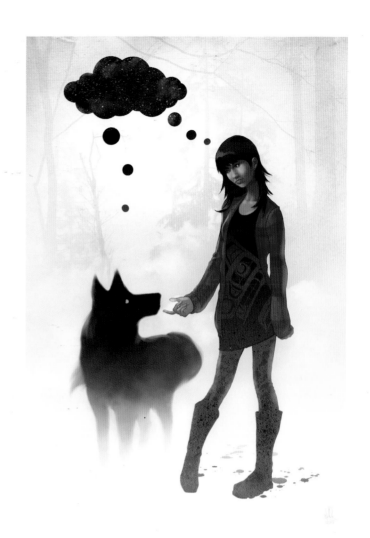

Daarken

Art Director: Zoe Robinson *Client:* Fantasy Flight Games

Title: Warhammer Fantasy Roleplay *Medium:* Photoshop

Nigel Quarless

Client: Mixed Bag Mythography *Title:* Wolf Spirit

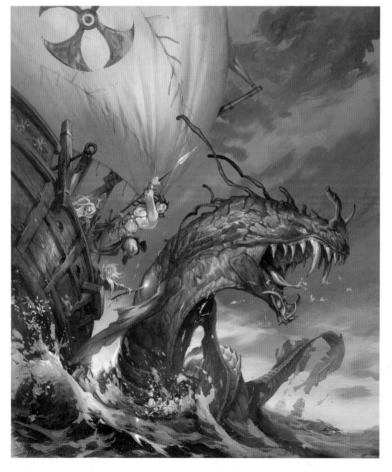

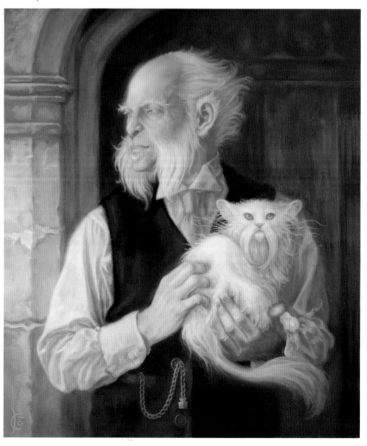

Jesper Ejsing

Art Director: Christian Petersen *Client:* Fantasy Flight Games

Title: Sea of Blood *Size:* 40x50cm *Medium:* Acrylic

Kristina Carroll

Art Director: Richard Saja *Client:* Richard Saja

Title: Richard *Size:* 20"x24" *Medium:* Oil on panel

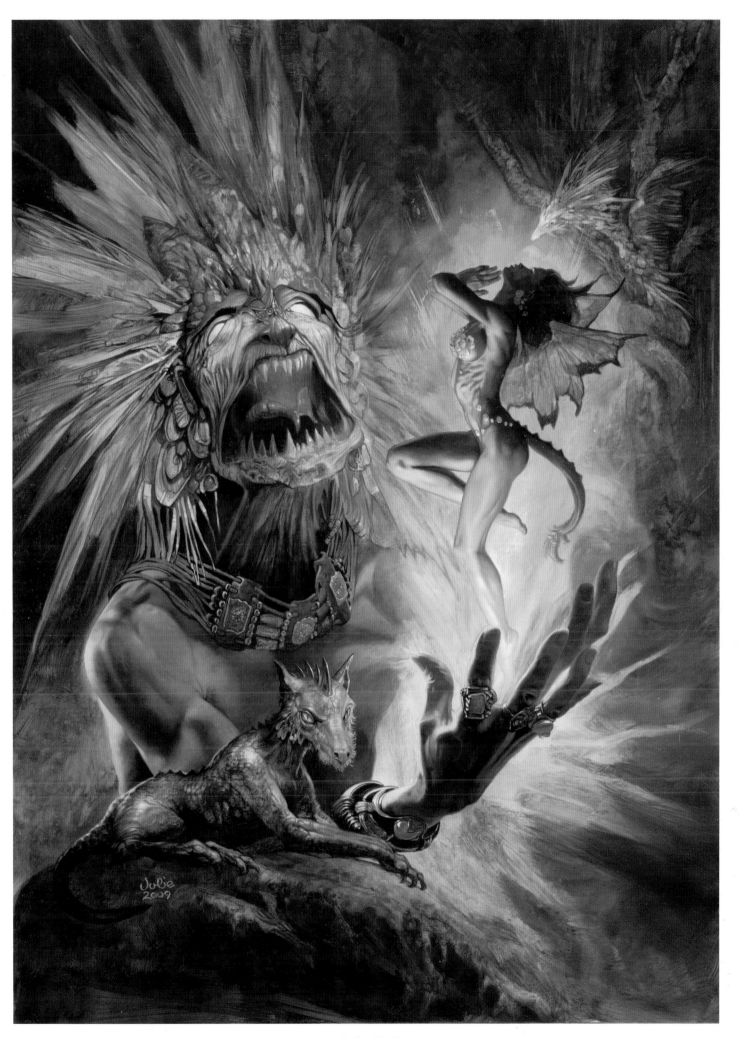

Julie Bell

Client: Workman Publishing *Title:* A Creator's Love *Size:* 18"x24" *Medium:* Oil

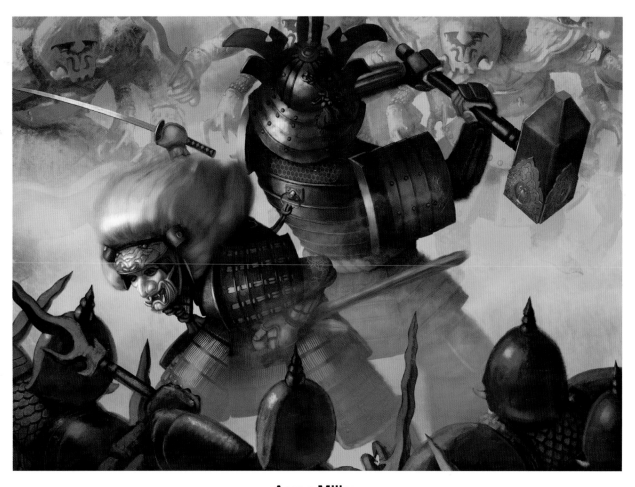

Aaron Miller

Art Director: Jim Pinto *Client:* AEG *Title:* Eye For An Eye *Size:* 5000x3651px *Medium:* Digital

Adam Volker

Art Director: Cory Godbey *Client:* Terrible Yellow Eyes *Title:* Where Did You Say Those Wild Things Were? *Size:* 11″x8″ *Medium:* Ink/digital

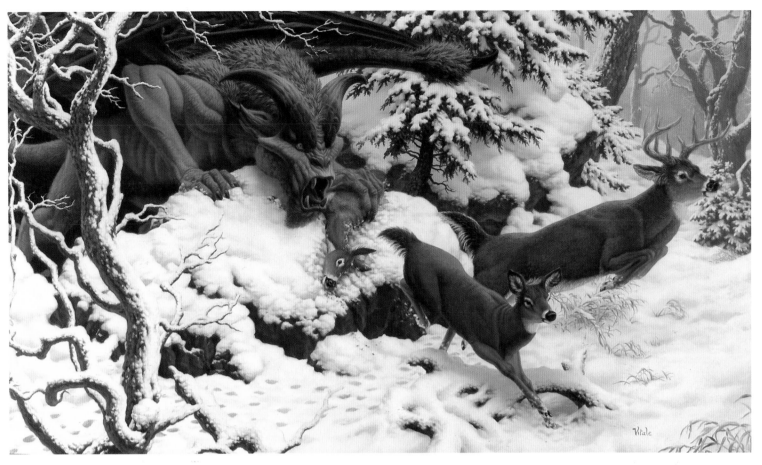

Raoul Vitale

Title: Mountain Gargoyle *Size:* 24"x14" *Medium:* Oil on masonite

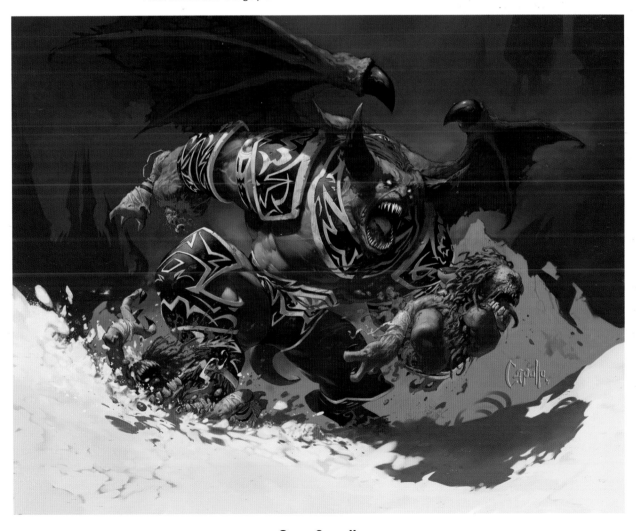

Greg Capullo

Art Director: Jeremy Cranford *Client:* Blizzard Entertainment *Title:* Doomguard *Medium:* Digital

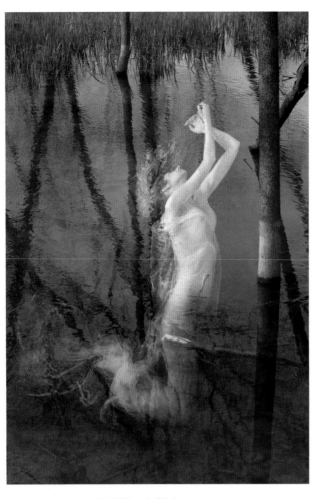

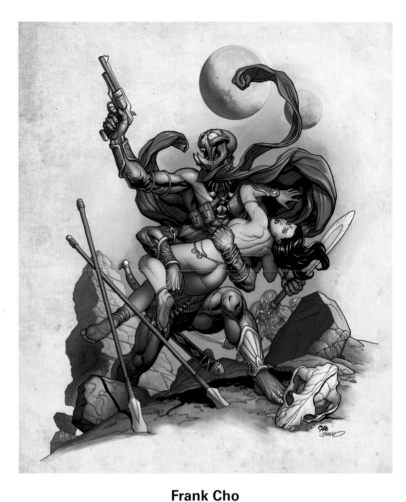

R. Ward Shipman

Title: Water Lilly *Size:* 18″x26″ *Medium:* Photoshop

Frank Cho

Art Director: Frank Cho *Colorist:* Brandon Peterson *Title:* Kidnapped
Size: 18″x24″ *Medium:* Ink/digital color

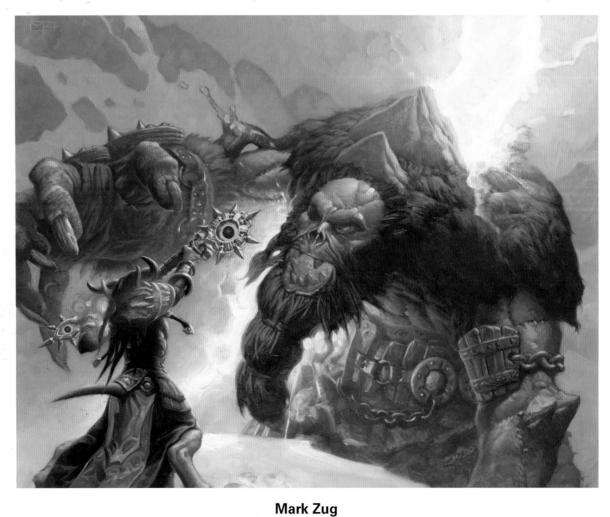

Mark Zug

Art Director: Jeremy Cranford *Client:* Blizzard Entertainment *Title:* Vanquish the Evil *Medium:* Oil

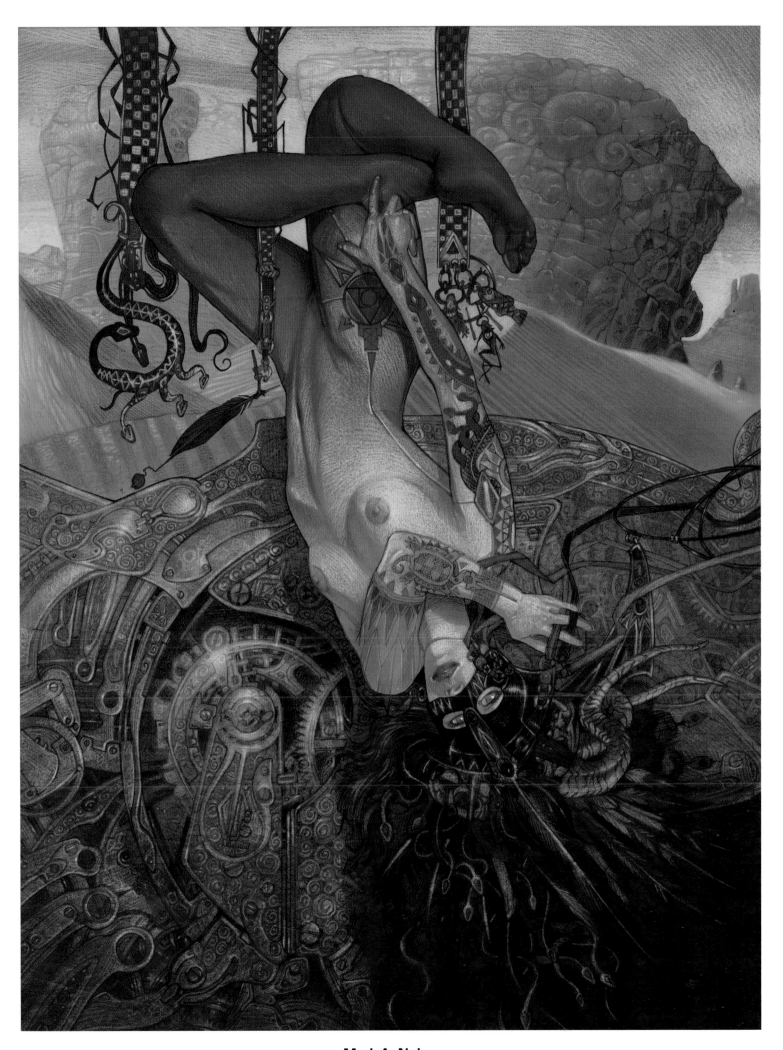

Mark A. Nelson

Client: Grazing Dinosaur Press *Title:* ER: The Trickster *Size:* 10 1/2″x13 1/2″ *Medium:* Pencil/digital

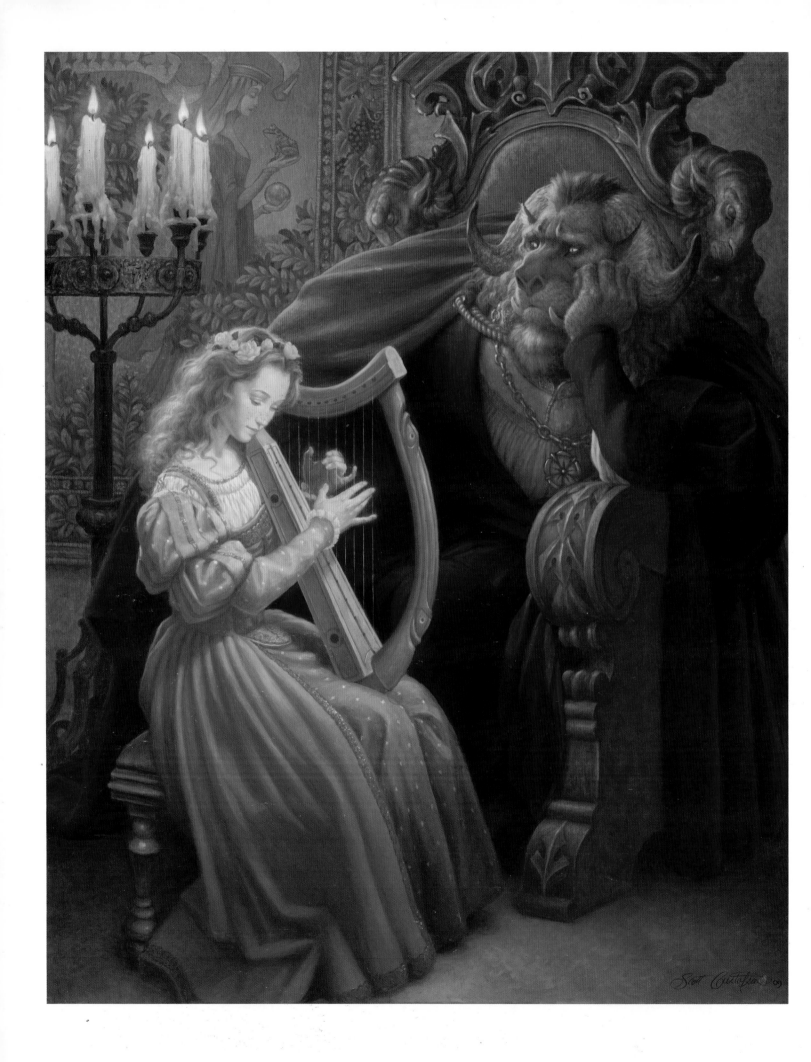

Scott Gustafson

Client: The Greenwich Workshop *Title:* Beauty and the Beast *Size:* 26″x32″ *Medium:* Oil on panel

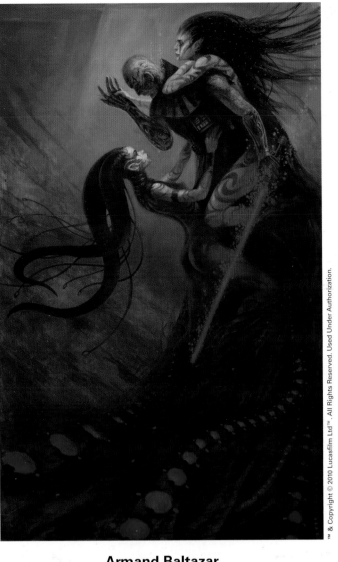

Armand Baltazar

Client: Lucasfilm Ltd. *Title:* Vader in the Sacrificial Pool of the Sith Witches *Size:* 27"x48" *Medium:* Oil

Jaime Jones

Art Director: Jeremy Jarvis *Client:* Wizards of the Coast
Title: Eldraz1 Conscription *Medium:* Digital

Ursula Vernon

Client: Red Wombat Studio *Title:* Rabbird Doves *Size:* 18"x10" *Medium:* Digital

David Palumbo

Client: Heavy Metal *Title:* The Scavenger Size: 16"x22" *Medium:* Oil

Matt Stewart

Art Director: Patrick Wilshire *Client:* IlluxCon2 *Title:* The Battle Under the Mountain *Size:* 33"x50" *Medium:* Oil on paper

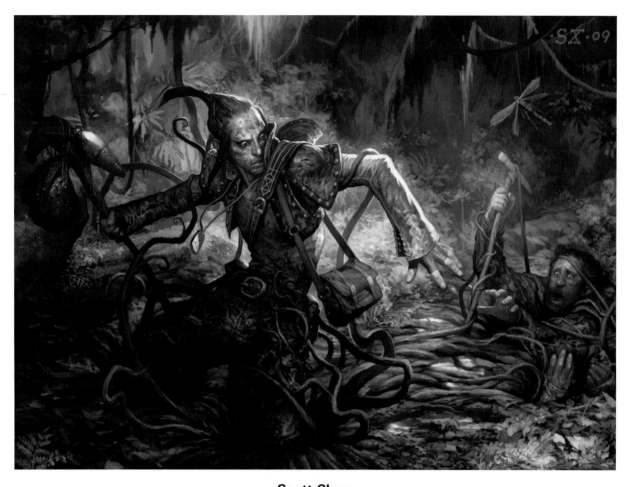

Scott Chou

Art Director: Jeremy Jarvis *Client:* Wizards of the Coast *Title:* Demonic Tutor *Medium:* Digital

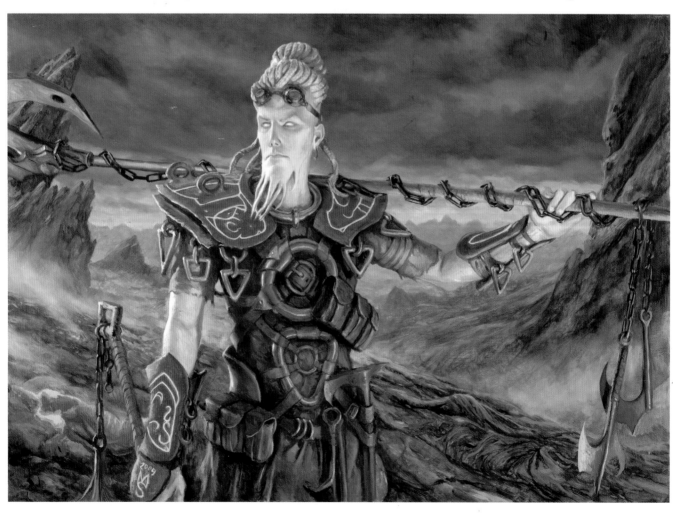

Matt Stewart

Art Director: Jeremy Jarvis *Client:* Wizards of the Coast *Title:* Kor Firetreader *Size:* 16 3/4"x12 1/2" *Medium:* Oil on paper

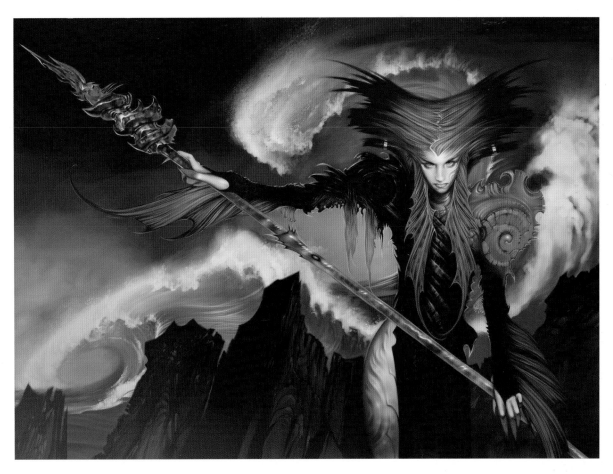

Allen Williams

Art Director: Jeremy Jarvis *Client:* Wizards of the Coast *Title:* Maritime Guard

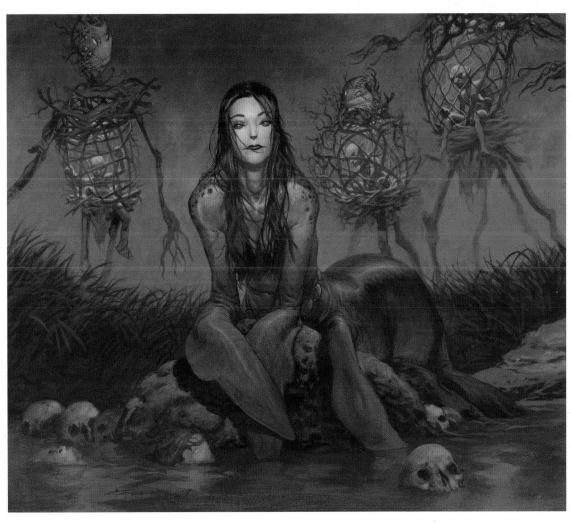

Christopher Moeller

Art Director: Jeremy Jarvis *Client:* Wizards of the Coast *Title:* Twilight Watcher *Size:* 24"x18" *Medium:* Acrylic

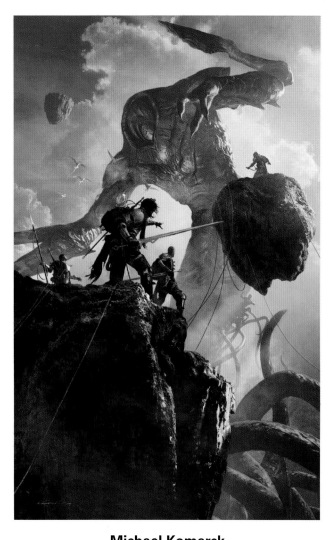

Michael Komarck

Art Director: Jeremy Jarvis *Client:* Wizards of the Coast
Title: Rise of the Eldraz1 *Medium:* Digital

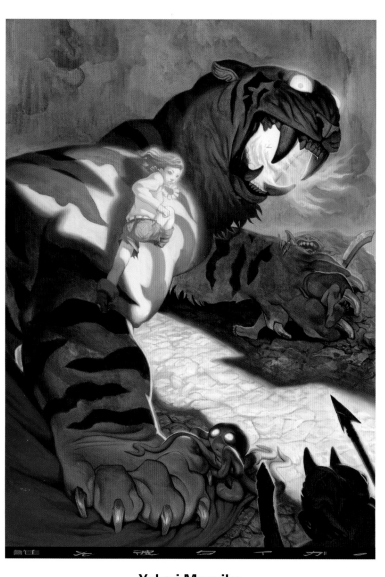

Yukari Masuike

Title: Twilight Tiger *Size:* 23"x33" *Medium:* Digital

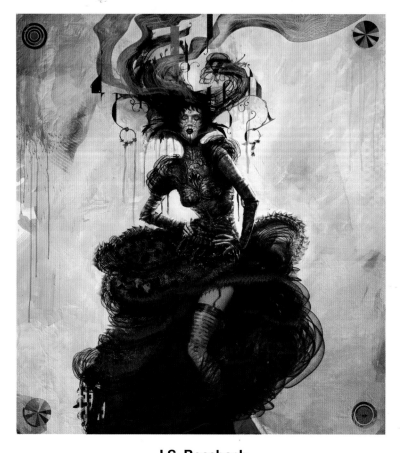

J.S. Rossbach

Title: Alligator 432 *Size:* 40x37cm *Medium:* Digital

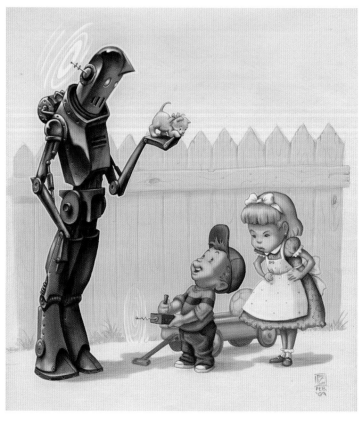

Frank Grau

Title: Tinker Toy *Medium:* Mixed

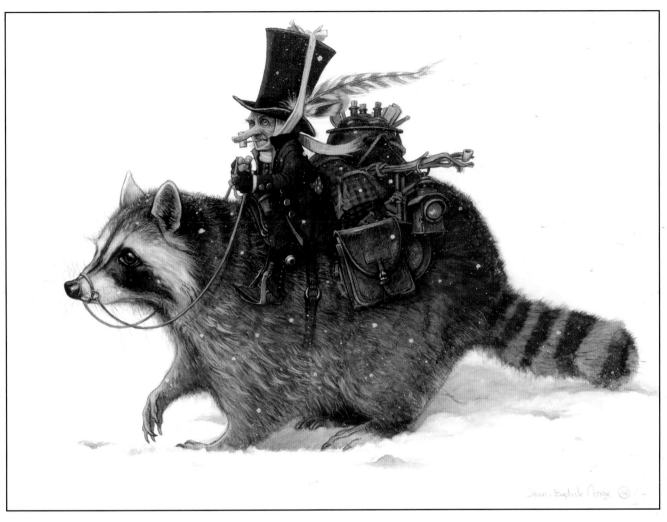

Jean-Baptiste Monge

Art Director: Jean-Baptiste Monge *Client:* Au Bord Des Continents *Title:* Cluricaun *Size:* 22 1/4"x14 5/8" *Medium:* Watercolor/gouache

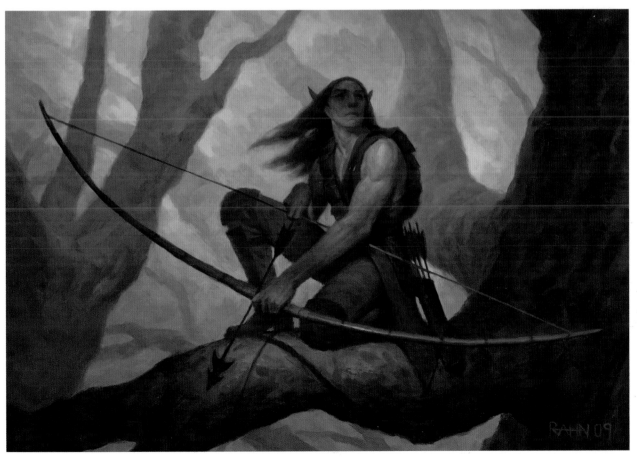

Chris Rahn

Art Director: Jeremy Jarvis *Client:* Wizards of the Coast *Title:* Tajuru Archer *Size:* 16"x12" *Medium:* Oil on masonite

Spectrum 17 205 ● ● ●

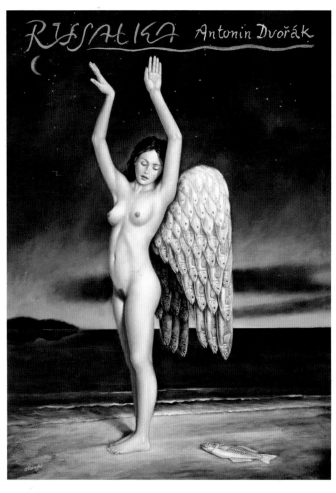

Rafal Olbinski

Client: Allegro Corp. *Title:* Rusalka *Medium:* Acrylic

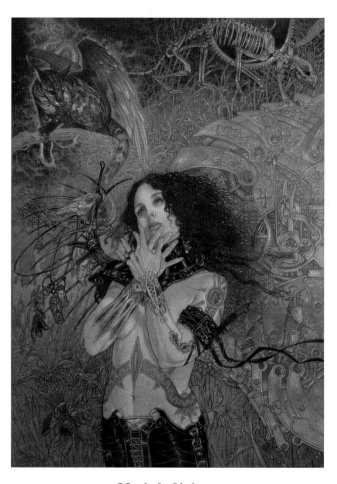

Mark A. Nelson

Client: Grazing Dinosaur Press *Title:* PD: Chronos
Size: 10 1/2"x13 1/2" *Medium:* Pencil/digital

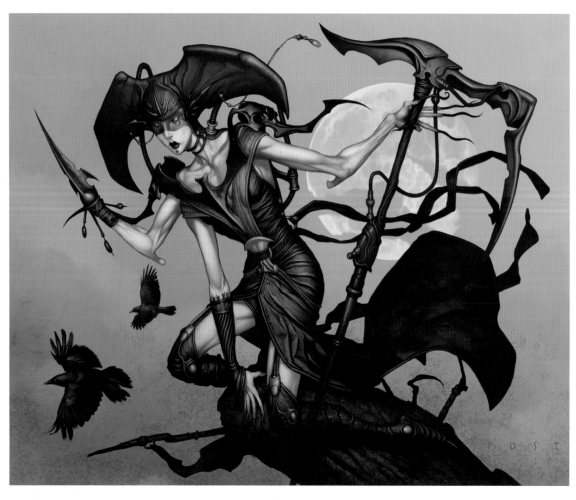

r.k. post

Art Director: Jeremy Jarvis *Client:* Wizards of the Coast *Title:* Avatar of Woe PT *Size:* 14"x10" *Medium:* Pencil/digital

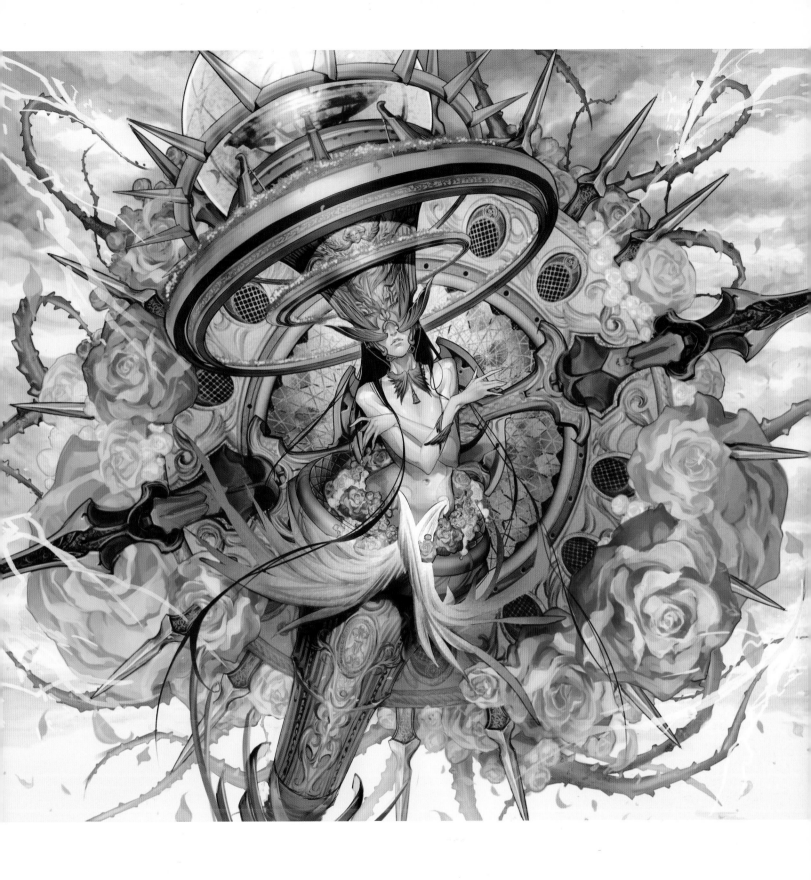

Harunoichi

Art Director: Akira Hamada/Syuichi Obata/Dawn Murin *Client:* Wizards of the Coast/Shgakukan/Mitsui-Kids
Title: Ekaterina the Channeler of Light *Size:* 13 1/4″x11 3/4″ *Medium:* Digital

Nina M. Pak

Title: Anticipation — Princess Wars *Medium:* Photography/digital

Erin McGuire

Art Director: Limbert Fabian *Client:* Reel FX Creative Studios
Title: Contraption *Size:* 11"x16" *Medium:* Digital

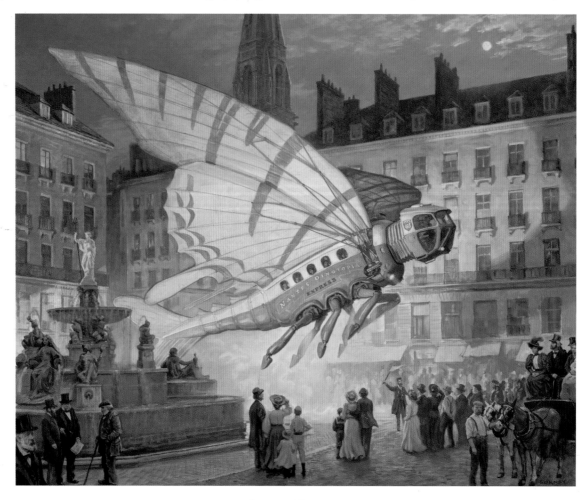

James Gurney

Art Director: Marie Masson *Client:* Utopiales Festival *Title:* Décollage Nocturne *Size:* 24"x20" *Medium:* Oil

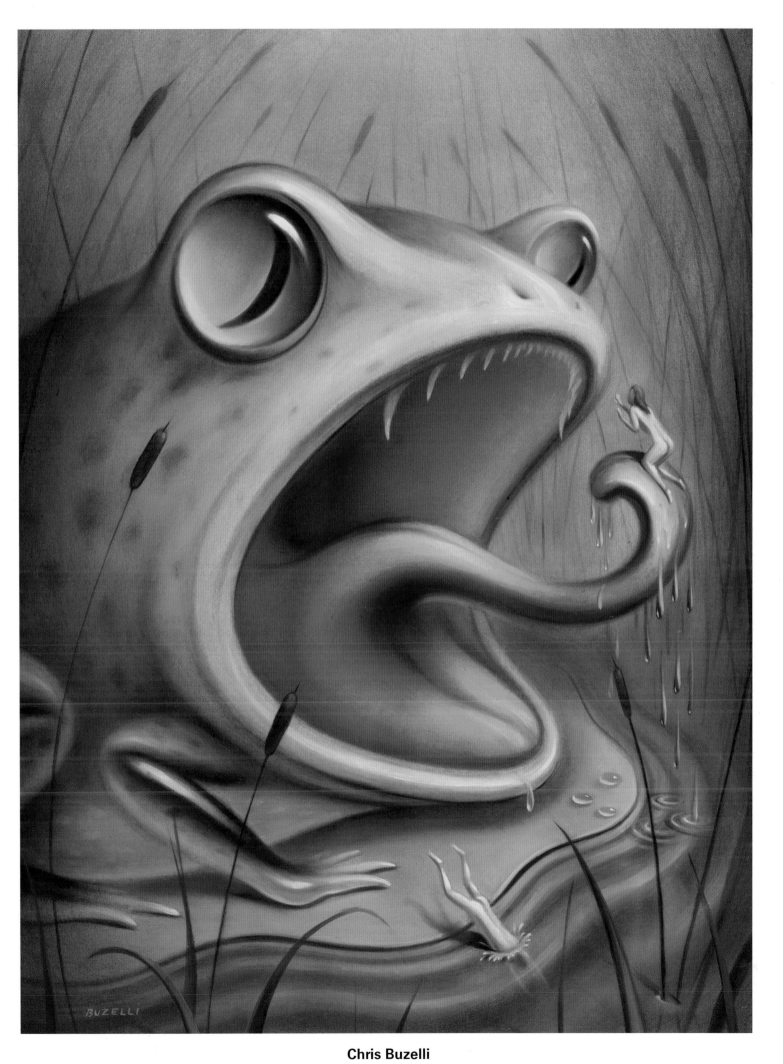

Chris Buzelli

Art Director: Jim Burke *Client:* Dellas Graphics *Title:* Skinny Dippers *Size:* 14″x19″ *Medium:* Oil

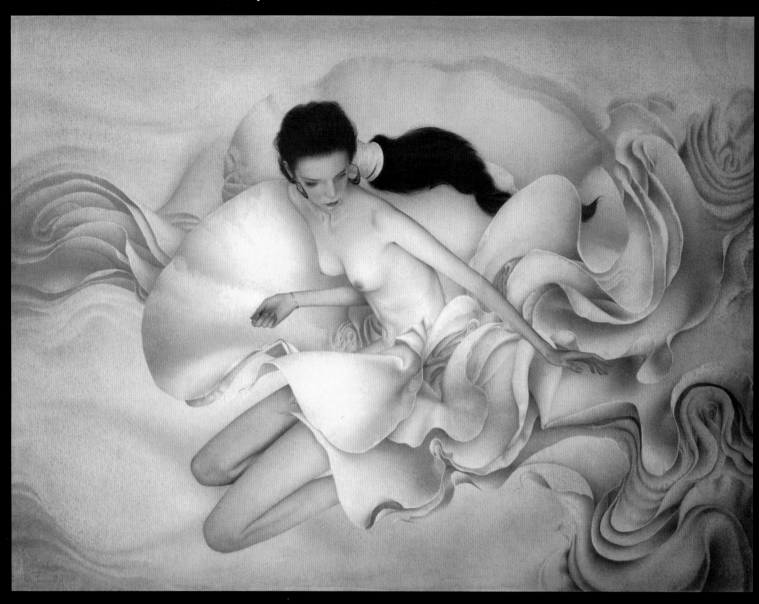

Eric Fortune

Title: Beyond the Past *Size:* 30"x22" *Medium:* Acrylic

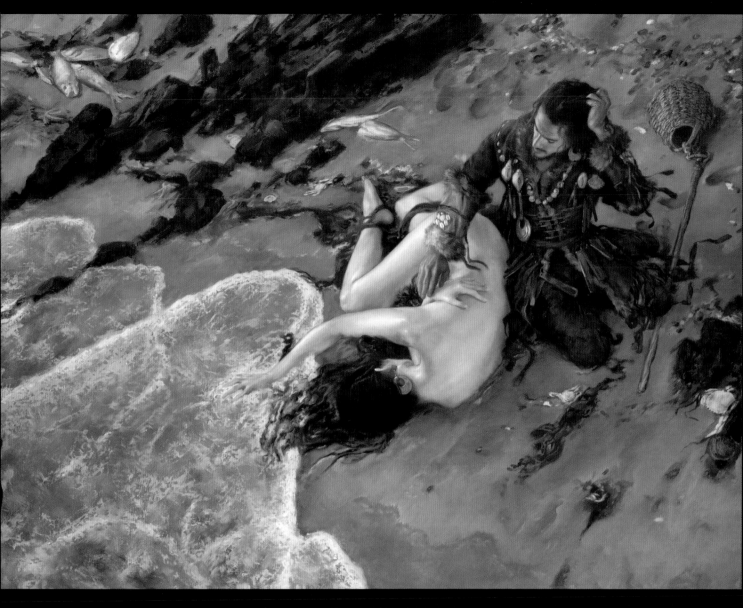

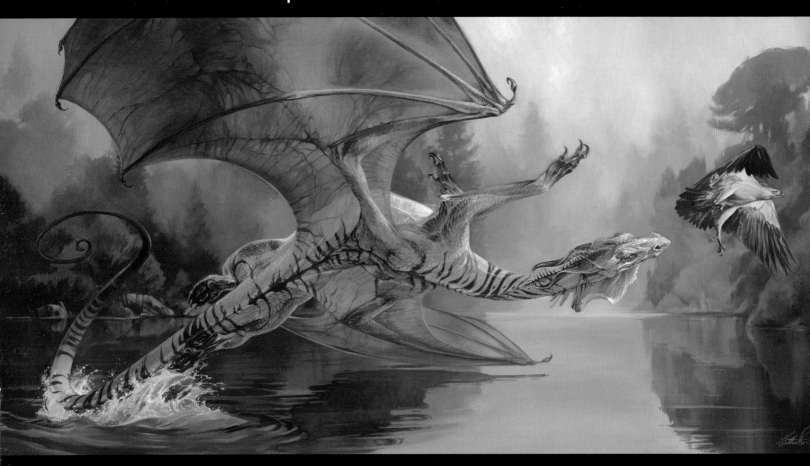

Heather Theurer

Title: Game of Chase *Size:* 48"x24" *Medium:* Oil on canvas

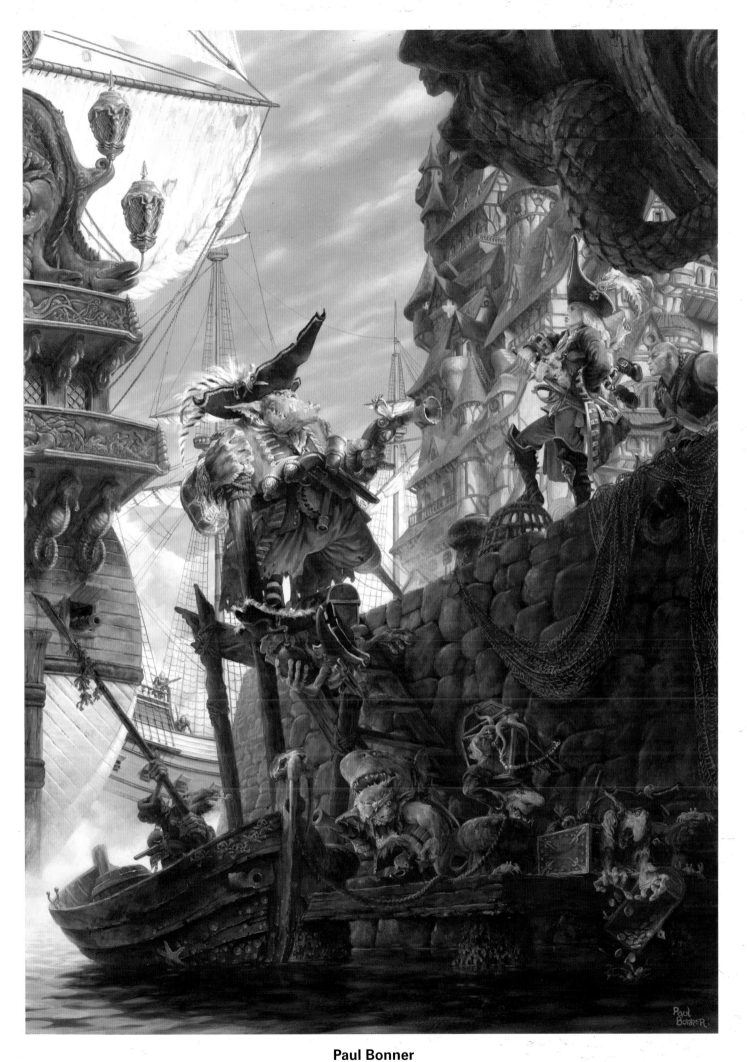

Paul Bonner

Art Director: Werner Klocke *Client:* Freebooter Miniatures *Title:* Freebooter *Size:* 36x50cm *Medium:* Watercolor

Andrew Silver

Title: Space Mechanic *Size:* 8"x12" *Medium:* Digital

Jacob Romeo Lecuyer

Title: Dark Stalker *Size:* 12 1/2"x17 1/2" *Medium:* Mixed

Carolina Tello

Title: Bartleby Picklespot Saves the Day *Medium:* Digital

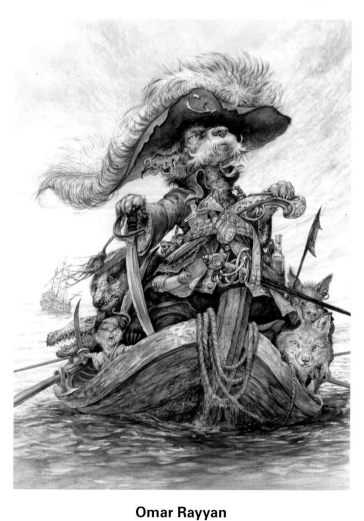

Omar Rayyan

Title: Captain Cur *Size:* 12"x16" *Medium:* Watercolor

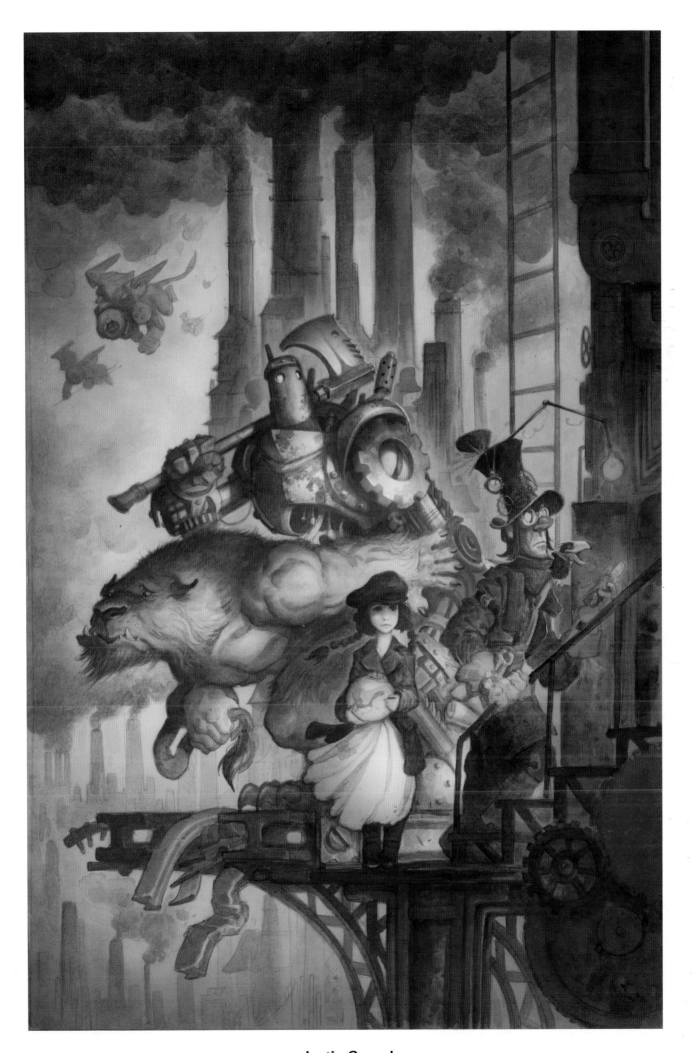

Justin Gerard

Title: SWO No.1 *Size:* 12"x18" *Medium:* Watercolor/digital

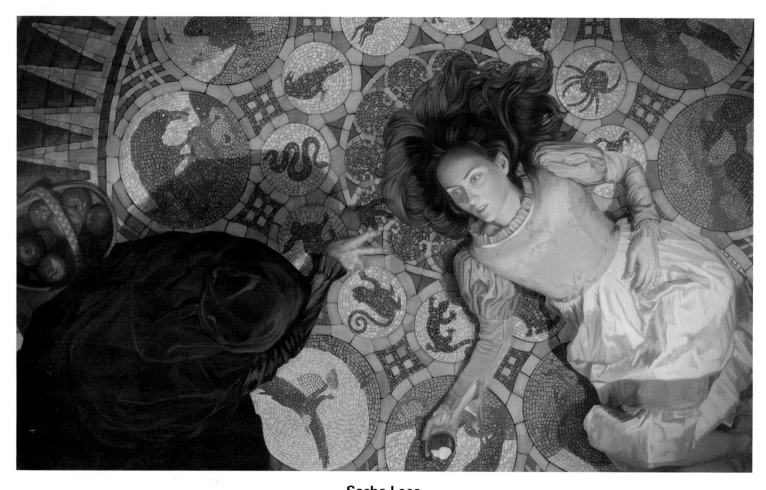

Sacha Lees

Size: 60"x36" *Medium:* Oils

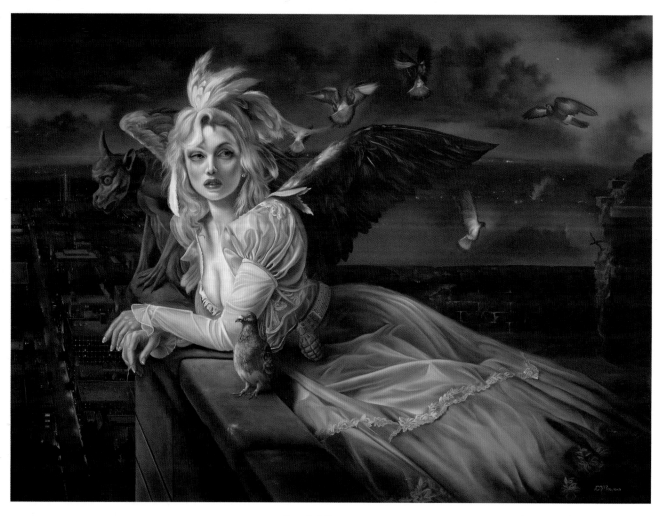

David Bowers

Client: 101 Exhibit *Title:* The Last Angel *Size:* 28"x23" *Medium:* Oil on panel

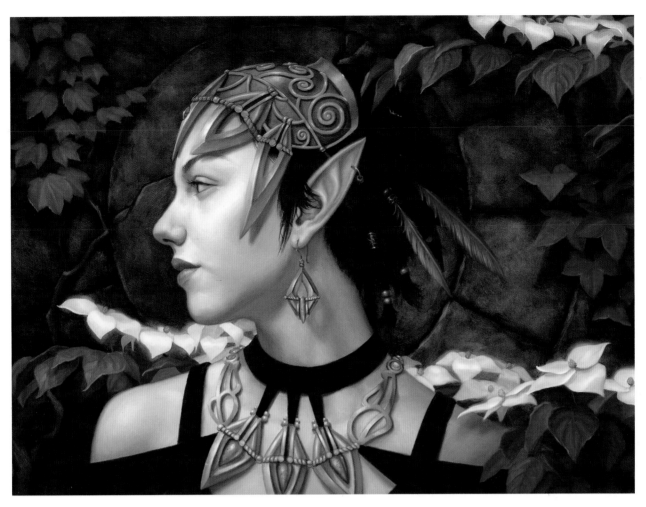

Dan dos Santos

Title: Solow Elf *Size:* 20"x15" *Medium:* Oils

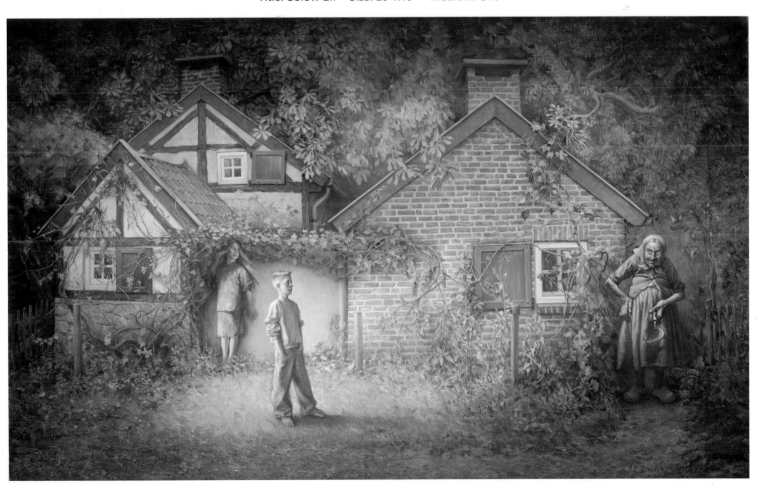

Petar Meseldžija

Title: Hans, Greta, & The Old Lady *Size:* 90x50cm *Medium:* Oil on panel

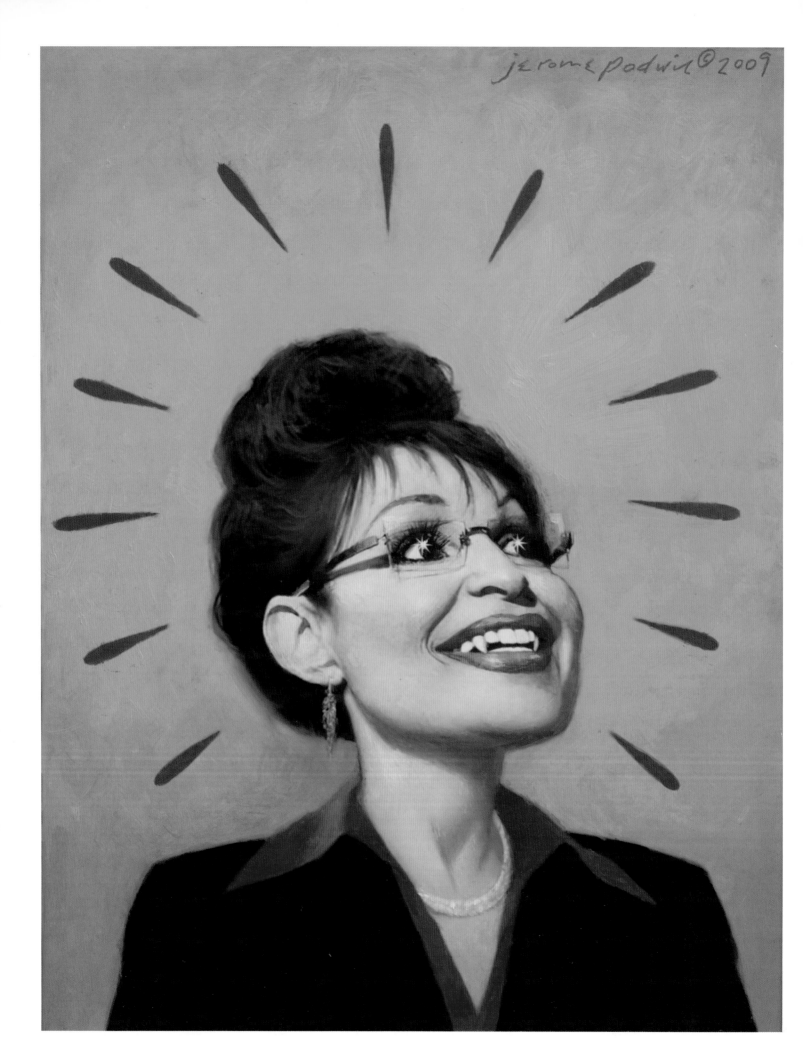

Jerome Podwil

Title: "I See Russia" Size: 11"x14" *Medium:* Oil

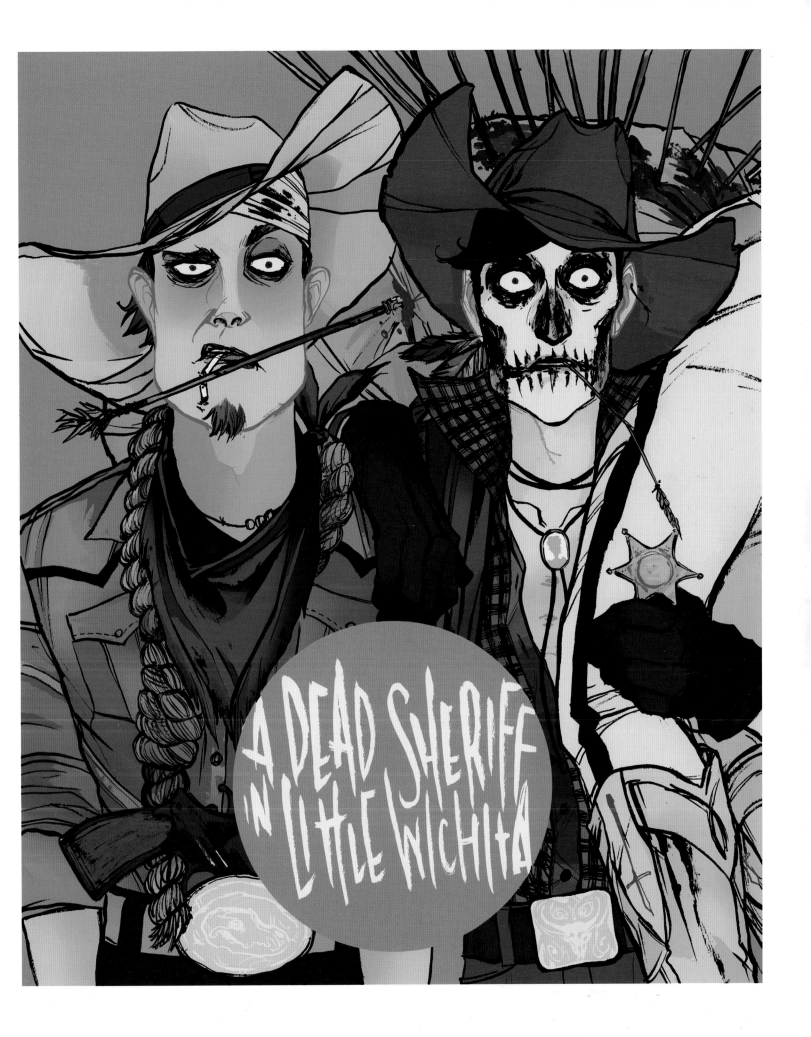

Annie Wu

Title: A Dead Sheriff in Little Wichita *Size:* 11"x14" *Medium:* Digital

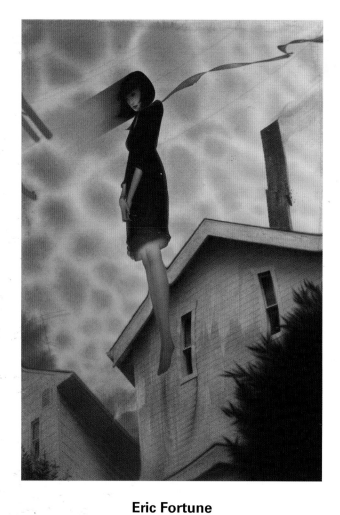

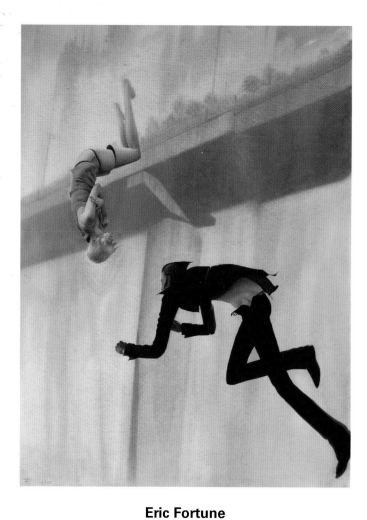

Eric Fortune

Title: A Place That I Remember *Size:* 15"x22" *Medium:* Acrylic

Eric Fortune

Title: Apart from Falling *Size:* 22"x30" *Medium:* Acrylic

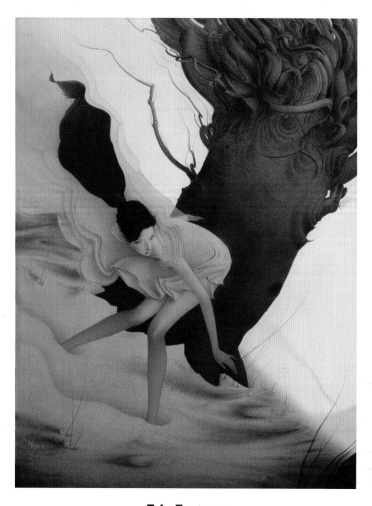

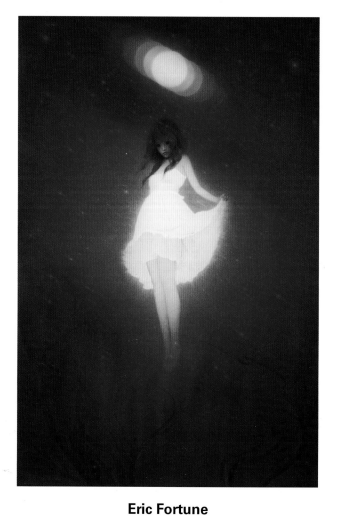

Eric Fortune

Title: Wanting *Size:* 22"x30" *Medium:* Acrylic

Eric Fortune

Title: A Muse Among Stars *Size:* 15"x22" *Medium:* Acrylic

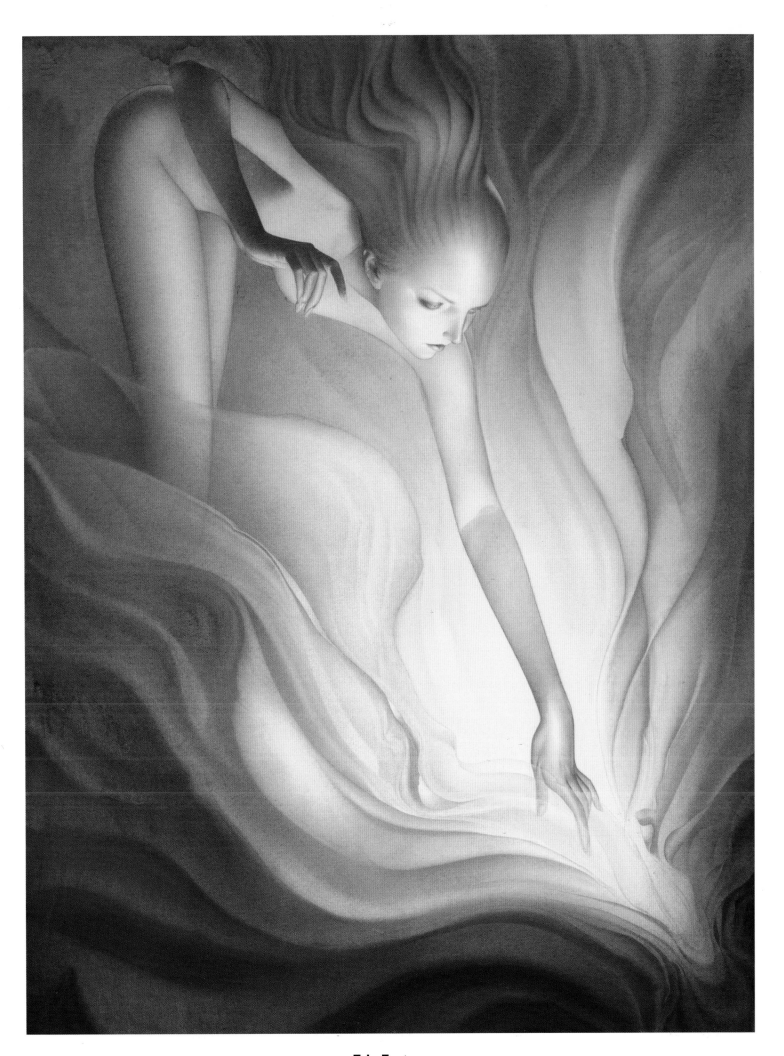

Eric Fortune

Title: Allure *Size:* 22"x30" *Medium:* Acrylic

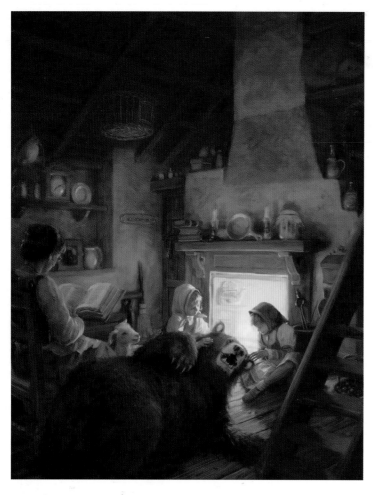

Chris Beatrice

Title: Snow White & Rose Red *Medium:* Digital

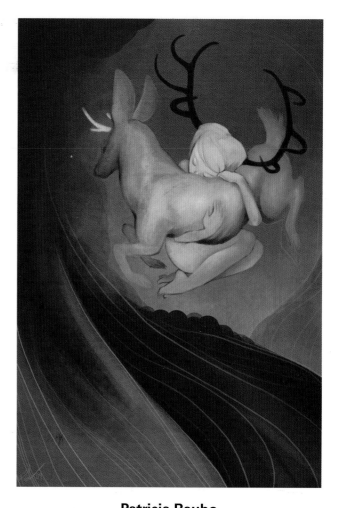

Patricia Raubo

Title: Mooncalf *Size:* 11"x17" *Medium:* Watercolor/digital

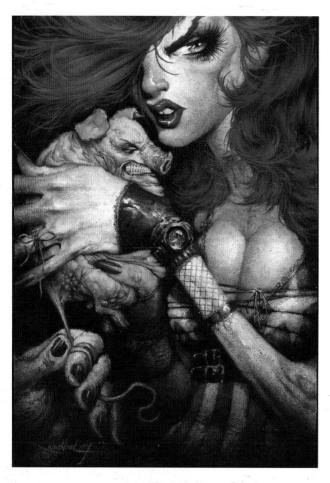

Jon Wayshak

Art Director: Gregg Spatz *Title:* Piggie Piggie
Size: 16"x20" *Medium:* Mixed

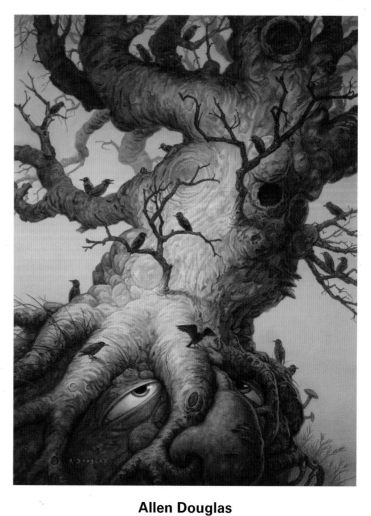

Allen Douglas

Title: Awakening *Size:* 13"x17" *Medium:* Acrylic on panel

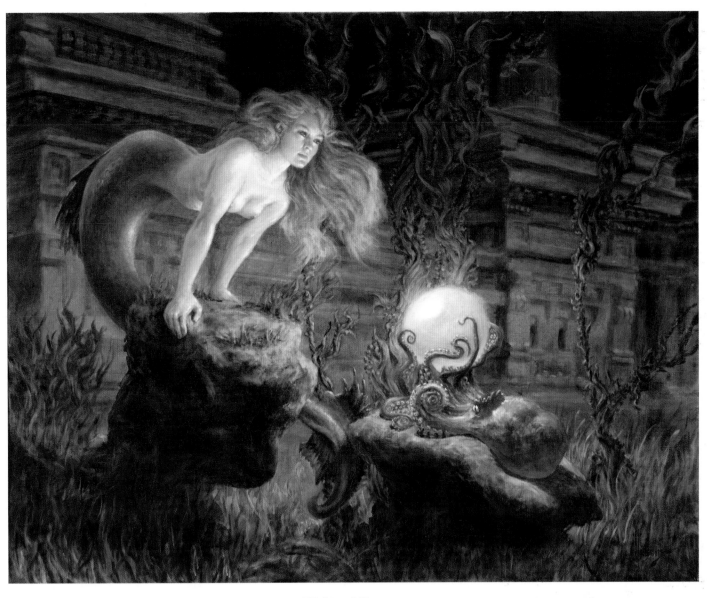

Richard Hescox

Title: The Hearts of Atlantis *Size:* 30"x24" *Medium:* Oils

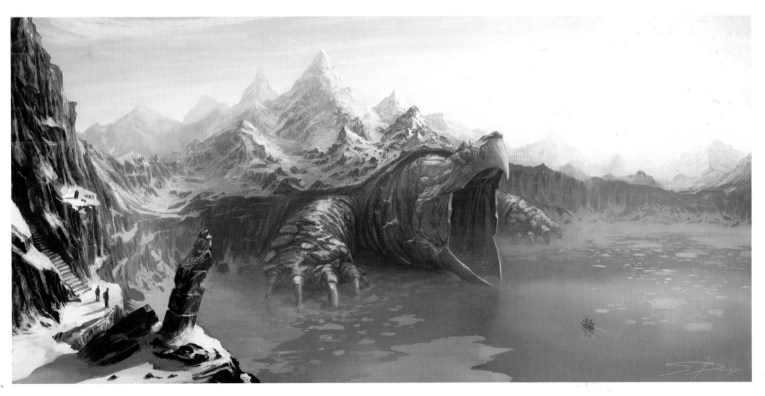

Sam Burley

Title: Warhammer: Ancient Threshold *Medium:* Photoshop

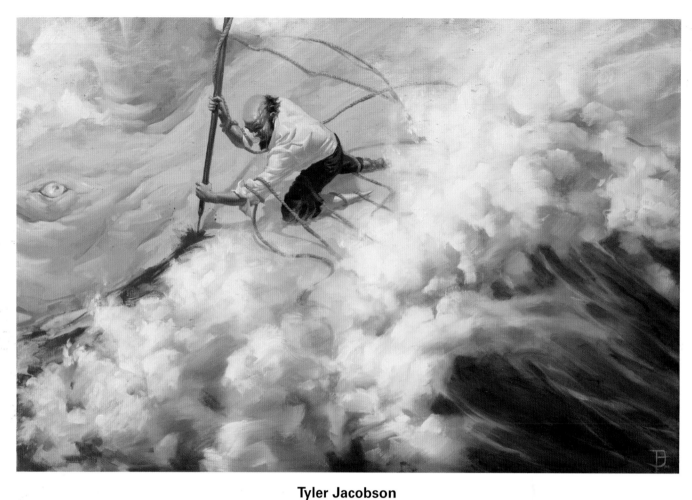

Tyler Jacobson
Title: "For hate's sake I spit my last breath at thee" *Size:* 36"x24" *Medium:* Oil on canvas

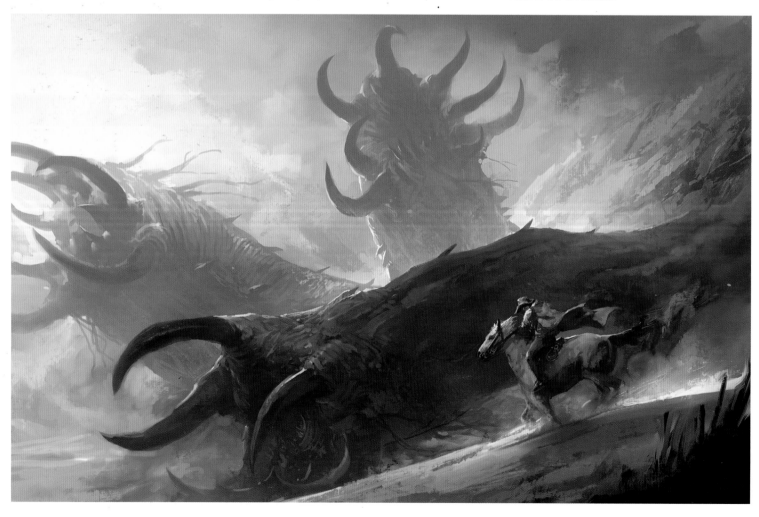

Kekai Kotaki
Title: Cowboy Vs Sandworms *Size:* 11"x7" *Medium:* Digital

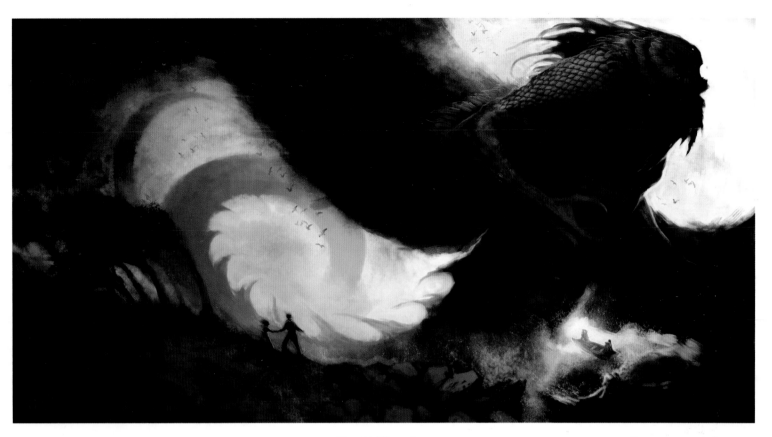

Scott Flanders
Art Director: Jon Schindehette *Client:* Art Order *Title:* Hurakan, God of Storms *Medium:* Digital

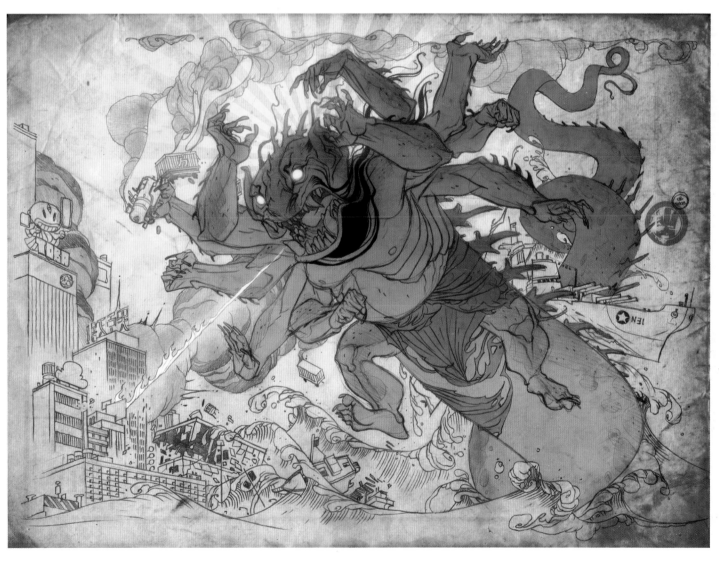

Ben Caldwell
Title: Abunai! *Size:* 13 1/2"x10" *Medium:* Digital

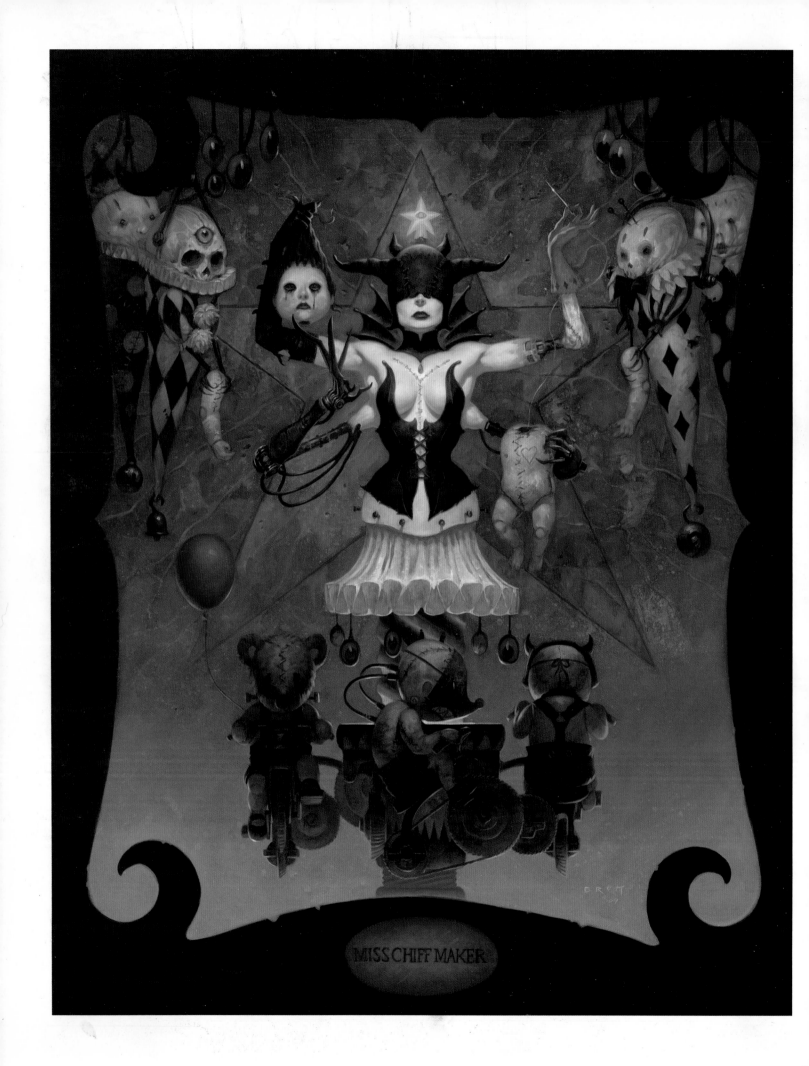

Brom

Client: Leo Gonzales *Title:* Miss Chiff Maker *Size:* 12"x20" *Medium:* Oil

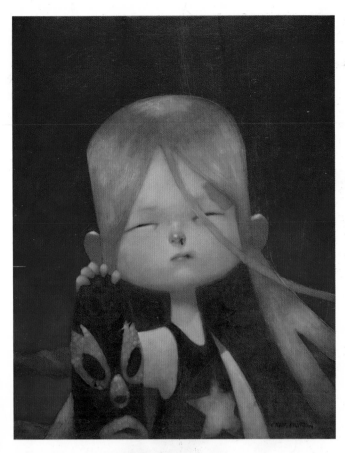

Craig Davison

Title: A Small Victory *Size:* 24"x31" *Medium:* Oil

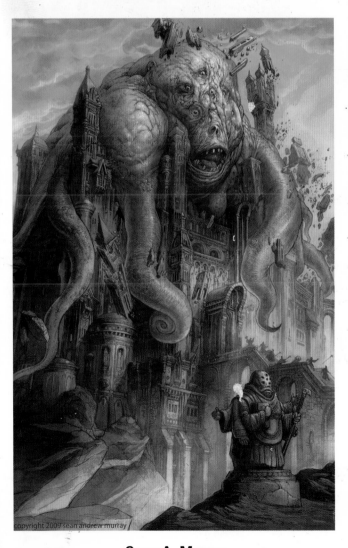

Sean A. Murray

Title: Oops! *Medium:* Pencil/digital

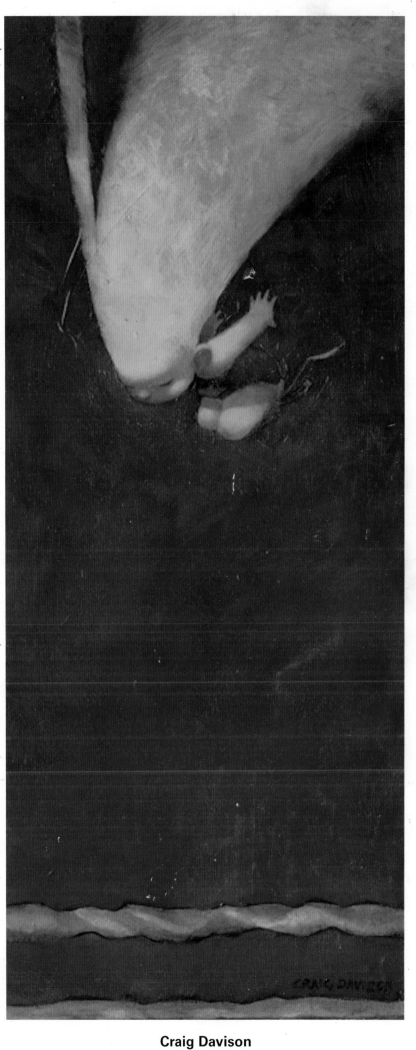

Craig Davison

Title: Eve of Destruction *Size:* 12"x27" *Medium:* Oil

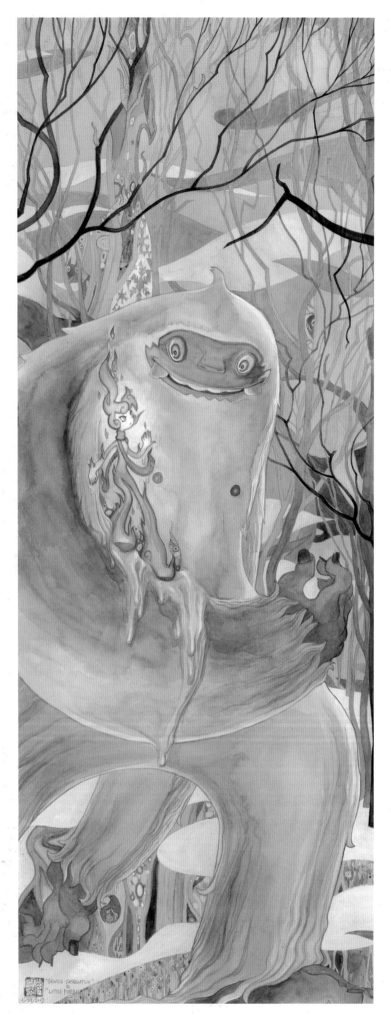

Tohru Patrick Awa
Title: Gentle Sasquatch & Little Fireball *Size:* 14"x30"
Medium: Watercolor

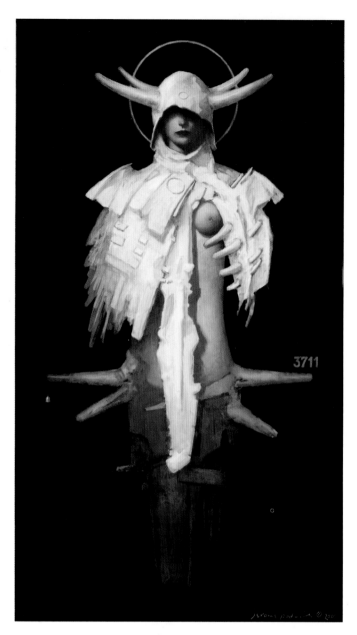

Jerome Podwil
Title: The Sentinel *Size:* 19"x34" *Medium:* Oil on canvas

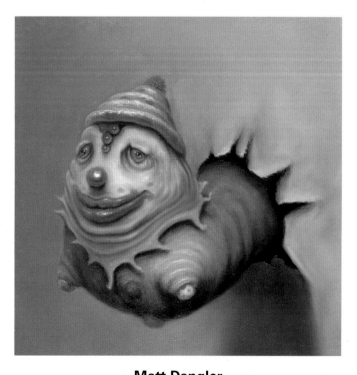

Matt Dangler
Title: Binky's Big Breakout! *Size:* 3"x3" *Medium:* Oil

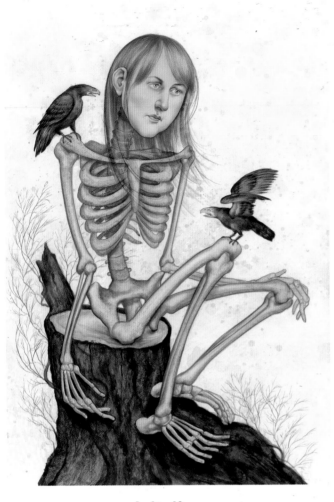

Anita Kunz

Title: Death of Venus 1 *Size:* 20"x28" *Medium:* Acrylic

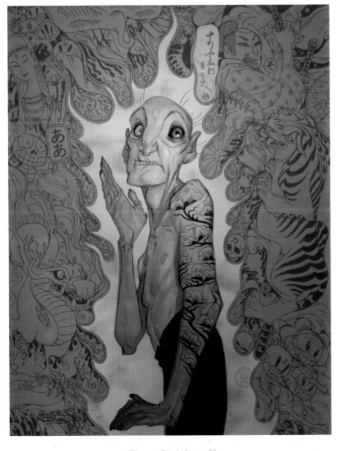

Ben Caldwell

Title: Jimmy Nosferatu: Last of the Undead Tattoo Kings

Size: 7"x10" *Medium:* Digital

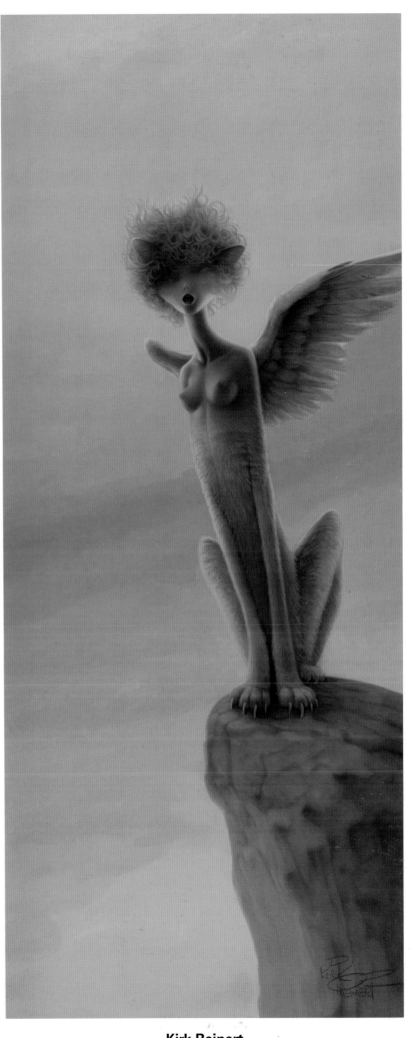

Kirk Reinert

Title: Welcome to Thebes *Size:* 10"x24" *Medium:* Acrylic

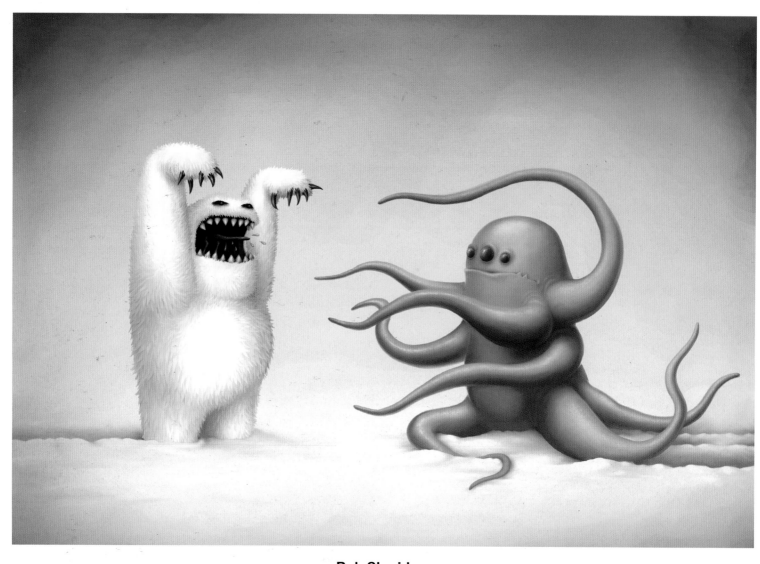

Rob Sheridan

Title: Scare Tactics *Size:* 32"x17" *Medium:* Digital

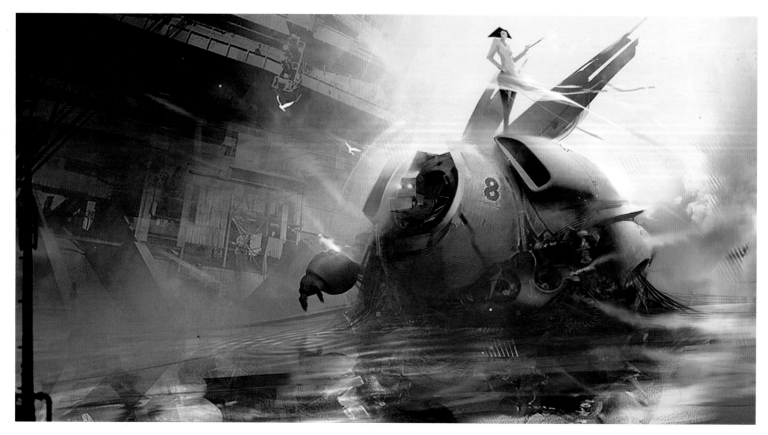

Eduardo Peña

Title: A Smoke *Size:* 13"x8" *Medium:* Photoshop

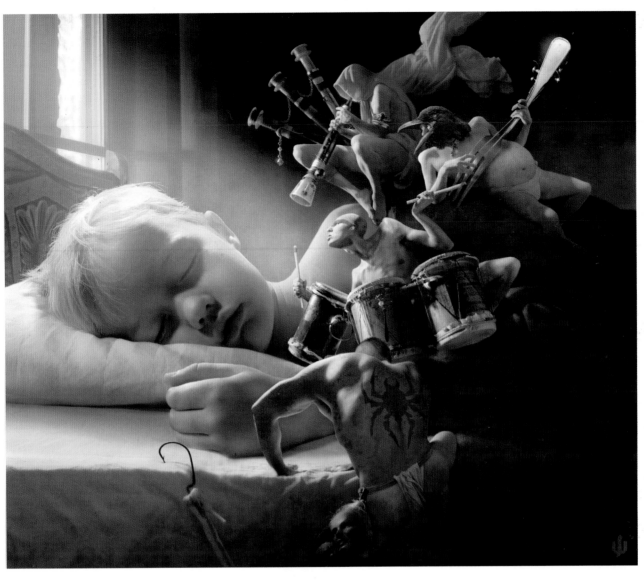

Stan Watts

Title: Nocturne *Size:* 20"x17" *Medium:* Digital

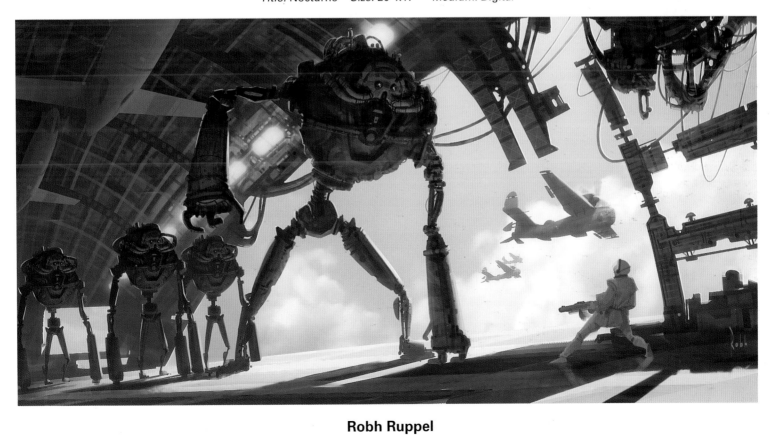

Robh Ruppel

Title: Robot Trouble *Size:* 2200x1300px *Medium:* Digital

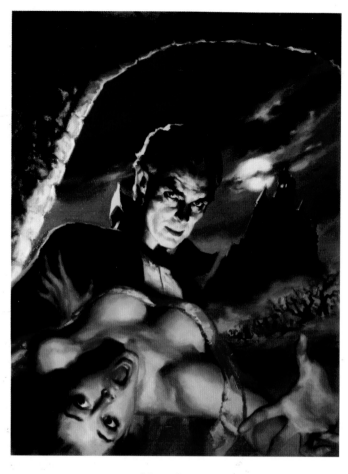

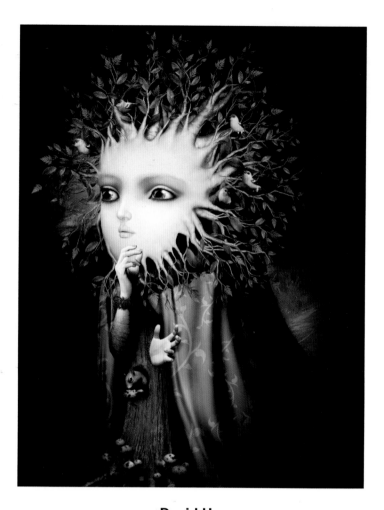

Glen Orbik

Art Director: John Gall *Designer:* Glen Orbik /Laurel Blechman
Title: The Vampire Archives *Size:* 16 1/2"x21 1/2" *Medium:* Oil

David Ho

Title: Wood (Element 5) *Size:* 24"x30" *Medium:* Digital

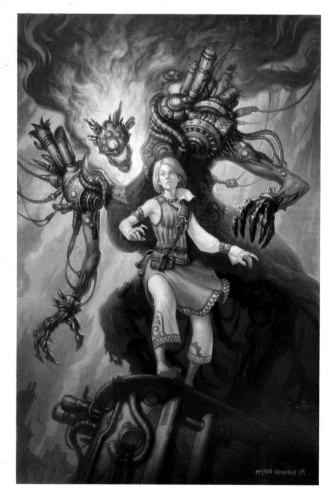

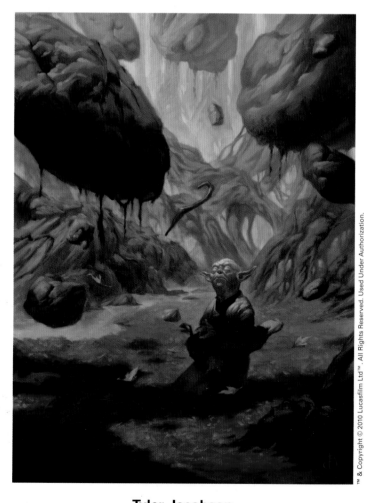

McLean Kendree

Art Director: Rebecca Guay *Title:* Dorothy *Medium:* Digital

Tyler Jacobson

Title: Jedi Master Yoda *Size:* 18"x24" *Medium:* Oil on board

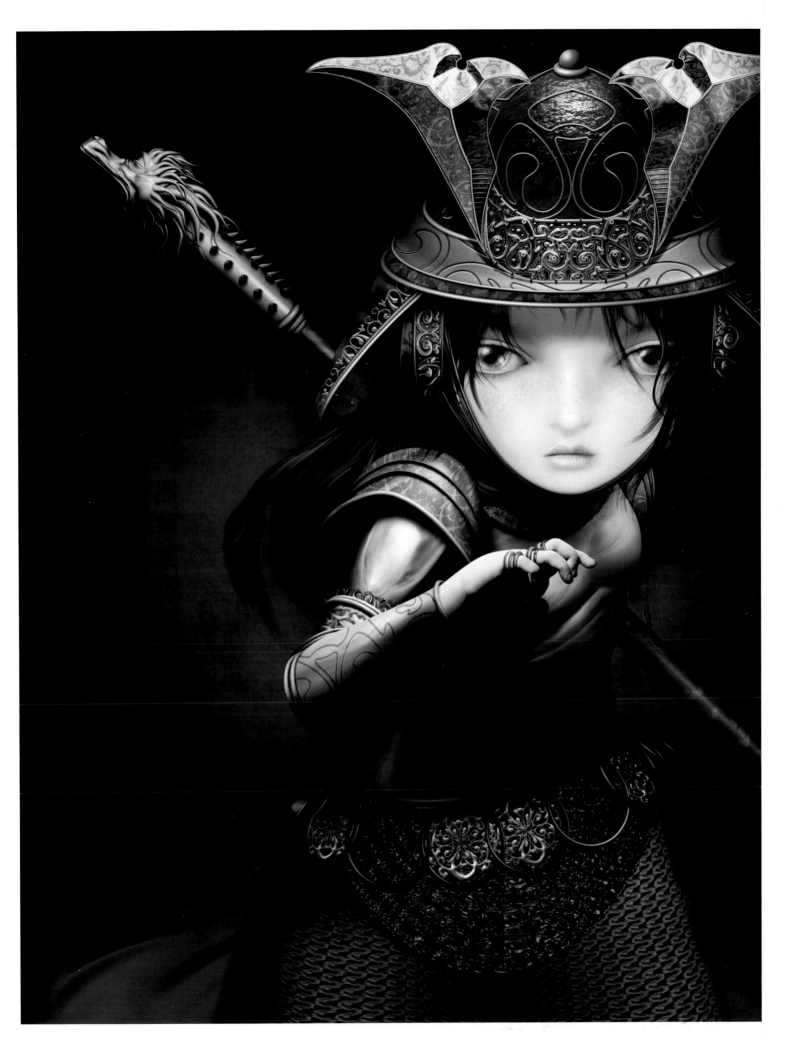

David Ho

Title: Metal (Element 5) *Size:* 24"x30" *Medium:* Digital

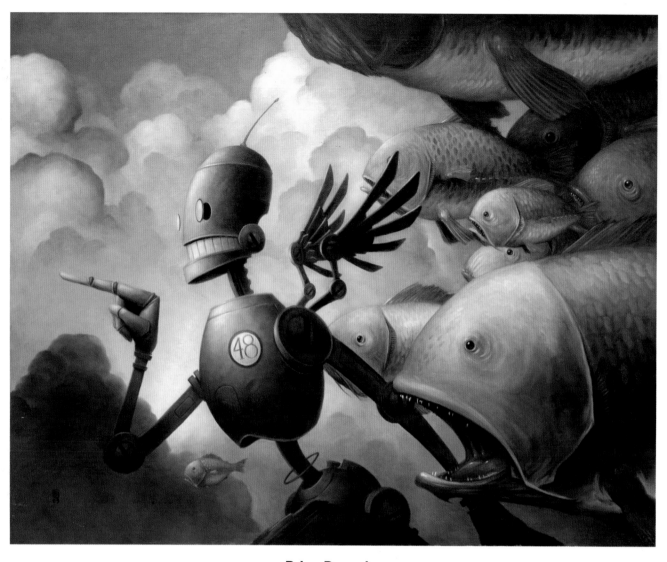

Brian Despain
Title: The Prodigal Son *Size:* 20″x16″ *Medium:* Oil on panel

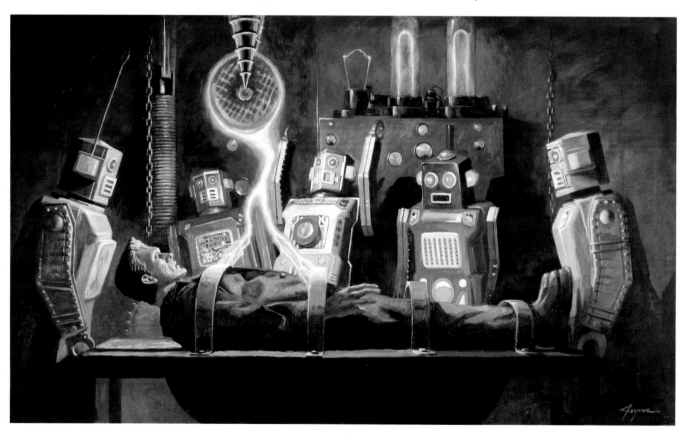

Eric Joyner
Client: Mark Glassy *Title:* Gangenstein *Size:* 48″x34″ *Medium:* Oil on panel

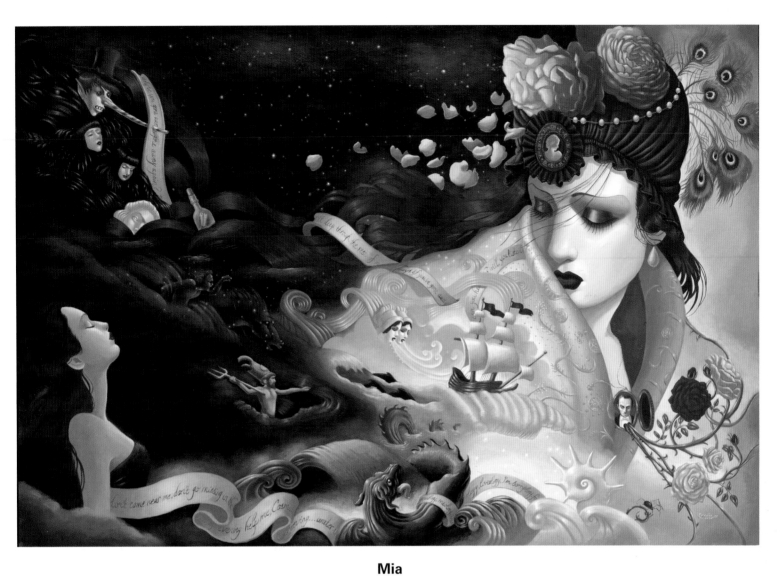

Mia

Art Director: Jan Corey *Model:* Natalie Shau *Client:* Corey Helford Gallery *Title:* Ocean of Memories *Size:* 22"x15 1/2" *Medium:* Oil

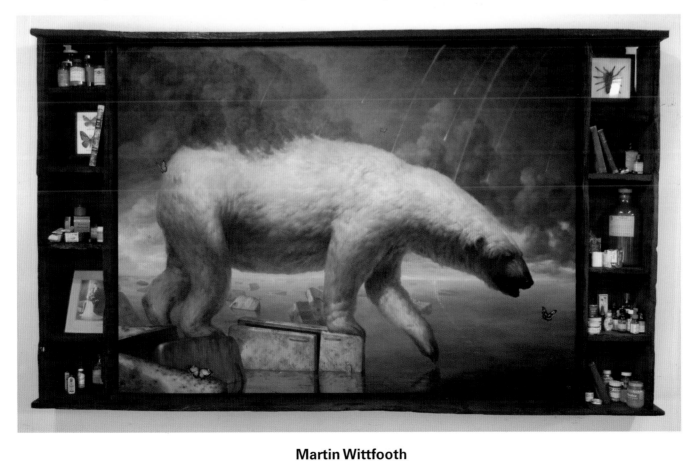

Martin Wittfooth

Client: Copro Gallery *Title:* Saints Preserve Us *Size:* 81"x53" *Medium:* Oil on linen/mixed

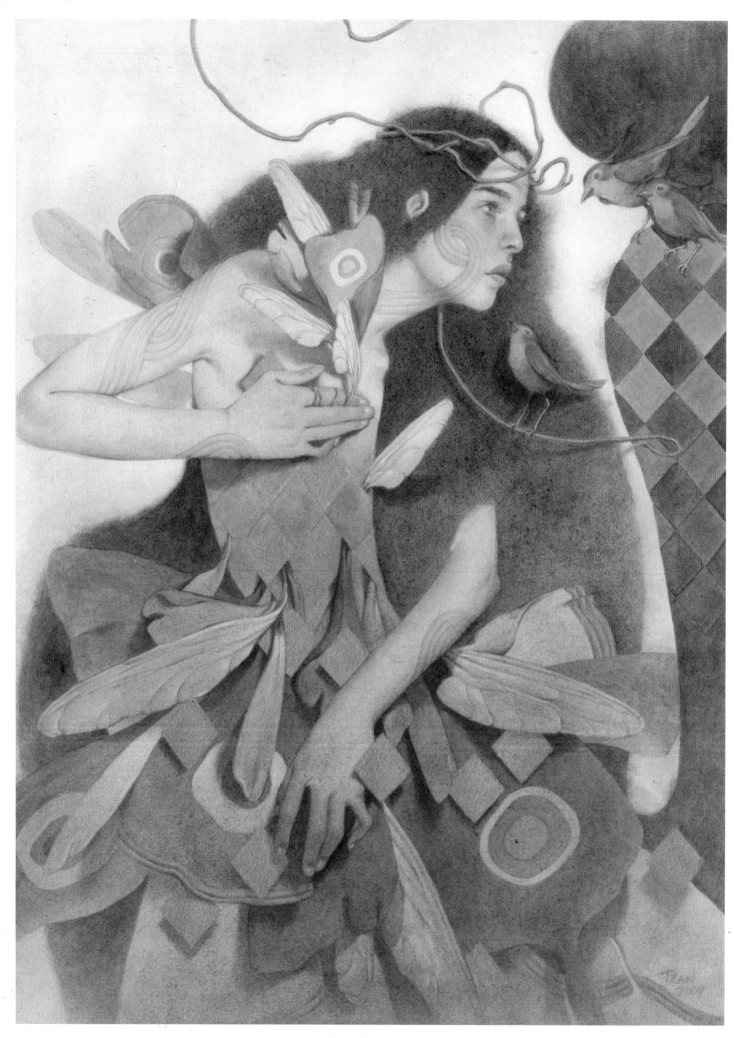

Tran Nguyen
Title: Our Flutter-some Ordeal Size: 12″x17 1/2″ *Medium:* Acrylics/color pencil

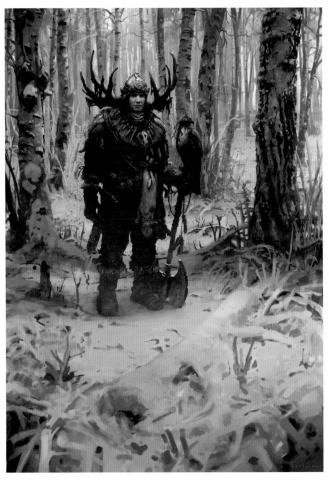

Michael Phillippi

Client: Sloth Productions LLC *Title:* Holidays With Friends

Size: 8 1/2"x8 1/2" *Medium:* Ink/gouache

Karlsimon

Title: Barbarian Warrior *Medium:* Digital

Joe DeVito

Client: Jack Juka *Title:* Doc Savage: Dust Demons

Size: 25"x35" *Medium:* Oils

Heather Theurer

Title: Dragonfly *Size:* 36"x36" *Medium:* Oils on canvas

Matt Dangler

Title: Munchkins' Main Menace *Size:* 9"x12" *Medium:* Oil

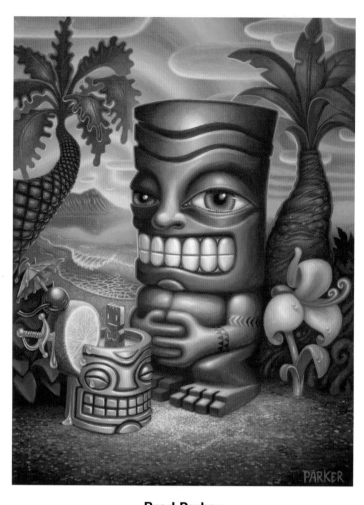

Brad Parker

Title: Diga Diga Doo *Size:* 18"x24" *Medium:* Acrylic on canvas

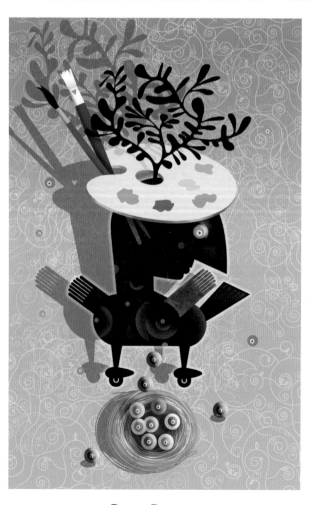

Doug Panton

Title: Birth *Size:* 10"x15" *Medium:* Digital

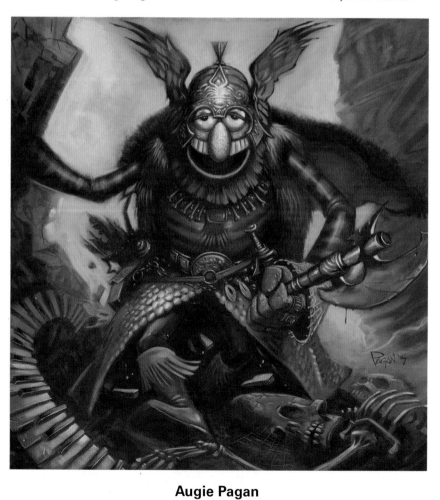

Augie Pagan

Client: Ouch My Eye Gallery *Title:* Flirting With Mayhem

Size: 24"x24" *Medium:* Acrylic on canvas

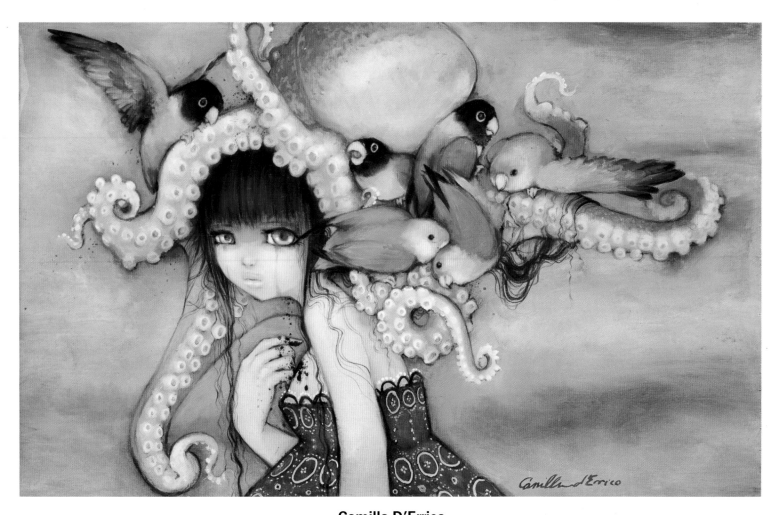

Camilla D'Errico
Title: Loveless Bird *Size:* 22"x14" *Medium:* Oils on wood

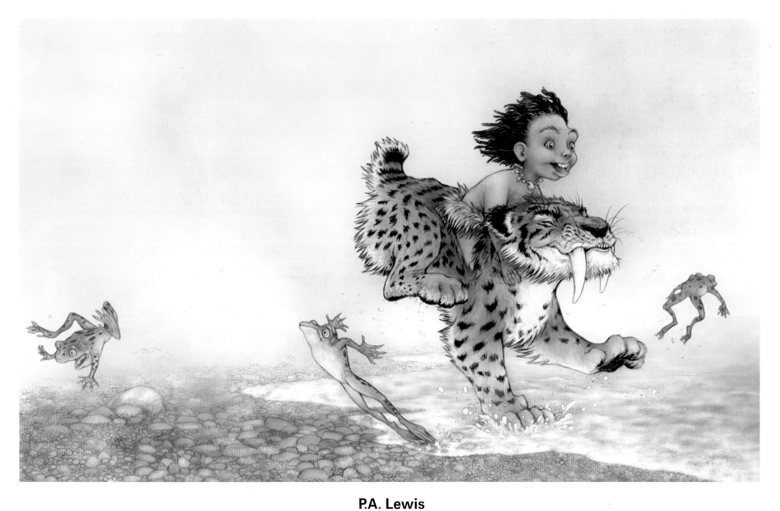

P.A. Lewis
Art Director: Larry MacDougall *Title:* Outta Da Waaaayyyy!!! *Size:* 9"x6" *Medium:* Pencil/digital

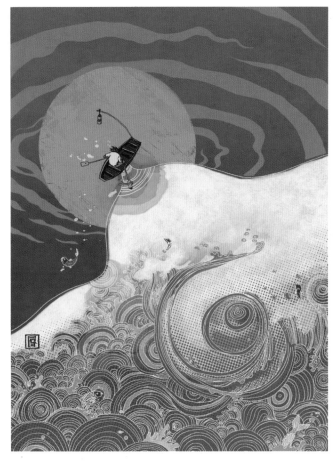

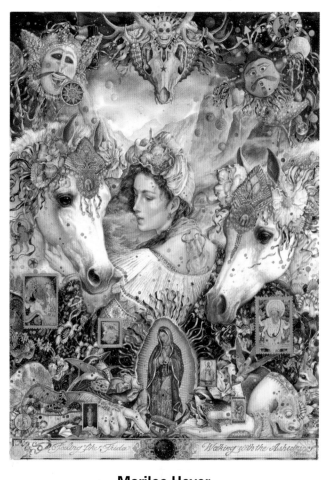

Victo Ngai

Title: Maneater *Size:* 21 1/2"x29" *Medium:* Mixed

Marilee Heyer

Title: Walking With the Ashvins *Size:* 19"x26" *Medium:* Watercolor

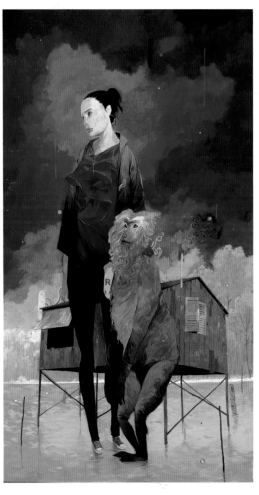

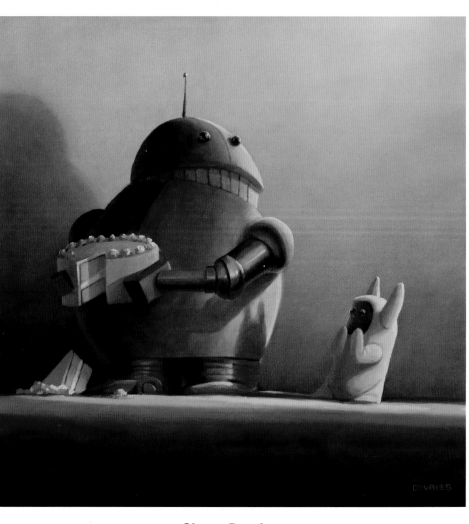

Andrew Hem

Title: Make the Best of Things

Size: 18"x33" *Medium:* Acrylic on panel

Shane Devries

Title: Oops! *Size:* 50x50cm *Medium:* Oil on canvas

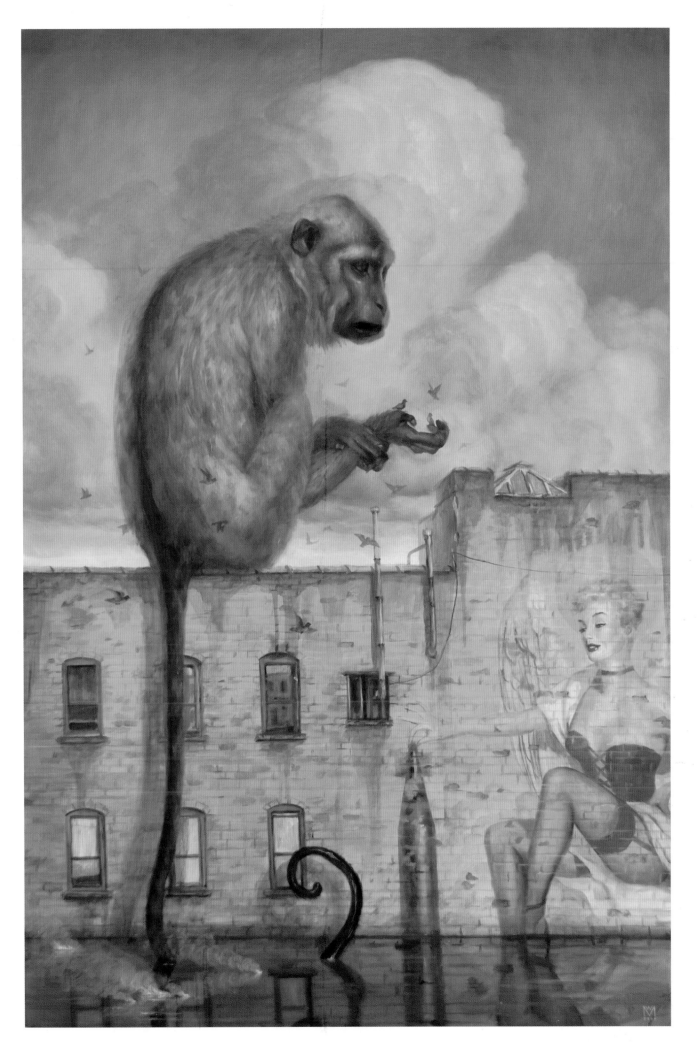

Martin Wittfooth

Client: Jonathan LeVine Gallery *Title:* Messengers *Size:* 24″x36″ *Medium:* Oil on panel

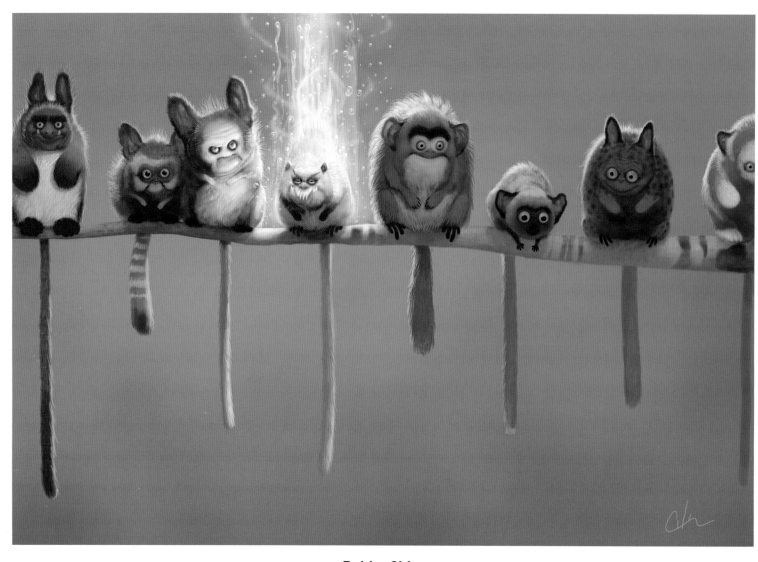

Bobby Chiu

Client: Imaginism Studio *Title:* Beam Me Up, Scottie *Size:* 14"x11" *Medium:* Digital

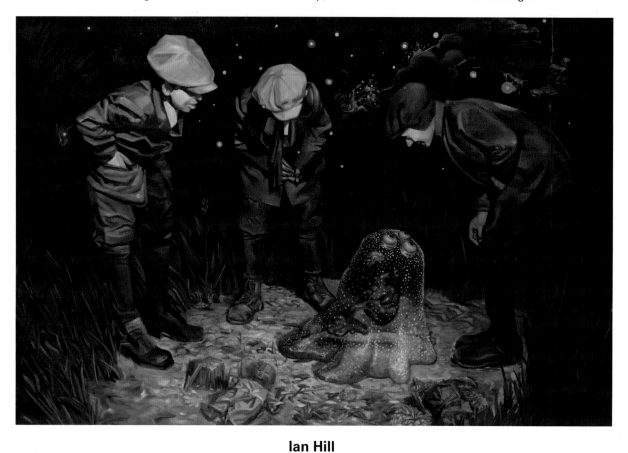

Ian Hill

Title: A Message From the Future *Size:* 72"x48" *Medium:* Oil on canvas

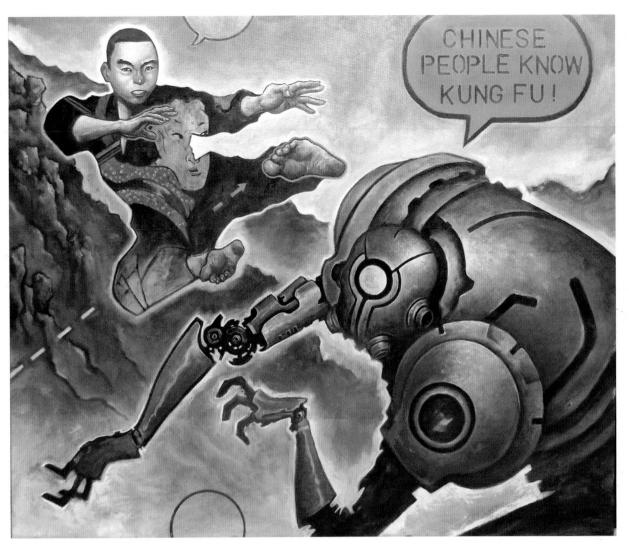

Sonny Liew

Title: Chinese People Know Kung Fu *Size:* 120x100cm *Medium:* Oil on canvas

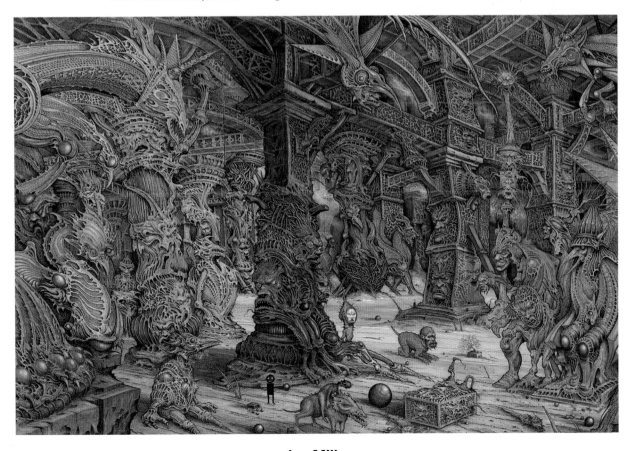

Ian Miller

Art Director: Gregg Spatz *Client:* Gregg Spatz *Title:* Hall of the Bright Carvings *Size:* 26"x18" *Medium:* Acrylics/mixed

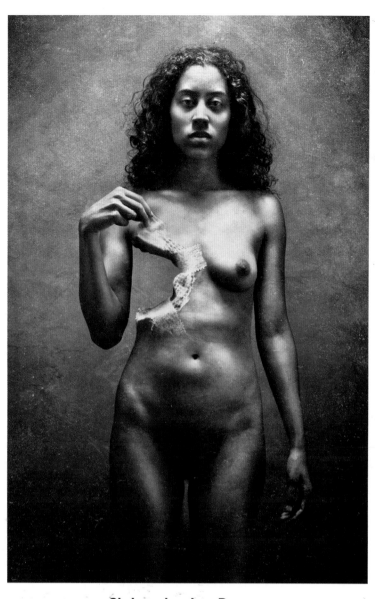

Christopher Lee Donovan

Title: Shandra, Wound *Size:* 16"x28" *Medium:* Photography/mixed

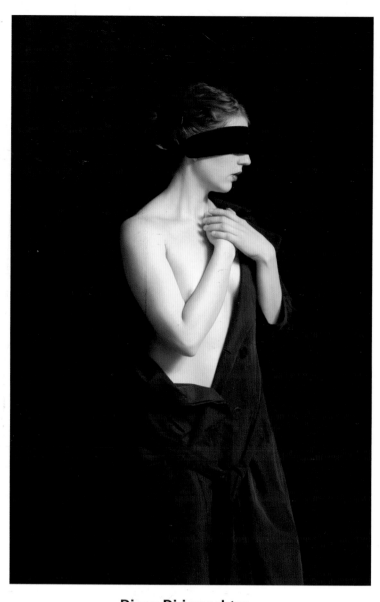

Diana Diriwaechter

Title: Innocents Lost *Size:* 12"x18" *Medium:* Photography

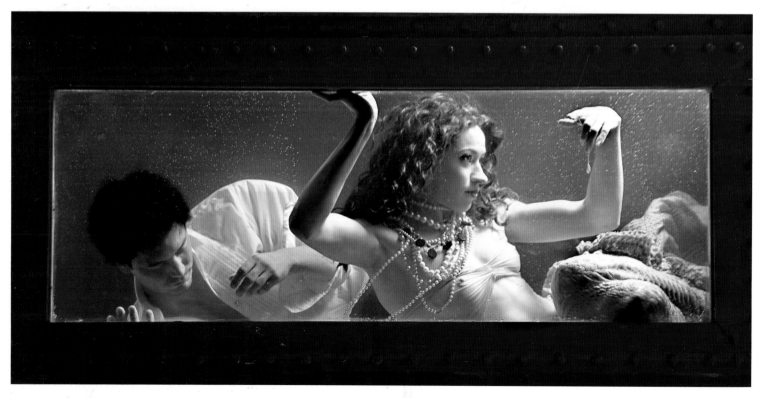

Annaliese Moyer

Title: At What Cost *Medium:* Photography/digital

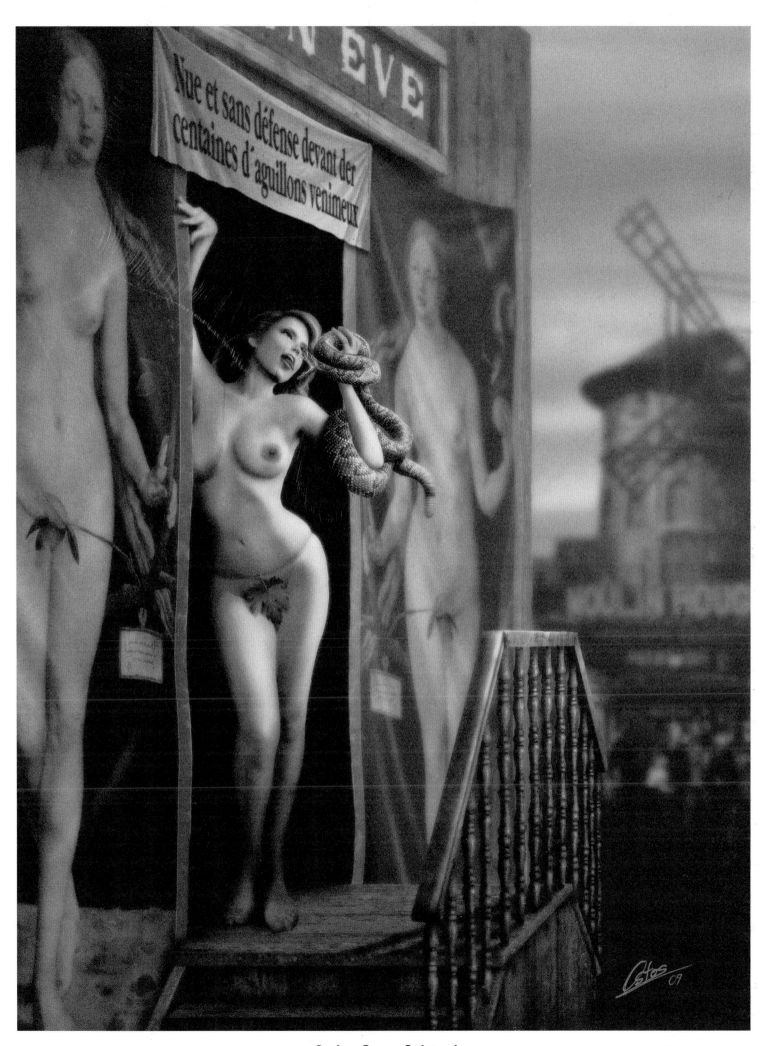

Carlos Ostos Sabugal

Title: Poison Eve *Size:* 9"x12" *Medium:* Digital

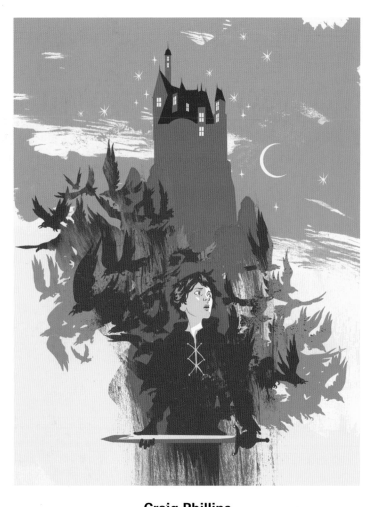

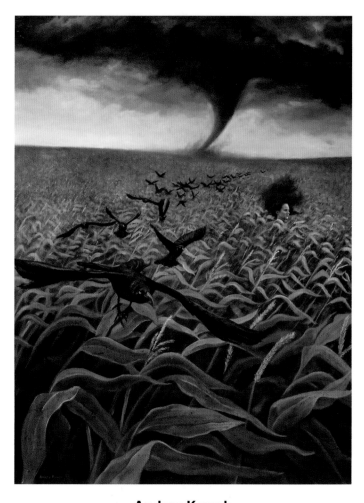

Craig Phillips
Size: 8″x11″ *Medium:* Ink/digital

Andrea Kowch
Title: In the Path of the Wind *Size:* 30″x40″ *Medium:* Acrylic

August Hall
Art Director: Patricia Gauch/Semader Megged *Client:* Penguin
Title: Ghost Tree *Size:* 8″x11″ *Medium:* Digital

Bill Carman
Title: Cyclaurian Bunny *Size:* 8″x10″ *Medium:* Acrylic

Thomas Simpson

Title: Marshwalkers (after "The Hunter" by N.C. Wyeth) *Size:* 10"x12" *Medium:* Painter IX

Justin Gerard

Title: The Battle *Size:* 24"x16" *Medium:* Watercolor/digital

Allen Song

Title: Rain *Size:* 3000x1759px *Medium:* Photoshop

Irvin Rodriguez
Title: Nizari *Size:* 15"x11" *Medium:* Digital

Dominick Saponaro
Title: Ambush *Size:* 26"x14" *Medium:* Mixed/digital

Jeremy Geddes

Title: Cafe *Size:* 20″x40″ *Medium:* Oil on linen

Brian Valenzuela

Title: The Shadow Over Innsmouth

Size: 8 1/2″x18″ *Medium:* Mixed

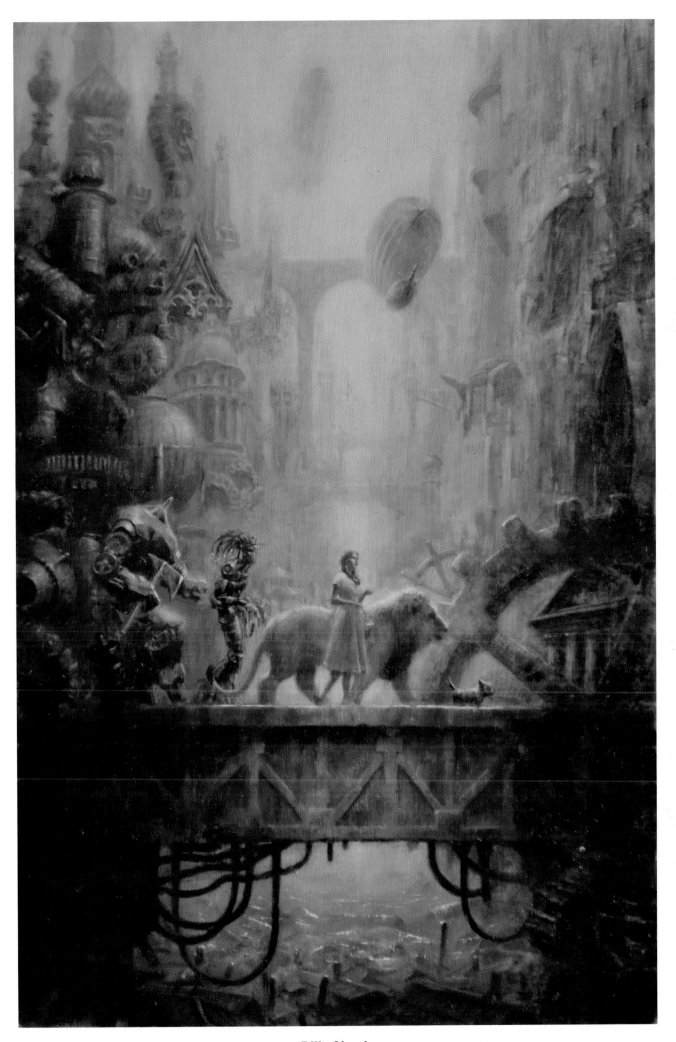

Billy Norrby

Title: The Wizard of Oz *Size:* 14"x20" *Medium:* Oil

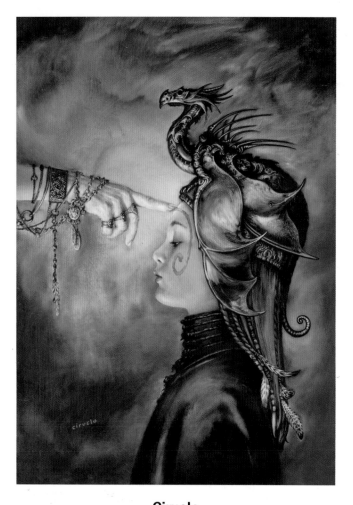

Ciruelo

Title: Initiation *Size:* 20″x28″ *Medium:* Oil

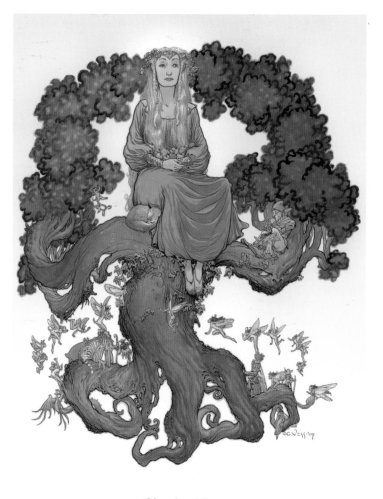

Charles Vess

Title: A Bounty of Apples *Size:* 24″x28″ *Medium:* Mixed

Dave McKean

Title: Rhetoriciam *Size:* 61x61mm *Medium:* Photography/digital

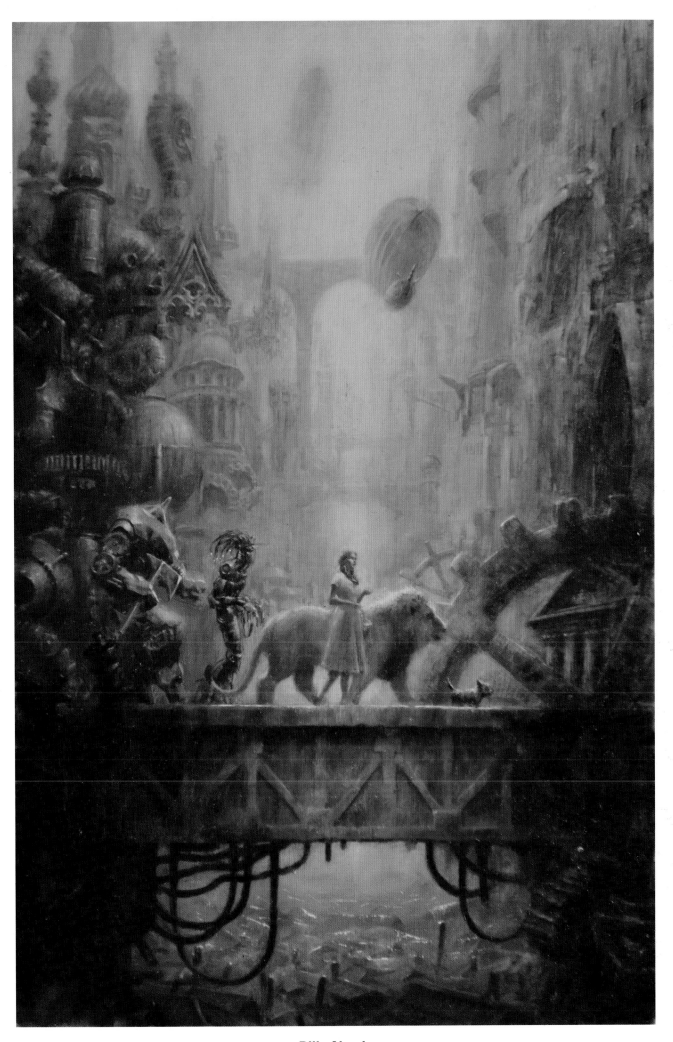

Billy Norrby

Title: The Wizard of Oz *Size:* 14″x20″ *Medium:* Oil

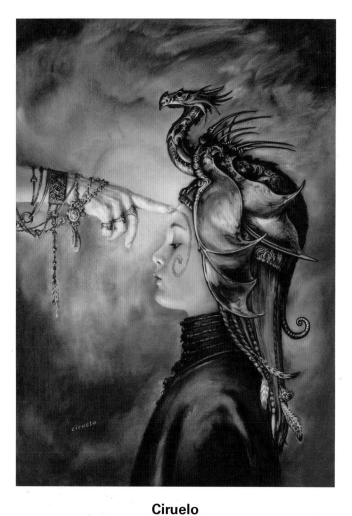

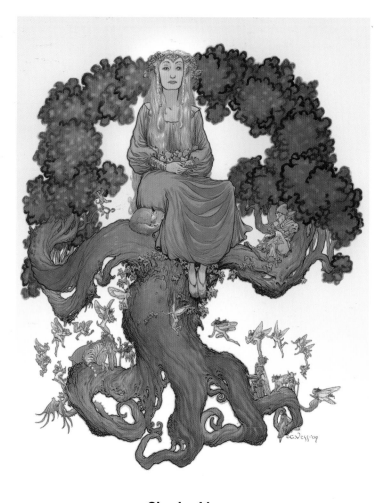

Ciruelo
Title: Initiation *Size:* 20″x28″ *Medium:* Oil

Charles Vess
Title: A Bounty of Apples *Size:* 24″x28″ *Medium:* Mixed

Dave McKean
Title: Rhetoriciam *Size:* 61x61mm *Medium:* Photography/digital

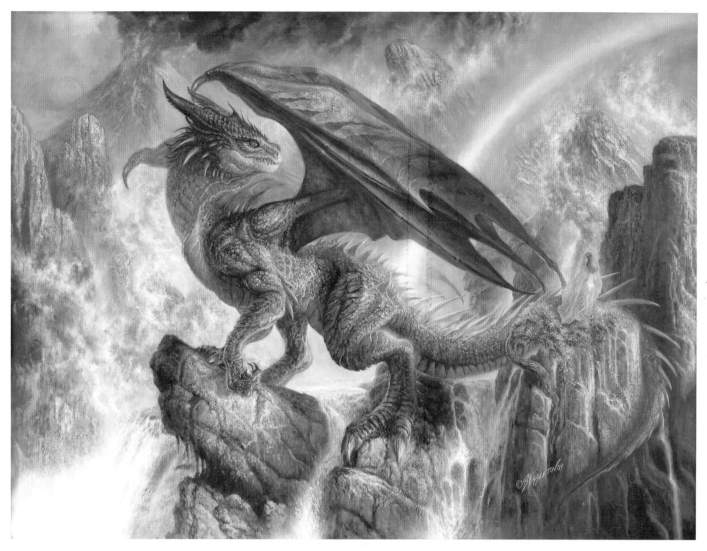

Bob Eggleton
Title: The Rainbow Dragon *Size:* 40"x30" *Medium:* Oils

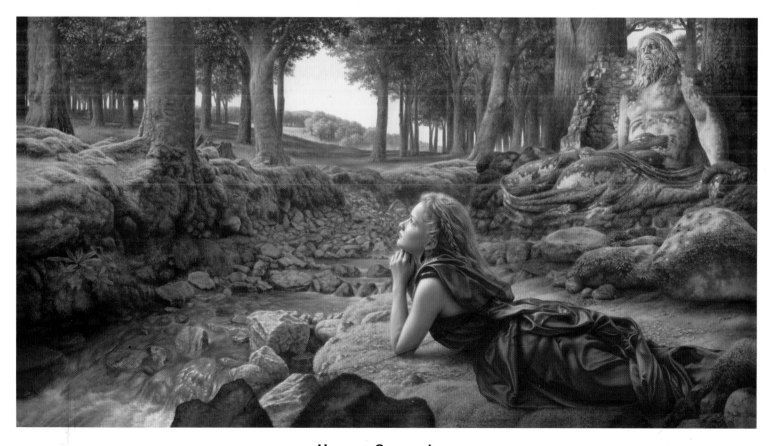

Herman Smorenburg
Title: Spirit of the Forest *Size:* 125x62cm *Medium:* Oil on wood

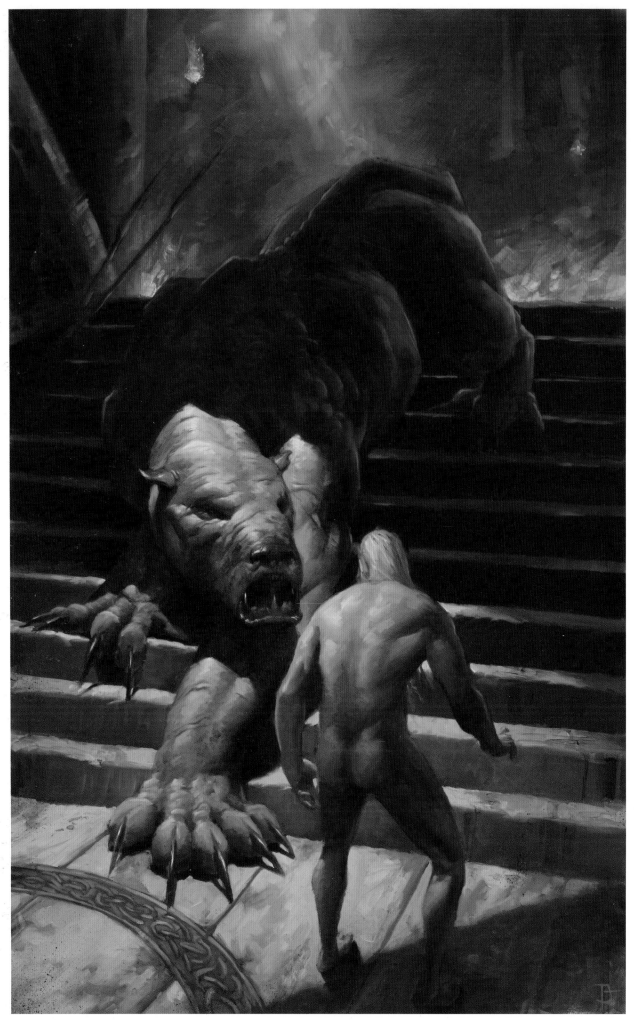

Tyler Jacobson

Title: Grendel and Beowulf *Size:* 18"x28" *Medium:* Oils on board

Frans Tedja Kusuma

Title: The Wicked Witch is Dead *Size:* 7"x10" *Medium:* Mixed

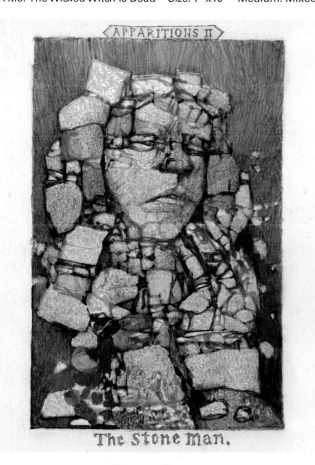

Barron Storey

Title: Apparations II: The Stone Man

Size: 5 3/8"x8 3/8" *Medium:* Ink/graphite/watercolor

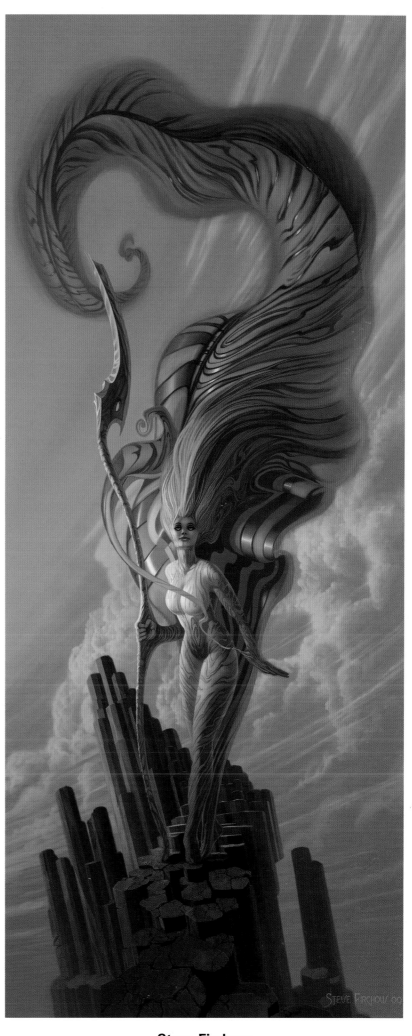

Steve Firchow

Title: Damascus *Size:* 13"x28" *Medium:* Digital

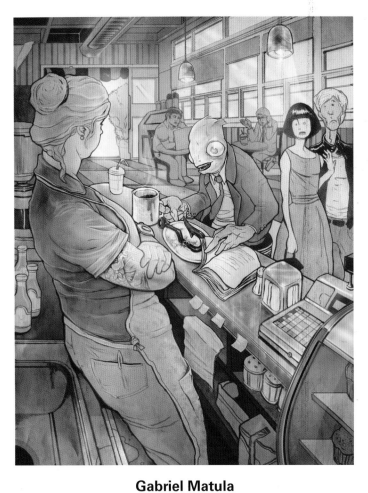

Gabriel Matula

Title: Grande Latte *Size:* 25.4x32.81cm *Medium:* Photoshop

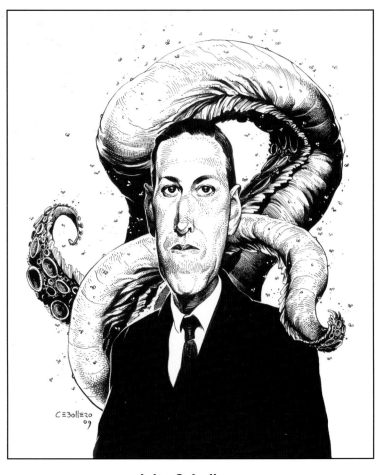

John Cebollero

Title: H.P. Lovecraft *Size:* 8″x10″ *Medium:* Pen & ink

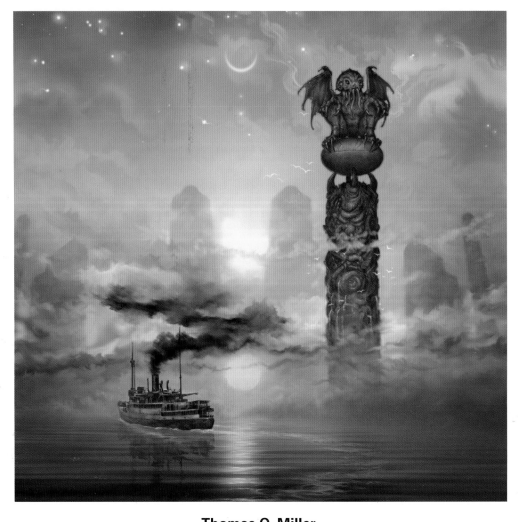

Thomas O. Miller

Client: Atomic Art *Title:* The Call of Cthulhu *Size:* 8″x8″ *Medium:* Digital

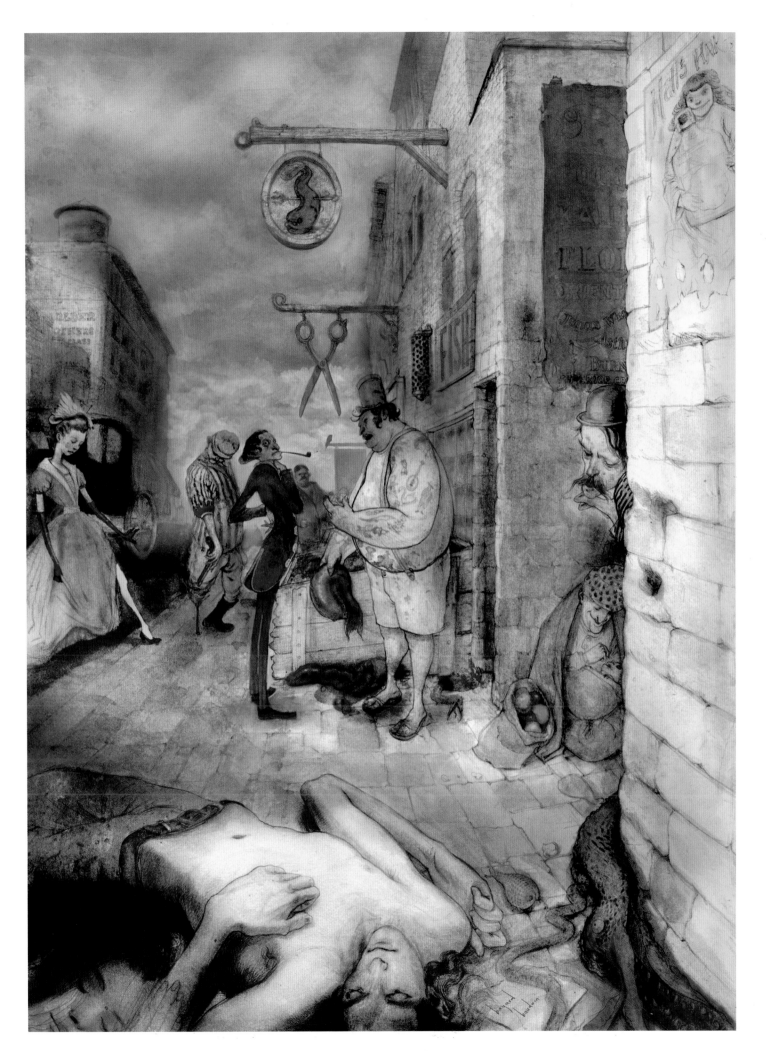

Bayard Baudoin

Title: The Fish Market *Size:* 13"x18" *Medium:* Watercolor/digital

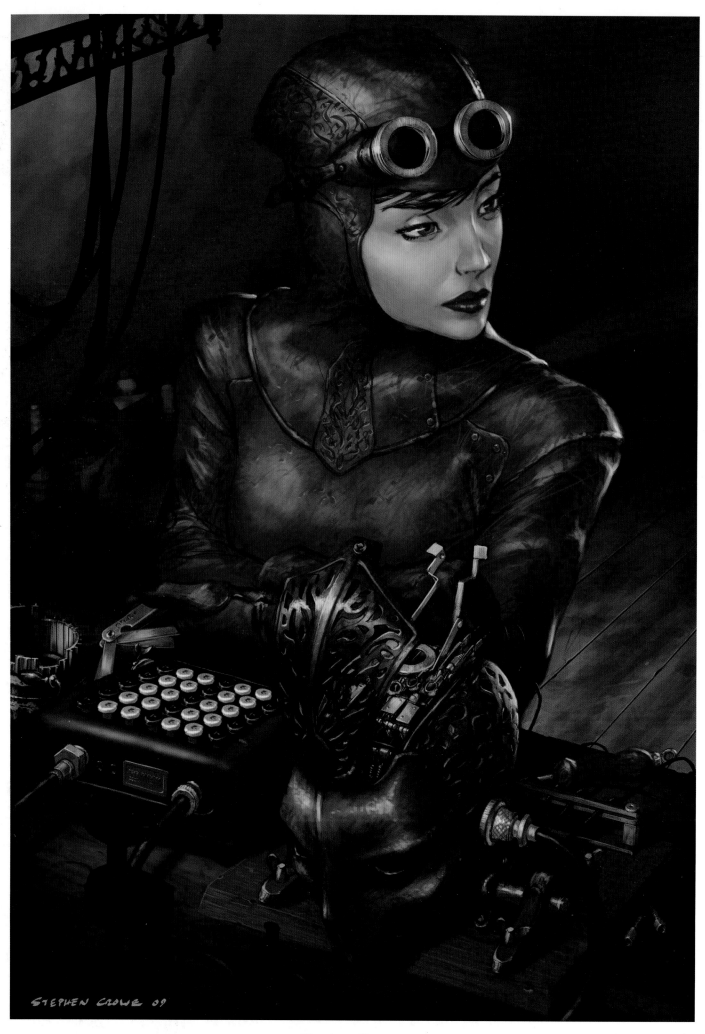

Stephen Crowe

Title: Engineer *Size:* 11 1/2"x16 1/2" *Medium:* Photoshop

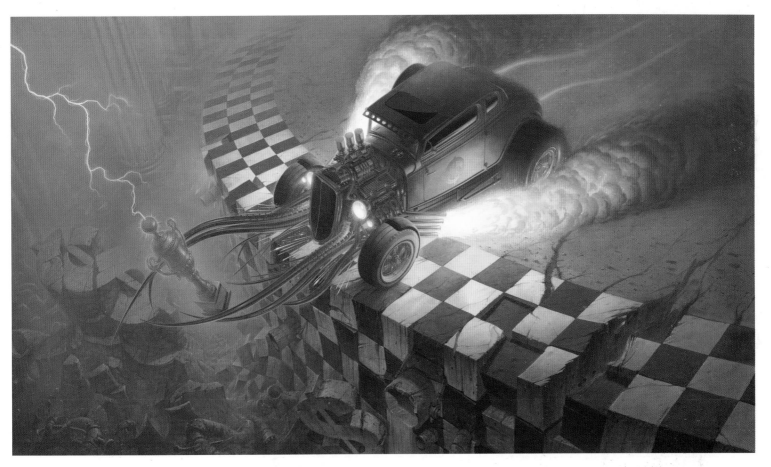

Marc Gabbana

Title: Bitterweet Bictory *Size:* 34"x19 1/2" *Medium:* Acrylic

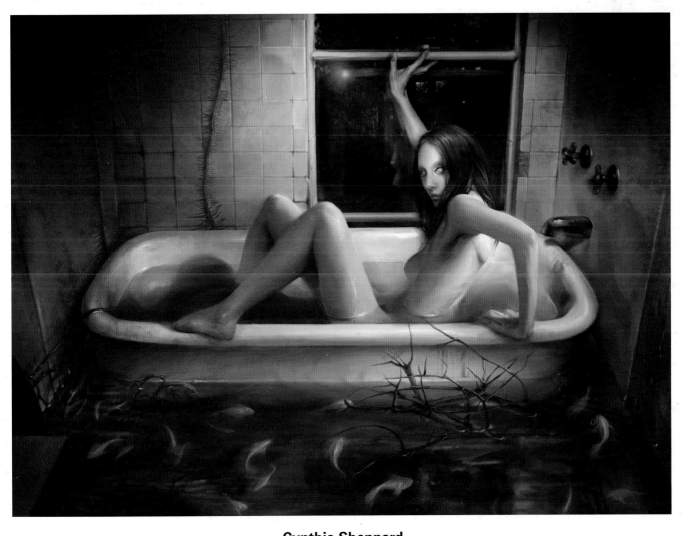

Cynthia Sheppard

Title: Escapism *Medium:* Digital

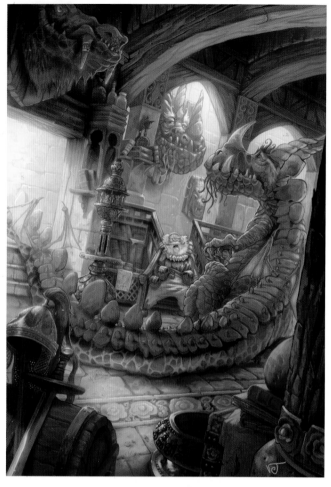

Vincent Joubert

Title: L'échoppe *Size:* 27.6x39.4cm *Medium:* Pencil/digital

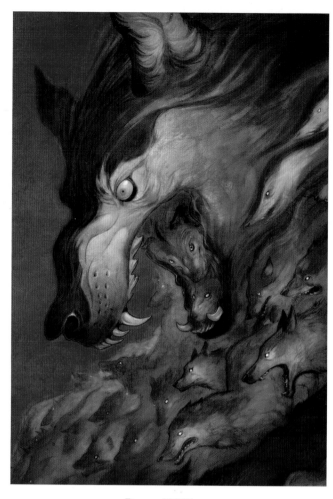

Doug Williams

Title: Wolf Wave *Size:* 14"x21" *Medium:* Mixed

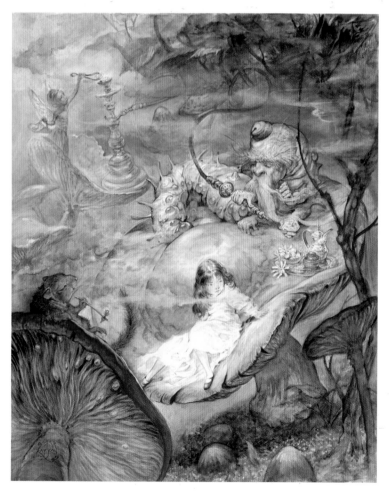

Omar Rayyan

Title: The Caterpillar *Size:* 11"x14" *Medium:* Watercolor

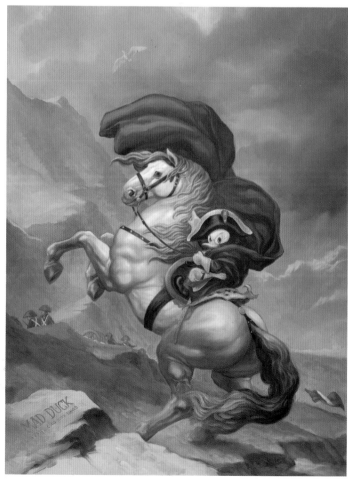

Frank Cho

Title: The Mad Duck *Size:* 36"x48" *Medium:* Oil

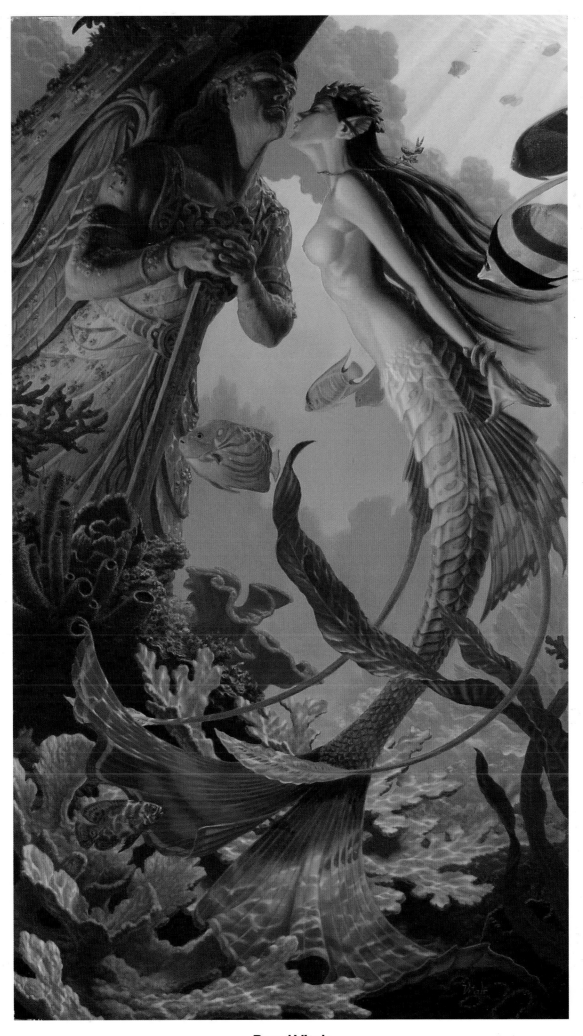

Raoul Vitale

Title: Unrequited *Size:* 16"x28" *Medium:* Oil on masonite

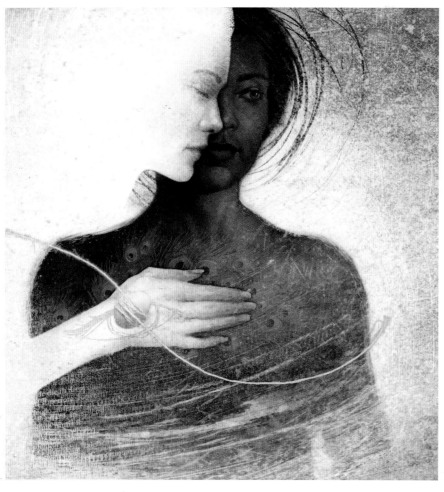

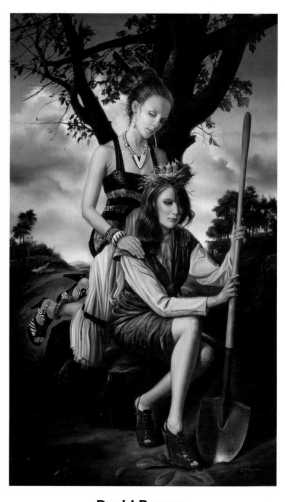

Matt Manley

Title: Albedo *Size:* 15″x15″ *Medium:* Oil/mixed

David Bowers

Title: The Crown *Size:* 20″x34″ *Medium:* Oil

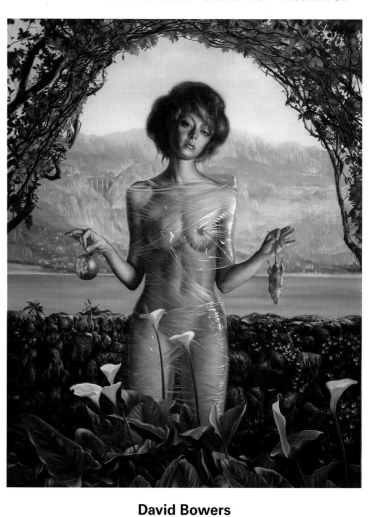

Gil Bruvel

Title: Read Between the Lines *Size:* 30″x40″ *Medium:* Oil

David Bowers

Title: Unspoiled *Size:* 11 3/4″x15 3/4″ *Medium:* Oil

David Bowers

Client: 101 Exhibit *Title:* Access Denied *Size:* 14"x17" *Medium:* Oil on panel

Austin Hsu

Art Director: James Ahang *Title:* Emperor *Medium:* Digital

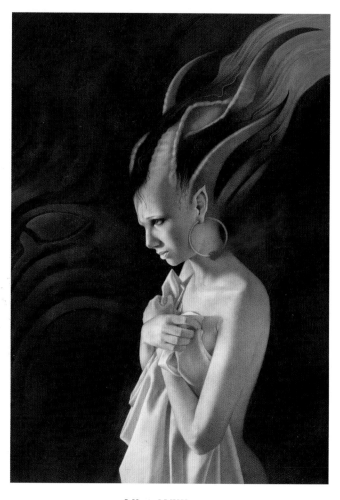

Allen Williams

Title: Love Lost *Size:* 14"x20" *Medium:* Mixed

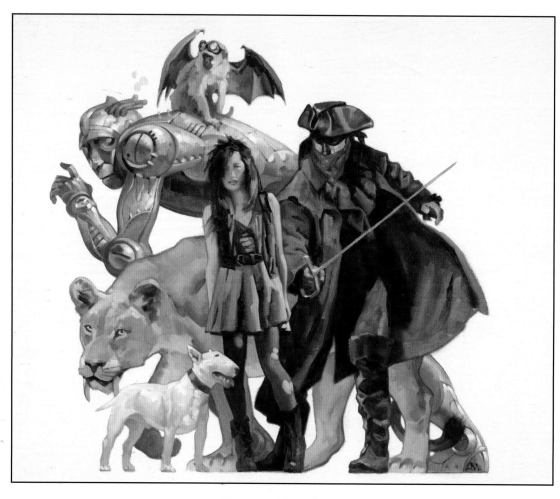

Gregory Manchess

Title: A Different Wizard of Oz *Size:* 22"x22" *Medium:* Oil on linen

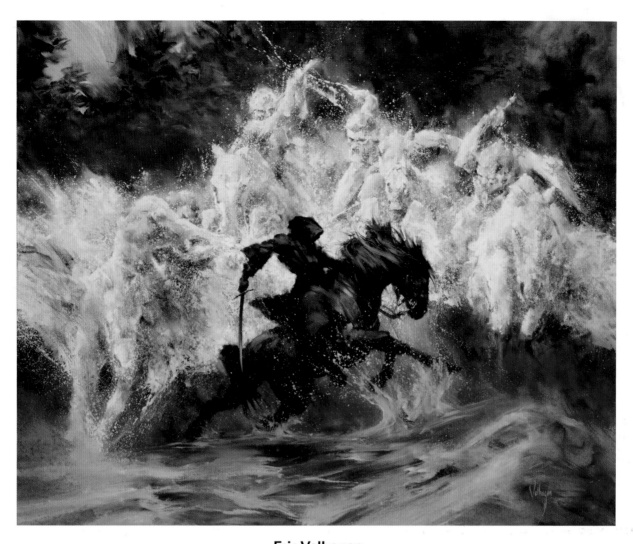

Eric Velhagen
Title: The Roar of Bruinen *Size:* 48"x42" *Medium:* Oil on linen

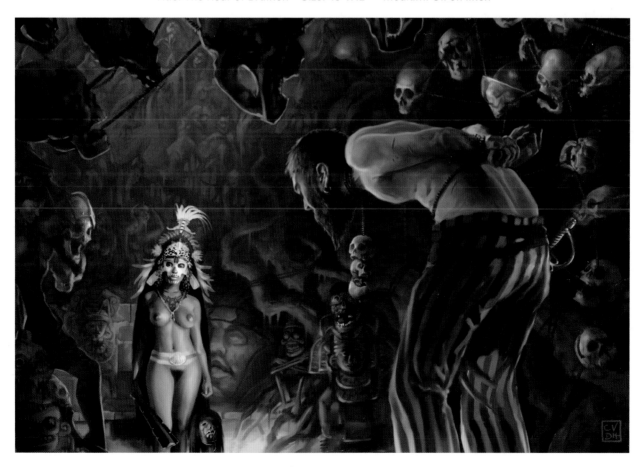

Cyril van der Haegen
Title: The Lifeless Forest, Part 2 *Medium:* Digital

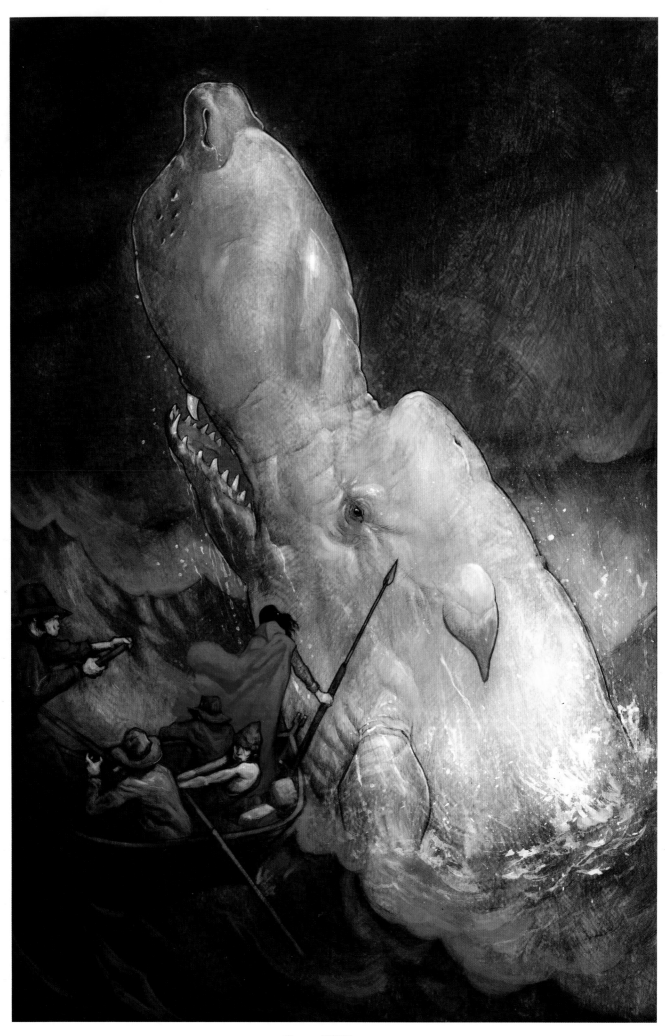

Doug Williams

Title: Moby Wolf Size: 14"x22" *Medium:* Mixed

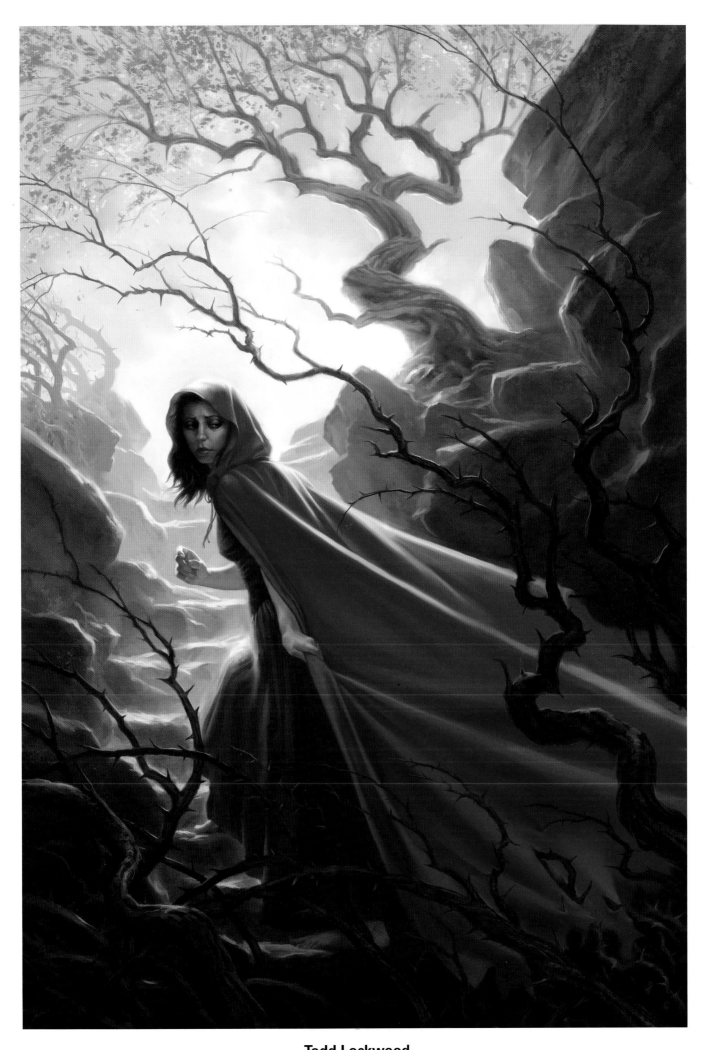

Todd Lockwood

Art Director: Mary Hamer *Client:* S.I.G.M.A. Project *Title:* In the Shadow *Size:* 15"x22" *Medium:* Digital

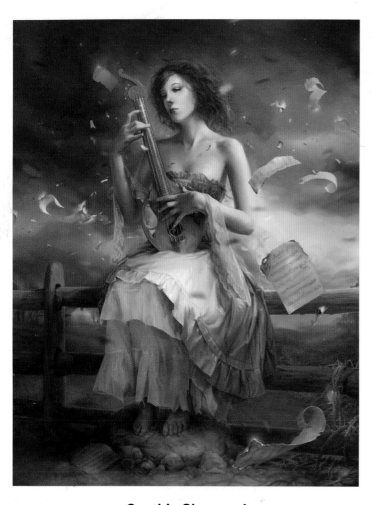

Cynthia Sheppard

Title: Half Her Heart's Duet *Medium:* Digital

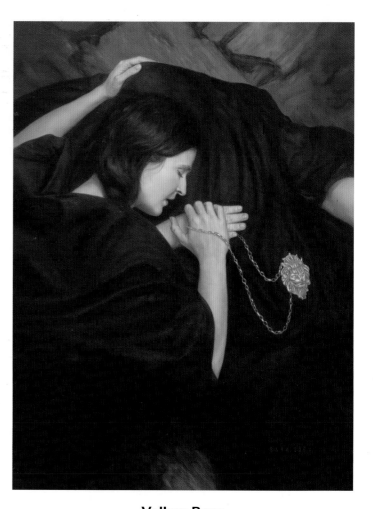

Volkan Baga

Title: Patroclus *Size:* 22 7/8"x30 3/4" *Medium:* Oil

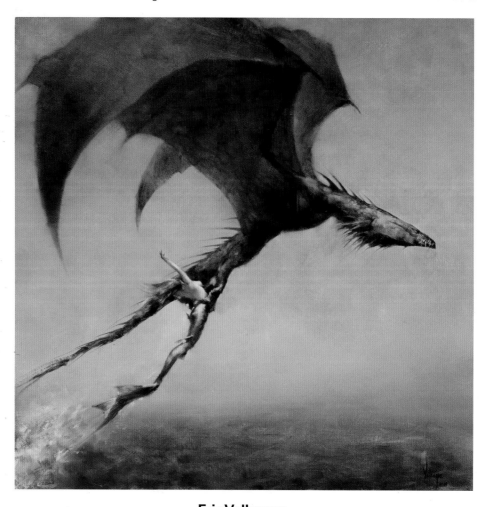

Eric Velhagen

Title: Fantasy Feast *Size:* 24"x24" *Medium:* Oil

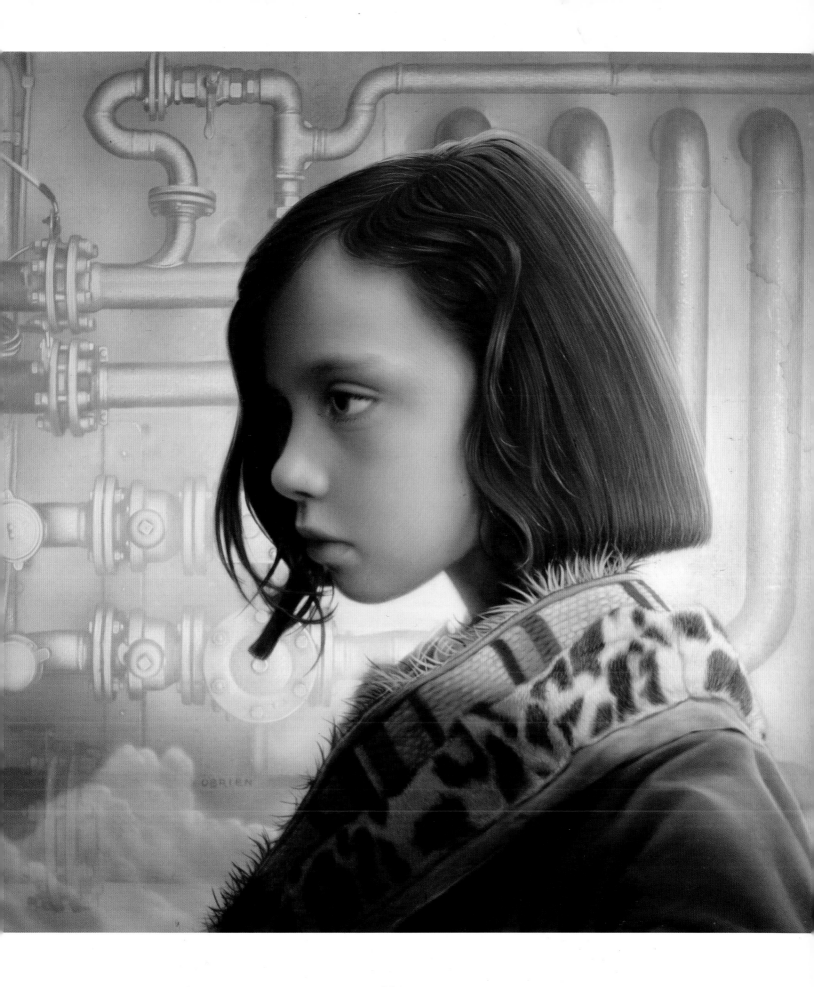

Tim O'Brien

Title: 101 Ella *Size:* 18"x18" *Medium:* Oil on panel

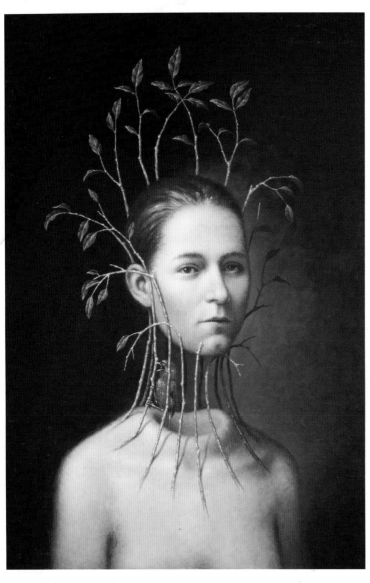

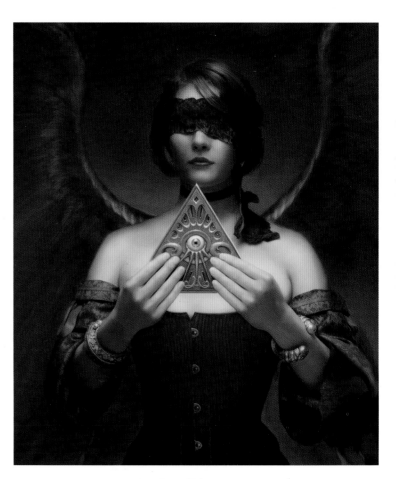

Lee Moyer

Title: Thedora *Size:* 20″x26″ *Medium:* Oil/digital

Steven Kenny

Title: The Shout *Size:* 18″x26″ *Medium:* Oil on linen

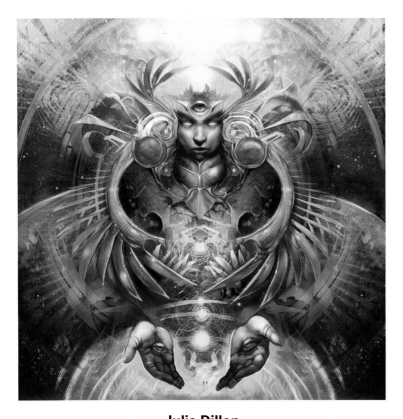

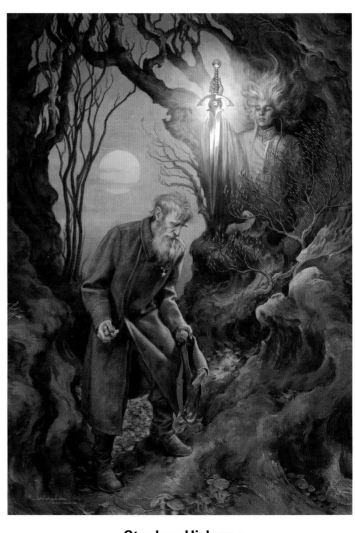

Julie Dillon

Title: Wat *Size:* 10″x8″ *Medium:* Photoshop

Stephen Hickman

Title: Apotheosis *Size:* 21″x31″ *Medium:* Oils

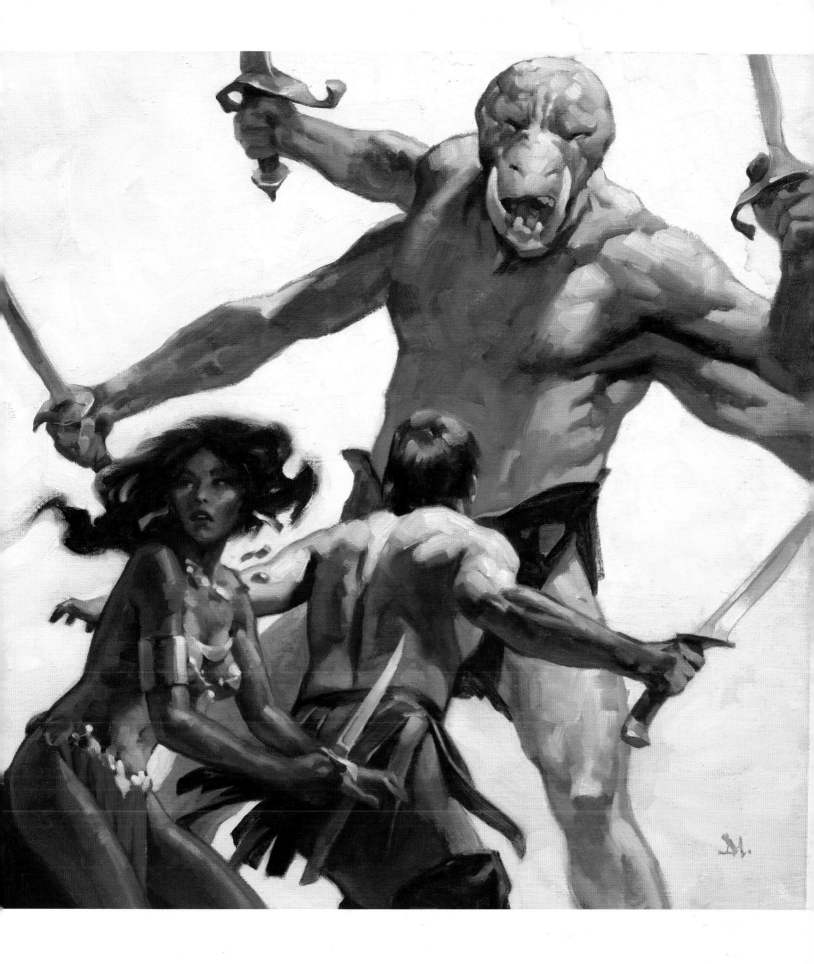

Gregory Manchess

Title: A Princess of Mars *Size:* 19"x19" *Medium:* Oil on linen

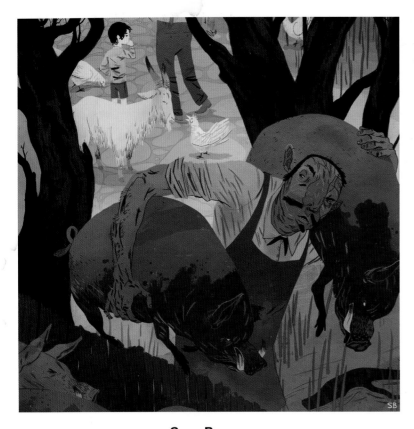

Sam Bosma

Art Director: Allan Comport *Title:* The Butcher *Medium:* Digital

Gino Acevedo

Title: Angelic Reaper *Size:* 11"x17" *Medium:* Photoshop

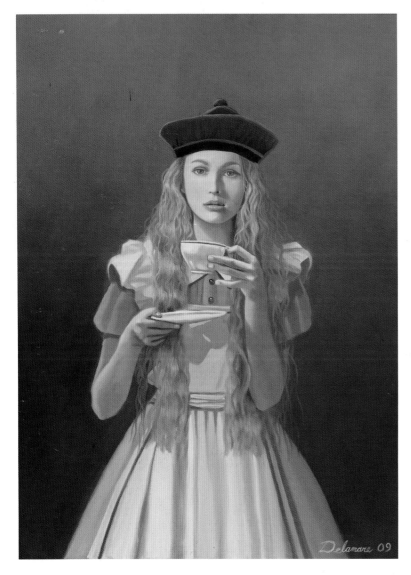

David Delamare

Client: Bad Monkey Productions *Title:* Alice *Size:* 18"x24" *Medium:* Oil

Cathie Bleck

Title: In Awe of Life Itself *Size:* 18"x24" *Medium:* Mixed

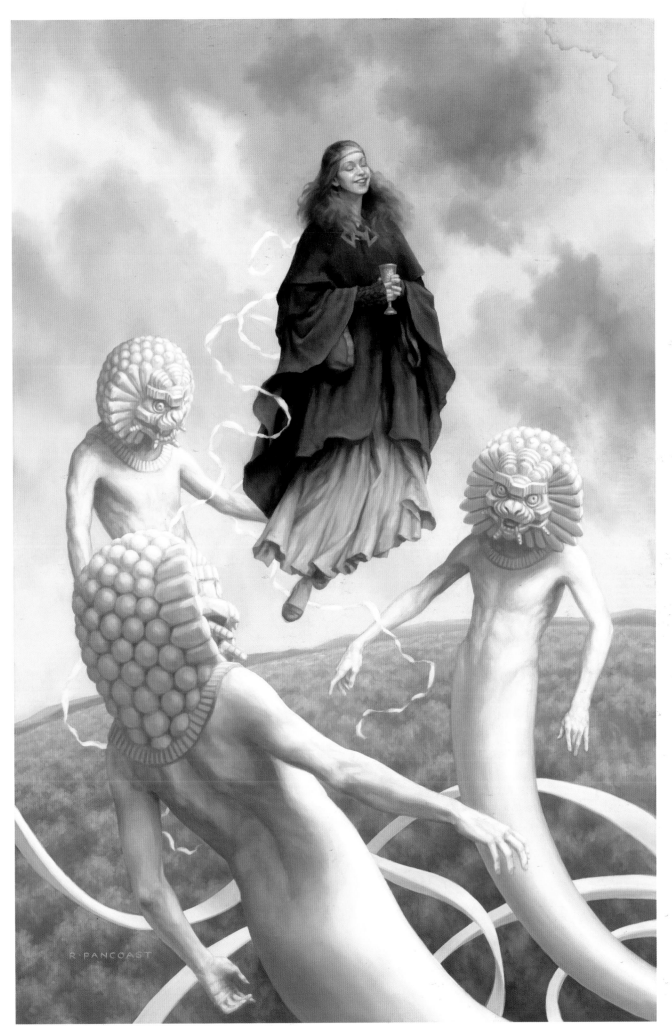

Ryan Pancoast

Title: Wind Spirits *Size:* 24"x36" *Medium:* Oil on canvas

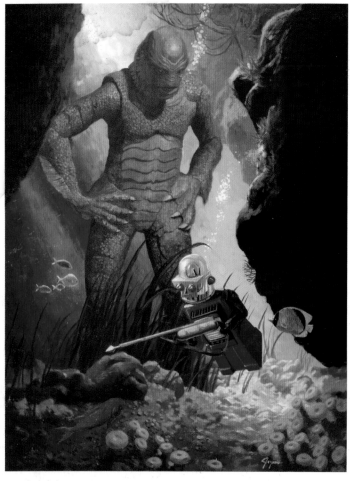

Eric Joyner

Client: Mark glassy *Title:* Looking For Trouble *Medium:* Oil

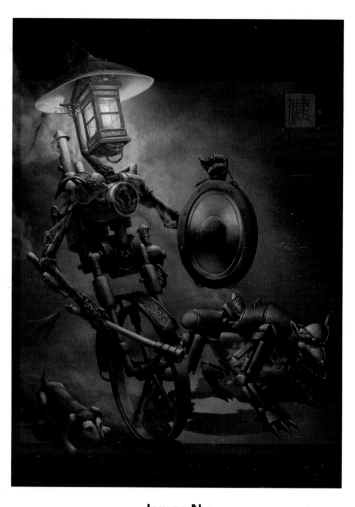

James Ng

Title: Night Patrol *Size:* 11"x15" *Medium:* Pencil/digital

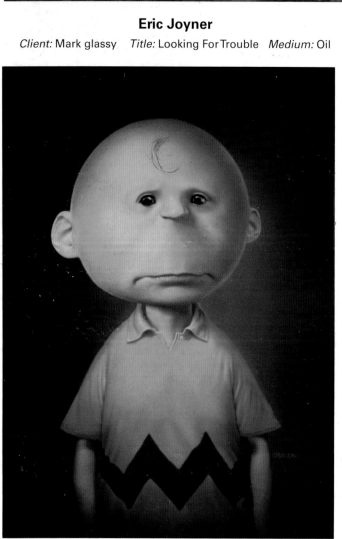

Tim O'Brien

Title: Chuck Brown *Size:* 14"x20" *Medium:* Oil on board

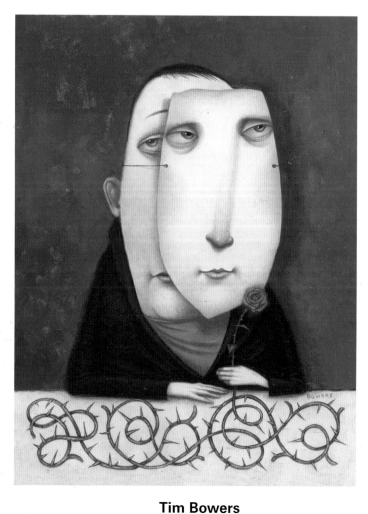

Tim Bowers

Title: 2 Faced *Size:* 12"x16" *Medium:* Acrylic on board

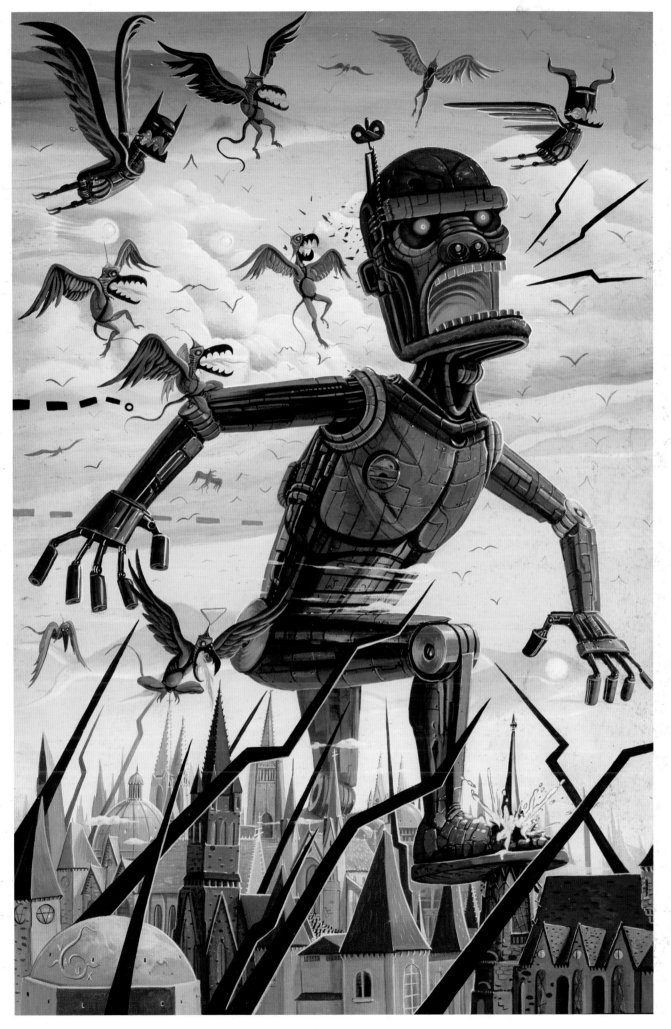

Joe Vaux

Title: Part 2 *Size:* 16"x24" *Medium:* Acrylic on panel

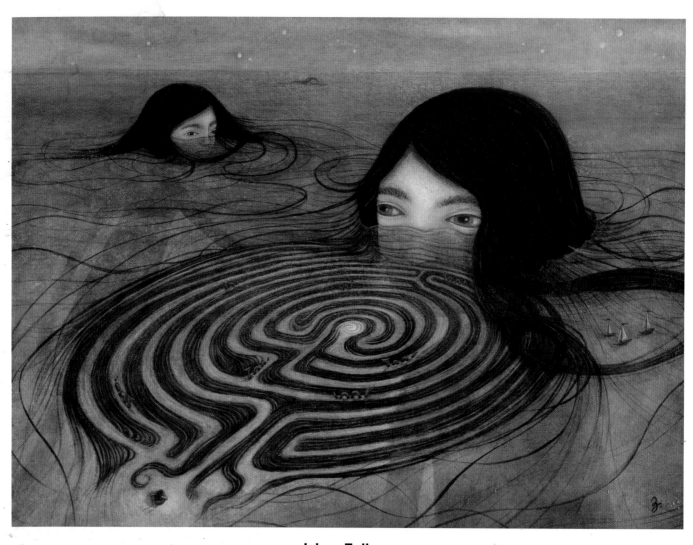

Jaime Zollars
Title: The Maze. She Breathes. *Size:* 10"x7" *Medium:* Acrylic/graphite/ink

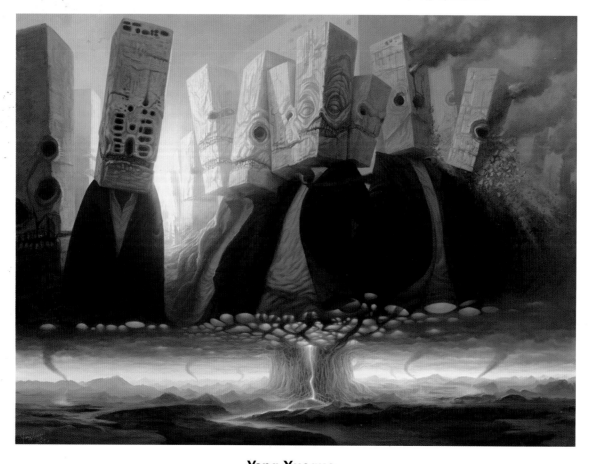

Yang Xueguo
Title: Concrete 9 *Size:* 4000x3000px *Medium:* Digital

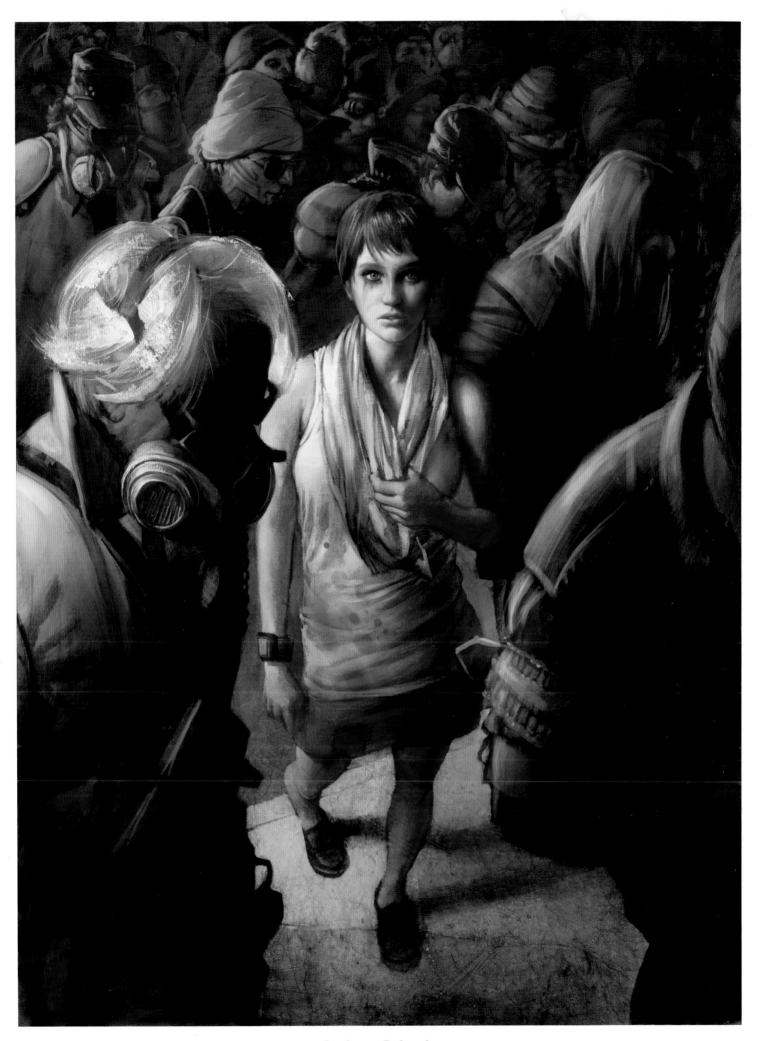

Anthony Palumbo

Title: Move Along *Size:* 18"x24" *Medium:* Oil/digital

John Watkiss

Title: Ring of Roses *Size:* 24"x36" *Medium:* Acrylic

Rene Zwaga
Title: Eternal Glory *Size:* 100x110cm *Medium:* Oil

Antonio Javier Caparo
Title: Sleeping Beauty *Size:* 11"x16" *Medium:* Digital

Yuta Onoda
Title: All is Mine *Size:* 17"x16" *Medium:* Mixed/digital

Dave McKean

Title: Faust *Size:* 110x110cm *Medium:* Mixed

Joe Vaux

Title: Ooze and Oz *Size:* 32"x24" *Medium:* Acrylic on wood

Shelly Wan

Art Director: Sonny Liew *Liquid City 2* *Medium:* Digital

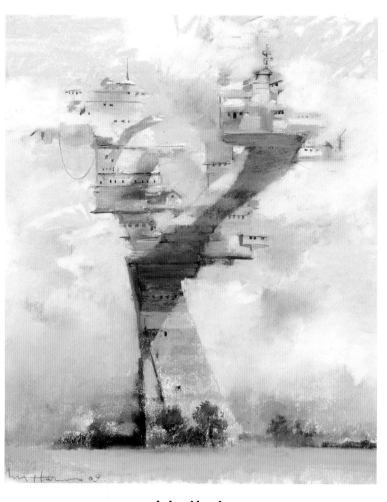

Matt Duquette
Title: A New Day *Size:* 15"x20" *Medium:* Acrylic on board

John Harris
Title: Tree Town *Size:* 10"x14" *Medium:* Pastels

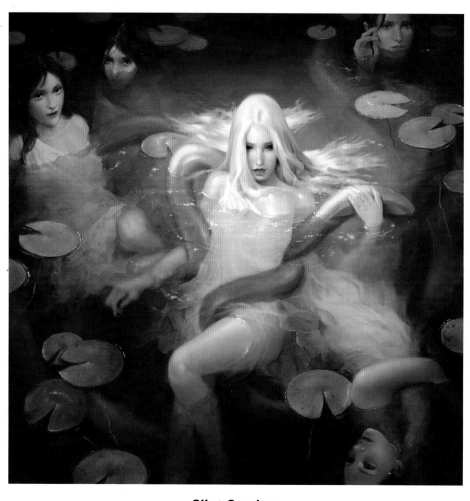

Clint Cearley
Title: The Naiads *Size:* 16 5/8"x 16 5/8" *Medium:* Digital

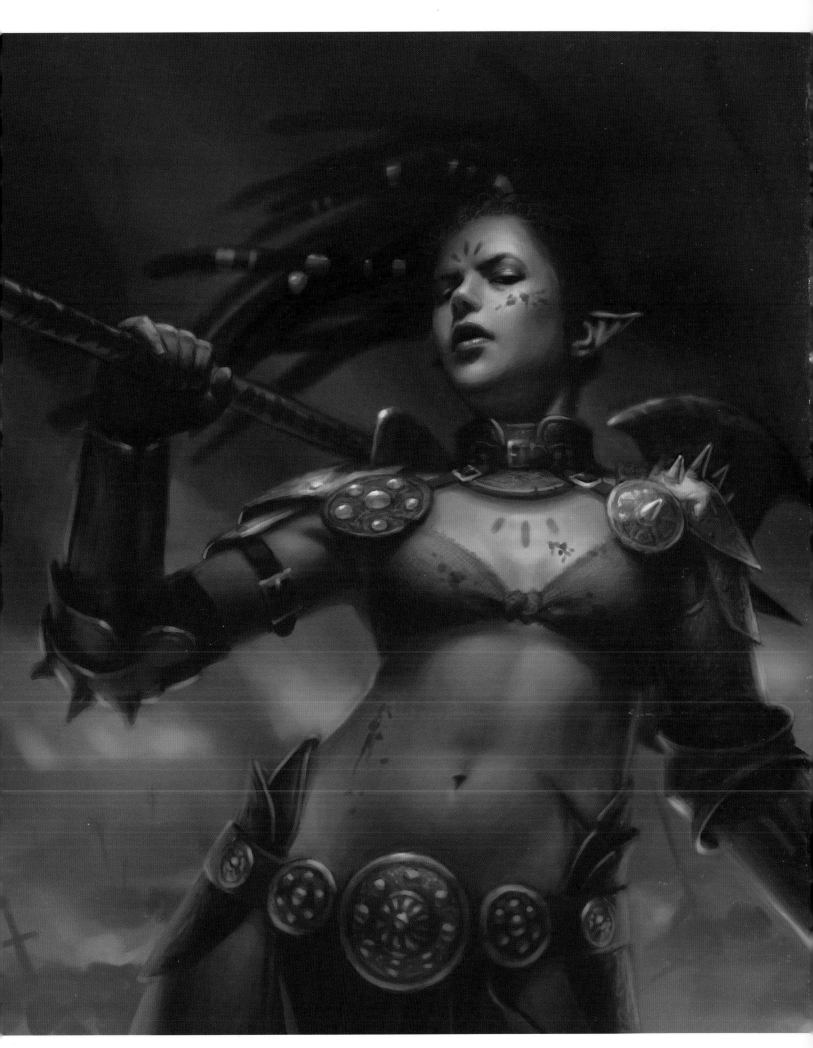

Winona Nelson

Title: Battle Elf *Size:* 10"x11 1/2" *Medium:* Photoshop

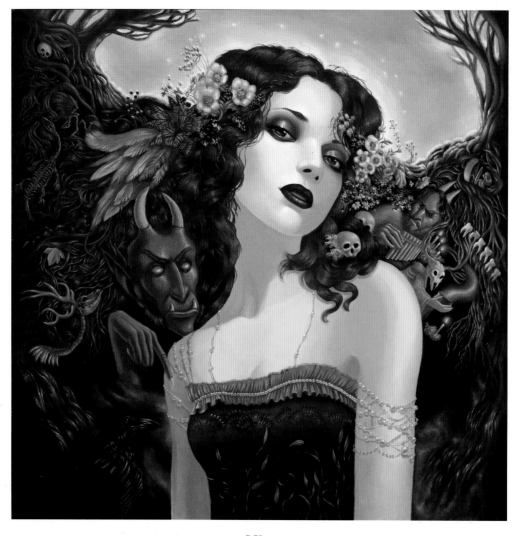

Mia

Client: Murphy Design *Title:* Persephone *Size:* 18"x18" *Medium:* Acrylic on wood

Scott Gustafson

Title: The Imaginary Invalid *Size:* 16 3/4"x13" *Medium:* Oil on panel

Mark Zug

Title: Helium *Size:* 24"x24" *Medium:* Oil on canvas

Larry MacDougall 191
mythwood.blogspot.com

Jim Mahfood 22, 114
c/o Allen Spiegel Fine Arts
asfa@redshift.com
www.asfa.biz

Don Maitz 73
donmaitz@paravia.com

Emmanuel Malin 126, 127
www.emmanuelmalin.com

Gregory Manchess 45, 264, 271
15234 SW Teal Blvd #D
Beaverton, OR 97007

Matt Manley 262
www.mattmanley.com

Slawomir Maniak 134
www.maniak.com

Julie Mansergh 146, 149
julie@faeriesintheattic.com

Andrew Martin 140
monstercaesar.com

Jack Mathews 137

Stephan Martiniere 71, 107, 131
www.martiniere.com

Jorge Mascarenhas 31
1940 Franciscan Way, #216
Alameda, CA 94501

Yukari Masuike 178, 204
toronn0423@gmail.com
toronn.daa.jp

Jonathan Matthews 151
matthewsculptor.com

Gabriel Matula 256
hello@gabrielmatula.com
www.gabrielmatula.com

Chris McGrath 84
www.christianmcgrath.com

Erin McGuire 208
emcguirestudio@gmail.com
www.emcguire.net

Dave McKean 109, 252, 280
c/o Allen Spiegel Fine Arts
asfa@redshift.com
www.asfa.biz

David Meng 140, 141
mengdavid.2010@gmail.com
davidmengart.blogspot.com

Petar Meseldzija 25, 217
Kogerwatering 49
Koog a/d Zaan 1541 XB
NETHERLANDS
www.petarmeseldzija.com

Mia 235, 284
mia@art-by-mia.com

Aaron Miller 194
www.aaronbmiller.com

Ian Miller 243
wasphelm@ntlworld.com
www.ian-miller.org

Thomas O. Miller 256
11523 Kemper Woods Dr
Cincinnati, OH 45249
tomiller@atomicart.com

Bruce D. Mitchell 142, 143
swornluddite@yahoo.com
conceptualexecutioner.blogspot.
com

Christopher Moeller 203
www.moellerillustrations.com

Jean-Baptiste Monge 44, 205
mongejb@gmail.com
www.jbmonge.com

Clayburn Moore 153
service@csmoorestudio.com
www.csmoorestudio.com

Annaliese Moyer 244
am@stagerightphoto.com
www.stagerightphoto.com

Lee Moyer 270
(503) 737-3344
www.leemoyer.com

Sean "Muttonhead" Murray 227
sean@seanandrewmurray.com
www.seanandrewmurray.com

Mark Nagata 145
www.maxtoyco.com
www.marknagata.com

Vince Natale 60
18 Van De Bogart Rd
Woodstock, NY 12498
www.vincenatale.com

Mark A. Nelson 197, 206
www.grazingdinosaurpress.com

Winona Nelson 283
www.winonanelson.com

Mark Newman 136
newmanmark@sbcglobal.net
www.marknewmansculpture.com
marknewman.deviantart.com

James Ng 274
House #253, Seasons Monarch
183 Kam Tin Road
Kam Tin, Yuen Long
Hong Kong
jamesngart@gmail.com

Victo Ngai 164, 240
victo@victo-ngai.com
www.victo-ngai.com

Tran Nguyen 236
mail@trannguyen.org
www.trannguyen.org

Cliff Nielsen 60
c/o Hachette/Orbit Books
www.hbgusa.com

Terese Nielsen 178
tnielsen.com

Billy Norrby 251
billy_norrby@hotmail.com
billynorrby.com

Lawrence Northey 142
1574 Gulf Road
Point Roberts, WA 98281
lawrence@robotart.net

Tim O'Brien 269, 274
(718) 282-2821
obrienillustration@me.com

William O'Connor 82
woconnor@wocstudios.com
www.wocstudios.com

Rafal Olbinski 206
142 E 35th St
New York, NY 10016
olbinskiart@yahoo.com

Yuta Onoda 165, 279
407 Drewry Ave
North York, ON M2R 2K3
CANADA
yuta@yutaonoda.com

Glen Orbik 185, 232
glenandlaurel@earthlink.net
www.orbikart.com

Eric Orchard 95
12 Thirty Third St
Toronto, ON M8W 3G8
CANADA
www.ericorchard.com

Augie Pagan 238
augiejp@gmail.com
www.augiepagan.com

Nina M. Pak 208
www.ninapak.com

John Jude Palencar 62, 63, 74, 177
www.johnjudepalencar.com

Anthony Palumbo 277
anthonypalumbo.palumbo@gmail.
com

David Palumbo 49, 200
dave@dvpalumbo.com

Ryan Pancoast 273
ryanpancoast@gmail.com
www.ryanpancoast.com

Doug Panton 238
www.dougpanton.com
www.theispot.com/dpanton

Andy Park 114
andyparkart@aol.com
www.andyparkart.com

Brad Parker 238
brad@tikishark.com
www.tikishark.com

Mike Pedro 122
www.mpedro.com

Eduardo Peña 230
caareka20@hotmail.com
chino-rino2.blogspot.com

Michael Phillippi 237
c/o Sloth Productions LLC
PO Box 2609
Mandeville, LA 70470-2609
www.slothproductions.com

Craig Phillips 246
(212) 333-2551
www.craigphillips.com.au

John Picacio 67, 68
www.johnpicacio.com

Jerome Podwil 218, 228
108 W 14th St
New York, NY 10011
(212) 255-9464

RK Post 206
postrk@aol.com
www.rkpost.net

Dave Pressler 143
705 N Arden Dr
Beverly Hills, CA 90210

Nigel Quarless 192
nigel@nlgames.com

Joe Quinones 106, 114
me@joequinones.net
joequinones.blogspot.com

Chris Rahn 205
chris@rahnart.com
www.rahnart.com

Patricia Raubo 222
www.patriciaraubo.com

Omar Rayyan 40, 87, 214, 260
(508) 693-5909
www.studiorayyan.com

Kirk Reinert 229
42 Longview Rd
Clinton Corners, NY 12514

Owen Richardson 78
325 North 200 West
Salt Lake City, UT 84103

Mike Rivamonte 152
mike@mrivamonte.com
www.mrivamonte.com

Paolo Rivera 98, 99, 107
mail@paolorivera.com
paolorivera.blogspot.com

Irvin Rodriguez 249
www.irvin-rodriguez.com

Jose Roosevelt 110
webmaster@juanalberto.ch
www.juanalberto.ch

Virginie Ropars 138, 148
vropars.free.fr

Jean-Sebastien Rossbach 88,
89, 204
livingrope.free.fr

Luis Royo 81, 83
c/o Alan Lynch Artists
www.alalynchartists.com

Steve Rude 114
steve@steverude.com
www.steverude.com

Robh Ruppel 162, 231
robhrr@yahoo.com
www.robhruppel.com

Carlos Ostos Sabugal 245
www.circusdivas.com

Ritche Sacilioc 119
12212 Otsego St
Valley Village, CA 91607

Dan Santat 72, 90
257 Hampden Terr
Alhambra, CA 91801
www.dantat.com

Dominick Saponaro 249
don@swashbucklestudio.com

Marc Sasso 128
blkmetal1@aol.com

Bente Schlick 83
webmaster@creativesoul.de
www.creativesoul.de

Dan Seagrave 24, 37
dan@danseagrave.com
www.danseagrave.com

Dave Seeley 78
seeley@daveseeley.com
www.daveseeley.com

David Seidman 31
dseidman@comcast.net
www.davidseidman.com

Jason Seiler 128

Erwan Seure-Lebihan 104
erwan.seurelebihan@free.fr

Cynthia Sheppard 259, 268
www.sheppard-arts.com

Rob Sheridan 230
www.rob-sheridan.com

R. Ward Shipman 196
(905) 387-2504
www.guyinaboat.com

James Shoop 150
316 N Adams St
Saint Croix Falls, WI 54024

David Silva 146
160 Overlook Ave
Apt 19C
Hackensack, NJ 07601

Andrew Silver 214
andrew@andrewsilverart.com
www.andrewsilverart.com

Thomas Simpson 247
13 Tanera Crescent
Brooklyn
Wellington 6021
NEW ZEALAND
artoftomsimpson@gmail.com

Andrew J. Sinclair 139
+44 (0) 1296 620099
info@andrew-sinclair.com
www.andrew-sinclair.com

Jeff Slemons 48
jeffslemons@mindspring.com
www.comicspace.com/slembot

Matt Smith 60
matt@mattksmith.com

Herman Smorenburg 253
Hargewaard 24
Alkmaar 1824 TC
NETHERLANDS
www.hermansmorenburg.com

Katarina Sokolova 77
c/o Alan Lynch Artists
www.alanlynchartists.com

Allen Song 248
(510) 334-5471
www.allensong.com

Joel Spector 162
joel@joelspector.com
www.joelspector.com

Hethe Srodawa 132
www.hethe.com

Derek Stenning 182, 183
derek.stenning@gmail.com
borninconcrete.blogspot.com

David Stevenson 130
www.davidstevenson.com
davidstevenson.blogspot.com

Matt Stewart 201, 202
matt@matthew-stewart.com
www.matthew-stewart.com

Frank Stockton 178, 179
frank@frankstockton.com
www.frankstockton.com

Barron Storey 255
c/o Eidolon Fine Arts
eidolonfinearts@gmail.com

William Stout 57, 92, 93
www.williamstout.com

Philip Straub 133
www.philipstraub.com

Haitao Su
Mailbox No. 33
Nangang Post Office
Harbin Heilongjiang 150001
CHINA

Carissa Susilo 132
carissa-s.blogspot.com

Raymond Swanland 36, 82, 103, 111
raymond@oddworld.com
www.raymondswanland.com

Greg Swearingen 65, 68
(503) 449-8998
www.gregswearingen.com

Justin Sweet 115
www.justinsweet.com

Carisa Swenson 150
www.carisaswenson.com

Sym 7 146
jbredy@aol.com

Gabor Szikszai 169
studio@boros-szikszai.com

Steven Tabbutt 94
stovetabbutt@nyc.rr.com
www.steventabbutt.com

Chuck Tam 147
chuckakaballistyc@hotmail.com

Sharon Tancredi 57
c/o Hachette/Orbit Books
www.hbgusa.com
www.sharontancredi.com

Carolina Tello 214
www.caotello.com

Ben Templesmith 68, 116
contact@templesmitharts.com
www.templesmith.com

Thom Tenery 120, 130
ttenery@gmail.com
www.thomlab.com

Heather Theurer 212, 237
h_theurer_artwork@yahoo.com
www.heathertheurer.com

Brian Thompson 121, 133
bthompsonart.blogspot.com

Keith Thompson 79
k@keiththompsonart.com
www.keiththompsonart.com

Richard Tilbury 35
ibex80@hotmail.com
www.richardtilburyart.com

Brian Valenzuela 250
bval@brianvalenzuela.com
www.brianvalenzuela.com

Boris Vallejo 175, 181
bjartists@aol.com

Cyril van der Haegen 167, 265
tegehel@cox.net
www.tegehel.org

Joe Vaux 275, 280
joe@joevaux.com
www.joevaux.com

Eric Velhagen 265, 268
(505) 872-9149
www.ericvelhagen.com

Ursula Vernon 199
ursulav@metalandmagic.com
www.redwombatstudio.com

Charles Vess 44, 157, 252
c/o Green Man Press
152 E Main St, #1E
Abingdon, VA 24210
charles@greenmanpress.com

Vincent Villafranca 145, 156
www.villafrancasculpture.com

Raoul Vitale 195, 261
www.raoulvitaleart.com

Adam Volker 194
adam@moonbotstudios.com

John Watkiss 278
c/o Eidolon Fine Arts
eidolonfinearts@gmail.com
www.eidolonfinearts.com

Shelly Wan 281
c/o Eidolon Fine Arts
eidolonfinearts@gmail.com
www.eidolonfinearts.com

Stan Watts 231
stanwatts@sbcglobal.net

Jonathan Wayshak 222
(408) 823-4620
www.scrapbookmanifesto.com

Sam Weber 20, 60, 61, 159
sam@sampaints.com
www.sampaints.com

Claire Wendling 83, 88
www.claire-wendling.net
www.stuartngbooks.com/
wendling.html

Michael Whelan 39, 91
www.michaelwhelan.com

Tom Whittaker 140
420 Midstreams Rd
Brick Town, NJ 08724
whittakertom@yahoo.com

Grim Wilkins 108, 110
grimwilkins@gmail.com
www.grimwilkins.com

Allen Williams 203, 264
ijustdraw.blogspot.com

Doug Williams 260, 266
18210 19th Dr SE
Bothell, WA 98012
dugmunkey@hotmail.com

Kent Williams 28
c/o Allen Spiegel Fine Arts
asfa@redshift.com
www.asfa.biz

Martin Wittfooth 235, 241
info@martinwittfooth.com
www.martinwittfooth.com

Shawn G. Wood 127
shawn@sgwart.com
www.sgwart.com

Alena Wooten 144
alenawooten.blogspot.com
lilgizmo@gmail.com

Annie Wu 219
anniewuart@gmail.com
www.anniewuart.com

Yang Xueguo 276
Design College
Yunnan Arts Institute
Kunming Yunnan 650031
CHINA
yangxueguo@gmail.com

Paul Youll 74
c/o Alan Lynch Artists
www.alanlynchartists.com

Stephen Youll 24, 45
www.stephenyoull.com

Jaime Zollars 276
jaime@jaimezollars.com
www.jaimezollars.com

Mark Zug 56, 196, 285
www.markzug.com

Chrissie Zullo 101
chrissiez.blogspot.com

Rene Zwaga 279
rene@zwaga.com
rene.zwaga.com

Su Hai Tao 168
Mailbox No.33, Nangang Post Office
Harbin Heilongjiang, CHINA
150001
suhaitao.blogspot.com

Be one of the best.

The Spectrum Annual is the result of a juried competition sponsored by Spectrum Fantastic Art LLC.
Artists, art directors, designers, students, and publisher who would like to receive a Call For Entries poster (which
contains complete rules and forms necessary to participate) can send their name and address to:

SPECTRUM FANTASTIC ART
P.O. Box 4422
Overland Park, KS 66210
Or e-mail us via the official website: **www.spectrumfantasticart.com**

Posters are mailed out in October each year.